The Art of Gupta India

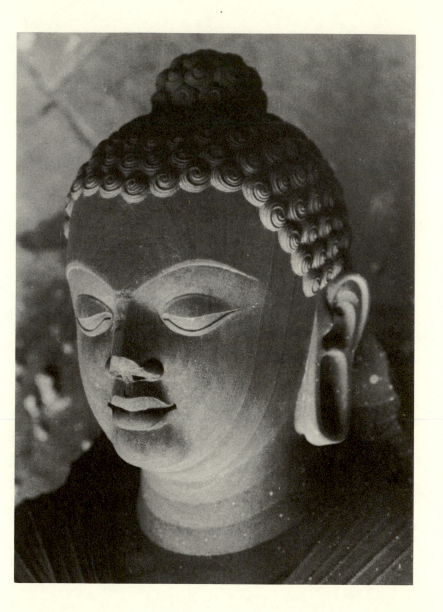

The Art of
GUPTA INDIA

Empire and Province

J OANNA G OTTFRIED W ILLIAMS

Princeton University Press
Princeton, New Jersey

This book has been composed in Linotron Bembo
Designed by Barbara Werden
Clothbound editions of Princeton University Press books are printed on acid-free paper,
and binding materials are chosen for strength and durability

Printed in the United States of America by
Princeton University Press, Princeton, New Jersey
Illustrations printed by Meriden Gravure Company, Meriden, Connecticut

Library of Congress Cataloging in Publication Data

Williams, Joanna Gottfried, 1939-
 The art of Gupta India.

 Bibliography: p.
 Includes index.
 1. Architecture, Gupta. 2. Temples, Hindu.
3. Sculpture, Gupta. 4. Sculpture, Hindu. I. Title.
NA6002.W5 722'.44 81-13783
ISBN 0-691-03988-7 AACR2
ISBN 0-691-10126-4 (lim. pbk. ed.)

To Dylan,
who has played on many Gupta ruins

Contents

List of Figures

List of Plates

All photographs are those of the author unless otherwise noted.

Acknowledgments

Like many a foreign researcher in India, I am grateful for the warm good will of countless people of that country, ranging from central officials to villagers who ply the visitor with tea and permit the relics of their past to be studied. Above all among Indian scholars, I should single out Professor K. D. Bajpai, whose wisdom and kindness guided my work for a year; if the regions of Bundelkhand and Mālwa are over-represented in this volume, it is the result of my stay in the ashram-like atmosphere of Sagar University. Other Indian scholars who have helped and inspired my work on Gupta art, often by all-too-brief conversation, include Dr. U. P. Shah, Dr. R. C. Agrawala, Dr. P. L. Gupta, Dr. N. P. Joshi, Dr. S. R. Goyal, Mr. R. C. Sharma, Mr. M. A. Dhaky, and Mr. Krishna Deva. All have shared their ideas generously but may well disagree with the outcome here. The offices of the Archaeological Survey of India in New Delhi have been a friendly haven, providing not only official permission for my work and the use of their library and photograph collection, but also a friendly exchange of information and ideas. It is impossible to thank the staff of every museum that has welcomed me and allowed me to photograph their Gupta objects; to them the photo captions must convey my gratitude.

I am deeply indebted to James Harle and Walter Spink, who have taken interest in my work over the years, read this manuscript carefully, and made many acute suggestions. Both are models of the rigorous but encouraging guru. In specific areas, I have picked the brains of Frederick Asher, Wayne Begley, Susan Huntington, Michael Meister, and Sara Schastok. My own graduate students have been involved willy-nilly in this project. Donald Stadtner has turned from student to valued colleague in the process. Nancy Hock, Padma Kaimal, Mary Linda, and John Seyller have worked on the manuscript. And Judith Patt labored long over the drawings.

My work in India on the present topic was made possible by grants from the American Institute of Indian Studies (in 1965-1966 and 1974-1975) and from the Center for South and Southeast Asian Studies of the University of California at Berkeley (in 1969). The Center for Art and Archaeology of the AIIS in Vārāṇasī has supplied much practical assistance. The

writing and preparation of the manuscript have been supported over the years by the Committee on Research of the University of California at Berkeley. Finally, I am delighted to be able to thank the staff of Princeton University Press for their labors on this book, in particular Christine Ivusik for her understanding enthusiasm throughout two years of preliminaries, and Dr. Margaret Case for her meticulous, thoughtful, and informed editing.

List of Abbreviations

ASI	*Archaeological Survey of India, Reports* (Cunningham Series)
ASIAR	*Archaeological Survey of India, Annual Reports*
ASIPR, NC	*Archaeological Survey of India, Progress Reports, Northern Circle*
ASIPR, WC	*Archaeological Survey of India, Progress Reports, Western Circle*
CII	*Corpus Inscriptionum Indicarum*
EI	*Epigraphia Indica*
GAR	*Gwalior Archaeological Reports*

The Art of Gupta India

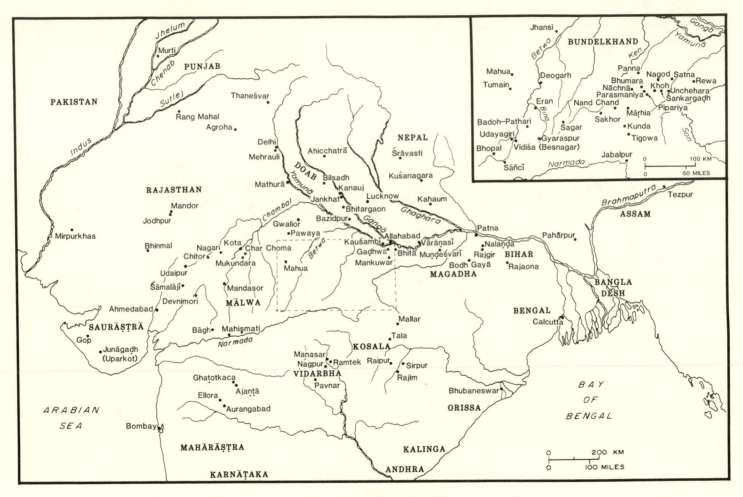

Fig. 1. Map of North India

Introduction
ISSUES AND METHODS

A central problem for any work that deals with Gupta sculpture and architecture is the very meaning of that label, Gupta. For a reader new to India and its art, the question may seem to be one of labels in general. Categorization, in particular periodization, inevitably violates the integrity of the individual artist and work of art. Many art historians these days are acutely aware of these dangers. And yet we may at times legitimately bring together works that are contemporary and related. This enterprise seems, in fact, necessary in order to articulate the long development of Indian art, where no consensus and few theories exist concerning major sequences or breaks in sequences. The question remains, when and where do we stop in casting a net of significant relationship?

To a reader familiar with India, the problem may seem a matter of dynastic terminology per se, for Gupta is the name of a family of so-called emperors. Literary historians have generally avoided political periodization. Historians of Indian art are moving in the same direction, expressing a certain dissatisfaction with the dynastic divisions that are traditionally in use.[1] Even

political historians today recognize that the genealogy of rulers governs only superficially the events of ancient India.[2] On the one hand, the accessibility of lists of kings in inscriptions and, on the other hand, parallels to a simplified view of European history have encouraged the use of a dynastic model. Yet if the term Gupta Rāj occasionally occurs in the present work, I do not propose to cast Samudragupta in the role of Queen Victoria.

For this book, then, the political connection is a secondary aspect of the images and temples considered, not a primary basis for their selection. The basis for that selection lies in the works themselves. Broadly speaking, Gupta carvings seem to me designed primarily as works of art, composed deliberately (if with varying success) as aesthetic objects. For both earlier and later periods of sculpture, this is not the rule. This formal status does not imply a lack of concern with what is ultimately religious content. Like Sanskrit poetry, and not just the poetry that is contemporary to it, Gupta art has a strongly intellectual flavor, whatever its theme. The art considered here balances a certain rep-

1. P. Chandra, "Study of Indian Temple Architecture," pp. 35-36.
2. Philips, *Historians of India, Pakistan and Ceylon*, p. 3 and *passim*.

Thapar, *Communalism and the Writing of Indian History*, p. 19.

resentational credibility with abstracting tendencies.

These shreds of definition are, of course, too vague to indicate why a given work has been included. For that, a catalogue of specifics would be necessary, which would at this point be both tedious and inconclusive. No motif or particular detail is either necessary or sufficient. Only in the discussion of the actual works of art can their inclusion be justified.

Clearly the limits of this book are not those of the Gupta empire. Nor are we to expect direct Gupta patronage for the principal monuments. It is instructive if ironic that the only works whose donor is clearly a Gupta emperor are three images dedicated by Rāmagupta (Plates 12-15), the ephemeral and ignominious brother of Candragupta II, under whose rule in the late fourth century the style that we call Gupta commences. Again, however, in the broader perspective of art history as a discipline it is today recognized that the role of patronage in informing the work of art may easily be exaggerated. The absence of imperial donors in India should not overly distress us.

The political label does, however, seem significant and is retained here for reasons beyond simple convenience. At least in the late fourth and fifth centuries, I would like to argue that there is a real relationship between political climate and the development of art. The evasive term climate is used deliberately, for it is clearly not political control or institutions that are at stake. The existence of roads and the possibility of communication may explain the truly imperial extent of the

Gupta style, beyond the sway of Gupta administration. Equally important are the claims, in the first place to dominion on the part of the Guptas themselves, and in the second place to rivaling the Guptas on the part of their successors. These claims must have encouraged the spread of a common artistic idiom across a broad area. It thus seems that the Guptas were responsible less for the form of Gupta art than for its extent. Two periods in the history of Indian art that might justify a comparable imperial label are the Maurya and the Mughal. In both cases, there is room for reconsideration of the assumption that the dynasty directly conditioned works of art.[3]

If our overall program is to delimit a style in its own terms and to consider the relation between this style and a putative empire, it remains necessary to plot this style on a more precise grid. A three-dimensional image includes significant coordinates of time, place, and social level. Of these, the last may seem the most controversial. The social level of patron or artist is infrequently documented in ancient India. Yet it is possible to distinguish some works in their own terms as *jungli* or folkish. This quality should be appreciated in its own right and not equated with inferiority. The social dimension is not discussed for every work in the following study, in part for lack of evidence but in larger part because the forms of Gupta art belong with unusual consistency to the Great or Sanskritic Tradition. Even here, an occasional difference between images can be understood as a matter of less urbane taste: for exam-

3. The association of the early Indian columns with Aśoka has been challenged by John Irwin in a series of articles in *The Burlington Magazine*, 1973-1976. Similar revisions are implicit in Pramod Chan-

dra's work on Popular Mughal painting in *Lalit Kalā* VIII, and in the recent discovery of an astrological treatise painted for Mirza Aziz Koka, Akbar's foster brother.

ple, a variant version of the Buddha's First Sermon (Plate 93), or a cave dedicated by a tribal ruler in central India (Plate 35). It is at least worth recognizing this as a contextual basis for some differences in form among works produced at a single place and a single point in time. In the realm of content, moreover, folk themes will be seen frequently taking on the style of fine art in this period: for example, the subjects of Durgā killing the Buffalo Demon or the seven Mother Goddesses.

The second dimension to which I have referred, the spatial one, accounts for the paucity of examples in this book drawn from non-Indian museums and private collections, as well as the total absence of portable bronze images. There are so many works for which a provenance is known that I have excluded those for which one is not. This concern with location is part of a groundswell in Indian studies as a whole, usually centering on the definition of a region as it changes through time.[4] In the history of Indian art, regional studies proliferate, some of which cover the material treated here with a more limited geographical scope and a broader chronological one. In fact, one of the most controversial theses in this book is that unifying forces transcended regional ones in the core period, A.D. 370 to 550. The political theme mentioned initially may to some extent explain the spread of artistic norms. In addition, a more strictly geographical force seems to me the role of Mathurā as a pilgrimage center. This must have outweighed any other center or *tīrtha* for all three major religions of north India, and its workshops must

have had a widespread impact, whether by means of the actual export of images and artists or by means of more loosely defined prestige.[5] Pilgrimage exists as a counterforce to regional diversity in many periods. Why this should be of greater import in the Gupta age than in others I cannot explain. In fact, art testifies more clearly than any other kind of evidence to the role of Mathurā at this point. The fact that Gupta Mathurā was neither the capital nor apparently an important administrative center leads me to see this as a force separate from the political one. Perhaps the symbiotic effect of the two can one day be studied.

The third dimension for placement of a work of art, that of time, needs least defense, except insofar as my dating of specific works may become the focus of specialists' disagreement. Indeed, chronology is an integral part of every thesis presented here. For example, the denial of the role of western India as a source for Gupta forms presupposes a relatively late dating for the monuments of that area. I am embarrassed to admit that in the early stages of this manuscript, the temporal dimension was my central concern, and I thought of my task as the traditional one of establishing a chronology for Gupta art. The perceptive reader will distinguish layers in the writing as I became progressively interested in other matters. I now think of chronology as the warp of art history. Thus a study dealing with dates alone seems as insubstantial as a loom that has been strung but awaits the woof of place and the pile of social context. It is only from the completed fabric that

4. Crane, *Regions and Regionalism*.
5. For a general consideration of the role of *tīrthas*, see Bharadwaj, *Hindu Places of Pilgrimage*. For a sense of the dynamics of transmission, not only by pilgrims visiting Mathurā but also by peripatetic artists, see Hein, *Miracle Plays of Mathurā*.

patterns emerge, which are the proper concern of the art historian.

Yet chronology is implicit as an issue not only in much of the discussion of individual works but also in the sequence in which these are presented. The broad distinctions of three phases (corresponding to Chapters II, III, and IV) seem to me more important than the precise years given in the plate captions with the intention of clarifying what are on the whole only hypothetical dates. Even decisions about the placement of a monument in one phase or another are often tentative, and I have changed my mind in a few cases quite late in the writing.

The methods by which I have arrived at a chronology are, frankly, eclectic. In general, external criteria are invoked first, less from faith in their conclusiveness than as a means of getting these out of the way before discussion that brings us in contact with the work of art itself. Few inscriptions establish a date without leaving some controversy about their interpretation or applicability. Archaeological excavation does not provide even a relative sequence into which we can place any major works with confidence. Precise parallels between sculpture and coinage are rarer in the Gupta period than, for example, in the Kushan, although some coins are included as works of art in their own right. When the iconography of an image can be related to a specific literary text, which is rare, one is invariably struck that the dates of literature are even less clear than those of the visual arts in India.

Thus one inevitably depends upon a method that French scholars have employed for South and Southeast Asian art, one which might be called the *analyse de motif*.[6] In brief, elements are isolated and placed in a convincing sequence of development in their own terms, on the supposition that it is more objective to deal systematically with parts than with the complex whole. That whole may, as a final stage, be dated on the basis of this relative sequence. Despite the fact that chronology is not my ultimate goal, insofar as I must order works of art I am profoundly indebted to this method. The following warnings are, however, important. The more elements that can be used in such an analysis the better, as the French themselves admit in the name of science. Nor need one expect each sequence to support the others. Failing objective dates (usually invoked by the French at a final stage), the sequences are determined by credibility in the mind of the scholar, and alternative arrangements remain possible. In dealing with sculpture, it is essential to consider characteristics that are not easily quantified, for instance the way the human body moves. These are certainly open to question by other viewers, but so are the very descriptions of architectural motifs. No area is ultimately objective. And finally, one must admit the possibility of deviations from general tendencies, not only by virtue of regional developments (admitted by the French), but also by virtue of the will of the artist and the peculiar demands of the particular work of art—its physical properties, its content, and its integrity in terms of design. Thus the development of motifs does not follow immutable rules, but rather represents possibilities, realized in specific cases

6. For example, Odette Viennot's *Temples de l'Inde centrale*; cf. Williams review.

by human choice. This belief leads me to submerge these developments in footnotes rather than to present them with the directness of many French publications. Readers who seek such clarity are referred to the index, where all examples of easily isolated motifs are brought together.

Ultimately it is the purpose of this book to relate works of art, selected on the basis of their aesthetic character and located on a grid of time, place, and social milieu, to factors outside the realm of art that may explain or correlate with their particular nature.[7] These outside factors include not only problematic political circumstances, but also intellectual and religious circumstances that govern the very conception of what carvings and buildings are. As is apparent from my remarks so far, the discussion weaves between style and iconography, in tribute to a belief that the most distinctive accomplishment of a work of art is the way in which its form and content are most clearly inseparable.

It might also be useful to indicate what this book is not. This is not a handbook, in the sense of a work including every possible Gupta example, or even every fine one. The realities of publication have sharply pared down the number of illustrations. In particular, I have eliminated many works reproduced in James Harle's excellent *Gupta Sculpture*.[8] Nor does the present work attempt to provide all possible information about monuments, as would an archaeological mongraph. For those cases in which such a monograph exists, the reader is referred to that. But such extended, descriptive treatment would be impossible here. Although coins and inscriptions are discussed as they bear upon the history of Gupta art, this book does not pretend to completeness in the spheres of numismatics or epigraphy.

Finally, a definition of my concept of the audience may be useful. Clearly this book is directed to historians of Indian art, and every effort has been made to enable scholars in the field to check and evaluate what is written. It is hoped that undergraduate students might be able to make their way through such a book; those at Berkeley gasp for works between the generalized text and the specialized article. It is also hoped that at least the conclusions may be of interest to readers who deal with India from the perspective of disciplines other than art history. Perhaps an understanding of Gupta art may even bring pleasure to those totally unfamiliar with Indian sculpture; with that aim, I have minimized the use of Sanskrit terminology by means of English equivalents. Some acquaintance with Indian religions is presumed, the sort which could easily be gained by reading a brief survey of the subject.[9]

7. My image of this relationship owes much to Michael Baxandall, *Painting and Experience in Fifteenth Century Italy*. Oxford: Clarendon Press, 1972.

8. Cf. Williams review. Another work, which appeared after the present manuscript was written, is Pratapaditya Pal's attractive catalogue, *The Ideal Image*. This addresses distinctly different problems from those treated in Harle's work or this volume. On the one hand, it accompanied an exhibit of sculpture in the United States; hence the deliberate inclusion of works without the unimpeachable credentials of those recorded in situ in India. On the other hand, Pal explicitly seeks to justify a thesis (going back to Coomaraswamy) that the claim to glory of Gupta sculpture rests on its impact on other ages and places; hence the inclusion of works from the seventh century in India, from T'ang China, and from much of Southeast Asia.

9. For example, Basham, *The Wonder That Was India*.

Chapter I
THE POINT OF DEPARTURE

In the second century A.D., a large swath of north India was ruled by foreigners. These were the Kushans, who had made their way down from the steppes of Central Asia, across Afghanistan and Pakistan, as far as the Indian religious center Mathurā, 150 kilometers south of the modern Delhi. Kushan power remained at Mathurā, but dwindled elsewhere with the growing independence of their own Iranian subordinates or Kṣatrapas, as well as with the appearance of Indian rulers. Our knowledge of the political history of India is sketchy until the fourth century. At this point the Guptas appear, clearly Indian, with their capital in the northeast along the Ganges. The archival impulse in their records as well as the praises of Indian playwrights have given us a rounded picture of their accomplishments, rising above the mist that shrouds much of the Indian past. The Gupta emperors' names have become identified with the Golden Age that preceded the darker present. This picture is of course based upon verbal claims, in the form of the rulers' inscriptions and of the products of official panegyrists. The physical remains of the age provide certain checks on the myth, despite the fact that the visual as well as the verbal arts in India are on the whole more concerned with the ideal than the real.

The art of north India in the fifth century has been seen as a worthy component of the Golden Age, both in the beauty of sculptural style and in the growing ambitiousness of its architecture.

Nothing in Indian art of the two centuries preceding A.D. 370 shows the self-conscious aesthetic harmony that distinguishes the Gupta oeuvre. Yet the background in these years is worth considering as a key to certain problems central to this book. In the first place, to what extent were the new concerns correlated with the boundaries in time and space of the Gupta empire? What was the relationship of the new style to the various diverse regional traditions of Indian art that preceded it? Did the changes that produced Gupta art occur gradually or in a sudden reaction against the predecessors? When change came, what kinds of forces motivated the artists?

The first question, the relationship between dynasty and art, is one whose answer will unfold throughout this book. Already by the statement that a Gupta style does not appear until the end of the fourth century, it is clear that a simple political definition will not suffice. We are not considering only art produced from A.D. 320 until 486, the known dates of the Guptas, within

the area that they controlled, which may have been relatively small. But I feel that there is a sufficient relationship between the dynasty and the style to warrant using the term "Gupta art."

The question of the relationship between this unifying style and the previous regional diversity, which is the rule in Indian art, is a matter that previous writers may seem to have answered. It is commonly implied that Gupta artists combined characteristics from all the separate schools that had flourished while the non-Indian Kushans ruled north India. This is a focal concern of the present chapter, in which I disagree with this assumption. The Kushan style of Mathurā and of areas directly influenced by that great pilgrimage city on the River Yamunā seems to me the sole real source for the Gupta style. The central role of Mathurā, at least until the end of the fifth century, is another theme that runs throughout this book.

The nature and role of artistic change as well as its explanation will be taken up in Chapter II. Here it must simply be stressed that remarkably little alteration occurred in the two centuries that followed the formulation of the hybrid Kushan image type in Mathurā. In order to appreciate the fundamental shift in the role of the artistic image around the year 370, it is particularly important to be clear about the nature of what came immediately before.

A number of regional styles existed in areas to which Gupta power spread in the fourth century and in adjacent regions, all conceivably potential sources for the new Gupta art. One style I shall begin by dismissing as a major contributor to Gupta sculpture is that associated with Andhra Province. The workshops of the Sātavāhanas, the Ikṣvākus, and their successors flourished in the third and probably early fourth century. It seems unlikely that the naturally draped and softly modeled Buddha type of this area could have contributed to the harsher early Gupta versions.[1] A study of the Gupta scenes of the Buddha's life from Sārnāth demonstrates that their composition and iconography owe nothing to Andhra.[2] For architectural decor as well, the South provides no sources that are not also found in Kushan art.[3] More innovative are the Brahmanical remains from Andhra in the third and fourth centuries, introducing sometimes crude, sometimes elegant images of the Hindu gods, who were simultaneously beginning to be represented in Mathurā.[4] Again the lack of correspondence to Gupta forms of the same subjects

1. Longhurst, *Nāgārjunakoṇḍa*, pl. VIb. Ramachandran, *Nāgārjunakoṇḍa*, pl. Xa. Specific differences between these and the early Gupta Buddhas (Plates 18, 19) include the disposition of the robe with a billowing fold below and the shape of the head. Sheila Weiner has recently suggested major Andhra contributions to the style of Ajaṇṭā (*Ajaṇṭā: Its Place*). Her strongest argument may be the baring of one of the Buddha's shoulders there and in the south. Yet there are enough examples of the bared shoulder in north India after the third century (Kauśāmbī, Sāñcī, Pāla sculpture) to make one doubt that this is a simple geographical issue.

2. Williams, "Sārnāth Gupta Steles." Obviously that article invoked only a limited sample of reliefs from Andhra and Gandhāra. Yet no examples I have subsequently encountered suggest that Gupta sculptors drew their compositions from either of these schools.

3. For example, twisted bands are common in Andhra, but in a form no closer to the Gupta version of this motif than are Kushan examples (e.g. Barrett, *Sculptures from Amaravati*, pls. XXX, XLI).

4. *Indian Archaeology 1956-57*, pp. 36-37, pl. LVII B, C. Khan, *Early Sculpture of Narasiṃha*. (Cf. the Gupta Narasiṃhas of Udayagiri, Besnagar, and Eran, all human-bodied.)

is most striking, both in form and in iconography. In general a barrier seems to have developed by the third century between north and south Indian styles, one that was, of course, surmounted in certain cases, but significantly not in the Gupta period.

A second candidate for the role of a major source for Gupta styles is the art of the northwest. In fact, a standard formulation of Gupta Buddhist sculpture is that this style weds the two Kushan schools of Mathurā and Gandhāra.[5] Here I must demur strongly. The study of Buddha life scenes produces no evidence for compositions drawn directly from Gandhāran reliefs. An iconographic innovation such as the preaching gesture (*dhyāna mudrā*), which appears both in Gandhāran art and in Gupta, might suggest a connection; in fact, the physical form is quite different in the two, implying not visual influence but rather a common content.[6] For those aspects of the Gupta Buddha image, such as string-fold drapery, that might be traced to Gandhāra the ground had already been laid in Kushan Mathurā. Likewise, most decorative elements shared by the two ends of the Kushan empire (the twisted garland, for instance) were present in Mathurā by the second century A.D. To discern a major wave of Gandhāran influence in the fourth century is to ignore the complexity of Kushan Mathurā styles. At most, I can think of one common Gupta motif found also in the northwest, the checkered grid (e.g. Plate 84), that has not been found so far in a work ascribed to the Kushan period in Ma-

thurā. Even in this case, it is conceivable that the pattern became current in the fifth century in central India and thence spread to Gandhāra in its late phases.

Mathurā, apparently one of the prime sources for Gupta art, was already a major economic and religious center by the first century A.D., yet it grew in importance when it became part of the Kushan empire with trading connections that led across Central Asia and the Near East. The sculptural output of Mathurā at this point skyrocketed. The absolute dating of the art of the Kushans hinges upon the beginning of the era initiated by the greatest of these foreign rulers, Kaniṣka. Controversy on this subject is inevitable as long as conclusive evidence is lacking, but it appears to me that a date in the second decade of the second century A.D. is most reasonable, as argued in two recent discussions of the subject by scholars who have attempted to consider various sources of information, John Rosenfield and Alexander Soper.[7] Both give greatest weight to the testimony (in part negative) of the Chinese annals. It is to be noted that from the point of view of Gupta sculpture alone, it would be possible to argue for a later date, such as A.D. 144 or even 287, for these would exclude a period in which there was a dearth of art. In fact, this apparent gap is one that can be in part filled and in part understood.

A second question that Kushan chronology entails is the number of dating sequences in use. Both Lohuizen

5. Rowland, *Art and Architecture of India*, p. 229.

6. Lohuizen, *Scythian Period;* pp. 126-27 (suggesting a Gupta origin for the *dharmacakra mudrā*).

7. Rosenfield, *Dynastic Arts*, pp. 253-58. Soper, "Recent Studies," especially part 2, p. 112.

and Rosenfield have pointed out that the acceptance of a single sequence of dates ranging between K.E. (Kaniṣka Era) 2 and 98 results in grave inconsistencies in palaeographic and sculptural style.[8] Lohuizen argued that the difficulty can be resolved by supposing that certain inscriptions are, in fact, dated in the second century of the Kaniṣka era, 100 being omitted from the date. Rosenfield's suggestion that a second era was instituted at some point after K.E. 98 seems to me less likely, implying that the weak Kaniṣka III founded a new era that endured for over half a century. At all events, the difference between the two theories in terms of absolute dating on this basis is small. If we accept the suggestion that the Kaniṣka Era commences in A.D. 110–115, and if we accept Rosenfield's convenient listing of inscribed images in the second sequence, the latest date being 57, we possess dated Kushan images ranging through the third quarter of the third century A.D.

Petty and largely anonymous subordinates continued to rule Mathurā after the last of the great Kushan emperors, Vāsudeva (K.E. 64–98). Numismatic and inscriptional evidence falters at this point, suggesting an end to the power that had employed these means of announcing itself. At the moment there is no way of ascertaining when the Kushans disappeared from the scene. The Purāṇas report, in what seems to correspond to the early fourth century, that seven rulers of the Nāga dynasty enjoyed the charming city of Ma-

thurā.[9] Nāga coins have been found in plenty at Mathurā, as well, although they were probably not minted there.[10] The Nāgas of Mathurā seem to have been part of a groundswell of various native dynasties in north and central India in the third and fourth centuries, including the Nāgas of Padmāvatī, the Yaudheyas of the Punjab, the rulers of Ahicchatrā, the Maghas of Kauśāmbī, and ultimately the Guptas. At times there must have been both alliances and conflicts between the powers surrounding Mathurā, but no clear evidence of outside control exists until A.D. 381, with the first Gupta inscription of the area.

For the stylistic development of Buddhist and Jain images in Mathurā under the Kushans, Lohuizen has presented a convincing picture.[11] The "national" or *kapardin* (that is, with hair knotted like a shell) image formulated under Kaniṣka was modified late in Huviṣka's reign. Thus by K.E. 51 we see various forms of Gandhāran influence: semitextural waves were substituted for the formerly smooth cap of hair, heavy garments with symmetrical folds replaced the clinging robe, and lions faced inward with somewhat more naturalism than the heraldic out-turned creatures of previous Buddha thrones. The assertive gestures of the previous images were reduced in prominence, so that the subject became less a *cakravartin* and more a monastic teacher. After the reign of Vāsudeva (K.E. 98), these ultimately foreign elements were altered, for example in a small

8. Lohuizen, *Scythian Period*, pp. 235–62. Rosenfield, *Dynastic Arts*, p. 106.

9. Pargiter, *Purāṇa Text*, p. 73.

10. Particularly the coins of Vīrasena; Smith, *Coins of Ancient In-*

dia, pp. 191–92.

11. Lohuizen, *Scythian Period*, ch. 3. Lohuizen, "The Date of Kaniṣka."

seated Buddha image inscribed with the date (1)36 of the Kaniṣka Era (Plate 1).[12] At this point, ca. A.D. 250 in the dating to which I subscribe, the drapery falls asymmetrically in a fanlike arrangement of terraced pleats. The previously textural conception of hair had by now given way to small snail-shell curls. These may represent a new concern with orthodox Buddhist *lakṣaṇas* or divine marks, and at the same time they harmonize aesthetically with the spherical forms of the body. The Gandhāran textural concern, however modified, imparts to the figure a slightly distracting sense of pattern. The eyebrows arch from their previous horizontal, and the curves of the face are pinched. In addition to the original outer scallops, the halo shows a band of pearls, a large lotus, and between these two a garland that is divided by small rosettes into sections of various patterns.[13] Yet despite this catalogue of new motifs and elements, the image is still fundamentally akin to the earliest Kushan works in its direct, emotionally affecting warmth.

Other dated works from the third century bear out this picture of the absorbed Gandhāro-Kushan style. Jain *sarvatobhadras* (four-sided images that depict four Tīrthaṃkaras) retain wavy hair for one of the four figures as late as the year K.E. (1)40.[14] Thus the new curls

did not totally replace the previous hair style, and the two were perhaps used to make an iconographic distinction. Late Kushan Jain figures, lacking drapery, are often extremely broad in the shoulders. This may be explained by desire to represent the supernatural body of the divinity rather than by mere clumsiness on the part of the carver. Yet no works after K.E. (1)12 are of large scale or refined execution.[15] Apparently both Jain and Buddhist patrons declined in affluence with the collapse of the Kushan empire.

Where were such images originally located? Undoubtedly many were placed around the base of *stūpas* or relic mounds. In addition, a number of pieces of jambs and lintels from engaged doorways survive, indicating the existence of some kind of chamber. It would seem that the doorway fragments were inset into walls of brick or stone, which have not been preserved. It is possible that these were prototypes for the Gupta temple.

The door fragments themselves are often difficult to date, for they lack inscriptions. Lohuizen has suggested, on the basis of Buddha-image typology, that several remains of lintels are transitional between the Huviṣka and post-Vāsudeva phases described above.[16] She bases her argument on the coexistence of elements

12. *Indian Archaeology 1957-58*, p. 75, pl. XCI C. Lohuizen, "The Date of Kaniṣka," pp. 130-32, pl. IV. Harle, *Gupta Sculpture*, pl. 43. This piece is unusual in its very small scale and in the complete carving of the back.

13. Various other new motifs, such as a ring of rays or spokes, appear on other halos. Lohuizen, *Scythian Period*, figs. 57, 62.

14. Lucknow Museum J 234, inscription discussed in Lohuizen, *Scythian Period*, pp. 282-83. Rosenfield, *Dynastic Arts*, fig. 42.

15. Lohuizen, *Scythian Period*, figs. 54-56, 60-63.

16. Lohuizen, *Scythian Period*, pp. 225-29. If the significance is iconographic, it must be very generalized, for one member in the sequence of the Seven Buddhas of the Past does not always have the same drapery style. In the *sarvatobhadra* images, Pārśvanātha consistently shows curls; yet the independent Tīrthaṃkara with serpent hood, Lucknow Museum J 113 (presumably Pārśvanātha), has wavy hair. And wavy hair also occurs on an inscribed Ariṣṭanemi (Lohuizen, *Scythian Period*, fig. 63).

from the "national type" and others that reflect more Gandhāran influence. In light of the preservation of wavy hair side-by-side with snail-shell curls on Jain images dated as late as K.E. (1)40, one might wonder whether such a lintel is not later, with an iconographic explanation for the use of various hair styles. A piece such as that reproduced in Plate 2 seems to belong toward the end of the first century of Kushan rule.[17] What is of interest about such lintel fragments is their general organization, forming a T-shaped outline around the door. This configuration, usually associated with Gupta architecture, clearly existed by the second or third century A.D. It would seem that the basis for the T shape was a wooden version, where the projection of lintel beyond the jambs was practical: this prevented slippage of the lintel, which might shrink and was not securely bound to the jamb by weight and traction alone (hence the need for separate engagement in the wall fabric). A physical justification no longer existed when stone was used, and the projecting ends of the lintel in the Kushan period bear minor figural or decorative motifs. Rather than representing architectonic post-and-lintel construction, the repeated bands of decor are largely vegetative in origin. These trim the entrance with a rich variety of patterns, many of which continue, if altered, in the Gupta period. Thus while the Kushan doorway

is distinguishable in detail from the Gupta, it provides a crucial source for developments two centuries later.

Clearly some continuity existed between the Kushan and Gupta doorframes, yet the difficulty in dating makes it difficult to trace intervening forms. Two examples that I assign to the late third or early fourth century are illustrated in Plates 3 and 4.[18] Neither shows the ebullient foliage that was to become a Gupta hallmark, to be seen first on Mathurā Buddha images of ca. A.D. 390 (Plate 18) and at roughly the same time in an architectural context at Udayagiri (Plate 36). The band at the far right of Plate 4 moves toward this and certainly represents a transformation of the outer band in Plates 2 and 3. The next band in this same fragment is a simplified and flattened form of the rows of overlapping leaves that appear on the earlier door fragments (Plate 2). Plate 3 shows a narrow member representing a twisted garland, interrupted next to the lotiform capital by a fluted clasp. On the main projecting face of the pilaster, similar garlands interlace with elegant complexity around figures of birds and lotus flowers. In the fragment in Plate 4, the interlacing garland, again interrupted by a fluted clasp, appears in simplified form in the middle band. The capital in Plate 3 preserves the palmette, lion, and lotus, all going back to pre-Kushan sources. The lotus, however, is recognizable only from

17. For a jamb of what must be the same doorway, see Vogel, *Sculpture de Mathurā*, pl. 22d. V. S. Agrawala, "Catalogue," XXIV (1951), p. 77. The curly hair style of the standing figures need not be contemporary with this style in Buddha images. The second band from the outside, overlapping spiky leaves, is very similar to that below the Saheth Maheth Buddha of ca. K.E. 100-120, and is simplified and eliminated in later images (Lohuizen, *Scythian Period*, fig. 43,

cf. fig. 54).

18. V. S. Agrawala, "Catalogue," XXIV (1951), pp. 85-86, 135. The doorjamb in Plate 4 bears an earlier inscription referring to the kṣatrapa Śoḍāsa, on one side. But the placement of this does not suggest any relationship to the decor, and I take it to be a reused piece. Probably the fragments on Plate 3 were part of a doorjamb, such as Mathurā Museum 57.4446 and 7.

the lower edge of its petals, for an unexplained band encircles it below and the entire profile approximates in reverse the vase at the base of the pilaster. The principal motifs here are surely of significance: the lion capital evoking royal patronage, the birds perhaps representing the auspicious Garuḍa, and the vase from which foliage issues indicating abundance. The decorative elegance of the carving shows that the third and early fourth centuries were not entirely a period of artistic regression at Mathurā.

Undoubtedly other types of images were produced during this time. The recent German excavations at Sonkh, in Mathurā District, indicate a late Kushan date for several small plaques of Brahmanical deities.[19] In the third and fourth centuries, a number of Hindu iconographic innovations must have been made, presumably in relatively modest carvings for private worship. An unusually large example is the squatting figure in Plate 5, dated palaeographically to the third or fourth century.[20] The inscription describes this as "the Mahārāja, Graha Yakṣa called Dharmanitya." This subject would seem to be part of that hazy pantheon of minor nature or medicinal deities whose identity was highly localized, although he may have been associated with the more important Yakṣa Kubera or with a Brahmanical god such as Kumāra.[21] The squatting pose, first used for Kushan royal portraits, was by this time common for female figures, perhaps to suggest childbirth.[22] The face shows that sharp, geometrical version of the broad early Kushan curves that was remarked in the Buddha image in Plate 1. The eyes develop this tendency yet further in the way their petallike curves, broadening at the outer corner, merge with the form of the head. The tapered necklace with emphatic central jewel is not found in any distinctly Kushan works.[23] And the entire image is based upon consistently circular forms, heralding the new harmonies of Gupta sculpture. Yet when compared with the equally spherical forms of the fifth-century Kumāra in Plate 76, the sharp, simple, geometrical volumes of the Yakṣa still belong to a different and late Kushan world.

It would seem reasonable that under the Brahmanical Nāga dynasty, some of Mathurā's finest products would in fact be Hindu, while purely Buddhist and Jain art would suffer a decline. But the major conclusion that emerges from a consideration of this problematic period is the lack of fundamental change. There is no reason to think that the shifts from Kushan to Kṣatrapa

19. H. Härtel, "Excavations at Sonkh," p. 3.

20. Bajpai, "New Inscribed Image." This piece was discussed at length by Dr. Gritli v. Mitterwalner in an interesting talk on the Yakṣa cult delivered at a seminar on ancient Mathurā, under the sponsorship of the American Institute of Indian Studies, New Delhi, January 1980. She argued for a fourth-century date on the basis of palaeography and of certain formal features such as the pose and treatment of the eye.

21. For *grahas*, generally female, in the *Mahābhārata* associated with Kumāra, see Filliozat, *Doctrine classique*, p. 81.

22. Härtel, "Excavations at Sonkh," fig. 4. N. P. Joshi, *Catalogue of Brahmanical Sculptures*, figs. 53-58. Lohuizen, *Scythian Period*, fig. 59, illustrates an image of Sarasvatī that is particularly close to this in form of body and drapery; this image, dated K.E. (1)54 confirms a third-century date for the Yakṣa.

23. James Harle suggests that armlets with cockades rising above are also unknown before the late fourth century ("Late Kuṣana, Early Gupta," pp. 237-40). At least one image of the early Kushan period, to judge from its drapery, shows very developed armlets, however (Vogel, *Sculpture de Mathurā*, pl. XXXIIIa).

to Nāga dynasties were of any direct and immediate moment for the sculptural workshops. With the exception of the Mat royal portraits, local styles had in the first place been only superficially influenced by the Kushans and that dynasty's ties with the northwest. Nor are any particular connections visible between the art of Mathurā in the fourth century and other Nāga centers discussed below. Here surely a dynastic nomenclature would be misleading, and there is no need to distinguish the Kushan from the Nāga period in Mathurā.

Sārnāth is one of several centers in which Kushan Mathurā influence is demonstrated by imported works of sculpture. Whether Sārnāth belonged politically to Kaniṣka's empire is arguable. The main evidence is the well-known Buddha image dedicated there by a monk named Bala, dated in the year K.E. 3.[24] This might indicate Kaniṣka's rule in Sārnāth as is generally assumed, but it is also possible that two overlords mentioned in the same inscription controlled the area independently, or in fact that all three were merely Bala's political superiors in Mathurā. Certainly no other inscriptions indicate continuing Kushan presence, or for that matter any clear political power between the second and the fourth century.

The monumental image dedicated by Bala is of great significance because it is clearly an import, as the reddish sandstone proves, and because this was in turn locally copied. The image itself is characteristic of the earliest or "national" Mathurā Kushan style, with smooth hair, drapery defined only in selective areas by a ridged-and-incised fold conventions, and generally solid, spherical body forms. It is interesting that a knotted waistband holding up the undergarment is clearly visible, a style corresponding to the later Chinese pilgrim I-ching's description of the Sarvāstivādin monastic dress.[25] We know from other inscriptions found at Saheth Maheth that Bala was in fact associated with this advanced Hīnayāna sect.[26] The use of the term "Bodhisattva" to designate what appears to be a Buddha image (that is, representing Śākyamuni after his assumption of monastic dress) is understandable if we think of the original sense of the term before the Bodhisattva as a princely teacher became a separate Mahāyāna ideal. Moreover, three inscriptions from the third or early fourth century at Sārnāth demonstrate the importance of the Sarvāstivādins here.[27]

The first copy of this work, in the local buff Cunar sandstone, is close in scale, in bodily forms, and in disposition of the drapery (Plate 6). The chief difference lies in the execution of the drapery folds. Those falling

24. Rosenfield, *Dynastic Arts*, p. 51, fig. 53. Similar problems are raised by the image dedicated by Bala at Śrāvastī. Another piece of evidence for Kushan rule in this area is the Chinese and Tibetan account that Aśvaghoṣa was captured from either Pāṭaliputra or, more probably, Sāketa (Oudh or the Lucknow area, that is, to the west of Sārnāth).

25. Griswold, "Prolegomena," XXVI, 128-29. Griswold does not identify the Mathurā Kushan sect, because he interprets I-ching's description of the Sarvāstivādin mode as lacking a front panel. In fact, I-ching says only that the Sarvāstivādins pulled the skirt up on both sides, unlike the other Nikāyas. Moreover the Mathurā Gupta example that Griswold identified as Sarvāstivādin has a central panel (fig. 13a).

26. Lüders, "List," pp. 93-94.

27. *ASIAR* 1904-1905, p. 68; 1906-1907, pp. 96-97; 1907-1908, p. 73.

from the right hand show a few cases of the ridged-and-incised convention, but plain ridges predominate. The folds on the shoulder are reduced to pairs of incised lines. These extend over the body with a tentative and wobbly character, still following the general logic of the Mathurā model. The sculptor would seem to be simplifying what was, after all, a somewhat bizarre if purposeful convention.

The next stage in the localization of this image type can be picked up in Chapter II (Plate 26). Here it is worth pointing out that if we accept a relatively late date for the following form, Sārnāth presents a more clearly discontinuous tradition than does Mathurā. And in fact there are few fragments recorded that have any claim to a second-, third-, or fourth-century date.[28] The isolated position of Bala's image and its one local copy would explain why the first Gupta sculptors turned to this early Kushan source and hence began with a somewhat different basis than did their Mathurā contemporaries.

A second area peripheral to the Kushans, where on the one hand Kushan influence was minimal in political and artistic terms, and on the other hand evidence for an independent political unit is clearer, is the region to the south, extending as far as Mālwa and Bundelkhand. The Nāga dynasty or dynasties of this area pro-vide the most prominent example of the early growth of native power, whether Brahmanical or tribal, as opposed to the foreign rule of the Śakas. The history of the Nāgas is intertwined with the yet more problematic history of the Yaudheyas and early Vākāṭakas. Our lack of knowledge about all three during the third and fourth centuries lies in part in their failure to leave the kind of inscriptional genealogies that the Guptas used to legitimatize their power. A definite picture of Nāga history has been constructed by some scholars, notably K. P. Jayaswal, whose pioneering studies suggested the importance of this Hindu dynasty.[29] While I share Jayaswal's general assessment of the Nāgas' role, his detailed arguments are of varying validity, and I would prefer to indicate here some of the historical evidence in a less conclusive manner.

The Nāgas appear to have constituted several ruling houses, for the Purāṇas describe their presence in Vidiśā, Mathurā, Padmāvatī (or Pawaya), and Kāntipurya.[30] The only inscription that can be ascribed with any certainty to any branch is a damaged one found at Jankhat, 250 kilometers south of Mathurā, dated in the thirteenth year of the king Svāmin Vīrasena, whose coins are plentiful in this area, Mathurā, and the Punjab.[31] Indirect epigraphic evidence is provided by the later Vākāṭaka copper plates, which record that Gau-

28. Sahni and Vogel, *Catalogue*, pp. 38-39 for six fragments, some possibly from the same image.

29. Jayaswal, "History of India, c. 150 A.D. to 350 A.D."

30. Pargiter, *Purāṇa Text*, pp. 49, 53. The reading of Padmāvatī for Campāvatī in the *Viṣṇu* and *Vāyu Purāṇas* is preferable in view of the copious Nāga coins found at Padmāvatī (Pawaya). Kāntipurya is also mentioned only in the *Viṣṇu*. For its identity,

Jayaswal suggests Kantit, near Mirzapur on the Ganges ("History of India, c. 150 A.D. to 350 A.D.," pp. 28-29), while H. V. Trivedi defends Kutwar, dist. Morena (*Coins of Nāga Kings*, pp. xxxv-xxxvii).

31. *EI* XI (1911-1912), 85-87. Smith, *Coins of Ancient India*, pp. 193-97. It is perhaps significant that the ruler Vīrasena is entitled "Svāmin," as was Śiva Nandin of the earlier Pawaya Maṇibhadra inscription.

tamiputra of that dynasty (fl. before ca. A.D. 330) was married to the daughter of Bhavanāga of the Bhāraśivas; Bhava is also represented by a number of coins concentrated at Pawaya.[32] The epithet Bhāraśiva describes the Śaiva devotion of these rulers, who bore the image of Śiva, probably the *liṅga* or phallic emblem, on their shoulders. The Bhāraśivas are said to have performed the Aśvamedha, the prestigious horse sacrifice that was the perquisite of the orthodox *kṣatriya* or ruling caste, ten times; they are also said to have had their heads annointed by the Ganges, a mark of their purity and perhaps of the extent of their power. Finally Nāgasena and Gaṇapatināga, probably the rulers of Pawaya and Mathurā respectively, were conquered by the second great Gupta ruler around A.D. 370. In addition to Bhava and Gaṇapati, at least nine other Nāga rulers are represented by coins from Pawaya alone.[33] These copper issues are of little artistic interest, except by virtue of the Śaiva associations of many of the simple emblems they bear, such as the humped bull and the crescent. It is highly significant, however, that they show absolutely no relationship to Kushan coinage, unlike the Gupta coins. Numismati-

cally, the native Indian identity of the Nāga dynasty is clear.

The claims that the Nāgas and other related dynasties anticipate the Guptas as the destroyers of foreign domination lead one to wonder if they did not also anticipate the Guptas artistically. The evidence for Nāga artistic styles is, however, slim. One site of critical importance is Jankhat near Kanauj, where the third-century inscription of Vīrasena just mentioned occurs on a piece of decorative carving.[34] The inscription occurs at the top of the inner face of one of a pair of posts that must have formed a gateway on the pattern of the *toraṇas* or gates of earlier *stūpas* (Plate 7). The even, buff sandstone is quite different from the red variety of Mathurā, but the manner of carving is clearly derived from that center. For example, the two Yakṣīs or nature goddesses shown back-to-back on one bracket (Plates 8, 9) evoke the famous set of pillars from Bhuteśar in Mathurā city.[35] At the same time, the comparatively small hips and large feet of the Jankhat figures make them less unabashedly sensuous than their Mathurā counterparts. While the hair style with a rounded "cap" in front is that of the Bhuteśar Yakṣīs, the crossed

32. Mirashi, *CII*, V, 14. Trivedi, *Coins of Nāga Kings*, pp. xviii-xx.

33. Trivedi, *Coins of Nāga Kings*. The order of these rulers (aside from Bhava and Gaṇapatinaga) can be established only palaeographically.

34. Pargiter originally assigned this inscription to the third century (*EI* XI [1911-1912], 86), while Jayaswal argued for the second ("History of India, c. 150 A.D. to 350 A.D.," pp. 21-22). Some of Jayaswal's comparisons are with inscriptions of Vāsudeva, who can now be assigned to the third century; other letter forms that Jayaswal notes

are similar come from inscriptions now dated to the second Kushan era (e.g. that of the year 18). Thus a third-century date is probable. The pieces were in situ in Jankhat village, 10 km. south of Tirwa, when photographed, but they have since been removed to a museum in Kanauj.

35. Vogel, *Sculpture de Mathurā*, pl. XIX. Many of the comparable curved bracket figures from Mathurā are Janus: ibid., pls. XII, XXIa. H. Härtel, "Kuṣāna Nāga Temple," fig. 5. Almost all the Sāñcī Yakṣīs are, however, single figures, rather than two joined back-to-back.

bands on the chest in Plate 9 and the arm bands with chevron in Plate 8 are absent in early Kushan works. A sash flutters to the side of both figures with more independence than the usual vertical folds of Kushan drapery. Both brackets must have rested upon a large, three-dimensional *makara* or crocodilian head of a type common in Mathurā reliefs although not preserved beneath Yakṣī images there (Plate 7). On the whole, the Jankhat figures are late and provincial versions of the Kushan Mathurā idiom.

The decorative carving on the gateposts confirms the third-century date suggested above for some architectural fragments from Mathurā. In addition to a conservative outer band of very flat half-rosettes and palmettes, and the long-standing bead-and-reel, the jambs include a band of foliage with heavy, undulating stem and large, flat leaves, as in Plate 2. The central, raised member consists of a twisted garland on one face of each post, while on the other (Plate 9 to left of Yakṣī) foliate bands interlace. Similar motifs occur in reduced form on the halo of the Buddha of K.E. (1)36 (Plate 1) and on the architectural fragments in Plates 3 and 4. The execution of all these elements is only slightly less crisp and assured than the carving of Mathurā at its best.

The remains of the Jankhat gate indicate the extension of the Mathurā artistic "province" 250 kilometers to the south. The local stone and the slight provincialisms of style would suggest that these were produced locally by carvers not based in the great religious center on the Yamunā. If so, this defines the periphery of Mathurā as a creative sphere, unlike Ahicchatrā (almost equidistant to the north), let alone Sāñcī to the west or Sārnāth and Śrāvastī to the east, where Mathurā influence took the form of imported works or imported stone and craftsmen. One might expect to discover more of this idiom at Kanauj, some 20 kilometers from Jankhat, for, although no early sculpture has been found here, terra cottas and pottery indicate continuous inhabitation since the first millennium B.C.

On the other hand, Jankhat is interesting as a Nāga center, indicating that these new Indian, Brahmanical rulers chose to sponsor the style that had flourished under the Kushans. The same situation can be inferred for Mathurā itself, although it is more difficult to associate any single work with the Nāgas there. In short, the continuity of workshop and religious traditions must have outweighed the innovative influence of dynasty at this point.

The chief site where a Nāga style might be expected is Pawaya, the most established of the dynasty's centers. No sculpture from here, however, seems to belong to the third or fourth century.[36] Even if some isolated fragments are assigned to this period, their paucity makes it difficult to think of Pawaya as a major artistic center where a new and non-Kushan style was formulated so early. In one way, however, the Hinduism of the Bhāraśiva Nāgas may have borne tangible fruit.

36. Among the earlier remains are unpublished stone fragments still kept in a shed at the site, a large Maṇibhadra of the first or second century A.D. (to judge from its inscription), and a palm capital that is difficult to date, the last two both in the Archaeological Museum, Gwalior (*ASIAR* 1915-1916, pp. 105-107).

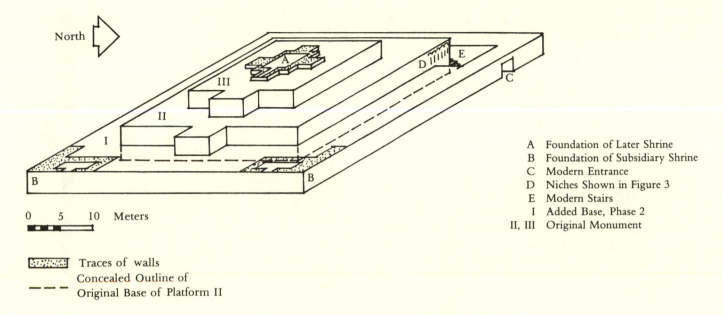

North

A Foundation of Later Shrine
B Foundation of Subsidiary Shrine
C Modern Entrance
D Niches Shown in Figure 3
E Modern Stairs
I Added Base, Phase 2
II, III Original Monument

0 5 10 Meters

Traces of walls
Concealed Outline of
Original Base of Platform II

Fig. 2. Pawaya, pyramidal shrine, reconstruction

The major architectural remain of the site is a brick pyramid originally of two terraces. 28 meters square at the base; to this was added at a slightly later point a third terrace, showing constructional improvements (Fig. 2).[37] The early excavation reports suggested that the original pyramid belonged to the Nāga period and was subsequently enlarged under the Guptas. The first part of this hypothesis has not been proved by any more archaeological evidence. But if, as is argued in Chapter

II, the later additions can be securely assigned to the late fourth or early fifth century, it would follow that the only slightly earlier phase is indeed likely to be Nāga. A similar terraced structure supporting a *liṅga* of Śiva was constructed at roughly the same time at Ahicchatrā, perhaps also a Nāga center.[38] It is reasonable that the fervent Bhāraśivas should erect such an impressive monument.

The decor of the present second terrace, part of the

37. *GAR* v.s. 1997 (1940-1941), 17-20. The report by M. B. Garde describes a total of three terraces, but the site merits re-excavation. The drawing in Fig. 2 is based upon site observations in 1975. The possibility that the inner core was Buddhist can be dismissed in light

of the total absence of Buddhist sculpture. No indications of bulging were found in the original base, and hence a structural necessity for the additional terrace is unlikely.

38. V. S. Agrawala, "Terracottas of Ahichchhatrā," p. 167. Agra-

original structure, consists of arches of the general type found on earlier *caitya* halls, a motif called *candraśālā* (literally "moon-room") in the early texts on architecture (Fig. 3).[39] Their simple, rounded shape approaches that of Kushan and earlier examples from Mathurā.[40] Below the arches is a row of pilasters with vaselike bases and round capitals topped by a bracket. The details must have been supplied in a coat of plaster. No forms survive that are not found in the third-century remains of Mathurā. What is innovative here is not details of style but rather the size of such a Hindu edifice. So far at least, no Brahmanical structure of comparable scale has been found from this period in any part of India. It would seem that the religious role of the Nāgas, introducing monumental Hindu architec-

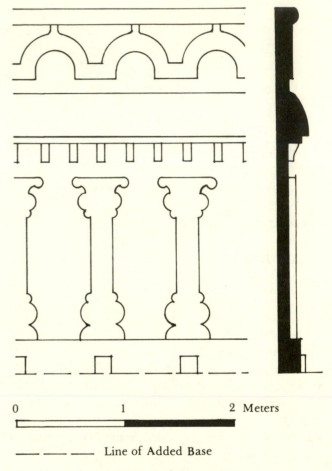

0 1 2 Meters

⎯ ⎯ ⎯ Line of Added Base

Fig. 3. Pawaya, shrine ornament

wala assigned the Śiva temple in plot AC1 a Gupta date on the basis of its position on top of a Kushan apsidal temple; a fourth century pre-Gupta date is equally possible. Agrawala also dated the terracotta plaques of this temple to a period between A.D. 450 and 650. It is possible that the plaques were later added to the shrine. Their style (and that of terra-cotta sculpture in general) is very difficult to date precisely, which is why they are not included here. I feel that they precede the terra-cotta panels of Bhitargaon, which I ascribe to the mid-fifth century (Chapter III). The suggestion of Nāga rule here is based upon the resemblance between the coins of Acyuta (the latest ruler of the site, conquered by Samudragupta according to the Allahabad *praśasti*) and those of the Nāgas (R. C. Majumdar and Altekar, *Vākāṭaka-Gupta Age*, pp. 39-40).

39. This term occurs frequently in the *Viṣṇudharmottara Purāṇa*, which is earlier and more relevant to Gupta architecture than the later Sanskrit usage, *gavākṣa* (in Orissa a radically different false-window shape) or the Tamil term *kuḍu*. One obvious problem in understanding the Pawaya pyramid is the absence of any decor on the covered portion of the original base.

40. Smith, *Jain Stūpa*, pls. XIV, XXVIII.

ture in permanent materials, may have stimulated indirectly the development of Gupta art as a competitive model. The actual form of this terraced edifice was of more direct significance for Southeast Asia than for India. Yet the image of the temple as a mountain appears graphically in the late Gupta period at Nāchnā and is implicit in much of later Hindu architecture.

One final candidate as a source for Gupta developments is western India, the parts of Gujarat and Rajasthan controlled throughout much of the fourth century by the western Kṣatrapas. This region will be discussed in the second chapter, for it is to the early fifth century that I attribute the emergence of a new style there.

On the whole, while few sculptural and architectural remains are securely dated in the third and fourth centuries, this does not seem to have been a period of total inactivity. The most obvious continuities can be traced at the long-standing religious and artistic center of Mathurā. Yet even here, it is well into the period of Gupta political power and then with a certain abruptness that a new aesthetic takes over.

Chapter II
THE INCEPTION OF GUPTA ART,
A.D. 370-415

Historical Background

In A.D. 320, Candragupta I, the first Gupta ruler to style himself *mahārājādhirāja* or "Supreme King of Great Kings," came to the throne and initiated a new era.[1] He is known from his successors' inscriptions to have married Kumāradevī of the Licchavi dynasty of northeastern India and Nepal, an alliance that must have strengthened the hand of the Gupta kingdom, then limited to Prayāg (the Allahabad area), eastern Magadha (eastern Bihar), and Sāketa (the Lucknow region).[2] Candragupta I and his queen appear on one coin type;

the costume of the king and that of the goddess on the reverse both continue Kushan numismatic imagery (Plate 10a).[3] This conservatism helps to explain why no sculptural innovations are yet perceptible. Artistically, the reign of Candragupta I belongs with the preceding period.

It is with Samudragupta that the Gupta empire came into being. He ascended to the throne probably between A.D. 340 and 350, perhaps after having defeated other sons of Candragupta.[4] In the next thirty years Samudragupta embarked upon a staggering series of

1. Authorities have also suggested that the year A.D. 320 marks Samudragupta's coronation (R. C. Majumdar, *Classical Age*, pp. 4-5) and that the era was initiated by Candragupta II on the basis of his grandfather's accession (Goyal, *Imperial Guptas*, pp. 102-10). The evidence is inconclusive. Two rulers preceding Candragupta are known from inscriptions, Gupta and Ghatotkaca.

2. T. R. Trautmann convincingly denies that Samudragupta inherited land from his maternal family ("Licchavi-Dauhitra," pp. 1-15).

3. This type was ascribed to Samudragupta as an issue commemorating his parents, by Allen, *Catalogue of Coins*, pp. lxiv-lxvi. For a summary of more recent literature, see Goyal, *Imperial Guptas*, pp. 115-21. One line of argument is that Candragupta would have included his *viruda* or epithet, while *licchavaya* (= *Licchavinām dauhitrasya*) on the reverse refers rather to Samudragupta; the latter maternal epithet on a coin is, however, as exceptional as the absence of

one of Candragupta. A second line of argument is that the type is further removed from Kushan models than is Samudragupta's standard type, chiefly in the inclusion of both queen and king. Yet Kushan coins have shown two figures on the reverse (Mao-Mihiro, Skando-Bizago); while these are too early and dissimilar to provide models for the Gupta type, they do suggest that the formal innovation of placing standing figures side by side was not a radical break with the north Indian past. For Kushan sources for the reverse, see Altekar, *Coinage*, pl. I, 6. Also, Rosenfield, *Dynastic Arts*, pp. 74-75, 83-90.

4. Goyal, *Imperial Guptas*, pp. 191-95, identifying Kāca as a brother. Cf. Altekar, *Coinage*, pp. 78-89 for a discussion of previous arguments in favor of identifying Samudragupta himself with Kāca. Altekar proposed an identification with Rāmagupta, which is, however, hard to reconcile with the latter's copper coins and the Vidiśā stone inscriptions.

exploits that earned for him the epithet *parākrama* or Bold Attacker. These are described in the Allahabad *praśasti*, a eulogy composed by the courtier Hariṣeṇa and incised upon a then six-hundred-year-old Aśokan pillar, which probably originated in Kauśāmbī.[5] Samudragupta's conquests described in the Allahabad *praśasti* are grouped according to their political status in the Gupta empire. First, several rulers in north India were eradicated, including Acyuta, Gaṇapatināga and Nāgasena, at least two of whom were the Nāga rulers of Mathurā and Pawaya, and perhaps the Vākāṭaka kings to the south.[6] The last two areas were Śaiva strongholds and must have constituted Samudragupta's greatest challenge. The next categories of less complete conquest were five frontier kingdoms (including Nepal and Kāmarūpa or northern Assam), and nine tribal peoples, including the Mālavas of Mālwa, the Yaudheyas of the southwest Punjab, and the Ābhīras (now scattered from Gujarat to U.P.). All of these groups offered taxes and obeisance to the Guptas.[7] In the third place, twelve rulers south of the Vindhya mountains were taken and released, among them the rulers of Kosala (the Raipur area) and Kañci (the Pallava kingdom).[8] There is no reason to think that this southern campaign amounted to real conquest. Finally, more distant peoples were said to have offered their service and gifts of maidens, and to have requested the Garuḍa seal of the Guptas on charters certifying their territories. In this loose category, possibly comprising any group which sent an embassy to the Gupta court, are enumerated the Daivaputraṣāhis. Ṣāhānuṣāhis, Śakas, Muruṇḍas (all four Iranian peoples of the North-West Frontier), the Sinhalese, and "all dwellers in islands."[9] In sum, Samudragupta must have occupied most of India north of the Vindyas except for the west, either as sovereign or as suzerain. He may have invaded parts of south India. And he must have had friendly relations with Ceylon as well as states to the north and west.

In addition to listing these martial accomplishments,

5. For the standard discussion and translation of this inscription, see Fleet, *CII*, III, 1-17. The identity of the first three rulers is generally accepted. On the Vākāṭakas see Goyal, *Imperial Guptas*, pp. 141-46; if Rudradeva of the inscription can be identified with Rudrasena I, one must note that the Vākāṭakas alone in this first category soon returned to an independent status. The other rulers in this "eradicated" group were Matila (perhaps of Kanauj), Nāgadatta (perhaps of north Bengal), Candravarman (perhaps of west Bengal), Balavarman (conceivably of Kāmarūpa or Assam), and Nandin (which may in fact be the last element in Acyuta's name).

6. Goyal, *Imperial Guptas*, p. 134.

7. The five frontier kingdoms are Samataṭa (southeast Bengal?), Davāka (Nowgong, Assam?), Kāmarūpa, Nepāla, and Kartṛpura (in Kashmir or Himachal Pradesh?). The tribes include the Ārjunāyanas (in eastern Rajasthan?), the Mādrakas (in the eastern Punjab?), the Prarjunas, Sanakānīkas, Kākas, and Kharaparikas (all probably in the Sāñcī-Eran area). Rulers of the forest states are also said to have been reduced to servitude.

8. These include the rulers of Mahākāntāra (western Orissa?), Kurāla (Kerala?), Piṣṭapura (Godāvarī District), Koṭṭūra (Coimbatoor District), Eraṇḍapalla (coastal Orissa), Avamukta, Veṅgi (near Ellore, between the Kṛṣṇa and Godāvarī Rivers), Palakka (Nellore District), Devarāṣṭra (Vizakapatam District), and Kusthalapura.

9. See Goyal, *Imperial Guptas*, p. 132, n. 1 for the possibility that seals (= coins) and charters are to be taken separately. Goyal identifies the *Daivaputraṣāhi* as the Kidāra Kushans, the *Ṣāhānuṣāhi* as the Sasanians, and the *Śaka-Muruṇḍas* as "some of the smaller Scythian rulers of the Punjab"—all with more confidence than I can share (ibid., pp. 175-80). The usual identification of the "islands" as Sumatra and Java is highly improbable in terms of any significant political connection, although quite conceivable in terms of trading exchange.

the eulogist proclaimed the moral character of the king, "whose mind was occupied with helping and instructing the miserable, poor, helpless, and sick." Samudragupta was said to be equal to the four Lokapālas or Guardians of the Directions, a theme repeated in his fragmentary inscription from Eran and on his coins.[10] Moreover, he was described as "the inconceivable being (*puruṣa*) who is the cause of the rise and fall of good and bad," an indication that he claimed identity with Viṣṇu; the emblem of that deity, the Garuḍa, figured as Samudragupta's royal seal.[11]

Samudragupta's interest in the arts is also attested by the Allahabad inscription. His own singing and playing were praised, and he was said to have won the title "King of Poets" (or "Poet-King") by compositions that would have afforded livelihood for a wise man. To be taken even more seriously are the references to his patronage of writers. He "destroyed, by his command over the quickened qualities of the wise, the discord between prosperity and good poetry," a reference perhaps to the discrepancy between the political and artistic achievements of his father's reign.[12] Vasubandhu the Elder, the Buddhist philosopher of the Yogācāra school, lived during Samudragupta's reign.[13] Even the greatest of Indian poets and playwrights, Kālidāsa, though

usually associated with Candragupta II, may have begun his career under Samudragupta.[14] The literary concern of the Gupta court is demonstrated by the very fact that Hariṣeṇa, who composed the Allahabad *praśasti*, itself an example of *belles lettres*, held several military and civilian offices.

Samudragupta's coins bear out this picture of his multiple interests. For example, the Battle-axe (Plate 10b), as well as several other martial types, depicts his prowess both in the image of the ruler and in the metrical legend on the reverse:

He who has the axe of Kṛtānta (Yama, Death)
 conquers,
The unconquered conqueror of unconquered kings.

Although the ruler retains his Kushan costume, his pose replaces the previous rigidity with a more relaxed *déhanchement*. The goddess on the reverse, now lacking a lion, is distinctly identified as the Indian Lakṣmī. On the Tiger-slayer type, Samudragupta sheds his tunic for a *dhotī* and crown, while the reverse shows an Indian theme, the River Gaṅgā standing upon a *makara* or crocodile. At the same time, the dynamic, asymmetrical design of the hunting scene itself resembles the configuration on Sasanian plates of a ruler turning back-

10. Fleet, *CII*, III, 21-22; Altekar, *Coinage*, p. 58. The comparison also occurs in the spurious Nālandā and Gayā copper plates (Sircar, *Select Inscriptions*, pp. 271, 273), as well as in later Gupta inscriptions applied to Samudragupta.

11. Sircar, "Sectarian Differences." Sircar's assertion that Samudragupta was not a Bhāgavata is based on his total rejection of the Nālandā and Gayā plates (*cf.* Goyal, *Imperial Guptas*, for the suggestion that these are based on genuine documents).

12. This translation of line 6 seems preferable to Fleet's (*CII*, III, 11).

13. Frauwallner, *Vasubandhu*, p. 46. It is not clear that this philosopher had a royal patron, as did Vasubandhu the Younger.

14. Goyal, *Imperial Guptas*, pp. 217-19, argued largely from the correspondence between the *Raghuvaṃśa* and Samudragupta's conquests.

ward to slay an animal that nestles against the rim.[15] Possibly the gifts of the Ṣāhānuṣāhi included some model for this image. The Lyrist type indicates that Samudragupta was indeed a musician. And the Aśvamedha type (Plate 10c) commemorates his performance of the Horse Sacrifice, which must have crowned his career; the coin shows with precision both the horse and *yūpa* or post on the obverse, and on the reverse the queen, whose duty it was to fan and bathe the horse.[16]

A single image, the life-sized figure of a horse from Khairigaṛh on the Nepal border, has been associated with Samudragupta on the basis of a now effaced inscription (Plate 11).[17] If the identification is accepted, a comparison with the animal on the Aśvamedha coin type is natural. The stone image is more geometrical in contour, suggesting a discrepancy between the increasingly natural and rich numismatic imagery and the still schematic forms of stone carving. Whereas music and

literature may have flowered under Samudragupta, and although coinage broke with the Kushan conventions, the arts of the stone-carver, not directly produced at the court and requiring more physical organization, were longer in the germ.

The next Gupta ruler, Rāmagupta, was until recently known only from a later, fragmentary Sanskrit drama.[18] According to this, Rāmagupta was a cowardly king who agreed to surrender his queen, Dhruvadevī, to the Śakas. His younger brother, Candragupta, posed as the queen, killed the Śakas, and won both the throne and Dhruvadevī. The discovery of copper coins with the name Rāmagupta at Eran and Vidiśā suggested that this king actually ruled briefly in eastern Mālwa, succeeding Samudragupta, although other explanations for the coins could also be found. In 1969, however, three Jain images were discovered near Vidiśā, inscribed as dedications of Rāmagupta (Plates 13-15).[19] These still conservative images are important,

15. For example, Ghirshman, *Persian Art*, pls. 247-53 (king mounted), 254 (king standing). The Sasanian source was suggested by Rowland (*Art and Architecture of India*, p. 254).

16. A possible source is the Sātavāhana horse coins. Rapson, *Catalogue of the Coins of the Andhra Dynasty*, pp. 25ff.

17. The use of Prakrit in a Gupta inscription is unique. Smith, "Observations," pp. 98-99. Two other colossal horses, both very damaged, are known: one from Darelgañj near Allahabad (Lucknow Museum G. 137), and one in situ at the Nagouri quarry, near Sāñcī.

18. The *Devī Candragupta* by Viśākhadatta. For a summary of the arguments against Rāmagupta's existence, see R. C. Majumdar and Altekar, *Vākāṭaka-Gupta Age*, p. 161. For the restatement of the positive arguments, see Bajpai, "Identification of Ramagupta," pp. 389-93.

19. Gai, "Three Inscriptions of Rāmagupta," Cf. Sircar, "Vidiśā Jain Image Inscriptions." Sircar assigns the images to the Later Guptas who ruled in eastern U.P. in the later fifth and sixth centuries. His chief arguments are palaeographic, based on comparison with the Sāñcī inscription of Candragupta II and the inscriptions of the Mandasor area. It seems to me that the script of the latter shows a slightly peculiar regional development. In the Vidiśā inscriptions, *va, ca, pa, ha,* and *kṣa* are very close to the Sāñcī version, although Sircar describes their form as later. Other possible questions can also be answered. The lack of reference to Rāmagupta in later Gupta genealogies is understandable if his descendants did not succeed him and if he was in disrepute as well. The lack of gold coins may be understood in light of the use of such coins to celebrate a major sacrifice and pay the Brāhmans, a need that the unfortunate Rāmagupta had no occasion to experience.

for, as discussed below, they show that the brief and troubled reign of Rāmagupta in the 370s lay just at the beginning of a period of major artistic change.

Who were the Śakas whom only Candragupta II could defeat? Rulers using this ethnic term, which indicates non-Indian origin, were found in western India as early as the first century A.D. They seem to have been subordinate to the Kushans at first, employing the title *kṣatrapa* in the sense of governor, hence the usual designation Western Kṣatrapas.[20] This was at times inflated to Mahākṣatrapa, and their generally independent status was maintained for roughly two centuries. Then in the first half of the fourth century, a gap of some 14 years occurred in the otherwise continuous sequence of coins. Probably at this point, Mālwa was lost to the main branch, for another Śaka Mahākṣatrapa overlord was mentioned at Eran and Sāñcī in the fourth century, interestingly with a Nāga as the local ruler.[21] The last powerful ruler of the Gujarat house was Rudrasena III, who ruled from A.D. 348 until 378. Despite apparent difficulties in the middle of his reign, he seems to

have reestablished his power by 364. The clearest testimony to the Śakas' strength at this point lies in the fact that Samudragupta's great *praśasti* mentioned them among the most distant tributaries, whereas the peoples on all sides were classed among those who offered taxes and obeisance. The coins of the Śakas retain debased Greek legends and a bust portrait of the ruler. Nor do any inscriptions indicate that the fourth century was a period of artistic activity in western India, with the possible exception of the controversial remains of Devnimori.

To return to the Guptas, Candragupta II came to the throne in A.D. 376 and ruled until at least 412.[22] His new conquests were smaller than those of his father, although he must have retained much of Samudragupta's power.[23] Candragupta focused upon the foreign enclaves to the west, defeating the last of the Śaka Kṣatrapas, a process begun with the rescue of Dhruvadevī. The remains, both inscriptional and artistic, of Sāñcī and Udayagiri indicate that the final defeat took place around the year 400. Certainly the area of the ancient

20. For a summary of Śaka history, see Majumdar and Altekar, *Vākāṭaka-Gupta Age*, pp. 47-63 and 296-98. Some caution in the interpretation of titles is suggested by Salomon, "Kṣatrapas and Mahākṣatrapas."

21. Majumdar, *Classical Age*, p. 47. Mirashi, *CII*, IV, 13-16 and 605-11. The Kanakhera inscription (near Sāñcī) may be dated S.E. 241 (A.D. 318/319), according to Majumdar, or K.E. 102 (A.D. 351/2), according to Mirashi.

22. Candragupta's ascent is determined by the Mathurā inscription of G.E. 61, *samvatsare pañcame* (in the fifth year of the reign) (Sircar, *Select Inscriptions*, p. 277). Candragupta's last date is supplied by the Sāñcī inscription of G.E. 93 (= A.D. 412) (Sircar, *Select Inscriptions*, pp. 280-32). We know that Kumāragupta was ruling by G.E. 96 (=

A.D. 415/416) from the Bilsaḍh inscription (Sircar, *Select Inscriptions*, pp. 285-87). The inscriptions of this period are all centrally located (Sāñcī, Udayagiri, Mathurā, and Gaḍhwa).

23. One's picture of the extent of Candragupta's conquests depends upon one's interpretation of the Mehrauli Iron Pillar inscription, describing the exploits of a ruler called Candra. If this is in fact Candragupta, he seems to have conquered from Vaṅga (= Bengal?) to Vāhlīka (= Bactria?), for which we have no other evidence. A solution to this impasse has been suggested by K. D. Bajpai, who identified Vaṅga and Vāhlīka as localities in Baluchistan and the western Punjab, respectively ("Identification of Vaṅga and Vāhlīka"). Goyal ingeniously argued that the inscription be ascribed to Samudragupta (*Imperial Guptas*, pp. 201-209).

metropolis Vidiśā had particular importance as a launching point for the campaign against the Śakas.

Candragupta had several queens, one of whom, Kuberanāgā, brought him into alliance with the Nāga families, that significant Brahmanical dynasty whose conquest was one of his father's major achievements.[24] He in turn married his daughter Prabhāvatiguptā into the Vākāṭaka dynasty. The early death of her husband, Rudrasena II, thrust Prabhāvatiguptā into the position of regent and secured for the Guptas, during at least a generation, the important friendship of the Vākāṭakas on the south. Thus by alliance as well as conquest, the already broad control of the Guptas was extended and consolidated.

As a whole, the coins of Candragupta II indicate a shift from the more martial concerns of his father to images of potential power. The designs show a number of breaks with the Kushan past, indicating a new self-assurance and the deliberate assumption of identity. Most interesting among the gold types is the rare *Cakra Puruṣa*, which represents the ruler receiving a *prasāda* or holy favor from a figure encircled by a spoked, oval form, the *cakra puruṣa* or personified discus of Viṣṇu (Plate 10d). The coin indicates the strong Vaiṣṇavism of the dynasty at this point. In that the *cakra puruṣa* appeared henceforth in this form in Gupta art,[25] it is possible that this represents a rare case of a numismatic origin for sculptural imagery.

Candragupta was also the first of his family to issue silver coins, reflecting the previous use of silver in the newly conquered Gujarat. The Gupta type continued the Śaka tradition of a bust on the obverse, but on the reverse instituted an image of the Garuḍa, already found on gold coins of the Standard Type. Candragupta, moreover, continued the copper coinage begun by Rāmagupta, largely variants upon his own gold and silver types, with a Garuḍa on the reverse, its wings outstretched and sometimes with human hands (Plate 10e). Another copper issue, both small and rare, bears on the obverse a vase overflowing with foliage (Plate 10f). This represents the *pūrṇa ghaṭa* or full vase, a motif signifying abundance, which appears to have been taken from coins of the Mālwa republic after Gupta conquest of that region.[26]

Although the usual sources for ancient Indian history are not directly informative about social and economic conditions, we do have an outside viewpoint for the early Gupta period. This is the diary of the Chinese Buddhist pilgrim Fa-hsien, who traveled in India from A.D. 401 to 411. He described the general well-being of the populace in the Mathurā area, and in fact this seems to be a period of prosperity, when both internal and external trade flourished.[27] Fa-hsien noted particularly the light hand of the government, perhaps underestimating the oppressiveness of taxation (although this was, indeed, heavier in other periods of Indian history).[28] The Chinese visitor also mentioned the *caṇḍālas* or outcastes, who "strike a piece of wood to make them-

24. Kuberanāgā appears in the genealogy of Prabhāvatiguptā (Mirashi, *CII*, V, 8, 37).

25. Begley, *Viṣṇu's Flaming Wheel*, pp. 44ff.

26. Altekar, *Coinage*, p. 161.

27. Fa-Hsien, *Record*, pp. 41–42. Maity, *Economic Life*, p. 66.

28. Fa-Hsien, *Record*, pp. 41–42. Maity, *Economic Life*, pp. 68–69.

selves known so that men know and avoid them and do not come in contact with them." Whereas the traditional divisions of Indian society were certainly recognized, however, it would seem that they were not rigidly binding in terms of marriage or profession.[29] The less restrictive character of caste in comparison with later periods may explain some of the free and intellectual character of Gupta sculpture, which would suggest that the carver aspired to be something more than a stonemason.

The Vidiśā Images of Rāmagupta

The three Jain images from near Vidiśā already mentioned as proof of Rāmagupta's existence bear inscriptions of which the best preserved (Plate 12) reads,

> This image of the Bhagavan Arhat Candraprabha
> was made
> By the Supreme King of Kings, Rāmagupta, at the
> insistance
> Of the pupil's pupil of Pāṇipātrika Candra-kṣam-
> ācārya, mendicant, *śramana*,
> Pupil of Ācārya Sarppasena, the mendicant of
> Golākhyantī, Cella the mendicant.[30]

Although the original controversy has not entirely been

laid to rest, it is reasonable to regard these as works of the 370s.

The Vidiśā images, in terms of style, should not be later than the fourth century A.D. Many features are remarkably close to the latest Kushan works considered in Chapter I. Thus the halo with large lotus, band of pearls, and outer scallops continues earlier types.[31] The eye of the Jina in Plate 15 gazes directly forward in the outgoing Kushan manner. The attendants with fly whisks are not significantly different in pose, body type, or details of ornament from a wide range of Kushan Buddha and Jina images. The thick proportions and low-set hips of the Tīrthaṃkaras themselves are indistinguishable from third-century Mathurā works. Two show somewhat more sensitive modeling of the torso, with a roll of flesh defining the chest (Plates 12, 13). This characteristic, not fully typical of either earlier or later periods, and absent in Plate 14, must be regarded as the idiosyncracy of one sculptor.

The sole feature that would indicate some movement away from the Kushan formulas is the treatment of the hair, visible only in Plate 15. No longer are the curls stacked in horizontal rows, but rather they are arranged in curving ranks that reinforce the spherical shape of the head.[32] In short, such a detail shows a new desire to harmonize the sculptural forms, which in the fol-

29. Fa-Hsien, *Record*, p. 42. P. C. Jain, *Labour in Ancient India*, pp. 17-20.

30. Gai, "Three Inscriptions of Rāmagupta," pp. 245-51. Sircar, "Vidiśā Jain Image Inscriptions," pp. 145-51. While I disagree with Sircar's discussion of the date, I do accept his corrections in the translation.

31. Lohuizen, *Scythian Period*, figs. 57 and 63.

32. Lohuizen, *Scythian Period*, figs. 71, 72. Occasional images of subjects other than Buddhas or Tīrthaṃkaras show curving rows of smaller curls, but I know of no exceptions among the principal icons, aside from Lucknow Museum J 212, a Tīrthaṃkara head that appears to me transitional, like the Vidiśā example (Plate 17).

lowing reign was extended to a variety of other features. Moreover the conservatism of these images confirms the assumption that no distinctively "Gupta" styles had been formulated so far.

Mathurā

Mathurā, as one might expect, retained its role as a center for the three major Indian religions. It has been suggested that the Gaṇapatināga whom Samudragupta conquered belonged to the Nāga dynasty of Mathurā. Certainly Candragupta's control of the city early in his reign is shown by an inscription of A.D. 380, engraved on the face of a small pillar (Plate 16).[33] The inscription records the installation of two *liṅgas*, each including the portrait of a teacher (probably in the form of an *ekamukhaliṅga* with head on one side). The donor was tenth in the line of Kuśika, who can in turn be identified as one of the four disciples of Lakulīśa, teacher and incarnation of Śiva associated with Gujarat. The *liṅgas* are commended to the care of the local Maheśvaras or Pāśupatas, worshipers of Lakulīśa. The inscription thus records the presence of one *guru* line of this important Śaiva sect in Mathurā by the late fourth century A.D.

The image on this pillar is of limited artistic significance. It appears to have been a minor architectural member; hence its crudity. A large trident (*triśūla*) arises above a small male figure, so corpulent and hunch-shouldered that it seems to represent an attendant (*gaṇa* or *triśūla puruṣa*), although the club in his right hand might suggest Lakulīśa himself. The puffy hair and the scarf waving stiffly to one side of the body are features that recur in more pronounced form at the Uday-agiri caves around the year 400, suggesting that that site, 500 km. to the south, did not lag far behind Mathurā. The fact that this was part of a shrine (*gurvāyatana*) built in the late fourth century should at least remind us that other early Gupta Brahmanical works must exist in Mathurā.

There are more plentiful clues to the development of Buddhist and Jain ateliers in this area. For example, the combination of frontal eye and curving rows of curls just described in the Vidiśā images was found at Mathurā as well (Plate 17). The Bodh Gayā Buddha of A.D. 384/5 (Plate 25), discussed below, would suggest that this head is earlier than that date, when downcast eyes were depicted even in outlying areas. It would also seem reasonable that the Mathurā work (or another like it) precedes the Vidiśā images in the matter of the hair, for there is nothing from the Vidiśā area itself that indicates a living and innovating late Kushan style on the spot. If we could pin down the precise time lag between those works from Mālwa and the great workshops of Mathurā, the problem of defining the role of the "central" style would be far easier.

One important standing Buddha figure from Mathurā (Plate 18) is dated in the year 280 of an unknown era—probably not the Gupta era, to judge from its numerous late Kushan features: squat body type, shelved drapery on the left arm, flower between the feet, raised

33. *EI*, XXI (1931-1932), 1-9; V. S. Agrawala, "Catalogue," pp. 141-43; Sircar, *Select Inscriptions*, pp. 277-79.

right arm, and *dharmacakra* (wheel) emblem on the palm.[34] The hair curls follow the curve of the head, as did those of the Vidiśā Jinas (Plates 12-15). The halo (*prabhāmaṇḍala*) marks a change from the late Kushan or Vidiśā type. Here, in addition to the late Kushan motifs that soon disappear (including spokes or rays), there are two bands that become common in later Gupta art. One represents several kinds of twisted garlands, separated by rosettes, a pattern already found in late Kushan works such as the Buddha dated (1)36 (Plate 1). The second is a ring of foliage, at this point a single long ribbon of indeterminate botanical identity, curving back and forth on itself in regular semicircles; only short tendrils issuing from the edge hint at the later ebullience of foliage.[35] The closest source is the leafy bands of works such as the doorjamb in Plate 4, where, however, an undulating stem and discrete flowers are more prominent. Between these two carvings lies a major shift in interest toward integrating such elements into a rich overall design.

This same Buddha image shows a new drapery type, except on its left arm, where the stepped drapery of late Kushan art remains. Elsewhere the edges of the steps alone survive in the form of stringlike ridges. In general, from now on the Gandhāran sense of independent cloth is subordinated to an Indian predilection for rounded bodily forms. The drapery clings, its folds retained as a conventional element and disposed with an ingenious symmetry untrammeled by the observation of reality.[36]

The most radically new feature, however, is the downcast gaze of the eyes (anticipated perhaps slightly by the Bodh Gayā image discussed below). This detail allows the bulge of the eyeball to be integrated into the skull, stressing its harmony with the cheek rather than the existence of a separate and contrasting aperture. Moreover, the withdrawal of the gaze puts the image in a plane clearly different from that of the viewer, suggesting the inner absorption of the Buddha. In fact, the very status of the image seems to change, becoming a reflection or evocation of the divinity rather than playing the previous role of icon or actual divine presence. The statue invites contemplation as a work of art apart from the viewer's experience. This shift is a major factor in giving Buddhist and Jain sculpture of the Gupta period an abstraction that sets it apart from the Kushan mode. This important change would seem to have taken place in Mathurā by at least the years A.D. 390-395, if we assume that the image's date refers to a Kushan era commencing around 110-115.

A recently discovered image from the site Govindnagar is highly unusual among Mathurā Gupta Bud-

34. Cunningham, *ASI* I (1871), 238. Lüders, *Mathurā Inscriptions*, p. 35. Williams, "Mathurā Gupta Buddha."

35. F.W.D. Bosch has emphasized the lotus as a basis for such foliage (*Golden Germ*). I would prefer to stress its protean and imaginary essence.

36. While the terraced ridges of the late Mathurā Kushan images appear to give rise to the string-like folds of the Gupta, it is worth noting that the former were arranged asymmetrically, in the Gandhāran mode. It seems that the slightly earlier Kushan pattern of symmetrical folds was revived, perhaps as part of the return to less foreign forms (cf. Lohuizen, *Scythian Period*, figs. 36, 37, 39, 40). Alexander Griswold has suggested that the Mathurā dress indicates a transparent cloth that was prepleated: "Prolegomena," XXVI, 111-13.

dha figures, for the drapery falls without folds over the body (Plate 19).[37] Is this a case of influence from Sārnāth, where smooth drapery was the rule? I think not, in the first place because the smooth drapery is the only non-Mathurā characteristic here. The eyes are not as fully downcast as those of the last example, which would imply a slightly earlier date. The halo, although close to that in Plate 18, lacks any foliate band, again indicating that this is typologically earlier. Other elements argue that the two are roughly contemporaneous: the heavy bodily proportions, the placement of the feet close together, and the presence of a vestigial flower between the feet. Thus it is unlikely that the Govindnagar figure is later than A.D. 400, at which point the Sārnāth sculptors were still copying Kushan works (Plate 26) with a radically different disposition of drapery from this or from later Sārnāth images.

In addition, if one wishes to question the dates for Sārnāth sculpture presented in this book, one must still admit that the Govindnagar piece relates only superficially to even the most similar Sārnāth examples (Plates 85, 86). The halo is of a type totally unknown there. The drapery falls on the right with the continuous, undulating line of Mathurā rather than with any of the more complex hem patterns of Sārnāth. Thus two alternative explanations present themselves. This image may illustrate the grafting of one Sārnāth ele-

ment onto an archaistic Mathurā idiom. Or it may represent an experiment at a moment of change in the Mathurā style. The latter explanation is recommended by simplicity, for it implies that the piece is unique in only one respect. To suggest an independent origin for such smooth drapery in Mathurā and Sārnāth in a period when artists at both centers were developing new and aesthetically coherent forms seems more credible than to suggest an independent origin in both for the complex forms of Gupta foliage. It is interesting that there was sufficient latitude within the early Gupta style of Mathurā for this solution to be tried, however arrived at. And at the same time it is significant that this solution was clearly rejected in favor of the complex patterns of string folds, which became almost a trademark of this city.

The Jain site at Mathurā, Kaṅkālī Ṭīlā, shows a surge of activity in roughly these same years. For example, the seated image in Plate 20 retains the inner spokes or rays, a motif that does not recur on any piece later than 435 (Plate 61).[38] The body is still heavy, and the head forms a relatively rounded oval. The foliage has evolved, however: a pair of distinct stems rise on either side, meander throughout the band to create elliptical compartments comparable to the curves of Plate 18, and finally entwine above the Tīrthaṃkara's head. The leaves of this band show a new freedom and en-

37. I am grateful to Frederick Asher for informing me about this piece. It appears to be of Mathurā manufacture, although an unusually even, buff piece of sandstone was employed. A second Gupta Buddha image with smooth drapery (of characteristic red sandstone) was found in the Archaeological Survey excavations at Govindnagar

and is now kept in New Delhi.

38. One other Gupta work that retains these rays is the Mathurā Museum Jina B 1, whose heavy body and simple foliage would also place it in the early phase (Rowland, *Art and Architecture of India*, pl. 81a).

ergy, forming a counterpoint to the main curves of the stem, and never precisely repeating from one compartment to the next. Whereas nodules on the stem suggest lotus roots, seedpods also emerge that resemble those of the *bignonia* or catalpa tree. One senses in the carving of this band a burst of creative fantasy that was to remain alive for at least a century. This Jina, in short, follows closely after the standing Buddhas in Plate 18 and 19 and can be assigned to the last half of the reign of Candragupta II.[39]

Two seated Buddha figures survive from the early Gupta period at Mathurā. The first is inscribed as the image of *Dīpaṃkara* (Plate 21), the twenty-fourth Buddha before the present, whose propitiation by Śākyamuni-to-be was a favorite subject in Gandhāran art.[40] The absence of the northern iconography (with the historical Buddha in his previous incarnation as the monk Sumedha spreading his hair below) reinforces the general impression that early Gupta art had little to do directly with Gandhāra. The figure resembles those of Plates 19 and 20 in its stockiness, particularly in the calves. From the hands, apparently in the *dharmacakra mudrā*, drapery falls to the left in the Kushan formula seen also in Plate 18. Here, however, the drapery is defined exclusively by ridges. The fan-shaped end between the feet is a decorative touch unknown in the Kushan, and no other features are backward-looking. A second seated Buddha, now in the Cleveland Mu-

seum (Plate 22), might be considered earlier because the raised left hand allows a full swag of drapery to descend with zig-zag hem in the Kushan manner. Yet this feature is also retained in the standing Buddha of Plate 18, surely not a Kushan work. Moreover, the body is more slender, notably in the legs, than the previous Dīpaṃkara. The drapery, although remaining symmetrical in its disposition, falls in more gracefully tapered parabolas than on any work seen so far, and points toward the next period.

Among the many architectural remains of Mathurā, it is likely that some belong to the early Gupta period. Such fragments are, however, hard to date in isolation. One square pillar (Plates 23 and 24) can be assigned to the beginning of the fifth century. The foliage that issues from birds' tails on the lateral faces is like that of the halo in Plate 20 in its clear and detailed representation of individual leaves. The foliage that fills one entire face, however (Plate 23), is the most complex seen so far, both in terms of three-dimensional overlapping (although the actual carving is shallow) and in the elaboration of the composition with two stems and human figures so that a diffused pattern results. The human couple in Plate 24 is on a par with the devotees in Plate 19 in conception, although the execution is less refined. Although the animal panels at top and bottom of the other two faces seem to be conventional creatures of fantasy, the two on this face both evoke religious themes:

39. A form of foliage transitional between that in Plates 9 and 11 occurs on the fine Mathurā Jina reproduced in Harle, *Gupta Sculpture*, pl. 46.

40. Lüders, "Epigraphical Notes," pp. 155-56 (incomplete read-

ing). A second example of a Buddha of the past is the Mathurā Kushan image inscribed Kaśyapa (V. S. Agrawala, *Studies*, pp. 152-54).

at the top a lion kills a buffalo, suggesting Durgā's battle with the Buffalo Demon, (Mahiṣamardinī), a theme found at roughly the same time at Udayagiri; below an elephant is entangled by a serpent, implying the legend of the Gajendramokṣa or Viṣṇu's delivery of the Elephant King, which is later represented at Deogarh. Certainly at this initial phase the workshops of Mathurā were inventive not only in Buddhist and Jain objects of worship and in decorative detail, but also in Brahmanical imagery.

Magadha: Bodh Gayā, Sārnāth, Rajgir, Patna

Whereas the old cities and pilgrimage centers in the eastern province of Magadha were in some ways the cradle of early Indian culture, none was the home of sculptural workshops active continuously throughout the Kushan and early Gupta periods. For example, at Bodh Gayā, the site of the Buddha's Enlightenment, the only clearly early Gupta work is a Buddha image generally considered an import from Mathurā (Plate 25). The inscription on the base gives a date of 64, under an unknown ruler named Trikamāla.[41] Although the era has been variously identified, the Gupta seems most probable on palaeographic grounds. If so, a date of A.D. 384/5 would result, a position that makes sense in relation to developments in Mathurā.

At the same time, this work must be a local product of Bihar. In the first place, the stone is a yellowish buff, not the Sikri sandstone of Mathurā, which is more

reddish even in its lightest portions. In the second place, the drapery does not follow the late Kushan type that is generally followed in Mathurā after the second century, developing into the Gupta string folds. Rather, this robe falls smoothly except for folds on the shoulder, the early Kushan formula that is preserved, for example, in the Sārnāth copy of the Buddha of the monk Bala (Plate 6). It would seem likely that some similar early Kushan image was in the mind of the sculptor. Yet not all characteristics are early Kushan. The halo decorated at the center with a large lotus appears as early as the reign of Vāsudeva. The curving rows of hair curls were noted above on the Vidiśā Tīrthaṃkaras and on the related Mathurā head in Plate 17. The downcast eyes occurred first in Mathurā between that point (ca. 370) and 390, to judge from the Buddha in Plate 18.

How are we to explain this situation of divergent sources? One possibility is that the innovations of curving rows of curls and downcast eyes were made independently in Bodh Gayā and Mathurā. In the case of the hair, however, we have seen that this form existed by the reign of Rāmagupta at Vidiśā, and probably earlier at Mathurā. In the case of the eyes, the reverse is true: we have a secure date of 384/5 at Bodh Gayā and a tentative one of 390-395 at Mathurā. Given the plethora of undated and often fragmentary material generally from this period at Mathurā, as opposed to the absence of any other work vaguely assignable to

41. For the most recent and convincing discussion of date and provenance, see Asher, "Bodhgayā Image." Cunningham, *Mahābodhi*, p. 53 (ascribed to the year 464 of the Seleucid Era). Lüders, "List," No. 949. Coomaraswamy, *Bodhgayā*, pp. 60-61. The inscription identifies the figure as a Bodhisattva, as is frequently the case with Kushan Buddha images.

the same phase at Bodh Gayā (or any other site in Magadha), it seems likely that the downcast eyes were initiated at Mathurā even before 384. Probably one or two workmen in Bihar were exposed to the new Mathurā Gupta elements and combined these with isolated early Kushan models that existed on the spot. The physical means of the transfer from Mathurā in this case might include patrons (with selective memories), portable objects (selectively imitated), or artists (themselves selectively simplifying the larger images they reproduced). Although this explanation minimizes the independence of the Magadha style, it is remarkable that there was no great time lag between the center and the "province." Perhaps a common attitude can also be invoked that led the Bodh Gayā artist to accept these innovations, modifying the Kushan traditions in favor of a newly harmonious and meditative image.

Sārnāth, the site of the Buddha's First Sermon, at the western end of Magadha, demonstrates the same retention of isolated local models. It is significant that no work or even fragment seems assignable to the period between the Kushan piece in Plate 6 and that in Plate 26, which I associate with the reign of Candragupta.[42] The relationship to the earlier Sārnāth work is obvious here. Changes occur in the drapery pattern. Folds are totally absent on most of the body; and the boldly curving lower front edge of the Kushan type is abandoned in favor of a uniformly vertical fall, the ends

rippling to provide a slight decorative relief. It is possible that this drapery configuration represents a new manner of wearing the monastic robes at Sārnāth, a fundamental change not likely to make its way into sculpture overnight, which is one reason for suggesting a date as late as ca. A.D. 400 for this figure. The motif between the feet has been minimized, a characteristic of Mathurā images following Kumāragupta's reign if not earlier. But unfortunately the head and halo, in which relationships to Mathurā would be clearest, are missing. This image stands as an intriguing bridge to the prolific products of Sārnāth in the next period. Fahsien mentions only four *stūpas* and two monasteries in his relatively modest account of Sārnāth, indicating that the major architectural growth at this site occurred after his visit.[43]

Rajgir, a Jain pilgrimage center as well as a site with Buddhist and Hindu associations, may have had the most active sculptural workshops in Magadha during the early Gupta period. One image installed in a shrine on the Vaibhāra Hill here has been connected with Candragupta II on the basis of its inscription (Plates 27 and 28).[44] Although the central part of this inscription is not clear enough to make out with certainty the name sometimes read as Śrī Candra, it does seem likely that the style of the image belongs to the early fifth century. The figure's proportions are broad, as in the Mathurā Tīrthaṃkara of Plate 20, although the resemblance is

42. Sahni, in the *Catalogue of the Museum at Sarnath*, p. 38, indicated that this was discovered by Oertel in a *stūpa* southeast of the Main Shrine.

43. Fa-Hsien, *Record*, p. 96.

44. *ASIAR* 1925-1926, pp. 125-26. R. P. Chandra here reads the central part of the inscription, just below the *cakra puruṣa*. The original photograph shows more of the base figures than is preserved today.

stronger for the two small images on the base than for the principal one. All three show the soles of the feet turned somewhat forward, as in the Mathurā Dīpaṃkara of Plate 21. The finely carved rampant lions at the corners of the Vaibhāra base would be exceptional in any period. The central standing *cakra puruṣa* is advanced, suggesting a date at the end of Candragupta's reign (Plate 28). His headdress of tiered curls, his fluttering scarf, clinging *dhotī*, and spirited pose are all represented as subtly and sensitively as anything seen so far in Mathurā. The conch shells on the base identify the main figure as Neminātha (literally, "Lord of the Rim").[45] The *cakra* was not, however, a common emblem of this Tīrthaṃkara even in later times, and the use of the symbol here in the same form that appears on Vaiṣṇava coins (Plate 10d) is an unconventional iconographic touch, of the kind common in Gupta Mathurā.

A second inscription at Rajgir is found in one of the Sonabhandar caves at the foot of the Vaibhāra Hill.[46] Although this is only roughly dated palaeographically to the third or fourth century, and although it is not directly associated with an image, there is a series of reliefs in the second cave that cannot be much later than the Vaibhāra Neminātha. For example, one in Plate 29 shows Ṛṣabhanātha (identified by his flowing hair) with the very broad shoulders common in late Kushan and early Gupta Mathurā. The two small Tīrthaṃkaras below also have the soles of the feet turned forward, as

do those in Plate 27. The Ṛṣabhanātha, like other Jain figures in the *kāyotsarga* or upright pose, displays the traditionally long arms of the superior being—reaching to his kneecaps, as the texts say. The upper attendants, however, both standing and flying, are as adept as the previous *cakra puruṣa*. Five other reliefs in the second Sonabhandar cave show the same combination of conservative and advanced traits, as well as traces of intriguing iconography. For example, a Tīrthaṃkara seated on a serpent (suggesting Supārśvanātha or Pārśvanātha) bears elephants on the throne (suggesting Ajitanātha). It is unfortunate that all these carvings are in bad condition, for it would seem that the Rajgir sculptors were most inventive of all the provincial schools.

One example found in Patna city shows that some artistic activity took place here in the supposed Gupta capital, the ancient Pāṭaliputra (Plate 30). This life-size image of Pārśvanātha in the Kanoria collection is obviously related to the Rajgir carvings both in the overall composition and in details such as the abrupt junction between neck and shoulders.[47] At the same time, the body is represented with more unnatural proportions and more schematic lines than that of the Sonabhandar Ṛṣabhanātha; and the *dhotī* of the standing attendant seems like a simplified version of the much smaller Vaibhāra *cakra puruṣa*. On the basis of this image alone (whether derivative or simply earlier in date), it is hard to conclude that the workshops of the great city on the

45. Bhattacharya, *Jaina Iconography*, pp. 57-58.

46. *ASIAR* 1905-1906, p. 98. Although Marshall here refers to two caves with images of Tīrthaṃkaras, the inscription mentions each in the singular.

47. P. Chandra, "Some Remarks on Bihar Sculpture," p. 59.

Ganges were of particular importance. In his seminal study of Gupta art, R. D. Banerji proposed to recognize a Pāṭaliputra school.[48] So far, no evidence for its existence has turned up at Patna itself, and in fact the scattered remains from Magadha as a whole would suggest isolated artists, each working out an individual reconciliation between local models and new stylistic movements from an area to their west.

Kauśāmbī

The ancient city of Kauśāmbī, thirty-two miles west of Allahabad near the great junction of the Gangā and the Yamunā (the Sangam), was a major political center.[49] Late Kushan works were found at this site. It is conceivable that Kauśāmbī was Samudragupta's capital, and it is clear that the area was part of the early Gupta empire.[50] Fa-hsien does not indicate that this was a particularly important Buddhist center in the early fifth century, although there were a *vihāra* and a community of Hīnayāna monks here, and although Buddha images continued to be carved. When the rich collection of sculpture from Kauśāmbī in the Allahabad University Archaeological Museum is published, it will be easier to trace the history of the city's ateliers. For example, a number of finely carved *chattras* or umbrellas, probably placed over Buddha images, may well span

the early Gupta period, to judge from their foliage. For the time being, I would like to suggest that Kauśāmbī was something of an artistic center in the early Gupta period.

One work from Kauśāmbī that probably belongs to the reign of Candragupta II is an image of Śiva and Pārvatī (Plate 31).[51] The inscription on the base refers the piece to the year 139, under an unidentified Mahārāja named Bhīmavarman. The era is not specified. Whereas Cunningham and Fleet assumed the Gupta era, Kramrisch rightly pointed out that stylistically a position as late as A.D. 458/9 was improbable, and suggested rather a date in the Kalacuri-Cedi era, equal to A.D. 387/8. The Kushan era has been espoused, most recently by Harle, implying a date of ca. A.D. 250-255 according to the chronology advanced here in Chapter I. If, however, Kauśāmbī was abreast of the styles at Mathurā, as the late Kushan Buddhist sculpture indicates, it is surprising that this image should be removed from any known Mathurā work at that date. For example, Śiva's hair is worn in smooth, bulging *jaṭā* or locks, pulled up in a distinct sheaf, a style of which I am not aware before the fourth century. Nor do the tubular, relaxed folds of drapery resemble any earlier example. Both face and body seem more suave than those characteristic of the late Kushan. They are closer

48. Banerji, *Age of the Imperial Guptas*, pp. 168ff.

49. Kala, *Terracotta Figurines from Kauśāmbī*; G. R. Sharma, *Excavations at Kauśāmbī, 1957-59*; G. R. Sharma et al., *Allahabad through the Ages*; G. R. Sharma, *Excavations at Kauśāmbī, 1949-50*. The preface of the last, p. xii, revokes the assertion in the text that the site was not occupied after the early fourth century. Surely Sharma's plate

LI b is fifth-century or later.

50. Goyal, *Imperial Guptas*, pp. 210-13. Pargiter, *Purāṇa Text*.

51. First published by Cunningham, *ASI*, X (1874-1877), 3, pl. ii, 3. Fleet, *CII*, III, 266-67. *ASIAR* 1913-1914, p. 262. Kramrisch, "Die figurale Plastik," p. 17.

to the devotees in Plate 59 than to even so advanced a figure as the Mathurā Yakṣa in Plate 5. Certainly there are anomalous features here: the narrow row of curls under the chin,[52] Pārvatī's mirror and headdress,[53] and Śiva's horizontal third eye.[54] This is clearly a transitional piece, and the Vidiśā and Mathurā evidence would imply that this transition took place in the late fourth rather than the mid-third century. Thus it seems reasonable to accept Kramrisch's assignment of the date to the Kalacuri-Cedi era.

If the Śiva and Pārvatī belong to the early Gupta period, it may follow that other pieces from Kauśāmbī are of the same date.[55] Moreover, other sites in the Allahabad Sangam region such as Jhusi and Unchdīh have yielded pieces in a similar style, transitional and ungainly, yet more radically innovative than the more elegant and continuous tradition of Mathurā.[56] Thus one glimpses in the area a number of workshops that were somewhat isolated and idiosyncratic. Although Kauśāmbī was geographically closer to the political center of the Gupta empire than Ma-

thurā, its sculpture would seem to have had a somewhat provincial character to begin with. Like Magadha, the Sangam area increased in output after A.D. 450.

Eastern Mālwa: Sāñcī, Udayagiri, Besnagar

Eastern Mālwa, although on the edge of the forested regions of central India, had its share of towns politically and religiously important in ancient times. Major pilgrimage and trade routes led from the south across this region to the Gangetic plains. The area came under Gupta control with Samudragupta's conquests. We have already considered the Tīrthaṃkara images of Rāmagupta, found near the major city of Vidiśā. It would seem that the region assumed particular importance under Candragupta II as a launching point for his campaigns against the Śakas, and during the second half of his reign a burst of artistic activity took place here.

An inscription on Sāñcī Stūpa I records a dedication of land by a protegé of Candragupta.[57] Most important among the early Gupta remains at this site is

52. Similar curls occur on a Kushan standing figure (Mathurā Museum 28-29.1726) as well as on one face of a *caturmukha liṅga* from Kauśāmbī usually assigned to the second century but possibly later (P. Chandra, *Stone Sculpture in the Allahabad Musuem*, pl. 88b).

53. The notch on the upper right edge of the mirror is original rather than later damage. Interestingly, a second female figure from Kauśāmbī holding a mirror also shows a circular mark in the same quadrant of the disk. This piece, Lucknow Museum B 734, might also be a transitional early Gupta work, although it is not significantly related to the Śiva and Pārvatī. A Janus Yakṣī figure from Eran, which might well be fourth-century, wears a similar rosette on one side. Cunningham, *ASI*, X (1874-1877), 84, pl. XXVIII. Bajpai, *Sagar through the Ages*, pl. III a.

54. The horizontal third eye (usually considered a characteristic of Indra) occurs also on a mustachioed Mathurā Śiva liṅga (Mathurā Museum 14-15.462), which is probably also from the fourth century.

55. For example, the *caturmukha liṅga* published as Kushan by P. Chandra, *Stone Sculpture in the Allahabad Museum*, p. 62, pls. XXXVIII and XXXIX. The female face wears a rosette in the headdress similar to the Pārvatī of Plate 22. The iconography with Rudra, Vāmadeva, Nandin, and Maheśvara differentiated also occurs on an early Gupta example from Mathurā (V. S. Agrawala, "Catalogue," XXII, 130; Mathurā Museum 516).

56. P. Chandra, *Stone Sculpture in the Allahabad Museum*, pls. LXII, LXXX.

57. Fleet, *CII*, III, 29-34.

the small temple known as Sāñcī 17, the first structural monument of the period that is preserved (Fig. 4; Plates 32 and 33). The basic plan consists of a square chamber, presumably the *garbha gṛha* or cella for the object of worship, to which a square porch or *maṇḍapa* is appended in front. The fundamental resemblance between the T-shaped doorway to the *garbha gṛha* and those of Kushan Mathurā (Plate 2) suggests that similar structures existed there. If this is true, the precise origin of the simple shrine type lies buried under the architectural debris of Mathurā. The construction of the walls in two layers roughly 50 cm. apart, filled with unbound rubble, seems relatively complicated in design and suggests earlier freestanding shrines in stone.

A related question is that of the superstructure of the chamber. Today, after Cunningham's restoration, the roof consists of large slabs, marked with a slight gutter at the edge and terminating in drainspouts. Odette Viennot has suggested that a wood superstructure or *śikhara* existed.[58] She argues largely from the absence of relief representations of flat-roofed structures. In fact, the Nāchnā panel in Plate 170 seems to me to represent a flat pavilion with acroteria but no superstructure. One might in general explain the preference for more elaborate buildings in such images by their greater decorative interest. I would certainly agree with Vien-

58. Viennot, "Temples à toit plat," pp. 27-30, 52-53. Viennot, *Temples*, p. 169. Gary Tartakov has developed the Viennot thesis in a paper which argues that drainage grooves are necessary to control water trapped inside a superstructure. This controversy might be resolved by the discovery that grooves are either present or absent on temples that actually preserve some elements of superstructure.

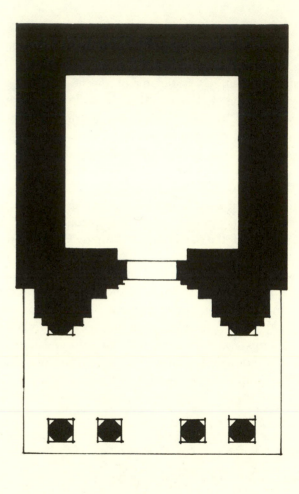

0 1 2 Meters

Fig. 4. Sāñcī 17

not that there is no way of knowing about the original roof of buildings such as Udayagiri Cave I (porch) and Tigowa, both largely restored. Yet Sāñcī 17 (as well as Kunda, discussed below) preserves some of its original roof slabs, and these show drainage grooves extending across the roof, which would seem improbable were there a covering at this level. Thus I prefer to admit that at least some "flat-roofed" temples existed in the Gupta period, though these were certainly continuous in constructional technique with the more complex superstructures that began to appear by the end of the fifth century.

Although the door frame of Sāñcī 17 continued the T-pattern of Kushan Mathurā, it introduced an L-shaped member at each end of the lintel, of which no pre-Gupta examples exist. To judge from other later examples where the hole is filled in, these must have been occupied by female figures, whose identity cannot be specified at this point. The Sāñcī door reveals its structure clearly (Fig. 18a). The corner piece must have had a tenon at the bottom, fitting into the socket that remains between jamb and wall. The general motif of a figure in such a position is probably borrowed from the earlier *toraṇa* gateway, known at Sāñcī itself as well as Mathurā and other sites. The inner band of the doorway bears rosettes on a lateral facet and foliage of

the characteristic Gupta type whose development we have already seen at Mathurā. The form here lies between those in Plates 18 and 20; this would support a date around the beginning of the fifth century. To judge from late Kushan pieces such as that in Plate 4, such foliage was probably used on early Gupta doors in Mathurā as well. The outer jamb member is a pilaster with lotiform capital, a traditional type whose sources are probably the earlier remains of Sāñcī itself.

The four porch columns are arranged with a greater space between the center two than on either side, a characteristic of such shrines which throughout the Gupta period emphasizes the position of the doorway.[59] Each column and pilaster follows a logical progression upward in its cross-section from square base to octagonal shaft, sixteen-sided member, round lotiform capital, sixteen-sided member, octagonal shaft, and back finally to square abacus. The whole remains predominantly rectilinear. As on the doorway, the lotiform capital continues a previous convention; a twisted band just above the lotus points in particular to the Sāñcī lion capital of the much earlier Maurya period as a model.[60] The polygonal members above are, however, unprecedented at the site and seem to represent a deliberate and systematic solution to the problem of combining a round capital with a square column, a problem awk-

59. Cunningham considered this large central intercolumnation a mark of the Gupta style: *ASI*, IX (1873-1877), p. 45. It occurs in the earlier *vihāras* (e.g. Nasik, Kanheri), and therefore appears to be a general means of emphasizing the entrance, and not a period characteristic. At Sāñcī, as in most Gupta columns, there is a slight taper: the base measures 34 cm. square, and the top below the lion

is 31 cm. square.

60. Marshall and Foucher, *Monuments of Sāñchī*, pl. 107. The profile of the lotus is less indented than in the Maurya original, and the distinction of rounded and angular faces in the petals is lost. Williams, "Recut Aśokan Capital."

wardly handled on the south gate of Stūpa I. The source for the enlarged crowning block with lions lies somewhere between the Aśokan original and the modification of such animals in Kushan Mathurā. The actual elements of the design are, however, significantly different from any earlier examples: the lions crouch on all faces of the column and coalesce at the corners, while a tree appears in the center of each face. Such a treatment emphasizes the basically square form of the column and retains its three-dimensionality. Again, given the continuity in the Mathurā workshops, it is probable that undated examples from that center actually anticipate Sāñcī. On the whole, this shrine is a modest but coherent record of a number of innovations in architectural decor that were probably not limited to Sāñcī itself.

Candragupta's association with the hill of Udayagiri five kilometers from Sāñcī is documented by the inscriptions of Caves 7 and 6. The first of these, on the rear wall of Cave 7, records the fact that the cave, dedicated to Śambhu (Śiva), was commissioned by Śaba-Virasena, a hereditary minister of the great Candragupta; the donor is described as one "who knows words, practical matters, and human nature, a poet who belongs to Pāṭaliputra."[61] The inscription on the north outer wall of Cave 6, visible in Plate 35 above the Viṣṇu and Mahiṣamardinī images, records that in G.E. 82, a

pious gift was made by a *mahārāja* of the Sanakānikas who meditated at the feet of Candragupta.[62] The Sanakānikas must be the Sanakānika tribe conquered by Samudragupta. These two inscriptions reveal two very different forces, significant for patterns of both politics and artistic patronage. On the one hand, Śaba-Virasena records his donation in verse and reveals himself as a *kavi* or poet, proud of his intellectual accomplishments and of his origin in the great urban center, Pāṭaliputra—a typical Gupta courtier and representative of the central government. On the other hand, the Sanakānika record is simpler, invokes only the name of the tribe, and reveals that such a unit retained some power within the pluralistic empire. It has usually been assumed that the Cave 6 inscription precedes Cave 7, but stylistic examination suggests that the relationship between the carving of the two doors is the reverse.

Udayagiri Cave 7 is cut into a separate round boulder with a ledge on top (hence the name *Tawā* or "Griddle" Cave), jutting out from the hill at the edge of a ravine.[63] The only interior decoration is a lotus carved on the ceiling, an element in use already in the center of halos, as well as on earlier umbrellas. The door frame is unadorned, with the exception of guardians (*dvārapālas* or *pratihāras*), now badly damaged, on either side (Plate 34). These guardians are closer in proportions to the latest Mathurā images we have seen (Plate 20) than

61. Fleet, *CII*, III, 34-36. For a slightly different translation and the suggestion that Vīrasena composed the Mehrauli pillar inscription and was descended from Hariṣeṇa of the Allahabad *praśasti*, see Roy, *Studies*, pp. 4-5.
62. Fleet, *CII*, III, 21-25.

63. The interior room is 4.2 x 3.6 m. Cunningham, *ASI*, X (1874-1877), 51-52. Patil, *Monuments of Udayagiri Hill*, p. 15-16. The plain door frame (which is not merely worn) may be explained simply by the fact that this is the first cave at the site, hence the sculptor's failure to transfer systematically the precedents of structural architecture.

to previous ones or to the attendants upon the Vidiśā Tīrthaṃkaras (Plates 12-14). Their hip-shot pose is comparatively convincing. Thus it would seem that the urbane Śaba-Virasena employed carvers who were fully aware of the current styles of such metropolitan centers as Mathurā.

Udayagiri Cave 6 is a different and more parochial story.[64] The inner ceiling is plain. The door is flanked by guardians who wield two forms of battle axe (Plate 36). These figures are so similar to those of Cave 7 that it is impossible that one is not a copy of the other. Despite the differences in preservation, some differences of style are visible. The Cave 6 figures are stiffer, their heads vertical and their arms more nearly horizontal than those of Cave 7. Their hair bulges to the side of the neck, seeming not to be fully understood.[65] Furthermore, the guardians are less integrally related to the door in Cave 6; possibly they were added after the jambs had been carved and the façade smoothed off, so that the figures had to be sunk within recessed panels. Such distinctions might be taken as signs of an earlier date for Cave 6, implying a transitional status such as

that of the Rāmagupta Jinas or the Kauśāmbī Śiva and Pārvatī (Plates 12-15, 31). It seems, however, that these are the ineptitudes of a copyist, not of a beginner. It is hard to conceive of the Cave 7 carver imitating the model of Cave 6 so closely and at the same time animating those leaden forms so successfully. Thus it appears that the sculptor of the Cave 6 guardians was a local man like his Sanakānīka patron, conceivably himself of tribal origin, who followed the lead of the center of the empire.

Unlike Cave 7, the door of Cave 6 is decorated along jambs and lintel, as are all subsequent excavations here. Several features of this second door have already been seen at Sāñcī 17: the T shape, female figures at the ends of the lintel (inferred in the case of Sāñcī 17), and the general pattern of bands of decor outlining the frame. The innermost of these bands bears foliage of the long, continuous ribbon type, comparable to that at Sāñcī 17 as well as the Mathurā Buddha of Plate 18. The next two registers bear a twisted garland and triangular teeth that end at the level of the guardians' hips; here a foliate band with offshoots resembles that

64. The interior room is 4.3 x 3.8 m. The veranda is 7 x 1.8 m. Cunningham, *ASI*, X (1874-1877), 49-50. Patil, *Monuments of Udayagiri Hill*, pp. 13-15. The interior contains a square rock platform with a central socket, into which a *liṅga* is now set. Patil felt that the *liṅga* was original, although a three-dimensional Viṣṇu image is also a possibility: one such figure was found at Udayagiri, which is fully carved on the back to show a lotus behind the figure (preserved in the Gwalior Museum). It is impossible to determine whether this cave is Vaiṣṇava (with Gaṇeśa attendant, as at Deogarh) or Śaiva (with Lakulīśa perhaps in the central *candraśālā* and with the two Viṣṇu images attendant upon the greater glory of Śiva).

65. This style resembles the standard Gupta headdress of curls in tiers surrounding a plain semicircle. K. P. Jayaswal identified these guardians as Viṣṇu's attendants Jāya and Vijāya on the basis of the phrase *bandhubhṛtyas* (with brother bound) in the *Devī Candragupta*: "Candragupta and His Predecessor," pp. 33-35. This compound, however, can hardly be taken as "his servants in the (two) brothers (= Jāya and Vijāya)"; nor does this identification fit the two similar figures of the Śaiva Cave 7. U. P. Shah calls the guardians Balarāma and Kumāra, perhaps on the basis of their weapons, although the axe is not usual for Balarāma, nor are the two commonly paired: "Some Medieval Sculptures," p. 58.

of the Mathurā image in Plate 20. In short, this is a case in which a motif is found in simpler and more developed stages simultaneously, the later stage representing the most "up-to-date" form.

The lintel of the Udayagiri Cave 6 door bears at the top merlons of a complex type, stepped three-dimensionally with human faces on the foremost plane. Similar plain merlons occur in Mathurā, although none with superimposed human heads has yet been found there.[66] Above these occur three *candraśālā* arches of a shape that goes beyond those of Pawaya in the elaboration of side and top excrescences (cf. Fig. 3). Finally, the outer edge of the jamb is a pilaster with polygonal base and lotus capital, both comparable to forms seen at Sāñcī but more uniform in overall contour, and hence less well articulated. Above, a square member shows a plant from which spring two rampant animals, probably lions if we compare their stringy manes with a fragment from the Udayagiri hill (Plate 41). These architectural elements, not continued to the base of the door, represent the same kind of slightly inept copying from some model such as Sāñcī 17 that the guardians of Cave 6 showed in relationship to Cave 7.[67]

The date of the images on the façade of Cave 6 is a subject of controversy.[68] It appears to me that all were executed at roughly the same time and by the same workshops, on the basis of the emphatic modeling of the stomach with a real sense of musculature. The guardians and the flanking Viṣṇus wear similar sashes, falling symmetrically with crinkled ends. A significant detail is the simple twisted garland with alternating plain and dotted bands, executed in precisely the same way in the middle band of the doorway and the wreaths that crown the guardians' and Durgā's heads. Thus if the inscription of 401/2 applies to any of the carving at Cave 6, it can be used as a rough date for all the reliefs.

The presence of Durgā killing the Buffalo Demon or Mahiṣamardinī (Plate 35 far right) in a Vaiṣṇava context is apt in terms of the *Devī Māhātmya*. In this early section of the *Mārkaṇḍeya Purāṇa*, whose im-

66. Faces decorate the dentils of Nasik Cave 18: Zimmer, *Art of Indian Asia*, pl. 45a. For three-dimensional merlons at Mathurā, see Smith, *Jain Stupa*, pl. XXX. A similar row occurs on a fragment now on top of the Udayagiri hill, which, if related to the pilaster in plate 41 from the same location, is slightly later than Cave 6. Cf. Williams, "Dentils."

67. Cave 17 may well represent a roughly contemporary local version of more sophisticated forms also, although its badly damaged condition makes discussion difficult. On one side of the façade is a twelve-armed Durgā Mahiṣamardinī with the buffalo's head wrenched upward in the Kushan pattern, found also in a very weathered relief to the north of Cave 6. (Harle, "Mahiṣāsuramardinī Images of Udayagiri," figs. 3 and 5). The door in general resembles that of Cave 6, with at least some simple foliage and pilasters with lotiform capitals to the side. The rather stiff guardians are also set into panels, and their size is smaller in relation to the door than at any other cave at Udayagiri. One puzzling feature is the absence of a T-shaped overlap at the top of the inner two bands of decor, which might be taken as suggesting a later date, in that this is the fate of the entire door frame in the sixth century. Here, however, the T shape is retained for the uppermost bands, and this would seem to be an anomalous experiment. A large lotus on the ceiling seems to represent an elaboration of that in Cave 7.

68. The debate has centered around the Durgā image. For the early date supported here, see Harle, "Mahiṣāsuramardinī Images of Udayagiri"; also Williams, "New Nāga Images." For suggestions of a seventh-century date, see Viennot, "Mahiṣāsuramardinī from Siddhi-ki-Guphā," pp. 72-73; also Barrett, "Terracotta Plaque," p. 66.

portance for early Brahmanical art has been explored by V. S. Agrawala, Devī emerges from Viṣṇu as Anantaśayana and her battle with the buffalo is vividly described.[69] The weapons on the whole correspond to those with which the multitude of gods endow this lustrous goddess in this same text: the *śūla* given by Śiva, the bow by Vāyu, the *vajra* by Indra, the sword by Kāla, the garland of lotuses by the Ocean, and the shield by Kāla again.[70] The twelve-armed form of the goddess is unique until three centuries later,[71] perhaps the result here of a desire to include as many as possible of the weapons and ornaments so richly described in the legend. The position of the buffalo, its head firmly downtrodden by the goddess's foot while its rear leg is wrenched upward, is also unprecedented. This image is constructed upon parallel axes, and is one of the most impressive early Gupta carvings at the site.

The two monumental reliefs of Udayagiri are not dated directly by inscription, but both show sufficient affinities with the carvings of Caves 6 and 7 to suggest that they belong to the reign of Candragupta II, and probably to the first twenty-five years of his reign. The relief of Viṣṇu as Varāha, the Cosmic Boar, is one of those works of art in which a theme is represented without major precedents and in which the sculptor

seems to have drawn more upon the realm of ideas than of visual forms (Plate 37; Fig. 5). A few previous images of Varāha rescuing the Earth Goddess, Pṛthvī, are known from Mathurā.[72] Yet the central dramatic ensemble of the *nāgas* or serpents who had stolen the earth, and particularly the background figures, have only literary sources. At the same time, it is apparently impossible to find a single textual version in which all the elements represented here are described. The closest source is the *Matsya Purāṇa*, in which the earth sinks spontaneously into the ocean from the weight of the mountains. Viṣṇu is thus invoked:

You are the great ocean in the form of the three Lokas; the twelve Ādityas are the islands thereof; the eleven Rudras are the foundations and towns; the eight Vāsus are the mountains, the Siddhas and the Sādhyas are the billows; the birds are the winds; the Daityas are the crocodiles; the Uragas and Rākṣasas the fishes; Brahmā is the great patience. . . .

Then the Lord manifested Himself as a boar that He might enjoy the playing in waters. That mighty Lord, incomprehensible by mind and speech of all the beings, that Brahmā extended Himself to a hundred yojanas in length and twice that in height.

69. V. S. Agrawala, *Devī-Māhātmyam*, chs. I-III, particularly II, vv. 19-31.

70. Harle, "Disputed Element." Cunningham also mentions a club and discus: *ASI*, X (1874-1877), 50. On the goddess's left is a conical form that seems to represent an umbrella made of feathers, folded upward and probably held by attendants. Similar forms occur frequently in the reliefs of Barabuḍur: e.g. Krom and van Erp, *Barabuḍur*, Ser. 1b, pl. XI, No. 22. In Somavaṃśī sculpture, the form is

sometimes thus (e.g. Adbhar) and sometimes folded out as an umbrella (e.g. Kharod).

71. For a later example, see the Kailāsanātha at Ellora, Zimmer, *Arts of Indian Asia*, pl. 210.

72. N. P. Joshi, "Kushaṇa Varāha Sculpture." Los Angeles County Museum of Art M 72.53.8, illustrated in *Archives of Asian Art*, XXVII (1973-1974), 99 (fig. 21).

A	7 Ṛṣis	H	Pṛthvī	L	8 Vasus
B	7 Classes of Ṛṣis	J	Śeṣa		e Agni
C	Narda	K	12 Adityas		f Vāyu
D	Tumburo		a Indra	M	11 Rudras
E	Brahmā		b Vāruṇa	N	32 Ṛṣis
F	Śiva		c Kubera?	P	Samudra?
G	Varāha		d Yama	Q	Yamunā
				R	Gaṅgā

Fig. 5. Udayagiri, Varāha, drawing after Debala Mitra

Shining and thundering like the blue clouds, looking like a mountain, with white sharp tusks, full of lustre like the sun, lightning and fire, with a high waist; with such a formidable form, adorable by all, He sank down into the Rasātala to lift the world. . . . He raised up the earth on his tusk from the Rasātala, and located it in its proper place. In other words, He let the Earth drop that was sticking to His tusk, though holding Her mentally, after which She felt blessed and made Her Obeisance to the Lord.[73]

Most of these classes of beings equated with Viṣṇu have been ingeniously identified in the Udayagiri relief by Debala Mitra (Fig. 5).[74] In a separate iconographic section of the *Matsya Purāṇa*, Varāha is also said to stand upon the serpent, Śeṣa, here carved to his left.[75] A further problem is the end panels, in each of which two female figures stand upon a *makara* and a tortoise. These vehicles identify them as the Rivers Gaṅgā and Yamunā, here differentiated for the first time, so far as we now know. Below the rivers, a man stands in the water, and two similar male figures occur to the left of

the Varāha on the back wall. These have variously been identified as Vāruṇa, god of water, and as Samudra, the Ocean. In no literary version of the Varāha legend are the two great Indian rivers mentioned, although their presence is appropriate in view of the role of the Ocean as a matrix for the main event.

It is possible that a more complete literary source remains to be discovered, but one also wonders if the explanation for this combination of *personae* lies not in religious iconography but in history. It has been pointed out by others that the play *Devī Candragupta*, which attests to Rāmagupta's existence, compares Viṣṇu's delivery of the Earth with Candragupta's rescue of his brother's wife.[76] Likewise the Gaṅgā and Yamunā may evoke the political power of the Guptas. The two rivers, although not a new theme in terms of legend and literature, come into unusual visual importance after this point. It is probable that the Udayagiri relief was not the unique example of the pair at this point, for Kālidāsa's *Kumārasambhava* mentions them as occurring in the form of images.[77] In the Purāṇic accounts, which are on the whole later and which deal specifically with

73. *Matsya Purāṇa*, II, 281-83 (ch. 248, vv. 23-25, 64-69, 76-78).

74. Mitra, "Varāha-Cave of Udayagiri." Mrs. Mitra cites the *Bhagavad Gītā* as a source, although the Varāha legend itself is lacking there.

75. *Matsya Purāṇa*, II, 308 (ch. 260, v. 30). I cannot agree with V. S. Agrawala that the large figure to the left of the *nāga* represents the Garuḍa; the object that he holds appears to be a lotus stem, not a serpent (V. S. Agrawala, *Solar Symbolism of the Boar*, p. 35). Harle's suggestion that this represents a donor is more reasonable (*Gupta Sculpture*, p. 35).

76. Jayaswal, "Chandragupta and His Predecessor," pp. 33-35. This theory is based on the interpretation of Viśākhadatta's passage as an

extended double entendre. In such a *kāvya* context, it is even conceivable that the *nāgas* refer to the dynasties conquered by Samudragupta. I must admit that some parts of this interpretation are strained, cf. n. 63 supra. Frederick Asher has considered such allegorical interpretations of Gupta art in an unpublished paper delivered at Carleton College, May 9, 1977.

77. VII, 42. Catherine Glynn has suggested that the image of Gaṅgā alone was an established visual type before the Gupta period ("Gaṅgā Image"). This rests on the assumption that early female figures with *makara* vehicles can be identified as Gaṅgā rather than unspecified Yakṣīs.

iconography, the pair play only a minor role.[78] This suggests that the theme was thrust into prominence for reasons other than religious and mythological ones. If the two rivers defined the heartland of the Gupta empire, as Goyal in particular has argued, their appearance at Udayagiri would form another reminder of Gupta political power. Such a topical and propagandistic interpretation of an Indian work of art may seem heretical. Yet a connection between ruler and deity was common in Southeast Asia and probably had Indian sources.[79] This suggestion would explain the particular combination of themes in the Udayagiri relief.

There are a number of stylistic resemblances between this relief and the carvings of the adjoining Cave 6. The torsos of all the large male figures show the bulkiness of Kushan origin that we see in the neighboring guardians as well as in the works of Vidiśā and Mathurā. The headdress of the *nāga* and of the images of the Ocean standing in the water might be considered a pre-Gupta feature. In fact, such a turban with large circular crest rising from a fillet around the head does occur frequently in the Kushan period. The Udayagiri *nāga* wears a version of this coiffure in which a roll of hair falls behind the ear to the shoulders, as do the attendants in the Vidiśā Rāmagupta images (Plates 12-13).[80] A Mathurā head displays the same central crest with a

more carefully delineated cloth fillet and with rolls of either cloth or hair behind the ear (Plate 38). The interest of this last piece lies in the fact that the disk is bounded by foliage that occurs in the development of *prabhā-maṇḍalas* at Mathurā discussed above around A.D. 405 (Plate 20). Hence such a headdress need not be dated before the middle of Candragupta's reign.

The composition of the Udayagiri Varāha relief is visually awkward. For example, the rows of small figures in the background end abruptly without relationship to the central pyramidal group or to the scenes on the end walls. It is possible that this tiered arrangement of background figures is borrowed from Sasanian reliefs. The Boar's head is small and uneasily joined to the powerfully thrusting body. The rescued Pṛthvī's position would still be precarious were it not for a lotus that conveniently supports her feet. While some of the inventive use of pattern noticed elsewhere in the art of this period appears here in the wavy lines that unify the background water with the inner face of the *nāga*'s hood, the overall composition seems not fully resolved.

A second monumental Vaiṣṇava relief at Udayagiri, Anantaśayana, is located in the central ravine (Plate 39). Here the iconography is faithful to a single textual source, the *Devī Māhātmya*, as was the Mahiṣamardinī of Cave 6:

78. C. Sivaramamurti cites only the *Jātakas* as a reference for the precise importance of the confluence at Allahabad: "Amaravati Sculptures," p. 70. The very fact that literary references include the mythical Saraswatī in this confluence, while only the two actual rivers are represented in Gupta art, implies that the visual motif had a more graphic source than did the literature. For the scanty Purāṇic references, see de Mallmann, *Enseignements*, pp. 202-203.

79. Filliozat, "New Researches," p. 103.

80. A head from Besnagar, now in the Cleveland Museum of Art, illustrates the same roll of hair worn beneath a mitre or *kirīṭa mukuṭa* (Harle, *Gupta Sculpture*, pls. 18, 19).

While the adorable lord Viṣṇu, stretching Śeṣa out, wooed the sleep of contemplation at the end of the kalpa, when the universe was converted into absolute ocean, then two terrible Asuras named Madhu and Kaiṭabha, springing from the root of Viṣṇu's ear, sought to slay Brahmā. Brahmā the Prajā-pati stood on the lotus *that grew* from Viṣṇu's navel; and seeing those two fierce Asuras and sleeping Janārdana, *and* standing with heart solely thereon intent, in order to awaken Hari, extolled that Sleep of contemplation which had made its dwelling in Hari's eyes—the lord of splendour *extolled* Viṣṇu's Sleep, which is Queen of the universe, the supporter of the world, the cause of permanence and dissolution, full of reverence, incomparable.[81]

Viṣṇu subsequently wakened to kill the demons Madhu and Kaiṭabha. In the relief, the subsidiary characters are enumerated from left to right: the Goddess Tāmasī (Darkness, Sleep); Brahmā on a lotus; the Garuḍa (who alone is not mentioned in the text); the personified *gadā* or club, *cakra* or discus, and *śaṅkha* or conch (three weapons alone being mentioned in verse 76); the kneeling sage Mārkaṇḍeya as narrator; and finally the two demons, Madhu and Kaiṭabha.[82] The four-armed Viṣṇu reclines upon the serpent Śeṣa, his fully prone position emphasizing the cosmic depths of his divine sleep.

This relief resembles that of the Cosmic Boar in its distinction between small background figures and the large principals. The body of Viṣṇu is treated with the same doughy weight as that of the Varāha. Motifs found in both include the wavy pattern inside the serpent's hood, the leaf arrangement of the long garland (*vana mālā*), the twisted drapery around Viṣṇu's waist, the lotus above the deity in both, and the headdress of the two demons. Other features in the Anantaśayana scene independently confirm a date of around A.D. 400. For example, the Garuḍa is shown with small arms, as on the copper coins of Candragupta II (Plate 10e). In short, this relief has the same formative importance as the Varāha. Other damaged carvings at Udayagiri such as a nearby Narasiṃha may well belong to this same phase.

From architectural remains at Sāñcī and Udayagiri, it is clear that building continued in the final years of Candragupta's reign. For example, in Plate 40 we see built into a much later shrine a column that represents a logical development from those of Sāñcī 17.[83] The

81. *Mārkaṇḍeya Purāṇa*, pp. 469-70 (ch. 81, vv. 49-53). Cf. V. S. Agrawala, *Devī-Māhātmyam*, pp. 37-38 (ch. 1, vv. 47-52).

82. This relief is discussed briefly by K. V. Soundara Rajan, who assigns it a date of ca. A.D. 500 on the basis of unspecified differences from the Varāha relief: "Anantaśayī Icon," pp. 82-84. In his chart, Soundara Rajan is surely mistaken in indicating that the Udayagiri Viṣṇu has but two arms, and in indicating the absence of Garuḍa. I do not understand his identification of five *Āyudha puruṣas*, Bhū Devī, and Varuṇa, nor his questioning of Mārkaṇḍeya. Tāmasī is most appropriate as an identification for the first female figure in

terms of the *Devī Māhātmya*, although Devī herself or even Śrī (in terms of later texts and because she holds a lotus) are possibilities.

83. Marshall and Foucher (*Monuments of Sāñchī*, pl. CXXVII) indicate that the present Temple 31 is a pastiche. Sets of jambs and of pilasters, as well as a plain lintel now on the ground near Shrine 19 may well be part of the shrine to which this column belongs. The jambs and pilasters are of roughly the same height (200 cm.), and both show plain faceted vase capitals with lotus petals above and below. Another perhaps related column stands against the west, outer wall of Shrine 4.

major innovation is the vase capital, its sides and base fluted to continue the sixteen-faceted section of the column below. Although vases had been used as capitals in Kushan Mathurā,[84] it is significant that the form radiated to Mālwa only in the early Gupta period. At this point, it was adapted with deliberate harmony to the polygonal forms traditional in columns in this area. Even the lotus capital was not entirely displaced, but survived in the form of two narrow bands of petals symmetrically bracketing the vase. The top band suggests a large flower resting upon the opening, yet this still lacks the foliage of a true *pūrṇa ghaṭa* or overflowing vessel.

Atop the hill at Udayagiri are the remains of a large structure. Cunningham suggested that this was Buddhist on the basis of railings and a lion capital found in the area, but neither feature is clearly sectarian.[85] The building plan is too unclear for architectural discussion, although its scale is remarkable.[86] One door post found here combines a lotus capital and lions like those of Cave 6, a vase capital like that in Plate 40, and more

three-dimensional foliage than any seen so far (Plate 41).

The fragment of a ceiling panel is particularly interesting (Plate 42). The large central lotus resembles those of Caves 7 and 17 at this site. Outside this is a circle of cartouches with small figures. To judge from those preserved, there were probably thirty-six in all. While the attributes of those still visible have not yet led to precise identifications, it is likely that these represent the thirty-six Decans or stars, three of which are associated with each sign of the zodiac.[87] A lion capital found at the site bears on its abacus the zodiacal symbols together with the twelve solar Ādityas.[88] Such iconography, unprecedented at this point in Indian art and with few later parallels, would seem to have been peculiarly apt, for both the ceiling and the column lend themselves to cosmological symbolism.

Finally, Udayagiri Cave 1 belongs to the end of Candragupta's reign (Plate 43).[89] The present structure was restored by Cunningham, who filled in the walls of the shrine and tarred the roof of the porch. A medieval Jain

84. For example, Smith, *Jain Stupa*, pl. VII; pl. XLIII appears to be transitional between the traditional lotus capital and a vase, suggesting that this shift occurred first in Mathurā. Whereas the earlier western Deccani caves had capitals topped with a member resembling a vase, this remained inverted and was not associated with any flower or vegetation.

85. Cunningham, *ASI*, X (1874-1877), 56.

86. The platform is roughly 8 x 15 m. A lintel still on the spot, generally resembling the door of Cave 6, must originally have been 2 m. long, to judge from the half with central ornament remaining. Cf. Williams, "Dentils."

87. Pingree, "Decans and Horās."

88. Williams, "Recut Aśokan Capital." The dots, originally thirty-

six, on the abacus, must have represented the Decans as well. David Pingree's work just cited, not known to me when I wrote my article, shows that the zodiacal signs were known in India as early as A.D. 269-270 (the date of composition of the *Yavanajātaka*); thus the iconography does not help to specify the date of the recut abacus. Possibly the recutting did coincide with the Udayagiri hilltop ceiling in the early fifth century. The capital was found on the north side of the village (*ASIPR, WC* 1908-1909) or "near Candragupta's Cave" (= Cave 19) (*ASIPR, WC* 1913-1914, photos 4020-21). The discovery of the lotus ceilings is reported in the same volume.

89. The interior is 2.0 x 1.7 m., with a defaced original image in the center of the rear wall. Cunningham, *ASI*, X (1874-1877), 46-47. Patil, *Monuments of Udayagiri Hill*, pp. 9-10.

figure is inset at the south end of the rear wall. A plain pillar supports the porch roof asymmetrically on one side, and the pillars in front at either end have flat rear surfaces, as if originally installed against a wall. Thus the present form appears to be a pastiche and it is pointless to discuss the architectural whole as a work of the Gupta period. The door frame resembles Sāñcī 17 in structure but replaces the lotiform pilaster capital with a vase like those in Plate 40; there is no other ornament (Fig. 18b).

The front pillars do, however, provide an important step in the development of the capital. These are topped with the first example of the *pūrṇa ghaṭa* or overflowing vase in this position. The vase itself is broadly fluted, its plain concave facets continuing the lines of the sixteen-sided shaft below. Similar vase forms occur also in the Sāñcī fragments just discussed (Plate 40), the Udayagiri hill fragment of Plate 41, and the Mehrauli Iron Pillar from the beginning of the next reign (Plate 142). The corners of the relatively simple vase at Udayagiri I overflow with foliage of the advanced type that occurs on the jambs of Cave 6, here descending one half of the total height of the vessel and turning back upon itself to curl upward. This form precedes that of Tigowa and other cases discussed in the next chapter. The motif of the vase of abundance is a long-standing one in Indian art. The innovation here lies in the place-ment of this motif in so prominent a position as a capital, a role that became general in the fifth century and endured much later. The *pūrṇa ghaṭa* capital is one element whose origin I hesitate to ascribe to Mathurā. No example comparable to those of Udayagiri Cave I has been found there. It is at least plausible that this use of the motif should originate in Mālwa, where small copper coins of Candragupta II continued the motif from issues of the local Mālwa tribe (Plate 10f). At the same time, it is worth remembering that what is new here is the particular use of the *pūrṇa ghaṭa* as a capital and not the motif itself. Certainly the element soon became widespread, moving from this chaste form, which here suits the basically square pillar, to less and less architectonic elaborations of the foliage.

The Brahmanical religious center of Besnagar lies only three kilometers from Udayagiri, and one would expect artistic activity in one to be echoed in the other. For example, the figure in Plate 44 resembles the Viṣṇu images of Udayagiri Cave 6 in a variety of ways: broad necklace, *śrīvatsa* emblem on chest, symmetrical *dhotī* ends, imbricated mitre, and the general treatment of the body.[90] Thus this image provides a clear picture of the facial type of sculpture in this region, something we only glimpse in the badly defaced Udayagiri reliefs. The eyes remain open in such a Brahmanical image but do not bulge from the head as did those of the Kushan

90. Sivaramamurti, "Georgraphical and Chronological Factors," pl. XVIII (mistakenly labeled Udayagiri). Bhandarkar suggested that this figure was a Gupta addition to the Heliodorus Pillar, and suggested that it represented Garuḍa (*ASIAR* 1913-1914, p. 195). I find this theory improbable for the following reasons: a. it shows no char-acteristic of Garuḍa, b. it is not exceptionally "in the round," and c. it was found over thirty meters from the Heliodorus column. It seems likely that this and the other Gupta fragments of Besnagar were part of a Gupta superstructure upon the platform that underlies "Babaji's House" (*ibid.*, pl. LI).

period; and the mouth is smoothly modeled with holes at the corners, which create a slight simper. The subject of the Besnagar image is usually regarded as Viṣṇu. Yet the lion-headed implement suggests that this may in fact represent Balarāma, who in two Kushan images is flanked by a staff topped with a lion, and who in the Purāṇas is identified with the lion-head vyūha of Viṣṇu-Vāsudeva.[91] The two earrings are differentiated as well, which may correspond to the description of Balarāma as wearing kundalam ekam (a single round earring) in the Bṛhat Samhitā, a sixth-century text.[92]

If the previous two figures can be ascribed to the period of Candragupta II, it seems probable that other less easily datable works from Besnagar belong to this phase. The L-shaped relief in Plate 45 has long been recognized as one of the earliest preserved examples of the pairs of goddesses that occupied the lintel ends on Gupta doorways such as that at Sāñcī 17 (Plate 32).[93] The fragment in Plate 46 may represent at least a portion of the opposite figure from the same door.[94] The two are clearly differentiated in pose and in the species of tree under which they stand, a mango (Plate 45) and custard apple (Plate 46) as later at Tigowa. The vehicle

of the Boston figure alone survives, a makara associated with the goddess Gaṅgā; she, however, in the later examples usually if not infallibly (cf. Bhumara) appears on the left side of the door, whereas this piece clearly belongs on the right. It thus seems at least possible that the two were in fact not differentiated as River Goddesses, as remained the case slightly later at Udayagiri Cave 19. In style these figures represent a crisper version of the type we have already seen in Mālwa, the foliage below the makara resembling that of Udayagiri Cave I. Yet this creature as well as the figures above do not bend with as great contortion as we shall see at Cave 19 of that site, let alone at Tigowa later in the fifth century.

Several columns indicate that an entire shrine was constructed at Besnagar under Candragupta II (Plate 47).[95] In this example the number of facets on the central shaft and capital increases to thirty-two; their extension on the base, body, and lip of the vase above is unique not only among early Gupta but also among later examples. The upper abacus bears a simple, all-over pattern, and human heads decorate the base along with half medallions that are repeated in decreasing size

91. N. P. Joshi, "Balarāma," figs. 1, 5, p. 24. For the association of Balarāma (= Saṃkarṣaṇa) with the lion head, see de Mallmann, Enseignements, pp. 19-21.

92. Varāhamihira, Bṛhat Samhitā, II, 512 (ch. 58, v. 36). An image of Balarāma at Tumain also has two differentiated earrings (ASIAR 1918-1919, pl. XIII).

93. This was found by Cunningham in the house of a sādhu: Cunningham, ASI, X (1874-1877), 41. It was published by Vincent Smith while it was in situ: "Gupta Period," fig. 3. In 1926 the piece entered the Boston Museum of Fine Arts. Other works from Besnagar prob-

ably of this phase are the Kubera and Narasiṃha in the Gwalior Museum: Dikshit, Guide, Gwalior, pp. 25-26, pl. 3. I feel that the colossal Mahiṣamardinī there is sixth-century or later.

94. The photograph listed as 4059 in the ASIPR, WC (1913-1914) shows a ruler, which permits the calculation of dimensions—found to be identical with those of the Boston piece. I do not know the present location of this second fragment.

95. A very similar pilaster from Besnagar is preserved in the Vidiśā Museum: ASIPR, WC (1913-1914), pp. 67-72, photo 4046.

as the eye travels up the column. Thus the architecture of Besnagar was an elaborate version of the Sāñcī shrine represented by the column in Plate 40.

A number of groups of images of the Saptamātṛkās or seven Mother Goddesses from central India show that this theme, already known in small form in Mathurā,[96] was of particular appeal in this less urban area. Two sets are carved at Udayagiri; neither, however, is very fully preserved. That to the north of Cave 4 does show that both legs of the figures hung pendant, and that at least one goddess held a child.[97] A set at Badoh Pathari is of importance because immediately to the right is an inscription palaeographically datable to the fifth century.[98] Here the eighth figure on the right is clearly Vīrabhadra, the horrendous form of Śiva associated with the Matṛkās. These figures lack children or distinguishing attributes, often found at Mathurā, except for Cāmuṇḍā, whose emaciated form is clear on the left. Probably the cult of this fiercest form of Durgā had particular strength in the still tribal regions of central India. Most impressive among the Saptamātṛkā sets is a three-dimensional one from Besnagar, most of which is kept in the Gwalior Museum (Plate 48).[99] None of the seven female torsos here represents Cāmuṇḍā, but headdress and costume are explicitly used to differentiate the figures. The Mātṛka illustrated in Plate 48 shows the same hair style, with large curled puffs and

a central ornament, that is worn by the Durgā of Udayagiri Cave 6. The necklace resembles the broad bands of the Udayagiri Cave 6 reliefs, and the body proportions and pose are consonant with the ceiling relief found on top of the Udayagiri hill (Plate 42). The figures of the Besnagar group are among the largest preserved from this region, comparable to the two great reliefs of Udayagiri. Their assured three-dimensionality has been used as a basis for a sixth- or seventh-century dating. In fact, however, it seems to me that they show many of the characteristics of the Udayagiri and Besnagar works, made more forceful simply by virtue of their size.

On the whole, eastern Mālwa is one of the most fertile regions in the history of early Gupta art. Even here, we can say with some confidence that the new styles appeared in response to developments in Mathurā. But this is not to deny that the art of the area had its own flavor. In part this seems to have been the result of sheer provincial ineptitude, as in the carvings of the Sanakānīka Cave 6 at Udayagiri. In part the difference from Mathurā is the result of local traditions (the Saptamātṛkā cults, the column precedents at Sāñcī). Most significant in the originality of Mālwa, to my mind, are the innovations in content, which seem related to the presence of the Gupta court here. Thus the dramatic and ingenious illustrations of the great

96. R. C. Agrawala, "Mātṛkā Reliefs," fig. 6.

97. Patil, *Monuments*, p. 12. The second flanks Cave 6.

98. R. C. Agrawala, "Mātṛkā Reliefs," figs. 11-15. Harle, *Gupta Sculpture*, pls. 27-30.

99. R. C. Agrawala, "Mātṛkā Reliefs," figs. 19-24. Six of the original set are in Gwalior, one in the National Museum, New Delhi. A head that is very close in dimensions and style remains in the Vidiśā Museum. I find a strong resemblance between these figures and images from the nearby Firozpur (Williams, "New Nāga Images").

Brahmanical myths at Udayagiri stem from the same intellectualism on the part of both artist and patron that we have seen less vividly in Mathurā. A new attitude, in short, was transplanted here and bore new fruit.

Pawaya

Pawaya or Padmāvatī has been discussed as an important center of the Nāga dynasty in the previous chapter. This area south of Gwalior must have entered Gupta control in the second half of the fourth century, and it seems reasonable to identify Nāgasena, whom the Allahabad *praśasti* describes as conquered by Samudragupta, with the Nāga ruler of Padmāvatī. One has no way of knowing to which branch of the Nāga family Candragupta's queen Kuberanāgā belonged, but if this was the Padmāvatī branch, a burst of activity at her home late in the fourth century would be understandable. Although this is the last point in this book at which remains of Pawaya are discussed, one should remember that the city, situated near the impressive and strategic junction of the Sindhu with three smaller rivers, continued to flourish long after the Guptas.[100]

The brick pyramid whose foundation was ascribed to the Nāgas in the previous chapter received an ad-

ditional base level at some slightly later point, turning what had been a vertical, abrupt form into one that sprawled outward (Fig. 2).[101] This additional "foot" was decorated only with horizontal courses, although the whole seems to have been embellished with terra-cotta plaques as well. Various motivations can be imagined for this addition. Possibly a sectarian conversion was involved, for one might expect the Nāga shrine to have been Śaiva and the Gupta Vaiṣṇava. Possibly it was felt necessary to assert the new dynastic presence by such a change and enlargement, for the first shrine had been roughly 28 meters square, while the new one measured 44 meters. It is difficult to reconstruct the entire form of the edifice; pits on the sides of the second platform indicate that there may have been wooden shrines on the terraces.[102] In purely aesthetic terms, the addition of the base, which extended the pyramidal contour of the whole, seems designed primarily to make what was already one of the largest Hindu shrines in India at this point into a yet more grandiose and impressive monument.

A number of terra-cotta fragments were discovered around this platform (Plate 49).[103] Some may go back to the Nāga phase, particularly if this only shortly pre-

100. *ASIAR* 1915-1916, pp. 101-109.

101. The addition of the bottom platform was first noted in *GAR* 1940-1941, pp. 17-20. The difference between the two phases lies not only in exterior decor but also in the brick thickness (5 to 8 cm. in the first phase, 8 to 9 cm. in the second). The foundation beneath the platforms, moreover, consists of a cement layer twice as thick beneath the second layer as beneath the first, followed by a masonry layer that is thicker beneath the second. Garde also reports an inscribed brick from the later platform, which he assigns to the fifth century with a confidence in palaeographical discrimination that I do

not share (*GAR* 1940-1941, p. 19). I am very grateful to Dr. Lohuizen for sending me copies of the Gwalior Archaeological Reports.

102. *GAR* 1940-1941, p. 19. Garde suggests a wood shrine on top of the pyramid as well.

103. *ASIAR* 1924-1925, p. 165, pl. XLIIIb. *GAR* 1939-1940, pls. V-VI and 1940-1941, p. 20, pls. IV-VIII. The first of these reports suggests that the terra cottas were associated with the upper terraces only. No exact findspots are recorded. While several are clearly Brahmanical (Durgā on Lion, Brahmā), a number of grieving heads raise the possibility of a Buddhist Parinirvāṇa scene.

ceded the Gupta enlargement. It seems to me, however, that there is a strong kinship not only among all the heads published, but also between these and the terra cottas associated with Gupta rule at Ahicchatrā, Bhitargaon, and Kauśāmbī. None of these is well dated, but their interrelationships are better explained in the fifth century than in the politically fragmented period before. The terra cottas are freely modeled and at times coarse versions of the figural style we have just seen at Mathurā.

The most unusual piece of sculpture from Pawaya formed the lintel of a gate or *toraṇa* (Plates 50-53).[104] This seems to have been associated with the brick structure, probably as a gateway at ground level. One face bears in what would have been its center the story of Viṣṇu's conquest of the presumptuous ruler Bali (Plate 50). At the left is Bali's sacrifice, accurately described with a sacrificial platform, three fires, the curved wooden post (*yūpa*), and a sacrificial sheep. Vedic implements are meticulously represented, such as three ladles (*juhū*) lying on the altar, and the double-bowled vessel for rice husks (*phalīkaraṇapātra*) in the hand of the Brahman beside the *yūpa*.[105] To the right, Bali raises his hand in

the gesture of the ominpotent ruler (*cakravartin*), and his *guru* Śukra pours holy water upon the hands of Vāmana, the dwarf who is Viṣṇu in disguise, granting the request for as much land as the dwarf could cover in three strides. In what would have been the center of the crossbar is dramatically juxtaposed the giant form of Viṣṇu humbling Bali as he takes the three steps (Trivikrama). Those of his eight arms that survive hold a garland, dagger, discus, and bow. On the upper left, a crescent with a central figure and two horses may represent the chariot of the Moon, Candra, whose presence, along with the Sun, is invoked in later textual versions of this subject.[106] Above the sacrifice, female figures lean from a palace with a gate, perhaps like the structure of which this lintel was a member. The panel to the far left contains a scene of courtly music and dance. The entire subject, unprecedented in the fourth century, evokes not only an anti-Brahmanical Bhāgavatism but also the idea of the righteous ruler replacing the scrupulous but excessive one, a theme of significance for the Guptas after their conquest of Nāga lands.

There is no way of determining which face of this lintel was the principal or exterior one. That on the

104. *ASIAR* 1924-1925, p. 165, pl. XLIII, c, d. A large sunken square on the upper surface above the side panel suggests that some further part of the *toraṇa* surmounted this.

105. Zimmer, *Art of Indian Asia*, pp. 39-40, pl. B 1.

106. Gopinatha Rao, *Elements of Hindu Iconography* I, part 1, p. 165 (apparently following the *Vaikhānasāgama*). Eight arms are common for Trivikrama, but the attributes here do not correspond to those in the *Viṣṇudharmottara Purāṇa* nor to any source I can find. The horses of the figure in the crescent are not commonly the Moon's vehicle, and it is possible that this is related to the late Kushan version of Varāha with two suns (N. P. Joshi, "Kushaṇa Varāha Sculpture").

A small broken image of Trivikrama, probably early Gupta, from Mathurā, appears to have six arms; no visible attributes correspond to those at Pawaya (*Indian Archeology*, 1970-1971, pl. LXXVIIIc). The Trivikrama relief at Parsora (= Ramagarth Hill) appears to me to be considerably later (*Indian Archeology*, 1958-1959, pl. LXXV B; Berkson, "Some New Finds at Ramagarth"). The reliefs themselves at this site may be too abraded for conclusive discussion, but an associated shrine bears *candraśālās* of elaborate split form that cannot precede the Viṣṇu Temple at Deogarh, and are possibly even later than the sixth century (Berkson, "Some New Finds at Ramagarth," fig. 2a).

reverse (Plate 51) bears an equally novel and impressive subject, the Churning of the Ocean of Milk, probably indicating a second form of Viṣṇu, in his Tortoise (Kurma) *avatār*, supporting the Churning. Below, four figures—either divine or demonic—pull on the serpent Vāsuki, who serves as the churning rope. The divine cow Surabhī and the goddess Lakṣmī, holding a jar, issue from the center. To the right sit four figures, one holding a noose (Vāruṇa?) and one a stick (Yama?). It would be appropriate that these *dikpālas* or guardians of the points of the compass should frame the cosmic churning. Above, Garuḍa appears frontally, as on coins (Plate 10e). This motif again emphasizes both the Vaiṣṇava and the royal aspects of the theme.[107] On the upper central register sit four haloed figures with splayed legs. The figure on the left has multiple heads (Brahmā) and that on the right is surrounded by a spoked halo (*cakra puruṣa* or Sūrya). The right end of this lintel depicts, in what must be a subordinate side position, Kumāra with six pairs of hands and six heads (Plate 52). As a war god, Kumāra had appeared in this many-armed and many-headed form on Yaudheya coins, and his presence here may reflect the recent conquest of the Yaudheya tribe, which seems to have had this god as

its totem.[108] Kumāra is not necessarily out of place on the otherwise Vaiṣṇava lintel, for his identification as the son of Śiva is a relatively late feature. Another fragment (Plate 53) from the same site seems to form part of the corresponding panel at the opposite end of the lintel.[109] Here the twelve-armed figure must be Kumāra's consort, Ṣaṣṭhī. This couple has been identified in a number of Kushan reliefs from Mathurā, none, however, as dramatically orchestrated as the Pawaya lintel.[110]

Stylistically as well as thematically, the carving is most likely to belong to the late fourth century. The dance scene in Plate 50 is the most backward-looking part, for the women's legs bend with a rubbery suppleness reminiscent of Amarāvatī reliefs. The attendants upon Trivikrama are, however, more solidly defined. The dwarf wears the characteristic Gupta headdress with side curls and a smooth semicircle on top, a style that appears in incipient form under Candragupta at Udayagiri Cave 6 (Plate 36). Viṣṇu Trivikrama's mitre resembles the surviving fragment of that of the Udayagiri Anantaśayana in shape and in surface imbrication (Plate 39). The flat but adequate space in which the figures are harmoniously arranged (for example, the deliber-

107. For a summary of various Epic and Purāṇic versions of the Churning, see Bedekar, "Legend of the Churning," and Chatterji, "Samudramanthana." I am unable to differentiate which source is closest to the Pawaya version, nor can I explain the figures above textually. It is of interest that the *Matsya* (ch. 249) specifically mentions Bali as the leader of the Asuras approached by the gods, suggesting a connection with the reverse of the lintel. It is also conceivable that the theme of Aryan and non-Aryan forces working in harmony may have had political implications under the Guptas. The

figure on the far left may represent Dhanvantari with the nectar, and the next with a club is perhaps Viṣṇu himself, as mentioned in the *Viṣṇu Purāṇa* (although Śiva-Lakulīśa as the swallower of poison is a distant possibility).

108. Sharan, *Tribal Coins*, pp. 93-97. Bhattacharji, *Indian Theogony*, pp. 181-83.

109. *GAR* 1942-1946, pp. 14-16, pl. X.

110. R. C. Agrawala, "Goddess Ṣaṣṭhī."

ately alternating positions of the women looking down on the sacrifice) points toward the later reliefs of Sār-nāth. The Churning seems to precede that above Udayagiri Cave 19, where the positions of the gods and demons are varied. The simple band of foliage winding regularly back and forth beside the scenes of Kumāra and the dance resembles that of the Mathurā image in Plate 18, which I have placed ca. 390-395, as well as that on the doors of Sāñcī 17 and Udayagiri Cave 6. The simple row of triangles also used as a border on the Pawaya piece occurs on the Udayagiri 6 door and at Mathurā (Plate 23) as well. Finally, the entire form of the lintel either revives the type of the Sāñcī gate-ways, dormant in stone form for three centuries in this region, or takes as its model wooden versions. In either case, in immediate terms this is an innovation, just as in the details of the carving the sculptor devises with ingenuity new forms to fit the significant themes that he was illustrating.

Among the separate sculptures from Pawaya, several pieces may be assigned to this early Gupta phase. The first, found on the brick mound, represents Viṣṇu, whose presence one would expect here both from the lintel above and from the Vaiṣṇava proclivities of the Guptas (Plate 54).[111] This figure retains the pneumatic sche-matism of Kushan sculpture but is slightly more slen-der in the waist than was the third-century type. The

upper hands are ingeniously treated: one taps the club, while the fingers of the other neatly interlace with the spokes of the discus.

In sum, this site plays an important role as an early Gupta center away from the dynastic heartland. Here in the years following Samudragupta's conquest, major images were executed in a style that both kept pace with the central style of Mathurā and simultaneously introduced new elements. The novelty may owe some-thing to local sources, but these would seem either to go back several centuries or else to have existed largely in wood. If the Nāgas played a role in the formation of early Gupta art, it is largely the indirect one of in-voking a new style from the conquerors.

Mandor

Mandor, just outside the Rajput citadel Jodhpur, was the capital of Mārwār in the sixth century and later. While its political history in the fourth century is not known, two large carvings clarify the relationship be-tween such peripheral regions and central artistic at-eliers at this point (Plates 55-56). These thin slabs of stone probably faced the jambs of a doorway at least 4 meters high.[112] Again we see the remains of a structure ambitious in scale, if not necessarily constructed all of stone.

The inscription in the middle of Plate 55, although

111. *GAR* 1940-1941, pp. 19-20, pl. VIII D. Another Pawaya im-age that I would ascribe to this period is the Janus capital reproduced in Harle, *Gupta Sculpture*, pl. 34. This has been identified as a *cakra puruṣa*: Begley, *Viṣṇu's Flaming Wheel*, pp. 46-47. This is preferable to Dikshit's suggestion of Indra and Upendra (= Viṣṇu) as two Ād-

ityas (*Guide, Gwalior*, pp. 13-14), a pair not elsewhere given such prominence, and whose *kirīta mukuṭās* are lacking here, as Begley points out. Another possibility, substantiated by no specific detail, is Nara and Nārāyaṇa.

112. *ASIAR* 1905-1906, pp. 135-40. D. R. Bhandarkar in this re-

totally illegible, has been used to buttress palaeograph-
ically a date at the beginning of the Gupta period.[113]
The figural style is generally comparable to that of the
Pawaya lintel or the Mathurā pillar in Plate 24. Thus
the figures at the top of the first Mandor slab resemble
those of Plate 50 in the general treatment of drapery,
clinging to the body with double lines that indicate folds.
The legs of the woman in the lower right of Plate 55a
bend with the same tubular form as those of the figures
in the Pawaya dance scene. For lack of more precise
evidence from Mārwār itself, the Mandor posts may
simply be placed within the reign of Candragupta II.

This position is borne out by the iconography of the
carvings, for these are rich in narrative terms and at the
same time are part of a widespread network of accepted
conventions for representing Kṛṣṇa's youthful exploits.
The scenes seem to read from bottom to top:[114]

Plate 55 a. The overturning of the cart-demon
 b. The churning of butter
 c. The lifting of Mt. Govardhana
Plate 56 a. The killing of the horse-demon, Keśin
 b. The killing of the bull-demon, Ariṣṭa
 c. The release of two Yakṣas imprisoned in
 twin Arjuna trees (?)[115]
 d. The taming of the serpent, Kāliya
 e. The killing of the ass-demon, Dhenuka

The compositions in Plates 55a and b resemble later
versions of the same subjects from Deogarh and the
area of Vārāṇasī, respectively.[116] The slaying of Keśin
seems to have been a subject favored on weight-lifting
stones at Mathurā, one of which has been found in
Pakistan.[117] This subject and the killing of Ariṣṭa oc-
cupy the ends of a Gupta-period lintel at Pipariya in

port points out that while James Tod referred to these posts as part
of a *toraṇa*, this is improbable in view of their thinness (ca. 20 cm.)
and the fact that they are one-sided.

113. *ASIAR* 1905-1906, p. 140.

114. These do not follow the sequence of Kṛṣṇa's life as told in
later texts such as the *Viṣṇu Purāṇa*. There is rather a thematic
grouping of domestic scenes (Plate 55) and more violent scenes (Plate
56), which Michael Meister has pointed out in later Kṛṣṇa cycles of
western India ("Kṛṣṇalīlā," p. 29).

115. I base this suggestion on what appears to be a mortar in the
lower right. Trees are not shown, as is generally true later, nor is it
certain that the flanking figures that I take to be Yakṣas are in fact
male.

116. The position of child and cart is the same at Mandor and
Deogarh (Vats, *Deogarh*, pl. XVIIIb). Kṛṣṇa and his mother stand in
the same positions in a scene of the butter stealing from Kara, near
Vārāṇasī (R. C. Agrawala, "Brahmanical Sculptures," fig. 338).
For a stimulating and more comprehensive survey from a religious

standpoint of these and other possibly identifiable Kṛṣṇa scenes, see
D. Srinivasan, "Early Kṛṣṇa Icons." Dr. Srinivasan convincingly
emphasizes the role of Vāsudeva-Kṛṣṇa, the hero of the Vṛṣnis, as
opposed to Gopāla-Kṛṣṇa, the cowherd, through the Gupta period.
I find it more difficult to accept her argument that Mathurā lags
behind other areas in producing Kṛṣṇa-Līlā images at this point. If
Kṛṣṇa the Cowherd was a minor folk divinity at this point, "the great
Yakṣa of Mount Govardhana," patronized primarily by the Ābhīras,
nonetheless it would seem that it was Ābhīras in the Mathurā area
(including Govardhana) for whom stone images were initially made.
Admittedly the wanderings of these herder tribes may have dispersed
the Mathurā types, in addition to other factors discussed below. I
am also indebted to Jack Hawley for sharing with me a revised man-
uscript of his Ph.D. dissertation, "The Butter Thief" (Harvard, 1977).
This catalogues Kṛṣṇa-līlā themes very systematically.

117. Van Lohuizen, "Gandhāra and Mathurā," pl. XI. N. P. Joshi,
Mathurā Sculptures, pl. 64. Others are known in private collections.

similarly abbreviated form (Plate 174). The subduing of Kāliya is known in at least three versions from Mathurā.[118] The composition of the killing of Dhenuka at Mandor corresponds exactly to that on a pillar, again from Mathurā.[119] The lifting of Mt. Govardhana to protect the animals and people of Braj from Indra's wrath is the most prominent scene of the Mandor cycle by virtue of its size. This event is represented in at least five other Gupta examples, ranging from northern Rajasthan to Vārāṇasī and again including Mathurā.[120] All depict Kṛṣṇa in the same pose, yet the Mandor example surpasses the rest in the anecdotal richness with which the scene is embroidered. One sees the same inventive yet literal approach toward subject matter in the great Udayagiri reliefs and the Pawaya lintel.

The Mandor pillars present a dilemma in their placement within a larger framework. To stop after the above comparisons would be to imply that Mandor originated imagery of Kṛṣṇa the Cowherd at this point, for these carvings are the earliest extensive cycle preserved. Yet of the eight scenes represented here, Mathurā also preserves at least four of the Gupta period and earlier.

Refined chronological judgments are difficult for many of the relatively simple pieces in question, a fact that makes discussion of priority difficult. It appears to me that the general role of Mathurā as a source of iconography and style, its central geographical position in relation to Kṛṣṇa scenes found on three sides of it, and the general association of the Braj area with the life of this divinity make it inherently more likely that Mathurā originated such imagery. The Katra Keśava Deo Temple there, leveled by Aurangzeb in the building of his mosque, as the birthplace of Gopāla-Kṛṣṇa might well have been the site of more ambitious carvings than those so far found in the Mathurā region. The means by which such models were transmitted as far as Mandor may have included artists' pattern books, portable carvings such as the weight-stones that depict the fight with Keśin, or the actual movement of sculptors themselves. Another possible vehicle in this case is the peripatetic troupes of *Kṛṣṇa-līlā* dancers who still circulate from Mathurā and whose stage conventions may explain iconographic formulae.[121] It seems impossible at this point to choose among such alternatives, yet it

118. N. P. Joshi, *Mathurā Sculptures*, pl. 89. Goetz, "Earliest Representations," fig. 1. Filliozat, "Représentations de Vāsudeva," pl. a. The last example is now in a French private collection.

119. This occurs at the top of a second face of the pillar reproduced in Filliozat, "Représentations de Vāsudeva," pl. a. The palm tree, Balarāma, and Dhenuka are in the same position as at Mandor. I am grateful to James Harle for sending me a reproduction of this image.

120. Shah, "Terracottas from Former Bikaner State," fig. 1. (This Rang Mahal example comes closest to the Mandor one in the elaboration of the mountain with animal life and in the whimsical treatment of the cows.) P. Chandra, *Stone Sculpture in the Allahabad Museum*, pl. LXIII. R. C. Agrawala, "Brahmanical Sculptures," fig. 337

(or Harle, *Gupta Sculpture*, pls. 64-65). Another example occurs at Deogarh, No. 225 in the site museum. Kalpana Desai describes a fragmentary Kushan piece, presumably from Mathurā, in the Bharat Kala Bhavan (*Iconography of Viṣṇu*, pp. 128-29). A Govardhanadhara image from Jatipara, near Govardhana, now in the Indian Museum, Calcutta, may perhaps be Gupta (*ASIAR* 1921-1922, pp. 103-104, pl. XXXVIe). Other Kṛṣṇa-līlā scenes not discussed here because they do not appear at Mandor include the Dānalīlā (Bikaner) and Vasudeva carrying the Babe over the Yamuna (Mathurā Museum 1344, a piece whose precise iconography is a subject of controversy).

121. Hein, *Miracle Plays of Mathurā*, especially ch. 9.

is probable that Mathurā, by its religious position as well as by its artistic position, explains what unity we perceive. To deny the Mandor artists the role of originators is not to disparage the lively quality of their carvings.

Devnimori

The final region to be considered under the period of Candragupta II raises the greatest controversy. Western India, and specifically the Buddhist site of Devnimori in northern Gujarat, has been claimed as the progenitor of much of the Gupta style. Such a claim rests upon a dating for the great *stūpa* at Devnimori to the fourth century, before Candragupta's conquest of the region. Hence the suggestion by some scholars that Gupta art in fact originates under the Śaka Kṣatrapas.

The importance of this question requires a detailed examination of the evidence for the date of Devnimori. Archeologically speaking, this is among the better understood Indian monuments, for it has been excavated scientifically by a team from M. S. University in Baroda.[122] We know that the gigantic *stūpa*, some 28 meters square at the base and 140 brick courses high, is a unified constructional effort, repaired in places on the exterior but not substantially altered. Eight terracotta Buddha images were discovered near the bottom and one near the top; all were found carefully covered over with the fabric of the monument. Fragments of architectural decor were also discovered lying flat within the *stūpa* in two places. The excavators suggested that all these buried terra cottas were overburned or broken, and were retained out of respect for their sanctity.[123] Niches were present on the exterior of the second tier of the monument, but none preserves an image.

The excavators proposed a date in the third quarter of the fourth century on the basis of two kinds of evidence. At course 94 in the center of the mound, a casket was found, whose inscription mentions the *Mahāstūpa*, built under King Rudrasena in the year 127. This year probably refers to the Kalacuri era, yielding a date of A.D. 375; in that case, the ruler is possibly the late Kṣatrapa Rudrasena III, known from his coins to have ruled from 348 to 378.[124] In the second place, at course 35 a pot was found with eight Kṣatrapa coins, whereas the only later coins were sixth-century Valabhi issues associated with repairs to the monument.[125] Without questioning this archaeological information, it is possible to question the interpretation put upon it.

122. Mehta and Chowdhary, *Excavations at Devnimori.*

123. Ibid., p. 56. I have not been able to discern any reason for such rejection in the pieces themselves.

124. Ibid., pp. 28-29, correcting an earlier ascription to the Śaka era. V. V. Mirashi independently suggested the Kalacuri era, but corrected some parts of the reading and suggested an Ābhīra rather than a Kṣatrapa identity for the Rudrasena of the inscription: "Devnī Morī Casket Inscription." While Mirashi may well be correct, the question of Ābhīra vs. Kṣatrapa patronage is peripheral to the art-

historical issue. Other identifications for the era have, of course, been proposed (see various articles in the *Journal of the Oriental Institute, Baroda* XIV, 1964-1965).

125. Mehta and Chowdhary, *Excavations at Devnimori*, pp. 28-30. Some lag between the period of the coins (the latest of which is an issue of Viśvasena, whose rule ended ca. A.D. 305) and the construction of the *stūpa* proposed by the excavators (at roughly the date of the casket, A.D. 375, and under Rudrasena III, who did not come to the throne until ca. A.D. 348) is necessary in any case.

Although a date just preceding A.D. 375 is most probable, it is also conceivable that the monument was erected after that point and that an earlier casket was preserved or reused. The absence of post-Kṣatrapa coins in the fabric of the *stūpa* is more troublesome, but the retention of earlier coins is quite possible even a century later. Early Gupta coins are scarce in Gujarat, and their absence here does not disprove a Gupta date.[126]

It seems that this second hypothesis is more consistent with the style of the sculptural and architectural ornament, for which a date of 400-415 is reasonable. The difference in absolute date between this suggestion and that of the Baroda excavators is less significant than the question of the general artistic role of the area. I would interpret Devnimori as an early example of styles developed in Mathurā that mingled with local traditions, rather than as a Kṣatrapa prototype for Gupta style.

One aspect of the images themselves that may have contributed to an early dating is the presence of some Gandhāran elements. Yet current scholarly opinion has come to recognize a longer duration for Gandhāran art than was admitted a decade ago. In the Buddha in Plate 57, for example, the crisp waves of hair arranged in neat rows are closer to northwest Indian styles, particularly in stucco and in terra cotta, than to any Kushan Mathurā versions of those Gandhāran traditions. At the same time, such forms continue at Fondukistan as late as the seventh century, so that an early date need not follow.[127] The Devnimori drapery types, claimed to be Gandhāran, are even less conclusive. While some of the terra-cotta Buddhas wear three-dimensional folds, these may be related to the string-fold convention whose gradual development in Mathurā we have already seen.

Among architectural elements, Devnimori preserves one example of a pilaster with inset central rectangle, a Gandhāran motif that survives in the fourth- or fifth-century phase of the Swat (Butkara) *stūpa* and again perhaps at Fondukistan.[128] The checker pattern is a motif that does not occur in late Kushan Mathurā; nor are there early Gupta examples from Mathurā, Mālwa, or Magadha. This motif certainly became common after A.D. 415, and it is possible that this does represent one Gandhāran-derived element that western India transmitted to the later Gupta style. Yet on the whole, the northwestern influence seems to be a limited phenomenon, surviving only in a restricted way in the sixth-century sculpture of Gujarat itself.

On the other hand, many stylistic elements at Devnimori are precisely in line with the art of Mathurā at the end of the fourth century. Most of the terra-cotta Buddhas show curving rows of hair curls, a development in central India by about A.D. 370 and probably before that in Mathurā. The downcast eyes of the

126. M. R. Majumdar (*Chronology of Gujarat*, p. 128) lists silver coins in plenty from Kumāragupta on, but only 9 previous examples, all gold and from a single hoard found at Kumarkhan, Ahmedabad District.

127. Hackin, "Fondukistan," fig. 178. See p. 57 for reference to the coin of Chosroes II; in fact this coin bears an overstrike, and a seventh-century date for the deposit is likely.

128. Faccenna, *Guide to Swat*, p. 39 (on dating), pl. VII. Hackin, "Fondukistan," fig. 189.

Buddha appeared by the year 384 at Bodh Gayā. The characteristic "Gupta" curling foliage that appears in a few decorative medallions at Devnimori (Plate 58) has been seen to develop gradually at Mathurā, reaching this form soon after A.D. 390. The rounded decorative arches resemble those of Udayagiri Cave 6 and Mathurā counterparts around the year 400. Most other motifs are current from late Kushan periods onward in Mathurā: broad spikey leaves, overlapping rows of small leaves, a single or double row of leaves issuing from a line, lotus petal rows, and the bead and reel border.[129] In short, it seems improbable that such elements at Mathurā should represent western Indian influence, when they have their own local history on the spot.

Thus, with the exception of the checker pattern, it is hard to see Kṣatrapa influence upon the rest of India. Whatever the date of the Devnimori *stūpa*, it would be remarkable that forms should originate here with no earlier sites in the region providing sources or suggesting established schools of sculpture.[130] The Devnimori terra cottas reflect the same kind of influence from Mathurā combining with local traditions that we have seen in Magadha to the east and Mālwa to the south. In western India, this situation is most likely to occur around A.D. 400, after Candragupta's victory over the Śaka Kṣatrapas, a date that is consistent with the evidence of the artistic motifs themselves.

Conclusion

It is only with the third major Gupta ruler that we can speak of a Gupta artistic style, or in fact of much artistic production. The campaigns of Candragupta I, Samudragupta, and even Candragupta II in his early years must have diverted both the attention and the resources of the emperor and of his courtiers from the patronage of temples and images. Likewise the Buddhist and Jain art of Sāñcī, Rajgir, and Mathurā would have been affected by periods of warfare during which the merchants, a central element in the heterodox communities, might have found livelihood difficult. Thus it is to be expected that art would take form only with the establishment of a *Pax Guptica*. Even more than the writing of literature, in which a single poet alone need be supported if he is a Kālidāsa, the building of stone architecture, the carving of images, and the endowment of religious foundations require an economic commitment that affects a large body of people (both the artisans and those farmers whose land is attached to the temple). Hence it is not surprising that there should be an apparent lag between architectural and sculptural endeavor on the one hand, and on the other the literary and musical accomplishments ascribed to Samudragupta's court.

An underlying concern in all the chronological dis-

129. The excavators use classical terminology (acanthus, olive, laurel) for what seem to me at this point more generalized decorative motifs. For Kushan examples, see ch. I, pls. 2-4.

130. Uparkot, often assigned to the fourth century, is discussed below as a later fifth-century excavation. The Rang Mahal terra cottas from Bikaner State may well belong to the fourth century, but these seem to me the sort of late Kushan style one would expect at that point, with few intimations of Gupta forms.

cussions has been the question of where the Gupta style was formulated. No area, it seems to me, could possibly have been the origin of as many aspects of this style as Mathurā. Yet each of the outlying areas added something of its own to the new "central" style. It is interesting that this centrality does not correspond to the political structure of the Gupta empire. Mathurā was neither the capital nor a major administrative center, as it had been under the Kushans. But it was the seat of active and long-standing sculptural workshops, which served the various religious communities that continued to thrive here. Moreover, there was only a short time lag between this center and the provinces, all of which seem to have been ready to move toward a common goal.

On the one hand, the goal can be conceived in terms of national artistic identity and abandonment of Kushan traditions for the first time in two-and-a-half centuries. These traditions, as outlined in the first chapter, derive from Iranian sources, from Greco-Roman elements showing Gandhāran influence, and from the local styles of the Mathurā carvers. The first two elements seem to have remained undigested in late Kushan art, so that developments under Candragupta II represent a major break with the past. While the capture of the Śaka-held lands on the west may not loom very large in comparison to Samudragupta's conquests, it justified Candragupta in claiming to be *Vikramāditya* and in assuming the perquisites of the ideal ruler, the *cakravartin*. More than the boasts of his prowess, which had been and were to be made by countless Indian rulers with less justification than by the Guptas, it is the conscious sense

of break with the immediate past at this point that corresponds to the appearance of a Gupta artistic style.

The new style can be understood at the same time in more limited aesthetic terms. The underlying impulse at work in various changes I have described was an emphasis upon the visual unity of the object. The new arrangement of the Buddha's hair, the downcast eye, and the reduction of drapery folds to a series of lines all show the subordination of details previously treated for their own sake to the overall effect. Similarly the development of the column, reconciling square and round elements, is motivated by the same quest for plastic harmony. This quest was perhaps understood by the artist himself less in aesthetic terms than in religious ones. The downcast eye integrated into the skull indicated the meditative nature of the Buddha more fully than did the outgoing Kushan type. The carving was not the god himself made directly manifest but an image *of* him, to be perfected by human endeavor. What is important, however, for the art historian, is that the change was consistently realized in these formal terms, indicating that the taste of the maker or patron placed a greater premium upon visual unity than ever before or after in Indian art. This was the means to a new end.

Some of the new content itself is to be explained by the fact that for the first time Hindu art had patronage that required and could sponsor major stone imagery. Undoubtedly this had something to do with the Gupta emperors' use of Hindu traditions, as in the horse sacrifice or the Bhāgavatism of Candragupta II. It is significant that the most striking images of Udayagiri and Pawaya are Vaiṣṇava. At the same time, it would be a

mistake to see the art of this period as deliberately sectarian. The doors of temples demonstrate that themes such as the River Goddess and the new foliage, motifs both connoting water and hence enriching the door as an ablutionary and purifying entrance to the shrine, were accepted in both Buddhism and Hinduism. It is as if the courtly poetics of *kāvya*, running throughout all Indian religions, at this point demanded a corresponding visual representation of the great literary themes and their rich embellishment or *alaṃkāra*. Yet, in this first phase of Gupta art, the new content was not fully worked out. The reliefs and doors of Udayagiri had not attained the harmony of the later fifth century; the new elements here were sometimes confused and lacked the organized complexity of the next phase. Thus, the art of the reign of Candragupta II set the stage for what was to follow.

Chapter III
MATURITY AND CRISIS,
A.D. 415-485

Historical Background

Gupta expansion came to an end with the ascent to the throne of Candragupta's son, Kumāragupta, between A.D. 413 and 416. Kumāragupta's forty-year rule was uneventful in terms of military exploits until its final phase.[1] It is significant that of his thirteen inscriptions, more than are preserved for any other Gupta ruler, only one mentions conquest. At the same time, these records indicate that Kumāragupta, "whose fame was tasted by the waters of four oceans," maintained power over as wide an area as had his father and employed a system of governors and subordinates to administer the kingdom.[2] None of his inscriptions records a royal act, let alone praises him in the manner of earlier and later imperial eulogies. It is thus possible both that his own personality was less exuberant than those of other Gupta emperors and that his administration was decentralized with unusual smoothness. His reign might be compared with that of the Mughal emperor Shah Jahan, as a period of seeming political stagnation and architectural activity. In short, while there are no historical events worth discussing under Kumāragupta's rule until its end, this period had some makings of cultural development: peace, prosperity, and pride in a dynasty already established.

The coins of Kumāragupta bear out this estimate of

1. It has been suggested that Kumāragupta had a competitor in an elder brother, Govindagupta, but Goyal convincingly argues that the latter was more likely younger and subordinate (*Imperial Guptas*, pp. 253-55). Goyal interprets the Rithpur (Ṛddhapura) copper plates of the Nala dynasty as a record of Gupta-inspired attack upon the Vākāṭakas under Kumāragupta (ibid., pp. 252-61). This argument raises two questions: 1. does this inscription indicate a major alliance between the rulers of Prayāg and the Nalas? and 2. what is the date of the Nala campaign against the Vākāṭakas? The date of the Rithpur plates is based on palaeography alone. Altekar suggested the fifth century in Majumdar and Altekar *Vākāṭaka-Gupta Age*, p. 116. Sir-

car suggested the first half of the sixth century in *Select Inscriptions*, p. 439. Even if the debacle is identified with that from which Narendrasena rescued the Vākāṭaka fortunes, there is room for argument both about his dates and about when, in relation to these, the Nala invasion took place. In any case, only a positive answer to 1. makes it possible to connect the Nala invasion with a powerful Gupta leader.

2. Karamdanda inscription, *EI*, X (1909-1910), 72. This records the same kind of governors as do the Dharmodarpur plates, hence a system of administration stretching from at least the Doab to eastern Bengal. Kumāragupta's coins have been found as far west as Kathiawaḍh and as far south as Satara (Altekar, *Coinage*, pp. 216-18).

the importance and creativity of his reign. He continued, with certain modifications, four types of his father, and revived four discontinued earlier types.[3] These last suggest an awareness of dynastic tradition of a particularly self-conscious kind, not merely continuing forms in use but deliberately invoking the period of greatest Gupta glory in the fourth century. There were some innovations as well. For example, the Kārttikeya type, with the war god seated frontally upon his peacock vehicle (Plate 10g), refers clearly to Kumāragupta's own name (Kumāra = Kārttikeya). This theme is echoed in several other coin types that gratuitously include a peacock on the reverse, as well as in a number of sculptures of the god Kumāra.[4] The most intriguing of Kumāragupta's coins is a rare type on which the ruler, dressed simply, stands between a male figure holding a shield, and an entreating female figure (Plate 10h). The reverse represents a conventional Lakṣmī, with the legend *Apratigha*, the term by which the type is known. It has been suggested that the ruler is shown contemplating abdication, while his queen and son attempt to dissuade him; thus the epithet *Apratigha*, usually taken as "invincible," may have a specifically Buddhist connotation of "one who is without anger."[5] On the whole, Kumāragupta's coins indicate a complex personage, less interested in simple self-proclamation than were his father and grandfather, yet shaping in subtle and enigmatic ways his numismatic imagery.

Skandagupta, Kumāragupta's son, ascended to the throne around 455 amid contending claims by his own family as well as threats from the outside.[6] The eloquent inscription on a pillar at Bhitari, near Vārānasī, describes him, "—By whose two arms the earth was shaken, when he, the creator [of disturbance like that] of a terrible whirlpool, joined in close conflict with the Hūṇas; . . . just as if it were the roaring of [the river] Gaṅgā, making itself noticed in [their] ears."[7] The Hūṇas were a branch of the larger group of Huns who attacked Rome as well in the middle of the fifth century.[8] In Afghanistan, a branch known as the Hephtal-

3. The continuations of Candragupta's types include the Archer, *Chattra*, Horseman, and Lion-slayer. The latter introduces Narasiṃha as a royal epithet, possibly the same kind of identification with an *avatār* that has been suggested for Candragupta II in the case of Varāha. The discontinued types that were revived include King and Queen, Tiger-slayer, Aśvamedha, and Lyrist (Altekar, *Coinage*, pp. 165-215).

4. Other types with the peacock include the Tiger-slayer and Horseman Class II. Other new types are the Elephant-rider, Lionslayer, and Rhinoceros-slayer; the latter need not indicate the ruler's presence in Assam, as has been inferred, for rhinos were known in Afghanistan in Mughal times.

5. Altekar, *Coinage*, p. 209. Goyal, *Imperial Guptas*, pp. 292-95.

6. The Junāgaḍh inscription says that Lakṣmī selected him above the "sons of kings" (Fleet, *CII*, III, 62, line 5). One of these rivals may have been a brother Ghaṭotkacagupta, known from the Tumain inscription (*EI*, XXVI [1941-1942], 115-18) and the Bhitari seal (Smith and Hoernle, "Inscribed Seal"). While Goyal presents a convincing case for such rivalry (*Imperial Guptas*, pp. 304-13), U. N. Roy has recently denied this (*Studies*, pp. 28-58). The Bhitari inscription mentions the Puṣyamitras as Skandagupta's enemies (Fleet, *CII*, III, 55). There is some question, however, about this reading (Majumdar, *Classical Age*, p. 24 and Sircar, *Select Inscriptions*, p. 322). Goyal uses Purāṇic evidence to connect these with the Pāṇḍavaṃśīs of Kosala (*Imperial Guptas*, pp. 276-77).

7. Fleet, *CII*, III, 56.

8. The Junāgaḍh inscription also mentions defeat of the Mlecchas (foreigners), probably the Hūṇas (Fleet, *CII*, III, 62). For recent studies of this large group, see Göbl, *Dokumente* and Maenchen-Helfen, *World of the Huns*.

ites invaded the Sassanian empire with increasing suc-
cess in the second half of the fifth century. The Hūṇas
appeared again in India after roughly fifty years. It is
significant that early in his reign Skandagupta checked
this group, which later succeeded in invading central
India in the same way that related groups had already
attacked the most powerful contemporary regimes to
the west.

Skandagupta's five inscriptions give an impression of
greater personal strength than do those of his father; all
name him and most detail his exploits. For example,
the Junāgaḍh rock inscription records not only the
standard profuse eulogies but also the king's concern in
appointing a governor over Saurāṣṭra. And this gov-
ernor, Parnadatta, in turn describes how the dam of the
great reservoir Sudarśana, established by Aśoka some
seven centuries before, burst and was repaired.[9] This
inscription of A.D. 458 implies that the ruler's presence
was strongly felt far to the west in the early years of
his reign. Skandagupta's rule endured only twenty years
at the most, and there are no inscriptions after A.D. 466,
a fact suggesting that his influence was in some way
checked. While there is no conclusive evidence of the

collapse of his power, the breakup that is documented
in the 470s is not likely to have begun suddenly. It is
quite possible that his control, even while recognized
in Saurāṣṭra and parts of central India, was nominal in
the intervening Mālwa.[10]

The strongest case for political decline under Skan-
dagupta lies in his coins. The gold content (about 90
percent under the early Guptas) was reduced to be-
tween 78 and 72 percent.[11] This would indicate some
financial strain on the empire. Moreover, only three
gold types were issued, and these with minor innova-
tions.[12] As a whole, it would seem that despite Skan-
dagupta's early successes, this was a period of stress for
the imperial power. Yet this is also a case of correlation
of economic hardship, emotional strain, and a sense of
impending disaster with unusual artistic activity, as in
Renaissance Italy.[13]

No sons of Skandagupta are known, and the next
three rulers are the offspring of his brother Purugupta.
The first two seem to have had ephemeral reigns—
Narasiṃhagupta Bālāditya I[14] and Kumāragupta II.[15]
Budhagupta, however, ruled from at least A.D. 477 un-
til perhaps as late as 500, bridging the line between this

9. Fleet, *CII*, III, 56–65.

10. For Rewa in eastern Madhya Pradesh, see the Supia inscription
of G.E. 141 (*EI*, XXXIII [1960], 306–308). Goyal suggests that the
-varman rulers of Mandasor turned against their Gupta overlords, whose
power was reasserted by Prabhākara, of another local family (*Impe-
rial Guptas*, pp. 288–89).

11. Altekar, *Coinage*, pp. 240–41. Goyal argues that there is no
numismatic proof of decline *within* the reign of Skandagupta, a slightly
different point (*Imperial Guptas*, p. 286).

12. The Archer and *Chattra* types are unchanged; the King and

Lakṣmī reverses the earlier King and Queen type (Altekar, *Coinage*,
pp. 240–49).

13. Cf. Lopez, "Hard Times and Investment in Culture."

14. Narasiṃha I is known from the Bhitari seal and from coins of
71 percent gold, to be distinguished from Narasiṃha II, who issues
coins of only 46 percent gold, and who appears in Buddhist literature
as the conqueror of Mihiragula (Altekar, *Coinage*, pp. 266–70; Goyal,
Imperial Guptas, pp. 323–24).

15. Kumāragupta II is known from a Sārnāth image inscription
to have ruled in A.D. 473 (Sircar, *Select Inscriptions*, pp. 328–29).

and the next stylistic periods.[16] His inscriptions fall into three groups. In the first place, there are those from what must have been the center of Gupta power: Sārnāth, Rājghat, and Nālanda.[17] All of these are short but indicate that his sway was recognized in the dynasty's heartland. In the second place, inscriptions from the Rajshahi District in what is now Bangladesh indicate that the administrative system of Kumāragupta I still applied far to the east. These cite the authority of Budhagupta's *uparika* or governor; this official is at the same time given the title Mahārāja, indicating a position of hereditary independence.[18] Thus while the old system of ties with the central government still functioned, it weighed less heavily than before in the eastern provinces. In the third place, a pillar inscription at Eran dated A.D. 484 reveals the condition of the empire to the west.[19] Although this calls Budhagupta *bhu-patiḥ* or Lord of the Earth, he is here eclipsed by more local potentates. One Suraśmicandra, who ruled between the rivers Yamunā and Narmadā, is compared to a Lokapāla (divine World-guardian), a simile hitherto reserved for Samudragupta in Gupta inscriptions. Furthermore, the local ruler Mātṛviṣṇu is styled Mahārāja and is in fact the subject of the entire eulogy, he whose "fame extends up to the shores of the four oceans." No Gupta inscription of Budhagupta's reign or after has been found to the west of Eran (in central India), which would hence seem to represent one of the border marches of the late Gupta empire. The inscriptions of the Parivrājaka and Uccakalpa dynasties discussed in Chapter IV show that already in A.D. 475 eastern Bundelkhand was not under Gupta power.

Budhagupta's coinage confirms the decline of central power, for it is rare, as impure in gold content as that of Skandagupta, and uninventive in image or legend.[20] In the west, Gupta silver coinage vanished, supporting the impression that the dynasty had no effective control there. The very vagueness of our knowledge of Budhagupta is a result of the paucity and indecisiveness of his remains.

S. R. Goyal has pointed out that Buddhism and to some extent Jainism flourished under Kumāragupta I and his successors. It is understandable that religion in general and ascetic beliefs in particular should prosper in the second half of the fifth century, a time of troubles when the Gupta glory and secular power were obviously in question. One piece of evidence is Kumāragupta's *Apratigha* coin type, discussed above, on which the ruler himself appears as an ascetic.

Under Skandagupta, royal interest in Buddhism quickened. The Life of Vasubandhu, written in the sixth century, says that Skandagupta respected Buddhism so much that he ordered the crown prince to study under the scholar Vasubandhu.[21] The *Mañjuśrīmūlakalpa*, the

16. The date of 500 is obtained from a coin inscription, which has tentatively been read as G.E. 180 (Fleet, "Coins and History").

17. For the Sārnāth image inscription, see Rosenfield, "Dated Carvings," p. 11; also Sircar, *Select Inscriptions*, p. 331. For the Rājghat pillar, see Sircar, "Two Pillar Inscriptions." For the Nālanda seal, see H. Sastri, *Nālandā*, p. 64.

18. *EI*, XV (1919), 134-41.

19. Fleet, *CII*, III, 88-90.

20. Altekar, *Coinage*, pp. 275-80.

21. Takakusu, "Study of Paramartha's Life," p. 44.

historical chapter of which may have been written in the tenth or eleventh century, praises Skandagupta and reports that Narasiṃha Bālāditya I became a Buddhist monk and committed suicide by *dhyāna* (literally, "meditation," perhaps "swooning").[22] The Nālanda seals of Narasiṃhagupta, Budhagupta, Viṣṇugupta, and Vainyagupta (the last two minor rulers mentioned in Chapter IV) corroborate such Buddhist textual evidence with an objective indication of some royal connection with the great Buddhist monastic center.[23] Likewise the Kahaum and Udayagiri Cave 20 inscriptions record the interest of established members of society in Jainism. In the second case, a scion of a military family who calls himself *ripughna* or "enemy-killer" announces that he himself adheres to the path of ascetics.[24] The Kahaum pillar most vividly ascribes the dedication of five carvings of Tīrthaṃkaras to the donor's *malaise* with the world's changes.[25] From such evidence, a picture emerges of both popular and royal interest in ideologies that prescribe an immediate, certain escape from the troubles of this existence in the form of an ascetic way of life.

Such developments are important, for there was an efflorescence of Buddhist art at this point, one that has puzzled scholars who thought in terms of an exclusively Vaiṣṇava dynasty.[26] Yet there was an increase in the sheer quantity of Hindu art produced, as well. Artists working for all kinds of patrons developed with intellectual deliberation the forms whose unity had just been achieved. Over roughly the same area discussed in the previous chapter, relationships to Mathurā continued; yet the degree of dependence upon that center somewhat decreased. In some cases, other major sites, such as Sārnāth, began to rival Mathurā in their impact. And in general, borrowed motifs were used inventively to new effect throughout the Gupta Rāj.

Mathurā

The workshops of the great religious center on the Yamunā continued to produce images for a variety of faiths throughout most of the fifth century. First we must establish a scaffolding of dated pieces, upon which other works can be placed. The earliest Mathurā inscription of Kumāragupta's reign is a Jain pedestal dated to the year 97 or A.D. 417 (Plate 59).[27] The lions here face inward in the manner of late Kushan works, indicating that the out-turned animals of the Vidiśā Jinas (Plates 12 to 15) and of some earlier Mathurā works were not the rule. In fact, considerable variety in the treatment of this detail continued. The carving of the pedestal is three-dimensional and includes two squat, round-headed worshipers comparable to some of the

22. This applies, however, to a ruler called Bāla (Jayaswal, *Imperial History*, p. 33). For the history of the *Mañjuśrīmūlakalpa*, see Macdonald, *Le Maṇḍala*, p. 19.

23. H. Sastri, *Nālandā*, pp. 64-67.

24. Fleet, *CII*, III, 258-60.

25. Fleet, *CII*, III, 65-68.

26. Rosenfield, "Dated Carvings," p. 26. Cf. Goyal, *Imperial Gup-*

tas, pp. 292-95. O'Flaherty has recently argued that the Gupta period was an age of intolerance toward the heterodox religions ("Image of the Heretic"). But her evidence, tentative at best, applies particularly to Candragupta II, Vikramāditya.

27. V. S. Agrawala, "Catalogue," XXIII, pp. 53-54. Lohuizen, *Scythian Period*, p. 321, fig. 65. Lüders, *Mathurā Inscriptions*, p. 53. The inscription refers to a small pavilion for Vardhamāna.

smaller figures of the previous period (Plates 16, 24, 28).

The second landmark of this period from Mathurā is a Jain figure dated 113 or A.D. 432/3, which indicates no major stylistic changes (Plate 60).[28] The treatment of the body with its exaggerated volume is so close to the works from Vidiśā and Mathurā considered in the previous chapter that without other evidence, one would be tempted to assign all to the same date. (Inscriptions, of course, prove otherwise.) Worshipers kneel, not following any pattern we have seen so far. On the whole this image is *retardataire* and indicates that a certain variety of styles coexisted, as one might expect.

A major new discovery from Govindnagar, within Mathurā, a Buddha image, dated G.E. 115 or A.D. 434/5, is more innovative (Plate 61, Frontispiece).[29] By comparison with the image in Plate 18, only some forty years earlier, we see a dramatic loss of "Kushanness." The drapery here consists entirely of string folds, and these are arranged asymmetrically on the torso to produce a varied yet harmonious pattern. Body and head are more elongated. The feet are set farther apart, their

arch is higher, and no object occurs between them. A pedestal dated 125 or A.D. 445 shows feet yet widely spaced, indicating that this was a continuing tendency.[30] All these characteristics give the Govindnagar Buddha a sense of buoyancy and elevation, befitting the aloof expression of the face. There is extraordinary precision in the lines on the hand and in the definition of the brows by the junction between forehead plane and recessed lid (and not by a raised ridge, as is more often the case). One senses the hand of a master artist, and it comes as no surprise that the inscription identifies him by name, Dinna.[31] Surely if there is a point in the history of Indian art when one might expect the individual carver to take pride in his artistry, it is this period of self-conscious aesthetic values. This is not to say that the personality of Dinna asserts itself as aggressively as has happened among Western artists in recent centuries. Nonetheless it is apparent that his particular ability in handling the canons and formulas of the Mathurā school earned him the right to be mentioned in the same breath as the monk who donated the image.

28. *EI*, II (1894), 210. Rosenfield, "Dated Carvings," p. 24, fig. 11.

29. Referred to in Pal, *Ideal Image*, p. 51.

30. Mathurā Museum 64, 2; found in the Collectorate compound (= Jamalpur, Jail Mound). V. N. Srivastava, "Buddha Pedestal."

31. I am grateful to Sri R. C. Sharma, then Director of the Mathurā Museum, for the following reading:

Sam. 100.10.5. Śrāvanāsa di . . . asya devasa pūrvvāyya bhagavataḥ daśabala balina śakyamune

Pratimā pratistāpitā bhikṣunā samghavarmanā yad attra punyaṁ tātmātapitror purvam

Sarva dukha prahānāyānuttara jānāvāya ye ghaṭītā dinnena

"In the year 115 in the month of Śrāvana on the specified date, an image of Śākyamuni, who has conquered all ten faculties, was installed by the monk Sanghavarman after paying respect to his parents. Whatsoever merit may be in this charity, may it be for the removal of all sufferings of all beings and for attainment of supreme knowledge. This was carved by Dinna."

For a second reference to a Mathurā sculptor named Dinna, possibly the same person, see n. 73 below. A painted record at Ajaṇṭā identifies the *sūtradhāra* or, presumably, architect (Dhavalikar, "New Inscriptions from Ajaṇṭā," p. 152). Artists are, of course, identified in other periods of Indian sculpture, most notably in the southern Deccan under both the early Calukyas and the Hoysalas.

A second masterful Buddha image appears to be more mature on several grounds, although not every feature is treated with the freshness of the Govindnagar piece (Plate 64).[32] The feet are spaced far apart, as in the broken pedestal of A.D. 445, which would suggest a date around the middle of the fifth century. The proportions are consistently elongated, and by comparison the previous example seems squat. The robe falls in more complex and graceful reverse curves on the left shoulder. On the well-preserved halo in Plate 64, rays are replaced by a large lotus, a band of wildly ebullient foliage gives rise to fantastic birds, and vegetative forms have taken over all but the outer margin. Apparently the earlier significance of the halo suggesting light has given way to chthonic and biological forces. In formal terms, this rich array of bands—originally heightened by paint, of which touches survive—like the sinuous lines of drapery sets off the austerity of the face.

A Buddha now in the Indian Museum in Calcutta (Plate 62) may fall in date between the two works just discussed. The legs are longer than those in Plate 61, although the torso is not. The drapery falls symmetrically, a feature absent in all other Mathurā Buddha images with such advanced characteristics. Yet not all differences are explained by chronology. The hem of the robe forms a horizontal line on the right arm (Plate 63), whereas in the following work the comparable end of

the robe is drawn beneath the wrist and held together with the underlying portion to form a bunch in the hand (Plate 65). The latter pattern is commoner in general and is by no means limited to late examples. A possible explanation might lie in sectarian differences in the way the monastic robe was worn, although both groups exhibit the sash that characterizes Sarvāstivādin dress. Another possible explanation might be that schools, workshops, or castes of sculptors distinguished themselves by their treatment of this detail.

The right legs of all these standing figures bend very slightly, as side views indicate, giving the figure a relaxed air. On the whole the image seems natural, if hardly naturalistic. At the same time, an underlying system of proportions structures the image with geometrical authority. In Dinna's work the brows meet with the nose to form three perfectly equal angles. While this is not true in the head in Plate 66, the nose here divides the face into equal thirds on a vertical axis. The horizontal lines of lower lip and upper eyelids balance the mirrored curves of the ends of the mouth and the inner corners of the eye. Yet the eyes are set credibly into the head. Thus the artist has combined an abstract form with a sense that these are actually human features.

At the same time, many details evoke nonhuman forms. Some of these correspond to the Marks of the

32. V. S. Agrawala, "Catalogue," XXI, 84-85. Lüders, *Mathurā Inscriptions*, p. 103. It has been suggested that the monk Yaśadinna, previously taken to be the donor of this image, should be understood as the sculptor and identified with the Dinna discussed above (Pal, *Ideal Image*, p. 51, n. 70). Despite my enthusiasm for the identification of sculptors in the Gupta period, I cannot concur in this equation. This inscription clearly begins *Deyadharmo yam Śākyabhikṣo Yaśadinnasya*. To suggest that Dinna subsequent to his first work became a monk, acquired the prefix Yaśa to his name, and dedicated the second image seems excessively speculative.

Great Man (*mahāpuruṣalakṣaṇas*) as well as to the Minor Marks (*anuvyañjanas*), both found in early Buddhist texts.[33] For example, the neck should resemble the top of a conch shell, hence the parallel folds that ring it. Likewise the eyebrows have the double curve of the Indian bow. Other attributes are found in later iconographic texts, which combine systems of proportions with injunctions that the face should resemble a fish's belly, and the torso a lion's body.[34] The comparison between the shoulders and an elephant's head aptly describes the Mathurā images: the upper arm is attached like a trunk. Some of these metaphors may be found in certain Kushan images, but never as systematically as in Gupta ones; the conchlike neck, for instance, is used haphazardly but is lacking as late as the Buddha in Plate 18. In the following medieval period, these, like the guidelines of iconometry, come to form a fixed set of rules that often governs carving in a uniform way. In the Gupta period, however, both are used freely but deliberately to enrich the significance of the image in a manner to which the West is accustomed in literary metaphor. The Buddha appropriately absorbs the perfections of nonhuman forms into his human body.

Seated Buddha images were not common in fifth-century Mathurā, although a piece recently acquired by the Cleveland Museum of Art shows that the type continued until around 450 (Plate 67).[35] The drapery folds, in part covered by arms originally in the *dharmacakra mudrā*, resemble those in Plate 61, while the halo cannot be far removed from that in Plate 64. The crisp details of what survives of the throne and the svelte forms of the legs suggest a work of considerable elegance.

Several Jain images seem to be contemporary with the most advanced Buddhist ones considered here, to judge from their slender body proportions (Plates 68, 69). The halos are similar in foliage type, if often more crudely carved; this suggests the greater wealth of the Buddhist community, as does the absence of Jain images as large as the great standing Buddhas. Yet the Ṛṣabhanātha in Plate 68 equals any Buddhist work in its crisp execution and assured design.

A miniature *stūpa* (Plate 70) should belong to the 430s or before, if the symmetrical drapery of all its small Buddha figures follows the development suggested above. The *stūpa* itself is elongated, with a high octagonal drum and square base, the whole being narrower than the characteristic Kushan-period examples at Mathurā. If the images so far considered were placed around the base of a *stūpa*, as this indicates, they would have

33. Lamotte, *Traité*, I, 271ff. Wayman, "Contributions," provides a useful commentary on the Minor Marks, although his Tibetan source appears to substitute *kumbha* or jar for *kambu* or conch in the Sanskrit comparison for the throat (p. 252). These metaphors have attained the status of cliché in modern writing about Indian art, and it is worth considering each carefully. For example, "lips like the Bimba fruit" seems to refer, not to the shape, as it is often taken, but to the red color, relevant to images only when they were painted. Nor are by any means all of the marks described in texts shown in sculpture.

34. A particularly helpful example of such a text (because of its strong Buddhist basis) is that known as the *Pratimāmānalakṣaṇam*, which appears with translation as Appendix B in J. N. Banerjea, *Development of Hindu Iconography*.

35. Czuma, "Mathura Sculpture," pp. 100-14.

been seen in the course of clockwise circumambulation or *pradakṣiṇa*. Hence the detailed carving of the right side (Plates 63, 65).

Plate 71 shows two elaborate pilaster capitals of this same period in which new motifs appear. The top band consists of large ridged leaves of the acanthus type, a motif common later, first with all the leaves rising upward and then in an overlapping row as the outer border of doorways. A pattern of checkers appears; as suggested in connection with Devnimori, this may represent a unique example of Gandhāran influence. Scenes of the Buddha's Temptation by the Daughters of Mara and of his Parinirvāṇa occur on the capitals, a rare case of narrative relief from Gupta Mathurā. Both scenes are represented in relatively simple form, for elaborate, small-scale scenes were never the *forte* of the Mathurā sculptor. Below the Parinirvāṇa, the monk Subhadra, the Buddha's last convert, identified by the tripod of the Tridaṇḍaka sect, is seen from the front, unlike the rear view standard at Sārnāth.

The Bodhisattva figure in Plate 72 does not invite comparison with the Buddha images of this period, yet it must be contemporary. The eyes are fully open, as befits the active role of the Bodhisattva in the world of men. The drapery is softly rendered, perhaps because pleated folds were identified with the monk and were not suitable for the princely Bodhisattva. The crown continues an earlier type (Plate 38) but adds small side disks, which appear generally from this point on. Bo-

dhisattva images are rare in Mathurā, slightly more common in Sārnāth, and increasingly abundant in the western Deccan during the sixth century, when the Mahāyāna clearly had a strong sway.

A Viṣṇu torso (Plate 73), distinguishable from the last example only by a narrow *vana mālā* or garland of forest flowers that falls over the upper arms and just below the knees, points up the continuity between Buddhist and Brahmanical work. This must rank as one of the masterpieces of the Mathurā artists, for every detail is carved with extreme refinement. In fact, the extraordinary verisimilitude of the fluid drapery and the boldly twisted necklace may conceivably be ascribed to central Vākāṭaka influence (cf. Appendix).

Among Viṣṇu images, the Viśvarūpa Vibhūti or Multiform Manifestation was particularly popular in fifth-century Mathurā (Plates 74, 75).[36] The central head in Plate 74 resembles that of the Bodhisattva in Plate 72, and in general this figure seems to belong to the reign of Kumāragupta or of Skandagupta. The flanking lion and boar heads figure in later textual descriptions of Viśvarūpa. The surrounding panoply of forms illustrates the manifestation of Viṣṇu in Chapter 11 of the *Bhagavad Gītā*:

> For into Thee are entering yonder throngs of gods;
> Some, affrightened, praise Thee with reverent
> gestures;
> Crying "Hail!" the throngs of the great seers and
> perfected ones

36. Pal, *Vaiṣṇava Iconology*, pp. 50-61. Maxwell, "Viśvarūpa." I cannot agree with Pal that Plate 74 is fourth-century: the lion head shows no greater affinity with those in early Indian art than with, for example, those on the Eran Budhagupta pillar (Plate 147), a work dated 485.

Praise Thee, and all are quite amazed.
The Rudras, the Ādityas, the Vāsus, and the
 Sādhyas,
All gods, Aśvins, Maruts, and the Steam-drinkers
 ('fathers'),
The hosts of heavenly musicians, sprites, demons,
 and perfected ones
Gaze upon Thee, and all are quite amazed.[37]

Rudras ("Red Ones," an epithet associated with Śiva) are indicated by the large heads around the outer edge of the Mathurā images, clearly fierce and Śaiva, to judge from the third eye, in Plate 75. This fragment also includes sages (Sādhyas, "perfected ones") in the form of ascetics holding water jars, as does the Varāha relief at Udayagiri (Fig. 5). The identification of every personage is perhaps not intended, for the artist seems to have juggled a variety of forms with some freedom in order to convey a cosmic host.[38] This subject is of particular interest in the context of growing Bhagavatism or devotionalism directed toward Viṣṇu. Whereas the great Udayagiri relief had showed comparable figures worshiping the god, here they are transformed into forms merging with or emanating from him.

One of the most eloquent Brahmanical works of the period is a large, circular relief of the Anointment of Kumāra (Plate 76).[39] The lance in the left hand and the śikhāṇḍa or three tufts of hair on the head are general attributes of that deity. The presence of Brahmā (three heads, visible on the left) and Śiva (knotted locks or jaṭa mukuṭā, on the right) who bathe the central figure is, however, unique. This must represent the abhiṣeka or consecration of the youth Kumāra as general of the gods against the demon Tārakāsura. The anointing was performed by Indra and other gods according to both the Mahābhārata and the Matsya Purāṇa.[40] Thus apparently the precise verbal source of the Mathurā image is not preserved. The inclusion of the two gods above, rather than of Śiva alone as the father, may indicate that the full absorption of an originally independent deity into the context of Śaivism was not yet complete.[41] Whereas the consecration of Kumāra is illustrated once at Ellora,[42] this subject is in general abandoned in favor of more strictly iconic forms of the god. In general, this is the fate of imagery, which in the Gupta period still has narrative rationale, albeit a seemingly iconic treatment. Characteristically, this Mathurā

37. *Bhagavad Gītā*, p. 57.
38. Pal, in his very helpful discussion of this piece, suggests that the figure at an angle with prominent areole in Plate 74 represents the Buddhāvatāra. The jewelry would seem to preclude this.
39. V. S. Agrawala, "Catalogue," XXII, 140-41.
40. *Mahābhārata* II, 494 (Aranyaka Parva, section CCXXVII): "anointed by Indra and all the other gods." *Matsya Purāṇa*, 114 (ch. CLIX, vv. 4-6): "installed by Brahmā, Indra, Upendra, Ādityas, and the other Devas." In the *Kumārasambhava*, canto XII (perhaps not by Kālidāsa), this function is fulfilled by Pārvatī's tears of maternal pride (148, v. 3).

41. Bhattacharji, *Indian Theogony*, pp. 181-82.
42. Gopinatha Rao, *Elements of Hindu Iconography*, II, pl. CXXIV. Animal-headed attendants here resemble the small outer figures in Plate 7. The ram-headed figure at Ellora was identified by Gopinatha Rao as Dakṣa-Prajāpati (ibid., p. 446), by J. N. Banerjea as Naigameya-Cāgavaktra, an aspect of Kumāra himself (*Development of Hindu Iconography*, p. 367), and by V. S. Agrawala as Agni, in some accounts Kumāra's father ("Catalogue," XXII, 141). Yet another possibility in the Mathurā example is one of the animal-headed *grahas* attendant upon Kumāra's birth.

work is designed with great coherence. The circle of the whole is repeated in the jars above, the chubby body of Brahmā, the peacock's feathered wings, and in the focal face of the young god himself.

The image of Śiva with his consort Pārvatī and the bull Nandin in Plate 77 seems to belong in the second or third quarter of the fifth century, to judge from the relatively free poses of the figures and the subtle carving of detail in those parts that are preserved.[43] The most unusual feature here is the fact that this is a Janus relief, the Nandin on the reverse being visible to the left in Plate 77. It seems most likely that this formed a three-dimensional object of worship within a shrine chamber.[44]

The three works in Plates 78 to 80 all fall within the period of this chapter by default: their forms are too assured to be earlier, yet they show no distinctly late characteristics. Each indicates that the same developments were occurring in Mathurā as in the provinces, although the exact chronological relationship between the two may remain in doubt. The Durgā on her lion with a child in the lap (Plate 80) relates both to the Mother Goddesses of central India discussed in the previous chapter and to the Bilsaḍh reliefs discussed below. Plate 78 illustrates the kind of female figure, probably a River Goddess, that occupied the end of lintels from Sāñcī 17 on. This figure shows particular sophistication in the way the complex curves of drapery echo the lines of the body, suggesting that Mathurā

was the leader in whatever formal stage this represents. The column in Plate 79 bears decor roughly akin to the halo in Plate 64. The *pūrṇa ghaṭa* appears here at the base, as became common by the end of the fifth century. The particular form of this *pūrṇa ghaṭa* with a broad, rippled leaf rather than the ebullient lotus foliage of Udayagiri Cave 1 is a variant that continues to occur elsewhere. Both versions are known from Mathurā. Finally, the spiral arrangement of the decor occurs at Ajaṇṭā only in the later caves, as well as at Bāgh and Uparkot. It is likely that Mathurā is the source for both western India and the Deccan, and that this column belongs to the middle of the fifth century.

The years considered in this chapter take on significance particularly in relationship to Mathurā. For that center, this is the period of a richly varied outpouring of sculptural activity, lavished upon a wide range of subjects. After this point, however, production falls off sharply, and it is hard to avoid associating this fact with the second incursion of the Hūṇas, which brought an end to Budhagupta's even nominal overlordship in central India.

Bilsaḍh

The site of Bilsaḍh, 150 kilometers east of Mathurā, demonstrates the extension of the city's style in pure form across the Doab, just as had Jankhat in the fourth century. The Bilsaḍh carvings seem to belong to Kumāragupta's reign, although not necessarily to the year

43. V. S. Agrawala, "Catalogue," XXII, 131-32.

44. While a pillar capital is possible (cf. the Pawaya and Eran Janus capitals), the shape in this case seems inappropriate. Mathurā had produced earlier puzzling Janus figures; Rosenfield, *Dynastic Arts*, fig.

21. Such an image might have given rise to Central Asian paintings of Hindu gods whose vehicle is unaccountably doubled (Stein, *Ancient Khotan*, pl. LX).

415/6 supplied by an inscription. This inscription, engraved in duplicate on two columns, recorded donations by one Dhruvaśarman, unidentified except for his piety and veneration of Kumāragupta, to whose praises half the inscription was devoted.[45] The donor was said to have constructed a *pratoli*, probably a gateway, and other buildings in connection with a temple of Kumāra; none of these can conclusively be identified with the carved pillars 25 meters to the east.

The carvings in Plates 81 through 84 are on the whole close enough to works from Mathurā to suggest that an artist from that center might have traveled here and worked in the local greyish stone. For example, the foliage in Plate 83 is as complex as any considered in this chapter, showing the alteration of direction and energy of detail that distinguish this phase from the formative one. At the same time, the leaves are broad and coherent, unlike the dissolved patterns that were to follow by the end of the fifth century. The left margin shows a plain ribbon running through spiraling foliage, a motif that appeared from Mālwa to Magadha. The checkered pattern observed at Devnimori and Mathurā is visible in Plate 82.

One decorative element on the Bilsaḍh pillars is of unusual significance for its architectural implications. To the left in Plates 81 and 84 are grooved, domical forms that must represent the roof member later known as the *āmalaka*.[46] Actual *āmalakas* of this same type, spherical in form with sharp grooves, have been found at Nāchnā (Plate 163) and Bhumara. It is probable that they existed in Mathurā as well, if Bilsaḍh can be taken as an offshoot from that center in the first half of the fifth century. The arrangement of the small *āmalakas* in the relief shows their use on a tiered superstructure, small ones below with a large one on top. Clearly from this, the flat-roofed temple was not the only type known at this point.

In figural style, the Bilsaḍh carvings approach the relaxed, complex poses we have seen in Mathurā. The comparison between the figures in Plates 80 and 81 is facile, yet it is significant that the two have more in common with each other than with the solemn, overblown Mother Goddesses of Madhya Pradesh (Plate 48). In fact, the iconography of these two probably differs. The Bilsaḍh figure was crowned by two elephants, now badly damaged, which identify this as a combination of Lakṣmī bathed by elephants, with Durgā seated on a lion. The reverse of some early Gupta coins also show

45. Cunningham, *ASI* XI (1875-1878), 13-22. Fleet, *CII*, III, 43-45; Sircar, *Select Inscriptions*, pp. 285-87. Suryanshi, "Explorations at Bilsaḍh." A rectangular trough decorated with a *nāga*, which is now in the village, apears to me later than the pillars. As indicated below, I find Cunningham's reconstruction of a *torana* improbable, for he does not explain the placement of the River Goddesses (which he considers to have formed the front face) at a level over a meter above the carving on the other two sides.

46. The *Bṛhat Samhitā* by Varāhamihira uses *aṇḍa* or "egg" for some element that is repeated on the superstructure (ch. LVI, v. 5).

It is possible, if this sharply grooved and rounded type represents the original form, that this element is modeled on some prototype in pliable materials or even wood. Perhaps the term *amalaka* or *āmalaka*, which occurs as early as the *Viṣṇudharmottara Purāṇa* (III, p. 86 *passim*, always in compound) should simply be connected with the root *amala*, "pure." Association with the *āmala* fruit (which is very round and veined rather than grooved) as well as analogy with celestial ring stones would seem to me to be secondary (Kramrisch, *Hindu Temple*, II, 348-56).

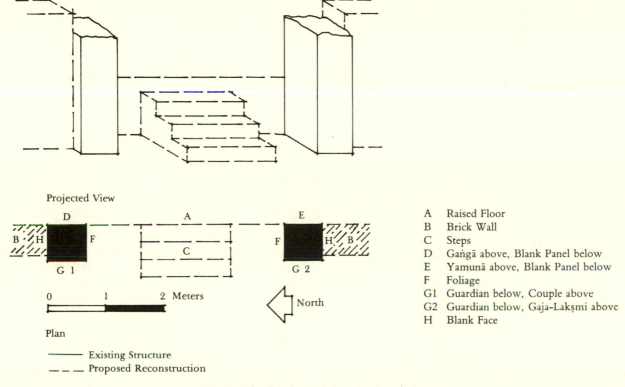

Projected View

D A E

B·H D F F H B

C

G 1 G 2

0 1 2 Meters

Plan

North

A Raised Floor
B Brick Wall
C Steps
D Gaṅgā above, Blank Panel below
E Yamunā above, Blank Panel below
F Foliage
G1 Guardian below, Couple above
G2 Guardian below, Gaja-Lakṣmi above
H Blank Face

——— Existing Structure
– – – Proposed Reconstruction

Fig. 6. Bilsaḍh, shrine front, reconstruction

this same combination, or rather this failure to distinguish goddesses who were later considered separate in association with Viṣṇu and Śiva, respectively.[47]

One puzzling feature of the Bilsaḍh pillars is the

placement of the River Goddesses roughly a meter above the base, which is bare (Plate 82). I would explain this by a reconstruction such as that in Fig. 6. The pillars seem too far apart (ca. 3¹/₂ meters) to have formed a

47. The King-and-Queen type of Candragupta I shows a goddess on a lion holding a cornucopia (an attribute of Ardoxsho, who is in turn associated with Lakṣmī). Some ambiguity about the identity of this goddess on the reverse of coins of Samudragupta and Candragupta II continues (Altekar, *Coinage*, pp. 31, 43, 93). Another image

of a female divinity seated on a lion and bathed, apparently by elephants, comes from northwest India (N. P. Joshi, *Catalogue of Brahmanical Sculpture*, line drawing 68), and a few Pāla images continue the type.

simple doorway. Thus, if the River Goddesses stood at floor level on the inside, the male guardians, Lakṣmī, and perhaps other divinities would have occupied the outer sides of a west-facing portal. No other fully comparable pillars exist, although Gaḍhwa preserves square pillars carved on three sides, all extending to the base (Plates 242-244). A structure such as that I am suggesting might have consisted of brick, and indeed Cunningham reported finding bricks and terra-cotta decor at this site. At the very least, the Bilsaḍh pillars demonstrate that already in the fifth century there existed alternatives to the doorway with River Goddesses at the ends of the lintel.

Sārnāth and Its Hinterland

After the limited artistic production at Sārnāth in the fourth century, this great Buddhist center may appear to have burst into prominence in the 470s, the period of our only three dated Buddhist works from the site (Plates 89, 90). Yet undoubtedly these were not the first works of the school. In the half century before them, the workshops of Sārnāth gradually became active, developed a local tradition with its own roots in the Kushan, and embellished this with forms borrowed from Mathurā.

The development of Buddhist sects supplies one clue to the chronology of Gupta sculpture at Sārnāth. Four

inscriptions of the third century show Sarvāstivādin allegiance, while two more in Pali suggest that the Theravādins were here as well.[48] The only sectarian inscription of the Gupta period is that engraved prominently on the shaft of the great Maurya Lion Column, praising the Sammitiyas.[49] This advanced Hīnayāna sect, which like the Sarvāstivādins used Sanskrit, was widespread in the seventh century, according to Hsüan-tsang. The Sammitiyas (and perhaps other newer groups as well) apparently grew at the expense of the Sarvāstivādins.

Thus, one might expect Sārnāth works associated with the Sarvāstivādins to be relatively early, and in fact those that display Sarvāstivādin monastic dress (specifically the belt) appear to precede the dated images of the 470s. The belted figure in Plate 85, for example, has broader hips, shoulders, and face than any other Buddha from the site. Shelf-like folds remain on the robe beside the neck. A second (Plate 86), although slightly less inflated in the torso, shows puffy legs pressed close together.[50] In both cases the eyebrows are defined by a raised ridge, a characteristic presumably going back to Kushan sources within Magadha. A famous image in the British Museum is heavy like the last, and reduces the brows to a single line, moving toward the distillation of forms in which Sārnāth artists excelled; this piece also adds frothy Gupta foliage to the halo,

48. For the Sarvāstivādin inscriptions, see *ASIAR* 1904-1905, p. 68 (later pointed out that the words *ācaryānam sarvāstivādinam* represent an addition); 1906-1907, p. 96; 1907-1908, p. 73; 1914-1915, p. 129. For Pali inscriptions, see *ASIAR* 1906-1907, p. 96; 1907-1908, p. 74.

49. Sahni and Vogel, *Catalogue*, pp. 30-31. On the Sammitiyas, see Bareau, *Petit Véhicule*, pp. 121-26.

50. *ASIAR* 1906-1907, p. 91, pl. XXVIII 2; Sahni and Vogel, *Catalogue*, p. 40. Puri and Fischer, *Kunst aus Indien*, pl. 29.

suggesting Mathurā influence of a stage before the image in Plate 64.[51] Finally, Plate 87 illustrates what seems to be the last of the belted images, for it is more slender and suave than the rest although still more fleshy than the Buddha of 474 in Plate 89.

A pillar erected some 150 kilometers to the northeast at Kahaum in G.E. 141 (A.D. 460/1) provides some sense of the timing of this early phase at Sārnāth.[52] The image of the Jina Pārśvanātha from its base (Plate 88), while retaining the long arms that are canonical for Tīrthaṃkaras, has advanced considerably beyond the Rajgir and Patna works treated in the previous chapter. The relationship of legs to hip and of shoulders to neck is less schematic; the attendants' poses are more three-dimensional. The Kahaum image is roughly comparable to the Sārnāth Buddha in Plate 86 in the rounded contours of the legs with their emphatic knees. Thus, it would seem that this initial Sārnāth style was in existence by 460.

From the belted Buddha of Plate 87 to the works dated 474 (Plate 89) and 477 (Plate 90) is not a large jump.[53] Other examples of the mature phase (Plates 91, 92) can be dated 465-485. Halos do not show as consistent a development as at Mathurā. For example, the two images dated 477 (one illustrated in Plate 90) retain a simple border of scallops and pearls, reserving characteristic Gupta foliage for the base upon which the

Buddha stands. In general, a band of foliage appears only on round-haloed images: even there, differences in foliage type, which in Mathurā would follow chronological development, seem rather matters of individual variety. Thus the figure in Plate 91 is close to that dated 474 (Plate 89), yet the foliage in the first is far simpler in its lines. Perhaps this variety results from the introduction of such a motif from the outside, making it possible that Mathurā models of different stages were presented to the Sārnāth sculptors simultaneously.

While the third quarter of the fifth century saw a wave of Mathurā influence, the distinctive early Kushan sources of Magadha were not entirely lost. Unpleated drapery remained the rule, and it seems unreasonable to ascribe this to the aberrant Mathurā precedent in Plate 19. Even in halos of the Mathurā type, the decorative bands were fewer, and the center remained plain. As a result, the effect of the entire image is more subdued and chaste. The head generally forms a rounder ovoid than at Mathurā, and the *uṣṇīṣa* above is more fully integrated into the head. It is tempting to characterize the emotional effect under the influence of the rich, red Sikri sandstone used in Mathurā, as opposed to the buff Cunar stone of Sārnāth. This is misleading, however, for the Mathurā pieces were at least in part covered with plaster, whereas the Sārnāth ones

51. Rosenfield, "Dated Carvings," fig. 9; Harle, *Gupta Sculpture*, pl. 52. A drawing of this image appears on page 156 of the Kitto Album in the India Office Library, London. The halo is intact there and bears two flying attendants.

52. Cunningham, *ASI*, I (1862-1865), 91-95. Fleet, *CII*, III, 65-68.

Sircar, *Select Inscriptions*, pp. 316-17. The capital is discussed in the next to last section of this chapter.

53. *ASIAR* 1914-1915, pp. 98, 124-26. Rosenfield, "Dated Carvings."

may well have borne polychromy.[54] As for the quantity of output, precise comparisons of the two centers are difficult. Mathurā images are generally more broken, in part because of their greater size (no Sārnāth work equaled that of Plate 64 in scale) and because of Mughal destruction in the seventeenth century. Yet a general impression emerges that the sheer number of Buddha images in the high Gupta style at Sārnāth exceeded that at Mathurā. Whereas the work at religious centers on the Yamunā may have been interrupted by foreign incursions at the end of Skandagupta's reign, those to the east would have profited from the more distant disorders with a wave of devotional patronage.

Among seated Buddhas, certainly the First Sermon was a favored subject at Sārnāth, where this event had actually occurred. In the seventh century, Hsüan-tsang reported that a life-sized metal image of the Turning of the Wheel was worshiped in the chief shrine here.[55] Possibly such an image existed already in the fifth century and served as a model for the sculptors in stone. The example in Plate 93 has a childlike and folkish quality; it seems to me that this preceded slightly the next example (Plate 94).[56] The throne of this second image is of a type that becomes standard in eastern India from the sixth century on; it may well have been borrowed from Mathurā, where, however, it was to die out. The First Sermon in Plate 94 has justly become one of India's best-known works of art. Such an image shows all the metaphorical allusions already discussed as characteristic of the mature fifth-century style. The geometrical framework is particularly assured: the head, almost round, is centered within the halo, and the brows meet to form three angles of 120 degrees with the nose. The irregular lines of the flying attendants above and the focal gesture of turning the Wheel of the Law, placed along the circumference of the halo, relieve any potential austerity. The result epitomizes the "science of beauty" (*citravidyā*), which is invoked in one of the dated Sārnāth inscriptions.[57] Spiritual perfection is translated into aesthetic terms.

Specific events from the life of the Buddha are illustrated not only independently at Sārnāth but also as a complete cycle in a number of steles. Perhaps the proximity of a number of sites where the great events had actually occurred made these attractive to the Magadha artists. The stele in Plate 95 seems to me to fall relatively late in the Gupta phase, about 475-485.[58] The figures are slender and supple, as in the dated images of the 470s, unlike the early belted Buddhas. There is in fact a certain exaggeration in the hip-shot poses of standing figures, which points toward the next period. The third panel from the bottom shows the First Ser-

54. Traces of whitewash remain on the Mathurā piece in Plate 64. The Buddha of the Monk Bala has polychromy—for example, golden flesh on the ankles. For literary evidence, see Varma, "Role of Polychromy."

55. Hsüan-tsang, *Buddhist Records*, II, 46.

56. Plate 93: Anderson, *Catalogue*, p. 26. Plate 94: *ASIAR* 1904-1905, p. 83, pl. XXIX c; Sahni and Vogel, *Catalogue*, p. 70.

57. In this translation I follow Rosenfield, "Dated Carvings," p. 11. Sircar reads the compound as *citravinyāśa*, "composed according to art" (*Select Inscriptions*, pp. 316-17), which would not substantially alter the meaning.

58. Anderson, *Catalogue*, p. 7. Williams, "Sārnāth Gupta Steles."

mon with the same elaborate throne type as in Plate 94. The Buddha is shown here with legs pendant *pralambapādāsana*, a position that enjoyed popularity in the last quarter of the fifth century.[59] The paucity of such narrative scenes at Mathurā in this period (Plate 71 illustrating a sole example) would make it unlikely that the Sārnāth sculptors were as directly influenced by that center for images of such subjects as for those of Buddhas.

Although some four hundred Buddha images of this period are preserved in the Sārnāth Museum alone, only eight Bodhisattva images from Gupta Sārnāth are known throughout the world. This suggests that the Mahāyānists, who presumably visited the site, found the traditional Buddhist imagery of the center on the whole sufficient. Like the Buddha's Life Scenes, Bodhisattva images at Sārnāth seem independent of those at Mathurā. One of the earliest examples is the Maitreya in Plate 96.[60] The usual fanning locks of hair may indicate Maitreya's identity as a Brāhman.[61] Such hair and the subtle definition of the drapery owe little to the more simplified forms of Plate 72 or to other Mathurā

works. The Avalokiteśvara in Plate 97 belongs somewhat later in the fifth century, to judge from its slender body.[62] At the same time, as in the dated Buddhas of the 470s, some details become conventionalized. A well-known Avalokiteśvara with Hungry Ghosts now in the National Museum, New Delhi, may belong to the end of this phase.[63]

Interestingly, female Bodhisattva images appear at roughly the same time as their male counterparts here. One, perhaps a Tārā (Plate 98), resembles the format of the Buddhas of 477 and related pieces (Plates 80, 92).[64] The heavy proportions and rigid legs indicate a slightly earlier date, closer to the Sarvāstivādin belted group. The cult of Tārā was important in Yogācara doctrine, and for lack of other tantric remains from Gupta Sārnāth, it is reasonable to ascribe the image to such a Mahāyāna source rather than to the esoteric schools of Vajrayāna. This example, one of the earliest images of Tārā known, fits with the increasing prominence of groups of Mother Goddesses elsewhere, indicative of the absorption of village-level cults into the sophisticated forms of urban religion.

59. Williams, "Sārnāth Gupta Steles," p. 182. Sheila Weiner discusses the *pralambapādāsana* at length in *Ajaṇṭā: Its Place*, pp. 62ff.

60. Sahni and Vogel, *Catalogue*, p. 119.

61. In addition, Sahni originally made this identification on the basis of the Buddha in the headdress, which he took to be Amoghasiddhi on the basis of gesture, the *abhaya mudrā*; the broken condition today makes the *bhūmisparśa* and *dhyāna mudrās* also possibilities. For the Brahman origins of Maitreya, see Lamotte, *Histoire*, pp. 775-77.

62. Anderson, *Catalogue*, pp. 20-21. The Buddha in the headdress is clearly in *dhyāna mudrā* and therefore Amitābha. Several prob-

lematic Nīlkaṇṭhalokeśvara images, sometimes assigned to the fourth century (Rosenfield, "Dated Carvings," p. 23) appear to me to be contemporary with this, to judge from body type and ornaments: Sārnāth Museum B(d)4 and 5.

63. *ASIAR* 1904-1905, p. 81, pl. XXVIIIb. Sahni and Vogel, *Catalogue*, pp. 118-19: Sārnāth Museum B(d)1. Rosenfield, "Dated Carvings," fig. 7. The inscription records its dedication by "the very devoted layman, Suyāttra, head of a district (*viṣayapati*)," an interesting proof of Buddhist patronage on the part of an important official.

64. Anderson, *Catalogue*, pp. 12-13.

Enough architectural remains have been found at Sārnāth to assure us that shrines existed, in addition to stūpas in the fifth century. These remains are, however, fragmentary and have been incorporated into later buildings as well, so that the overall structure is as difficult to assess as at Mathurā. Doorjambs are copious, including several found partly encased in brick in the later Main Shrine (Plate 99). The innermost foliate band is typologically early, although progressive elaboration of such forms is not consistent at Sārnāth, as noted above. The central register consists of flat ribbon entwined by a continuous band of foliage, a motif found at Bilsaḍh under Kumāragupta. The outer register is the common twisted garland, an element executed with precision at Mathurā, whereas here the diagonal lines are varied in angle. This suggests that motifs were being borrowed from the outside without full understanding of the principles of their organization.

Other members support our picture of Sārnāth architecture more tenuously. Two pairs of leogryphs with riders have been found, perhaps designed for a position beneath a T-shaped lintel, as later in the Kumrā Maṭh at Nāchnā (Plate 158).[65] Many elements of the superstructure exist, including candraśālā arches, but their disposition and date are not clear.[66] Columns abound.

For example, those in Plate 100 should belong to the second half of the fifth century on the basis of the pūrṇa ghaṭa capital and base, with foliage overflowing just half-way down the vase. The vase below bears rosettes and festoons on its body, a motif found at roughly the same point at Udayagiri Cave 19 (Plates 118, 119) and at Uparkot (Plate 136).

The art of the Sārnāth area was not exclusively Buddhist. At Sārnāth itself, some Brahmanical images were found, many but not all post-Gupta. Vārāṇasī, seven kilometers away, has long been a sacred place of pilgrimage for Hindus. Excavations at Rājghat on the Ganges have shown the importance of the city in the Gupta period.[67] Although the continuous habitation of Vārāṇasī has prevented systematic excavation and the discovery of as many images as are known from Sārnāth, those that are known show that Hindu sculpture was no less advanced than the Buddhist oeuvre.

A Vaiṣṇava pillar from Rājghat bears an inscription of the year A.D. 476, under Budhagupta (Plate 101).[68] The overflowing vase at the top is close in form to those of Plate 100, though the proportions are heavier. The figures seem also to be small, squat versions of the Sārnāth Bodhisattvas. They represent Viṣṇu as Nārāyaṇa (Plate 101), the dwarf Vāmana, the man-lion

65. Sārnāth Museum C(b)1-8; Sahni and Vogel, *Catalogue*, pp. 199-200.

66. Many are discussed as "face stones" in Sahni and Vogel, *Catalogue*, pp. 254-64. Stadtner, "Sārnāth Architectural Remains."

67. V. S. Agrawala, "Rajghat Terra-cottas." A number of Gupta fragments dot the modern city of Vārāṇasī, including the areas of Bakariya Kund and Gurudham Colony.

68. Rosenfield, "Dated Carvings," p. 25, figs. 12-14. Sircar, *Select Inscriptions*, p. 332. Harle, *Gupta Sculpture*, pls. 56-58 (with comparison of iconography with a similar pillar from Kutari). The face with what I identify as the goddess Śrī is abraded, and the broken head might be taken as a boar or even horse (Hayagrīva). The lotus and the breasts, also abraded, make these unlikely.

Narasiṃha, and probably the goddess Śrī. A second similar pillar from Rājghat is somewhat more finely carved. The iconography is the same, with the exception of Varāha (Plate 102), who replaces Śrī. This active little image retains the stubby boar head and the unstable position of the Earth Goddess that we have seen early in the fifth century at Udayagiri.

One of the most dramatic works from Vārāṇasī is a colossal Kṛṣṇa holding aloft Mt. Govardhana, more monumental than any Hindu work preserved at Mathurā.[69] The Kumāra image in Plate 103, when compared with the Mathurā example in Plate 76, seems on the other hand somewhat less impressive. The eastern relief is simpler in subject, representing the deity in the abstract rather than in a specific mythological moment. The basic lines are those of Kumāragupta's Kārttikeya coin type, although it does not follow that this image is quite so early.

While we cannot point to any other major centers of Buddhist sculpture in what is today east or central Uttar Pradesh, several significant isolated works are known from this area. The first is a rare dated piece, the Buddha image from Mankuwar, roughly 50 kilometers southeast of Allahabad (Plate 104). The inscription records the dedication of this image of the Bhagavan, Lord Buddha, by a monk Buddhamitra, under the king Kumāragupta; the date, long read as G.E. 129, has been convincingly reinterpreted by D. C. Sircar as 109 or

A.D. 429.[70] On this basis, I would consider the second quarter of the fifth century formative in the development of the Sārnāth school, to which this is related by virtue of its smooth drapery. The feet of the base figures are turned forward more than those of the principal one, implying that the image occupies a transitional position, as might be expected in 429. The double-edged eyebrows are a feature common in Mathurā and found also in two of the early Sārnāth pieces (Plates 85, 86). At the same time, in certain ways this image appears to be provincial and hence not accurate as a guide to the central styles. The *uṣṇīṣa* consists of a very slight rise atop the head, less pronounced than in other Buddhist works and suggesting that the sculptor might have followed a Jain model. Moreover the upper edge of the robe is not indicated at the neck or left wrist, either from "contamination" by a Jain image with no robe or perhaps because the image was unfinished (hence also the lack of hair curls). On the whole, the Mankuwar Buddha seems to be moving in the same direction as the concurrently emerging school of Sārnāth.

The nearby Bhīṭā has yielded two more inscribed Buddhist fragments, dated palaeographically to the fifth century A.D. The more complete of these (Plate 105) shows that the area continued to produce sculpture in the second quarter of the fifth century, and that its provincialism diminished.[71] The drapery remains close to the Sārnāth type, and the kneeling attendant resembles

69. Bharat Kala Bhavan 147. Cf. Harle, *Gupta Sculpture*, pls. 64-65. *ASIAR* 1926-1927, pl. XXXVId.

70. *ASIAR* 1922-1923, pl. *XXXVIII*. Fleet, *CII*, III, 45. Rosenfield, "Dated Carvings," fig. 10. Sircar, "Date of the Mankuwar

Buddha Image."

71. Cunningham, *ASI*, III (1871-1872), 48-49. Fleet, *CII*, III, 271-72. The second Bhīṭā (or Deoriya) inscription is on the pedestal of a destroyed image, Lucknow Museum 02.

those of Mathurā and Kahaum. The Sarvāstivādin sash here indicates a connection with the earlier Sārnāth group, as does the style. In this same small area, Kauśāmbī has also yielded a small Buddha image of the early belted type, whose smooth robe, however, leaves one shoulder bare.[72] Since this is true of no large Gupta Sārnāth image, it would seem again that the Kauśāmbī style did not derive directly from that school.

Farther to the west, more Mathurā influence understandably appears in a Buddha from Bazidpur (Kanpur District) (Plate 106). The drapery is smooth and follows Sārnāth conventions for its arrangement. Yet the head is rectangular, the *uṣṇīṣa* raised, and the halo includes large lotus petals around the head—all Mathurā characteristics. Here on the basis of body proportions in relation to either major school, the date would seem to fall around A.D. 450. The stone appears to be local, and again we see the existence of a minor independent workshop.

Finally, north of the Ganges at Kuśanagara (Kasia), the site of the Buddha's Parinirvāṇa, a large image of that event demonstrates the continuing role of Mathurā as an exporter of styles carried by itinerant craftsmen to an area that in fact lay closer to Sārnāth.

Two fifth-century inscriptions found here record the work of a sculptor Dinna, apparently from Mathurā.[73] Quite possibly this is the same Dinna who carved a Buddha image at Mathurā (Plate 61). The great reclining Buddha at Kuśinagara was discovered in fragments and, aside from its base, has been too heavily restored today for stylistic consideration. It does, however, preserve the stringlike drapery folds that one would expect a Mathurā artist to employ.

Thus at the Buddhist sites of the hinterlands between Mathurā and Sārnāth we see in the mid-fifth century the concurrent forces of Mathurā influence and independent local development. At none of these centers did a true school of sculpture flourish at this point, with the possible exception of Kauśāmbī. Yet the Kahaum column (Plate 88) shows the appearance of Sārnāth influence both farther to the east and at a slightly later point in time, when the workshops of Sārnāth and Vārāṇasī must have come into their own.

Bhitargaon

Within the same central area just considered, one monument stands apart by virtue of its medium: the brick temple at Bhitargaon, 20 kilometers south of Kanpur.[74]

72. *Indian Archaeology* 1956-1957, pl. XXXVIIA. I would assume that this Kauśāmbī image belongs to the fifth century on the basis of its figure style. The baring of one shoulder might be explained by dependence upon early Kushan prototypes or by other factors in Buddhist dress and belief that I do not yet understand.

73. *ASIAR* 1906-1907, pp. 49-50. The restoration of *Māthurena* is conjectural. One figure from the base of the image is illustrated in Williams, "Sārnāth Gupta Steles," fig. 12.

74. Cunningham, *ASI*, XI (1875-1878), 40-46. *ASIAR* 1908-1909, pp. 5-22. R. Singh, "Bhitargaon Brick Temple." Nath, "Bhitargaon." Percy Brown suggested a fifth-century date without substantiation (*Indian Architecture*, p. 41). M. C. Joshi supported a late sixth- or seventh-century position on the basis of architectural structure ("Śiva Temple at Nibiyakhera"). I would contend that the advanced techniques of Bhitargaon were widespread in brick temples now destroyed. Odette Viennot presents the most extended argument for an early seventh-century date (*Temples, passim*, especially p. 213). Cf. Williams, review of Viennot, p. 77.

Brick decorated with terra cotta was used for building in many parts of India, although only the Buddhist *stū-pas* of Devnimori and Mirpurkhas, the pyramidal structure of Pawaya, and the later Lakṣmana Temple at Sirpur are included in this book.[75] Bhitargaon is, however, unique among brick temples in the extent of its preservation and hence in the degree to which it can be dated by its motifs.

Before an overall discussion of style, it may be useful to consider the details that point toward a mid-fifth century date. Double-stepped dentils form continuous bands around the temple just below the two heavy cornice moldings of the *kapota* type (Plates 108, 109 top). This element has already been noted at Udayagiri (Plate 36) and continued in modified form at Eran. Thereafter, it was replaced by plain dentils or those decorated with heads in the central Gupta areas.[76] Two registers below the dentils appears a row of interlocking pyramidal shapes or merlons formed by diagonal lines of inset squares. This motif may at first glance suggest a date after the fifth century, for versions of it are a common later feature (for example, Plate 258). Yet these later versions differ significantly in covering the lower pyramidal forms with a floral pattern. The pilaster capital in Plate 109 not only follows general

globular forms of the fifth century found at Mathurā,[77] but also displays toward its top a horizontal band of overlapping leaves, a detail that occurs in this position as late as Nāchnā, but apparently not thereafter.[78] Finally, no distinctly late fifth-century motifs, such as the band of broad overlapping leaves, occur here. Thus it seems likely that Bhitargaon falls within the middle two quarters of the century, probably before 460, for its decor is less advanced than that of the more provincial Tigowa.

The terra-cotta sculpture of Bhitargaon is more curvilinear than the carved brick decor, undoubtedly a characteristic of the medium. Terra cotta is rapidly modeled, lending itself to spontaneity and to more subtle surface effects than do carved forms. The small plaques inset into the superstructure are varied and whimsical, like the Pawaya fragments, implying a light-hearted attitude on the part of the sculptors. At the same time, some show careful modeling, with folds of flesh rendered more sensitively than is usual in Gupta stone sculpture. James Harle gives a systematic account of the iconography of the large panels, identifying Śaiva subjects on the south, Vaiṣṇava on the west, and a mixture, largely Śakta, on the north.[79] The Śaiva-Vaiṣṇava mixture suggests a temple dedicated to Hari-Hara,

75. Other sites with Gupta and slightly later terra cottas used in architectural decor include Ahicchatrā, Apsaḍh, Bhitari, Causa, Kauśāmbī, Kurukṣetra, Mathurā, Nagarī, Newal, Rang Mahal. Saidpur, Saheṭh-Maheṭh, and Sārnāth. These indicate not only a broad geographical spread for the medium but also the fact that brick was not employed for lack of stone (*vide* Mathurā) or as an alternative for low-caste patrons (*vide* the apparently royal foundation at Bhitari). Bhitari is of particular significance in relation to Bhitargaon,

being located in the Gangetic plains and preserving the base of a large structure (*Indian Archaeology—A Review*, 1968-1969, pp. 38-39).

76. Such dentils do survive later in the Calukya area: Divakaran, "Ālampur," fig. 21a ff. Cf. Williams, "Dentils."

77. Smith, *Jain Stūpa*, pl. XLVIII, 2.

78. Examples include Sāñcī (Plate 40), Eran (Plate 124 rear), Tigowa (Plate 129), Kunda (Plate 135), and Pipariya (Plate 186).

79. Harle, *Gupta Sculpture*, pp. 55-56.

the joint form of the great gods. The front bore Gaṅgā and Yamunā in isolated mid-wall panels on either side, which would suggest a date before these figures became standard at the bottom of the doorway itself.

Architecturally, Bhitargaon is of great interest because it preserves a spire that still rises 20 meters.[80] The walls are articulated vertically by a single projection on each side and rear wall, making this a *triratha* or three-facet design (Figure 7). The central facet bears three relief panels undifferentiated in size or decor, unlike later hierarchical arrangements. The *candraśālās* in the superstructure are not uniform in size. A large row below is followed by a smaller and rounder row, which is in turn surmounted by a medium-sized row. This contrapuntal pattern of alternating and diminishing units appears to continue upward. The rich effect is not found on any other temple of the Gupta period or later in north India. The closest analogy is Chandi Bima on the Dieng Plateau in Java.

In the interior at Bhitargaon, the cella is a plain chamber surmounted by a pointed arch. The roof above the entrance porch was apparently similar, with a lower, rounded vault covering the intervening passage. All were based upon a version of the true arch, rare in the generally corbeled vaulting of India. The upper part of the superstructure consisted of a separate blind chamber, and the interior spatial effect is not one of great vertical expansion. Whatever the structural methods of the Bhitargaon architect, he retained a general Indian sense of the sanctum as a restricted enclosure for *pūjā* or wor-

ship by a single person. Thus expansive spatial effects were inappropriate.

Bhitargaon is of particular importance if the mid-fifth century date suggested here is correct. This implies that large structural temples were in existence before the decline of the Gupta dynasty proper. Specifically, it indicates that the northern spire or *nāgara śikhara* existed in the fifth century as one alternative to the flat-roofed type of Sāñcī. Moreover, Bhitargaon demonstrates the role of the Gangetic heartland, an area that might otherwise seem to lag architecturally. If brick was a common material here, its friable nature would explain the scarcity of architectural remains. At the same time, Bhitargaon should surely be considered as one of several temple types, rather than the rule even in this area, for texts such as the *Bṛhat Samhitā* indicate a range of variations possible at any time.

Eastern Mālwa: Sāñcī, Udayagiri, Tumain, Eran

Outside the Gangetic plains, it is again the rich and strategic region of eastern Mālwa that provides monuments most easily related to the urban ones to the north. For example, the Buddhist site Sāñcī continues the development discussed in the last chapter, with a number of images produced undoubtedly by workshops also employed at the nearby Udayagiri and Vidiśā. Four very similar Buddhas installed around the great *stūpa* at Sāñcī show the general elegance of this phase (Plate 110). An inscription on the railing of this *stūpa* dated G.E. 131 (A.D. 450/1) provides a probable

80. It is impossible to discuss the lower moldings of the temple, which are entirely the result of restoration, as Cunningham's litho-

graph indicates.

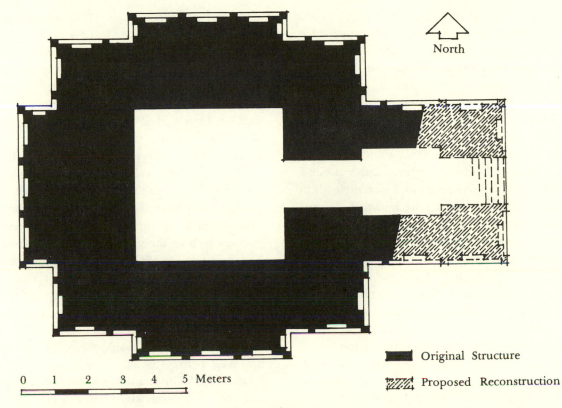

North

 Original Structure

▨▨ Proposed Reconstruction

0 1 2 3 4 5 Meters

Fig. 7. Bhitargaon

terminus ante quem for these images, for it records the donation of a lamp "in the place where the Four Buddhas are seated."[81] In terms of developments at Mathurā and Sārnāth, these Buddhas should be dated after

435. All are slender, the soles of the feet turn upward, and particularly the eastern and southern ones have drooping shoulders. The image in Plate 110 almost attains the elegance of the Sārnāth First Sermon (Plate

81. Fleet, *CII*, III, 260-62. For the other Buddha images, less well preserved, see Marshall and Foucher, *Monuments of Sāñchī*, pl. 70. Although it is impossible to identify the attendant figures in Plate

110 with confidence, those on the southern image wear *jaṭa* and *kirīṭa mukuṭā*, which would indicate Brahmā and Indra.

94). Perhaps the original placement of the Sāñcī piece high enough to be viewed from below explains the fact that the head is located beneath the center of the halo, unlike the perfect concentricity of Sārnāth. Lightly incised folds of drapery, a very low *uṣṇīṣa*, and the presence of two differentiated bands of foliage on the halo are all local characteristics. In short, these images were probably executed by sculptors of the area who were aware of stylistic developments elsewhere.

Three Bodhisattva figures have been found at Sāñcī, of which a Padmapāṇi will serve as an example (Plate 111).[82] If the Buddhas of Stūpa 1 are mid-fifth century, a slightly later date follows for this. The pose is close to the standing attendants in Plate 110, whereas the sash is more pronounced and low-slung, as in some Sārnāth Bodhisattvas (Plate 97). The headdress is quite close to the Mathurā style of Plates 72 and 74. Behind the head is a ruffled halo, which appears in simpler form behind the attendants in the Stūpa 1 images as well as behind the guardians of Udayagiri Caves 4 and 19.

At Udayagiri, the reference to models at the same site makes it difficult to distinguish the caves of Candragupta II from those of his successors. In general, the reason for considering A.D. 413 a dividing point is that before this, new forms and a new aesthetic were still in evolution; after this point primarily polishing and elaboration took place. Cave 4 seems to me to fall just after this dividing point and to represent a recasting of most of the elements of Cave 6.[83] The door frame itself is a simplified but refined version of the previous one (Plate 112). The guardians to the side are no longer recessed, as were those of Cave 6. But unlike even the sophisticated figures of Cave 7, the heads tilt sharply here, shoulders droop, and the carving is in high relief. Such features point toward a later date. The ruffled, elliptical halo is similar to that of the Sāñcī Padmapāṇi (Plate 111), as well as the guardians of Cave 19 (Plate 117). The pilasters, more three-dimensional than any at Udayagiri so far, are moved out of the door frame proper, and seem to have played an actual structural role in supporting a wooden porch roof. In general, this façade has a clarity and elegance that are new at Udayagiri. The *liṅga* inside seems more conservative, however, perhaps because it is a long-established type (Plate 113).[84] The round face, sharply defined features, and wide foliate necklace are still close to the Viṣṇu

82. For a second Padmapāṇi as well as a Vajrapāṇi that probably surmounted a column, see Marshall and Foucher, *Monuments of Sāñchī*, p. 51, pls. 125 and 108b. Marshall suggests a fifth-century date without discussion. Sheila Weiner argues for a sixth-century date, but none of the features she mentions seems to me to be exclusively late ("From Gupta to Pāla," p. 172). The image is less elaborate, fussy, and mannered in pose than the Mandasor figures discussed in Chapter IV.

83. Cunningham originally stated, "Outside the lines of ornament there are two short pilasters with bell capitals, like those of the Nasik Caves which support the usual figures of Ganges and Jumna" (*ASI*, X [1874-1877], 47). Cunningham's account of this cave is, however, unreliable (for example, in the description of a plain jamb and lintel surrounded by three ornate moldings), and need not be taken as fact. It is possible that the recesses above the capitals supported figures, but it seems more likely that these bore a wooden roof that rested in a horizontal depression above the door and perhaps on three free-standing columns, forming a *maṇḍapa* in front.

84. Stella Kramrisch ascribes this *liṅga* to the beginning of the fifth century (*Art of India*, pl. 46).

images of Cave 6 or of Besnagar. A date of 415–425 for the carving of Cave 4 would reconcile such conservatism with the more innovative character of the façade.

The only inscription of Kumāragupta's reign at Udayagiri occurs on a Jain cave at the top of the north end of the hill.[85] Although this inscription was dated in the year 106, "in the reign of the family of the best of kings, belonging to the Gupta lineage, who are endowed with glory and are oceans of virtue," and although no local governor was mentioned, the military donor Śaṃkara did not specify Kumāragupta's name. This indicates a less personal involvement by the emperor in this area than Candragupta had shown. The inscription records the dedication of an image of Pārśvanātha, which may refer to one of the reliefs in Plates 114 and 115. The principal figures are severely damaged, but the attendants are comparable to works at Mathurā and Sāñcī that I ascribe to the middle quarters of the fifth century. The capitals of the central and left pilasters in Plate 114 form a globular shape, elsewhere at the site clearly a vase, festooned with a band of pearls, which hangs from rosettes placed around the body. Thus this motif, seen already at Sārnāth (Plate 100, base), was in existence in simple form by roughly A.D. 425.

Cave 19 is more ambitious than any other at Udayagiri, both in its interior size and in its architecturally complex porch (Plates 116 to 119, Fig. 8). The door frame departs from the traditions of the site in several ways. The bands are successively recessed as they progress inward, rather than the alternating arrangement seen up to now at this site. These three bands, all bearing the same type of developed Gupta foliage, include human figures, an element seen at Bilsaḍh. At the bottom, two figures on each side are emphasized by their size, an initial stage in the shift of stress from goddesses at the lintel ends to those at the base of the jambs. It appears to me that all four female figures in both positions stand upon *makaras*, although the stone is admittedly abraded. The top of the lintel illustrates the Churning of the Ocean of Milk, a subject seen already in this position at Pawaya; here alternating figures are shown from the rear. Probably the upper register resembled that at Pawaya, with the addition of Rāhu, as the thief of the nectar of immortality, to the far right.[86]

The outer band of the door frame retains decorative pilasters, but a number of free-standing columns in front seem to have had the function of supporting a wooden porch roof, as at Cave 4. Two tall columns well to the front (visible in Plate 116, although only one survives

85. Fleet, *CII*, III, 258-60. The entire cave consists of a series of irregularly shaped rooms in a row. While Patil and others assert that the images described in the inscription must be lost (*Monuments of Udayagiri Hill*, pp. 48-49), I see no problem in identifying this with one of the reliefs. The inscription mentions Pārśva's serpent hood, which is visible surrounding the halo in both reliefs in Plate 113 and in the right-hand one in Plate 112. The inscription also mentions a female attendant; the attendant to the far left in Plate 113 is clearly

female, and one may surmise that the rest were, as well.

86. Cunningham described planetary figures or *navagrahas* here (*ASI*, X [1874-1877], 53). But the three figures now visible to the left of the enlarged head of Rāhu appear to be running or flying, a pose unknown for the planets. It is possible that the band immediately below the Churning bears a seated Lakṣmī bathed by elephants (Gajalakṣmī), as at Tumain.

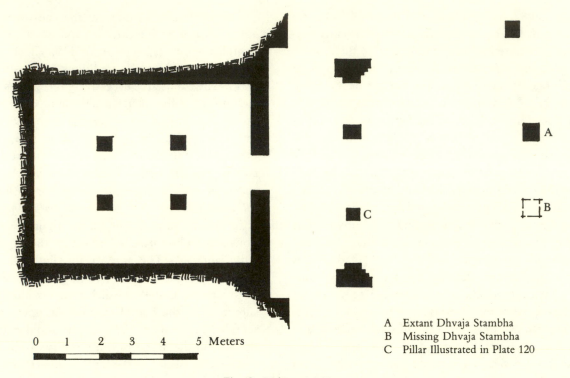

A Extant Dhvaja Stambha
B Missing Dhvaja Stambha
C Pillar Illustrated in Plate 120

Fig. 8. Udayagiri 19

today) may possibly have formed *dhvaja stambhas* or free-standing supports for an emblem of the divinity.[87] The exact nature of the porch cannot be reconstructed, but a wooden roof presumably rested in the long horizontal depression above the door.[88]

The capitals of all pilasters and columns in Cave 19 bear vases festooned with pearls, a form just observed in the Jain Cave. One porch pillar (Plate 120) shows the vase overflowing with foliage of a type slightly more exuberant and hence more advanced than that of Cave

87. One obvious problem with this suggestion is the fact that the nearer columns in their present condition are considerably shorter than the depression for a porch roof above the door, whereas the

outer pair approach this height. If the latter supported a roof, it must have consisted of very light materials to span such a distance.

88. Cunningham originally felt that "there was a long structural

I. Thus it seems likely that Cave 19 follows after the Jain Cave, perhaps roughly in the years 430 to 450. The interior columns (Plate 118) bear an imbricated band beneath the vase, a feature rare in most of the fifth century, more common after 485.[89] Animals originally reared at the corners of these capitals (their claws alone surviving on the lower rim of the vase, and in one case a pair of ears above), an element to be seen at Uparkot and Tala. The surviving column in front (Plate 119) shows forms unique in such a context: dwarves beneath the vase, and lion faces on the body of the vase from which the pearls issue (visible also in Plate 120). The lotuses above, however, are an elaborated version of those at the base of the Sārnāth columns in Plate 100 or of the Mathurā fragment in Plate 79. In general it seems that the carvers of Udayagiri at this point balanced forms drawn mainly from Mathurā, such as the advanced foliage type and slender figural proportions, against a certain number of idiosyncratic local inventions.

The isolated village of Tumain, 75 kilometers north of Udayagiri, was the site of a temple dedicated in A.D. 436/7, "shining like the moon and lofty like a mountain peak."[90] Although the inscription that records this

foundation is on an isolated block of stone, its date corresponds to that of one doorway at the site as determined by style (Plates 121, 122). This doorway is constructed with corner figures, now missing, keyed into the lintel and jambs like parts of a puzzle, a structural pattern found also at Sāñcī, Tigowa, and Kunda (Fig. 18a, b). Tigowa is particularly similar, for the corner figures overlap both lintel and jamb in the same way there. The foliage in the central register of the Tumain door winds around a band, a configuration seen at Bilsadh and Sārnāth (Plates 83, 99). The use of panels with human figures on the doorway becomes common after Bilsadh and Udayagiri Cave 19; and as at the latter there are larger female figures on animals at the base, whose identity is impossible to determine.[91] Only the lotiform capital of the pilasters might suggest an earlier date, for this was elsewhere replaced by the vase on doorways after Sāñcī 17 and Udayagiri Cave 6. Yet the lotus remains later on the free-standing *dhvaja stambhas* discussed at the end of this chapter, and in the context of the other motifs at Tumain, it seems reasonable to regard this alone as *retardataire*.

The lintel of the Tumain doorway embeds significant motifs within the decorative foliage. Above are the re-

verandah with three openings, to which a hall was afterward added, the whole forming an external building 27 feet square" (*ASI*, X [1874–1877], 53). Patil added the theory that the pillars were removed from the temple on the hilltop to construct the porch (*Monuments of Udayagiri Hill*, p. 45). I see no particular similarity between these pillars and the fragments on the hilltop, whereas their capitals do relate to those on the interior and doorway of Cave 19. Thus presumably this porch was contemporary with the façade and interior of the cave.

89. It occurs at Sāñcī on a column that I assign to the previous

period (Plate 40), but this becomes a common motif only at Nāchnā.

90. *EI* (1941–1942), XXVI, 115–18. Aside from the doorway discussed here, the other carvings at the site appear to me to be seventh-century or later. For example, Bajpai, "Madhya Pradesh Sculptures," p. 37 (pl. 25); p. 42 (pl. 41); and p. 45 (pl. 53). The Balarāma illustrated in the same article (p. 34, pl. 10) may possibly be a work of the fourth or fifth century, if one disregards the obviously recut face.

91. At the site Professor K. D. Bajpai kindly had enough dirt dug away around both figures to show that both vehicles are largely eroded.

mains of a scene of Lakṣmī with attendants; lotuses on either side must have supported elephants, now missing, which would have bathed her. In the lower register are the eight auspicious emblems: from the left, a vase (ghaṭa), umbrella (chattra), conch shell (śaṅkha), lotus (padma), paired fishes (matsya), spear (śūla), svastika emblem, and the taurine śrīvatsa symbol. Both registers invoke general well-being, in particular referring to the ablution and purification appropriate to a shrine door. The use of the central position on the lintel to introduce the particular cult of the temple (not Lakṣmī in this case) was not yet common practice. Even a site as provincial and in some ways conservative as Tumain does not precisely duplicate metropolitan models, but rather recombines its derived elements in an inventive way.

The site of Eran lies just outside Mālwa in the modern definition of that region, but in the Gupta period its strongest affinities were with the Vidiśā area. This city, strategically located on the River Bina, must have been an important center from the fourth century on. Although no inscriptions belong to Kumāragupta's reign, this seems to be the period of a large number of images and architectural fragments. Cunningham recorded here the bases of four small temples in a row.[92] None of these survives today in a form permitting reconstruction (except for the Viṣṇu temple rebuilt at a

later period). Nevertheless, it seems possible that the original placement reflects a coherent program, probably of the fifth century.

Several fragments at the site appear to belong to temples of this general period.[93] For example, the lintel in Plate 123 shows a row of bosses that logically follow after those of Udayagiri Cave 6: human heads, more three-dimensional than those of Udayagiri, alternate with lion heads applied to low dentils. Lion-head dentils are yet another motif that goes back to Kushan Mathurā.[94] The Eran lintel shows a band of pyramidal forms or interlocking merlons, similar to that at Bhitargaon (Plate 109), but here with a small flower superimposed on the lower pyramid. This is not yet the more prominently floral version of the motif that occurs later (Plate 258). The lower panels of the lintel include minor decorative figures and, in what presumably formed the center, the elephant-headed Gaṇeśa. The placement of such a figure in a panel foreshadows the later use of this position for a projecting image of the divinity of the shrine (lalāṭa bimba). The discursive treatment of religious themes at Pawaya, Udayagiri 19, and Tumain, here yields to a more condensed and axial effect.

Several capitals at the site of Eran seem closely associated with this lintel (Plate 124).[95] The candraśālā arches of the two are identical in form. In the background of this same plate is an upside-down fragment,

92. Cunningham, ASI, X (1874-1877), 76-90, pl. XXV.
93. A second lintel is illustrated in Williams, "Dentils," pl. 6. Here a Gajalakṣmī occupies the central panel in a position comparable to the Gaṇeśa in Plate 123. A jamb at the site belongs to this same doorway; its pūrṇa ghaṭa capital resembles that in the background

of Plate 124.
94. Williams, "Dentils."
95. A second survives at the site, and Cunningham illustrates a third (ASI, X [1874-1877], pl. XXX).

which likewise must follow soon after Udayagiri Cave 1, to judge from the extent of foliage on the *pūrṇa ghaṭa* (now broken off but visible in the lower left of the plate). The execution and quantity of such remains suggest that the Gupta buildings of Eran were impressive.

The colossal standing Viṣṇu image at Eran may well have been enshrined in such a temple, despite its present location in an early medieval shrine (Plate 125).[96] The torso, although broad and inflated, lacks the muscular modeling of Udayagiri Cave 6. The *dhotī* is smooth, with a rippling center fold and small sash like those of Udayagiri and Besnagar before, but now falling to the side. Stiff, plain body surfaces contrast with areas of precise carving, for example in the *vana mālā*, or garland. Lavish patronage requiring both a large figure, which creates physical problems for the sculptor, and also finely finished detail, might explain the unusual qualities of this image.

The skill of the Eran sculptor is best demonstrated by the Varāha image found by Cunningham in the local village and now removed to Sagar University (Plates 126, 127).[97] Here a date between A.D. 470 and 485 is probable on the basis of resemblance to the Eran Budhagupta pillar (Plate 147). The head is larger here than in the Udayagiri relief (Plate 37) and there is a

credible union between the animal and human parts. The stance is more stable both in itself and because of the strong vertical swag of drapery. The Earth Goddess is made purely dependent upon Varāha, from whose tusk she hangs like a coat on a hook. The image is just life-sized (for the boar-man) and detail is not elaborate, suggesting that its donors Maheśvaradatta and Varāhadatta were not the principal dignitaries of Eran. At the same time, there is exquisite care in the design, which puts this piece on a par with the masterpieces of Sārnāth. For example, the back of the image is coherently finished; a simple stem provides a whimsical lotus cap for the Boar, and leads the viewer around the statue. The overall lines show great authority, befitting the power of this *avatār* of Viṣṇu. Comparison with the Varāha on the second Rājghat pillar (Plate 102) may be unfair, given the difference in scale. On the whole, it is clear that Eran remained a major artistic center, combining elements from Mālwa with the general achievements of the Gangetic workshops.

Eastern Bundelkhand: Tigowa, Kunda

Two small temples show the extension of Gupta forms to a new part of the periphery of the empire, the modern Bundelkhand (ancient Mekalā), 240 kilometers east of Sāñcī. The temple at Tigowa is the first case of a

96. Cunningham inferred from the similar size of the later pillars and of Gupta examples at the site that the original Gupta temple was left unfinished, to be completed centuries later (*ASI*, X [1874-1877], 85-86).

97. Cunningham, *ASI*, X, (1874-1877), 86-87 (including the inscription); Bajpai, *Sagar through the Ages*, pl. IV. Harle ascribes the image to the late fifth or early sixth century (*Gupta Sculpture*, p. 39).

I find the modeling close to that of the figures surmounting the Budhagupta pillar of A.D. 485, with little resemblance to the subsequent theriomorphic Varāha carved under Toramāṇa (Plates 198-200), implying a previous date. Cunningham suggested that the image came from the shrine he labeled C-D, which is on an axis with the Budhagupta pillar, and which he therefore assigned to the same date. This precise provenance is not supported by other information.

Hindu shrine of cut stone preserved almost in its entirety.[98] The plan of this temple (Fig. 9) resembles Sāñcī 17, for its porch was originally open on the sides. The whole is, however, set on a much larger platform or *jagatī*, with stairs in front.

The porch capitals at Tigowa (Plate 129) bear lions separated by trees (differentiated in species here), like those of Sāñcī and Eran. The arches or *candraśālās* below on the front columns resemble those of the Eran capitals. Those on the rear pilasters, however, now half covered by a later wall but clearly part of the original fabric of the temple, must have been designed by a different and more advanced hand (Plate 130). The lions of these pilasters clutch small human figures between their paws. The arches differ markedly from those in front, showing a flamelike excrescence, a drop at the top, and pearled outlines. Most important, the entire arch is doubled, with the bottom member split in half. This configuration never replaces the simple *candraśālās*, but from this point on becomes increasingly common and gives rise to countless variations and elaborations. In that examples of such doubled arches, still rounded in shape and hence presumably early, occur among the undated fragments of Mathurā, it is probable that this significant new departure began there.[99]

The overflowing vase or *pūrṇa ghaṭa* on all the col-

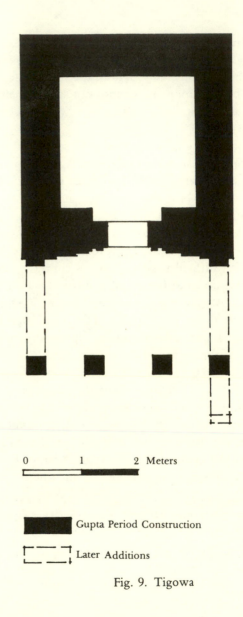

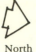

North

0 1 2 Meters

■■■■■ Gupta Period Construction

⌐---┐ Later Additions

Fig. 9. Tigowa

98. Cunningham, *ASI*, IX (1873-1875), 41-47. The walls are apparently double in construction.

99. For example, Smith, *Jain Stupa*, pl. XXXVIIIa, fig. 4; Williams, "Dentils," pl. 13. A door post with this doubled arch from Maholi appears at first glance to be Kushan, but careful examination of the figures suggests a fourth-century date (Mathurā Museum 00.P79).

umns resembles those of Udayagiri Cave 1 and of Eran, yet the foliage extends slightly farther down the body of the vase and shows a more developed leaf that fills the outer corner, an indication that Tigowa is later. The Tigowa form approaches the Rājghat Budhagupta pillar in typological terms, although it is larger and finer in execution. Foliage worms its way out of the vase from beneath a large lotus flower; such a flower, repeated beneath the vase, occurs at Sāñcī and Eran. The corner columns are encircled by a band of fantastic faces (*kīrtimukhas*) with foliage and hanging pearls, elements that appear at Sārnāth and Eran in this period (Plates 100, 124 rear).

The interior ceiling is decorated with a large lotus, replacing the figures of the Udayagiri fragment (Plate 42) with rosettes. The door follows the general pattern of Sāñcī and Tumain in its structure (Plate 131, Fig. 18b). This is the first place where the River Goddesses are unquestionably differentiated on a doorway. The images are quite close to those from Besnagar in the naturalness of their poses and in the composition with two attendants, which is more complex than that of Udayagiri Cave 6 or 19. In addition to outer pilasters, identical with the front columns in motifs, the doorway is decorated only with two bands of rosettes and with two bands of seven and thirteen plain dentils in the lintel. The relative simplicity of the door might be

taken to indicate that it is unfinished. Incompleteness in Indian art is usually a matter of parts sketched in (such as the front columns at Tigowa itself), however, and the registers at Tigowa are all smoothly finished. Possibly some of the decor was painted, as at Ajaṇṭā Cave 17. Moreover, a general restraint characterizes all the remains of this period at Tigowa.[100]

Three miles north at Kunda, another small temple has been discovered by Debala Mitra (Plates 132, 133).[101] On the whole, this is a simpler version of the Tigowa one. The door is similar in structure, although the missing corner pieces did not interlock with the jambs, as had been the earlier pattern. The T-shaped outline was apparently minimized in the inner moldings, and the decor is yet plainer than that at Tigowa. A lotus ceiling seems to have resembled that of Tigowa. No porch is indicated by pilasters or by any signs of the attachment of a roof in front. A single column fragment found here is identical with those of the Tigowa porch in its band of overlapping leaves and in general configuration. The temple at Kunda could be interpreted as an earlier prototype for that at Tigowa. But the pattern of the doorframe suggests that this follows slightly later, representing a less well-endowed and hence simpler foundation.

What then is the date of these remains? The *pūrṇa ghaṭa* capitals point toward a date after Udayagiri Cave

100. A second, larger door frame stands in isolation; this may be the one described by Cunningham (*ASI*, IX [1873-1875], 47), although he describes human and lion heads on bosses, whereas only plain bosses are visible today. A Narasiṃha of the fifth century is now installed in a later temple at the site. This may well have formed

the original object of worship in the Gupta temple, where Cunningham mentions that he found a Narasiṃha.

101. *Indian Archaeology* 1965-1966, p. 104. Mitra, "Śaṅkar-Maḍhā at Kunda." This temple clearly had double walls. Mrs. Mitra suggests that a porch was added later.

1. The split *candraśālā* appears here as early as any-where outside of Mathurā. The Tigowa temple seems to precede the Nāchnā architectural remains, which it will be argued below commence around 480. Thus a date of 445-470 should follow for Tigowa. A related question is that of the patronage or political overlord-ship of the area at this point. V. V. Mirashi has treated the Tigowa shrine as a Vākāṭaka monument on the basis of inscriptions that refer to Vākāṭaka overlord-ship of the area.[102] There are no distinctively Vākāṭaka characteristics here, however. For example, the River Goddesses are clearly differentiated, which is not the case at Ajaṇṭā. Moreover, a number of connections with Mathurā, Sārnāth, and Mālwa have been adduced above. Thus surely in terms of style, eastern Bundelk-hand was at this point part of the Gupta world. Possi-bly the Tigowa temple was the first monument of Vyā-ghra of the Uccakalpa dynasty (ca. A.D. 470-490), who did acknowledge Vākāṭaka overlordship in an inscrip-tion at Nāchnā discussed in the next chapter.[103] If so, however, I would expect to see a stronger continuity between the Tigowa remains and those of Nāchnā. Thus it is preferable to ascribe the buildings of the Ti-gowa area to some unidentified small potentate, still under the waning suzerainty of the Guptas and deriving his taste from the network of imperial centers of north and central India. The Tigowa carvers show some lo-

calism in minor ways (plain dentils, copious rosettes), but the elegance and variety with which they treated standard motifs indicate that this area was not cultur-ally backward.

Western India: Mirpurkhas, Uparkot

Western India is the home of a large number of Gupta *stūpas* with terra-cotta decor, largely fragmentary and hence difficult to date. That at Mirpurkhas in Sind (now Pakistan) can, however, be compared to the earlier re-mains of Devnimori in the same general region, and to the brick and terra-cotta monument of Bhitargaon, with which I believe it is contemporary.[104] On the Buddha images, as at Devnimori, Gupta curls predominate, al-though an occasional wavy-haired example (Plate 135) shows the continuation of models derived from north-west India. The drapery, however, which clings with softly defined folds in certain places, does not corre-spond to Gandhāran patterns but shows the directly sensitive modeling of Bhitargaon. The foliage (as in the halo in Plate 135) is often of the broad-leaved acanthus type, but the typical Gupta lotiform variety also occurs in a diffused form with notched edges, supporting a relatively late date.[105] The carved brick decor in Plate 134 shows doubled *candraśālā* arches as at Tigowa and presumably Mathurā, again a form one would not ex-pect before the middle of the fifth century. On the whole,

102. Mirashi, *CII*, V, lxii-lxv. The basis for assuming that the Vākāṭakas were overlords is twofold yet contradictory: the Ajaṇṭā XVII inscription made under Hariṣeṇa (ca. A.D. 475-500) of the west-ern branch, which describes the conquest of Kosala, Gujarat, and Orissa; and the later Uccakalpa inscriptions that admit the overlord-ship of the central Vākāṭaka branch at Nāchnā and Ganj.

103. Mirashi, *CII*, V, 89-93. The Supia inscription of G.E. 141

(A.D. 461) indicates that Gupta hegemony remained in force at this point in Rewa State, just to the north of Nāchnā and Tigowa (*EI*, XXXIII [1960], 306-308).

104. *ASIAR* 1909-1910, pp. 80-92. M. Chandra, "Study in Ter-racottas from Mirpurkhas." Harle, *Gupta Sculpture*, p. 53.

105. M. Chandra, "Study in Terracottas from Mirpurkhas," figs. 12b, 14e, 15b.

there is a flat, cut-out quality to the ornamental pieces here, which are more repetitive than the richly varied versions of the same motifs at Bhitargaon.[106]

The caves of Uparkot are located in a different part of western India, the peninsula of Saurāṣṭra; they lie at Junāgaḍh, the site of the great dam that Skandagupta's governor repaired, probably a major administrative center. The difference between the carving here and the decor of Mirpurkhas is thus in part one of subregion, as well as a matter of material and probably of religion. As caves, the Uparkot excavations are unusual in being cut down into the rock, rather than employing the normal side entrance.

Uparkot has received scanty attention, and has usually been assigned a third-century date.[107] In fact, the comparisons with Amarāvatī that have supported such a date are misleading. The broad-leaved, grooved foliage on the column bases (Plate 136), has as much in common with Gupta versions from Mathurā and elsewhere (Plates 71, 109) as it does with forms in Andhra. The figure style does not seem distinctly southern.

Other characteristics point clearly to a fifth-century date. The base of the columns in Plate 136 consists of a vase with small patterns on the surface, the body encircled by festoons that hang from rosettes. This is essentially the same motif we have seen in the Jain Cave and Cave 19 at Udayagiri, as well as at Sārnāth with

minor variations. The Uparkot capital bears fantastic creatures with human riders, which again resemble the animals on the interior of Udayagiri 19. On the whole there is a slightly baroque sense of fantasy to these columns that continues in sixth-century western Indian works. The very circular *candraśālā* arches visible in the background of Plate 136 are admittedly early in type, but these remain the standard form in Gujarat as late as the sixth century in the case of Gop. Uparkot also shows an occasional example (Plate 138) of the "unfinished medallion," in fact a completed motif, which was to remain popular in Mālwa and the western Deccan from the late fifth century on.[108] And finally, a few pilasters show diagonal flutes (Plate 139), a form noted at Mathurā presumably in the fifth century (Plate 79), and appearing relatively late in the development of both Ajaṇṭā and Bāgh.[109] Thus Uparkot, although different from Mirpurkhas, seems likewise to belong to the mature Gupta phase in western India, a region that imparts individual flavor to forms largely received from the central regions.

Dhvaja Stambhas of the Fifth Century

The period considered in this chapter is punctuated by six *dhvaja stambhas* or nonstructural columns that supported an emblem of a deity. This very form, usually with a eulogizing inscription of the donor engraved on

106. Double-stepped dentils with a flower on top occur here (M. Chandra, "Study in Terracottas from Mirpurkhas," fig. 14c), suggesting a continuity between such dentils and the pyramidal motif noted at Bhitargaon (Plate 109), which later acquires flowers.

107. *Indian Archaeology* 1958-1959, p. 70 reports coins of Rudrasena II (348-378) found here; these present the same problems as the Devnimori coins discussed in Chapter II. For a summary of other ac-

counts of Uparkot, see Nanavati and Dhaky, *Maitraka and Saindhava Temples*, p. 16.

108. Stern, *Colonnes indiennes*, pp. 95ff. Viennot, *Temples*, pp. 86ff. I do not share the French scholars' conviction that this motif originates in the sixth century.

109. Spink, "Bāgh," p. 60.

the shaft, evokes the Maurya columns of the third century B.C. Several of these earlier monuments must have remained standing at Buddhist centers such as Sāñcī and Sārnāth in the fifth century A.D. Moreover, Samudragupta's Allahabad inscription is located on a Maurya column, suggesting that this ruler recognized the form as an imperial symbol. The very number of new columns is as great in the Gupta period as under any post-Maurya rulers, which underscores the deliberate policy of proclaiming glory, both royal and lesser, by such means. Thus this type merits exceptional discussion as a nonregional group in view of the imperial theme of this book.

The first example of Gupta manufacture is the enigmatic Iron Pillar, now installed in the Qutb Mosque at Mehrauli, just outside Delhi (Plate 140). This was probably brought from another area, a hill referred to as *Viṣṇupāda* in the inscription.[110] A major problem that this inscription presents is the identity of the ruler "Candra," whose exploits from "beyond the seven mouths of the Indus" to Vaṅga (Bengal?), are described. S. R. Goyal has argued that it is likely that these exploits are those of Samudragupta, but I would prefer the traditional identification of the ruler in the inscription with Candragupta II.[111] Thus I ascribe the column itself to the early years of his son, Kumāragupta I.

The capital, lotiform here as on all these pillars of the Gupta period, demonstrates that the Aśokan model remained in force for this *genre* in a way it did not for architectural columns. The form of the lotus on the Mehrauli capital is relatively close to Maurya ones, except that the petal edges are all rounded (rather than round alternating with angular ones) and the "neck" or constricted portion above is not as deeply inset as on Aśokan originals. This neck consists of a twisted band found also as early as the Sāñcī Maurya Lion capital.[112] Above this rise three fluted forms, each slightly different in profile. The lower one, precedented by a Śuṅga-period capital from Besnagar,[113] suggests the broad-grooved version of the *āmalaka* form that was to serve as a capital at Mukundara and in the western Deccan. The upper cogged elements in the Mehrauli capital, taken together, may form a vase, fluted on its rim, a member occurring at Besnagar at roughly this same time (Plate 47). Together these shapes suggest the rich ambiguity of connotations inherent in elements treated with formal harmony. Above the topmost square block, an emblem of the god Viṣṇu would presumably have completed the capital.

A second capital that I would assign to the reign of Kumāragupta was found at Sāñcī (Plate 141).[114] This was discovered in conjunction with a shaft of similar measurements, inscribed with the name of an unidentified donor in fifth-century script; thus the column was not an imperial dedication. The lotus, abacus, and lions

110. Fleet, *CII*, III, 139-42; Sircar, *Select Inscriptions*, pp. 283-85.

111. Goyal, *Imperial Guptas*, pp. 201-209. Cf. Roy, *Studies*, pp. 1-27. If the date were A.D. 385, the forms of the capital would be unprecedented and exceptional for twenty-five years to come.

112. Marshall and Foucher, *Monuments of Sāñchī*, pl. 107.

113. Cunningham, *ASI*, X (1874-1877), pl. xiv.

114. Marshall and Foucher, *Monuments of Sāñchī*, pl. 108a; Cunningham, *ASI*, X (1874-1877), 62-64, pl. XXI.

are all so close to the Maurya capital of the same site that it is clear that this directly emulated that Aśokan model, rather than those of the south gateway of Stūpa 1 or of Sāñcī 17. There are, of course, differences from the Maurya sources here, particularly a softer carving and loss of articulation (such as in the lions' legs and manes). Minor changes are wrought in the twisted band above the lotus, which becomes the common twisted garland. Moreover, the disc at the top rests on a block covered with foliage of the Gupta type, in particular so similar to that of the four Buddhas of Stūpa 1 (Plate 110) that a date close to theirs is probable. Thus the Sāñcī capital shows a general but not slavish fidelity to the Maurya model of the same site.

A column at Bhitari, 25 kilometers northeast of Vārāṇasī, implies that such fidelity continued into the reign of Skandagupta, whose eulogy appears on the shaft (Plate 142).[115] The Maurya lotus here, as at Sāñcī, is followed with general integrity, although angular and rounded edges are not differentiated as on the originals. The flattened profile, with neck and curve of the lotus relatively little indented and with a squarish upper bulge, likewise betrays the fact that this is a post-Maurya work.

A column in the same area at Latiya, some 50 kilometers east of Vārāṇasī, shows a yet flatter version of the lotus petals (Plate 143).[116] The straightness of the profile is increased by the outset band immediately below the lotus and by the ring above. The upper surviving member of the Latiya column consists of eight addorsed lions, a number unprecedented, to my knowledge. This was apparently surmounted by a Janus carving of two human torsos with arms raised, now on the ground. Too little is clear for identification, although a Garuḍa is at least one possibility.[117] This fragment does indicate that inventive capital types were found near the Gangetic centers in the mature Gupta period, and were not merely provincial aberrances.

At Kahaum, another 95 kilometers to the north of Latiya, stands a column dated G.E. 141 (A.D. 460/1), which must follow that of Bhitari (Plate 144).[118] The panel representing Pārśvanātha at the base of this column was discussed in connection with Sārnāth sculpture, to which it is closely related (Plate 86). The Kahaum example differs clearly from its predecessors, both Gupta and Maurya. For example, while the inscription mentions Skandagupta, it records not his exploits but rather the motivation of the donor Madra, who dedicated this column with five images of Tīrthaṃkaras when the world's troubles led him to seek religious merit. Thus a personal and private twist is given to the concept of the *kīrtistambha*. The column differs from Maurya ones in its extremely tapered form and in the

115. Cunningham, *ASI*, I (1862-1865), 96-103. Fleet, *CII*, III, 52-56. Sircar, *Select Inscriptions*, pp. 321-24. Recent excavations at Bhitari have clarified the remains of the brick temple and have yielded an interesting stone panel of Vasudeva giving Kṛṣṇa to Yaśodha (*Indian Archaeology* 1968-1969, pls. XLIV-XLVI).

116. Cunningham, *ASI*, III (1871-1872), 61-63.

117. Forms behind the head suggest fanned-out curls, as in Pāla Garuḍa images. Another possibility is a Sūrya image, with the raised arms holding lotuses.

118. Cunningham, *ASI*, I (1862-1865), 91-95; Fleet, *CII*, III, 65-68; Sircar, *Select Inscriptions*, pp. 316-17.

division of the shaft into a series of differentiated sections (eight-sided, sixteen-sided, and round), the uppermost marked with a foliate band.[119] Above the lotiform capital, simplified as in all Gupta cases, a block bears niched images of four Tīrthaṃkaras (one with long hair, distinguished as Ṛṣabhanātha), a union of the *sarvatobhadra* or four-sided Jain image type with the column. A metal spike on the summit may have supported a wheel or other emblem.[120] On the whole, the Kahaum pillar transmutes significantly both the form and the content of earlier *stambhas*.

Finally, the Eran Pillar of the year 165 (A.D. 485) is a fitting conclusion to the era of Gupta presence in central India (Plate 145).[121] As mentioned at the beginning of this chapter, its inscription is hardly a eulogy of Budhagupta, but rather praises the local *mahārāja* Maitriviṣṇu, whose younger brother Dhanyaviṣṇu had this *dhvaja stambha* erected. The column rises from a square shaft, higher than the base of any of the previous four; above this is a short octagonal section. The next member has almost entirely lost its lotiform character, with no indication that the bottom represents petals at all. The curve of this capital is moreover very flaccid, the twisted band at the top only slightly inset. Above this occurs a second small octagonal section (the kind of logical sequence we have seen in the columns of Sāñcī),

followed by three square members. Lions remain at the top, their faces more grotesque than any seen so far. At the very summit is the emblem of Viṣṇu, apparently a Janus image of the Garuḍa bird holding a snake.[122] The wheel above lends itself to three interpretations: Viṣṇu's discus, a sun disc appropriate for the solar Garuḍa, and possibly the *cakra* of the *cakravartin* (although that claim on the part of the local rulers would seem pretentious). Perhaps several subjects were originally intended, for ambivalent imagery was entirely in keeping with Maurya capitals themselves, notably that of Sārnāth.

At Eran, the strong curves of the snake and of the legs and the tightly curling hair are consonant with images of Mathurā and Sārnāth at this point, although the canon of proportions is slightly heavier here. The images also resemble the symmetrical but equally strong and curvilinear Viṣṇu at Eran. On the whole, this area, while slipping from Gupta political control, seems not markedly out of touch with the style at Sārnāth and its hinterland.

Conclusion

By the reign of Kumāragupta I, the unifying principles of Gupta art are already implicit, particularly in the sculpture of Mathurā. Thus what remained in the pe-

119. The Heliodorus pillar at Besnagar shows similar banding, as do of course many structural columns by the fifth century (Irwin, "Heliodorus Pillar").

120. The wheel is suggested in particular by the Firozpur capital with four *nāga/nāgī* figures supporting a wheel (Williams, "New Nāga Images").

121. Cunningham, *ASI*, X (1874-1877), 81-82; Fleet, *CII*, III, 88-

90; Sircar, *Select Inscriptions*, pp. 334-36.

122. Wayne Begley suggests that a *cakra puruṣa* or personification of the wheel is equally likely (Begley, *Viṣṇu's Flaming Wheel*, p. 47). I would agree with him that the side flanges are not wings (not a necessary attribute of the Garuḍa, however); but the object held on the side I illustrate does clearly seem to be a serpent.

riod treated in this chapter was to work out these principles more systematically and to apply them to new situations. The first occurred in the Mathurā Buddha image itself, the proportions of the figure being refined and the treatment of drapery and halo enriched as a complex foil to the harmonious forms of the whole. The extension of this style to new areas took place, in geographical terms, with the growth of the Sārnāth and Sāñcī schools of sculpture. This is the period, moreover, when the principles of Buddhist art came to be fully understood in Brahmanical sculpture in stone. This transfer led to the appearance of new Hindu artistic centers (Bilsaḍh, Tumain, Tigowa), to the representation of new Hindu subjects (especially at Mathurā), to the development of an aesthetically satisfying doorway (from Udayagiri Cave 7 on), and to the architectural growth of the Hindu temple itself (as at Bhitargaon).

Each of these developments paradoxically opened the way to the end of Gupta art. The Mathurā workshops had, up to now, represented a clearly centralized style. This spread to and was enriched by provincial styles (as at Udayagiri under Candragupta II or the Sārnāth Kushan tradition), but defined in some sense an imperial artistic current. Sārnāth as a secondary center seems to have benefited even more than Mathurā from the crisis atmosphere of the mid-fifth century, which inspired a frenzy of Buddhist image making. The extension of the central styles in refined form to Eran and Tigowa was still part of a network of connections in which similar developments occurred throughout the Gupta Rāj. Craftsmen, their pattern books, portable models, and patrons (hence taste) must all have traveled freely. But the very presence of developed examples in outlying areas permitted a future diversity.

The growth of Brahmanical art also led the artist in new directions. Hindu sculptural subjects often required new action, and the delicate equipoise of the Gupta Buddha image, still shared by the Eran Varāha, was to be less and less in demand. Likewise, the development of the Hindu shrine as an architectural form invited the end of the aesthetic that had set apart the Gupta period in the history of Indian art. In the fifth century, the work of sculpture had formed a separable entity, but later the powerful and ultimately religious impact of the temple as a whole was to become the guiding consideration. Such concerns are not yet apparent, even in the comparatively elaborate decor of Udayagiri Cave 19 or Tigowa, where separate columns and doors are each admirable and self-sufficient. Likewise, the fifth century represents a great watershed in terms of declining naturalism and growing stylization.

In all these ways, the reigns of Kumāragupta, Skandagupta, and the early years of Budhagupta form a coherent whole. Political collapse threatened throughout the second half of this period, and perhaps fostered an adherence to artistic traditions that were identified with the established order. It is only when the political collapse materialized after A.D. 485 that artistic changes began, and those remarkably slowly.

Chapter IV
GUPTA ART AFTER THE GUPTAS,
A.D. 485-550

General Historical Background

To construct a coherent history of the Gupta dynasty after Budhagupta is impossible. No emperor is represented by more than two inscriptions, and what inscriptions there are remain relatively uninformative. Coins also grow scarce. It is tempting to turn to literary sources such as the records of the Chinese pilgrim Hsüan-tsang and the *Mañjuśrīmūlakalpa*. Yet Hsüan-tsang wrote a century later, and the historical section of the *Mañjuśrīmūlakalpa* is now ascribed to the tenth or eleventh century A.D.[1] Both are Buddhist sources, and their account of religious matters may be partisan. Thus the general historical picture is inevitably disjointed.

The ruler Viṣṇugupta is known from a broken seal found at Nālanda, which gives us a genealogy of Narasimha, Kumāragupta, and Viṣṇugupta; Narasimha's father's name is possibly to be reconstructed as Purugupta.[2] Viṣṇugupta, still styled *parama-bhāgavata*

mahārājādhirāja, is known also from gold coins of the archer type, but the limitation of these to southwest Bengal suggests that he ruled only in that area.[3]

The ruler Vainyagupta is known from a yet more fragmentary seal found at Nālanda as well as a copper plate inscription from Gunaighar in Comilla District, Bangladesh.[4] The latter begins with praise for Śiva and records the gift of land to a Buddhist monastery of the Mahāyāna dedicated to Ārya-Avalokiteśvara, the eleven-headed Bodhisattva whose image was carved at roughly the same time at Kanheri on the opposite coast of India.[5] This is also one of the first inscriptional uses of the term *Mahāyāna* in India. Texts of that school had been in existence for at least three centuries, as demonstrated by their dated translations into Chinese. A seal from Nālanda, although likewise found in a Buddhist context, describes the ruler with the customary Vaiṣṇava term *Parama-Bhāgavata*. It appears that Vainyagupta was eclectic in his religious beliefs. His

1. Macdonald, *Le maṇḍala*, p. 19. ·
2. *EI*, XXVI (1941-1942), 235-39. Pū fairly clear; Goyal denies this reading (*Imperial Guptas*, p. 325).

3. Altekar, *Coinage*, p. 280.
4. H. Sastri *Nālandā*, p. 67. D. C. Bhattacharyya, "Copperplate."
5. Fergusson and Burgess, *Cave Temples*, pl. LV 2.

gold coins of the standard type are found also in southern Bengal, where he probably succeeded Viṣṇugupta.[6]

Bhānugupta is known from the Eran inscription of G.E. 191 (A.D. 510/1) and possibly from a copperplate from Darmodarpur of G.E. 224 (A.D. 543/4), implying that this ruler enjoyed an extremely long reign and wide recognition.[7] The Eran inscription records a battle in which a local ruler named Goparāja was killed, presumably in fighting the Hūṇas. The Darmodarpur grant shows the perpetuation of the formula used for a hundred years in this area, including the title of *uparika-mahārāja* for the post of governor. It is remarkable that no coins of Bhānugupta have been found.

Finally, a ruler named Prakāśāditya is known only from gold coins that are clearly part of the Gupta numismatic tradition. These show the mounted king slaying a lion, with a Garuḍa standard in the rear. Possibly Prakāśāditya should be equated with a ruler using a different name on inscriptions. Altekar, for instance, suggests that he is the same as Purugupta, of whom no coins are known.[8] Goyal, on the other hand, identifies him with *Pra* of the *Mañjuśrīmūlakalpa* and accepts its account that this ruler, the son of Bhānugupta, was imprisoned by Goparāja and allied himself with Toramāṇa the Hūṇa.[9] The fact that his coins were found

largely in Uttar Pradesh, and the absence of any reference to Gupta overlords in the Gayā inscription of 551/2 suggest that his rule was limited to U.P. probably in the mid-sixth century. In any case one need not accept in detail the account of the *Mañjuśrīmūlakalpa* to admit that there were several late rulers named Narasiṃha, Kumāragupta, and possibly Candragupta. They may have ruled simultaneously in different areas, and perhaps were engaged in rivalries among themselves that led to alliances with various former feudatories and enemies of the Guptas.

The most important of the Guptas' enemies were the Hūṇas, already defeated by Skandagupta at the beginning of his reign. The complex interrelationships within this group of tribes in Afghanistan and Pakistan are best left to numismatists.[10] Their renewed presence in India is demonstrated by the colossal Varāha image at Eran (Plates 198-201) erected "in the first year, when Mahārājādhirāja, the glorious Toramāṇa, of great fame and lustre, is governing the earth."[11] This image was dedicated by Dhanyaviṣṇu, younger brother of the by-then deceased Mātṛviṣṇu, who had in A.D. 484/5 put up the Garuḍa column at Eran (Plate 145). It would follow that Toramāṇa came to power here after that date but within a generation, for Dhanyaviṣṇu was al-

6. Altekar, *Coinage*, pp. 281-82.

7. Fleet, *CII*, III, 91. *EI*, XV (1919), 141-44; *EI*, XVII (1923-1924), 193. Dikshit in the latter article correctly amends the reading of the date and hence distrusts the reading Bhānu. It is possible that the *uparika* at this point is a member of the imperial family, showing a resistance to the tendency to make such posts hereditary (Majumdar and Altekar, *Vākāṭaka-Gupta Age*, p. 216).

8. Altekar, *Coinage*, pp. 282-86. It seems to me that Altekar overstresses the early qualities of the coins.

9. Goyal, *Imperial Guptas*, pp. 342-44. For a reasonable explanation of an Orissan reference to the Guptas in A.D. 569/70, see Devahuti, *Harsha*, p. 14.

10. Göbl, *Dokumente*.

11. Fleet, *CII*, III, 158-61.

ready a codonor of the pillar. A roughly contemporary inscription recording a Buddhist dedication under Toramāṇa is known from Kurā in the Salt Range (Pakistan).[12] His coins, found as far south as Uttar Pradesh, bear a solar disc.[13] Apparently he at least tolerated a variety of religions.

Mihiragula, Toramāṇa's son, must have been different in character, to judge from the descriptions of his anti-Buddhist policy in Sung-yun's contemporary travelogue and the much later *Rājataraṅginī*.[14] His coins bear Śaiva symbols, and the Mandasor inscription of Yaśodharman describes him as showing obeisance only to Śiva.[15] Yet the sole inscription referring to Mihiragula (and that with lavish praise), is one from Gwalior that records the erection of an impressive sun temple in the fifteenth year of his reign.[16] The Eran inscription of Bhānugupta already mentioned describes a battle in this area in the year 510/1, which may have represented either a Hūṇa expansion (in view of the death of the Gupta ally Goparāja) or a victory over the Hūṇas (more likely, to my mind, in view of the carving of Goparāja's memorial pillar, which praises Bhānugupta). If Mihiragula had been defeated with the finality indicated by Yaśodharman's Mandasor inscriptions of about A.D. 533, the Gwalior inscription should precede these. Thus he presumably had come to power by about 515. His

strength undoubtedly continued longer in Kashmir and the northwest.

What were the effects of Hūṇa conquest upon northern India? Archaeological reports indicate some destruction toward the end of the Gupta period at Eran and Bhīṭā (near Allahabad).[17] At Kauśāmbī a layer of yet greater devastation corresponds stratigraphically to two Hūṇa seals, one bearing the name Toramāṇa.[18] Quite possibly at those sites where pitched battles were fought, towns were razed and there was an artistic hiatus. At the same time, the impact of such an invasion should not be exaggerated. Undoubtedly large areas both in the center and even more in the outlying parts of the former Gupta empire were hardly aware of the change in distant overlordship. An *entente* between the surviving Guptas and the Hūṇas is suggested by the *Mañjuśrīmūlakalpa*. Moreover, the Eran and Gwalior inscriptions indicate that the Hūṇas, whether by their own desire or from the inertia of local potentates, fell heir to the titles and descriptions of the Guptas. The foreign successors legitimated their presence in the same way that the new Indian dynasties clung to some Gupta formulae. Likewise, the theriomorphic Eran Boar indicates that the beginning of Toramāṇa's rule saw no sudden change in artistic style. In their defeat, the Guptas remained culturally in control.

12. Sircar, *Select Inscriptions*, pp. 422-24.

13. Smith, *Coins of Ancient India*, pp. 235-36.

14. Hsüan-tsang, *Buddhist Records*, pp. xcix-c; Kalhaṇa, *Rājataraṅginī*, I, 43-48.

15. Smith, *Coins of Ancient India*, pp. 236-37. Fleet, *CII*, III, 148.

16. Fleet, *CII*, III, 161-64. Fleet's reading of "broke the power of Paśupati" is open to question (Sircar, *Select Inscriptions*, p. 425, n. 6).

17. U. V. Singh, "Eran"; Mukhopadhyay, "Bhīṭā," p. 94.

18. G. R. Sharma, *Excavations at Kauśāmbī, 1957-59*, pp. 15, 37.

Probably of greater impact than the limited foreign presence was the growth of independent Indian states within the Gupta Rāj. It is appropriate to consider each of these in some detail in connection with regional artistic developments. Yet all bore some kind of organic relationship to the Guptas. In Bengal we have already seen the development of hereditary governors who called themselves *uparika mahārājas*. Likewise in Gujarat, the Maitraka dynasty was founded by a commander of the imperial army. In Mālwa, Yaśodharman continued the line of the fifth-century *aulikara* family, which had governed under the Guptas. In central India, the Parivrā-jakas, Uccakalpas, Śarabhapurīyas, Maukharis, and the later Guptas of Magadha indicate no firm proof of having been feudatories, yet all show an awareness of the Gupta past in their opposition to the Hūṇas, in the style of their inscriptions and art, or in their use of the Gupta dating system. All of these dynasties were clearly Brahmanical, and most were Śaiva. While Śaivism certainly flourished under the Guptas, and Buddhism and Vaiṣṇavism continued after the Guptas' eclipse, the shift in royal affiliation may have set a slightly different tone.

Northeastern Bundelkhand

In the late fifth and early sixth century, two families dominated the area between Satna and Jabalpur. These dynasties, known today as the Parivrājakas (forest as-cetics, from the status of the founder of the dynasty) and Uccakalpas (from the capital of the second family) are difficult to disentangle. Problems arise from the nature of their records, largely copperplate land grants, which are easy to transport from their original position, and whose findspots are often only vaguely recorded.

The first inscriptions of the Parivrājakas belong to the Mahārāja Hastin, fourth in the family, who ruled from at least A.D. 475 until 517.[19] All five of his inscriptions indicate that he was a Śaiva. In A.D. 518 he was succeeded by Saṃkṣobha, who reigned until at least 528, leaving two Vaiṣṇava inscriptions.[20] The first of these describes the Parivrājaka territory as including the kingdom of Dabhālā, the eighteen forest kingdoms, and Tripurī. Tripurī is certainly the later Kalacuri capital near Jabalpur; the forest kingdoms may represent the tribal area to the southeast bordering on Mekalā; and Dabhālā represents the earlier Ḍāhala, corresponding to the modern Bundelkhand.[21] It is significant that all the Parivrājaka inscriptions are dated "in the enjoyment of sovereignty by the Gupta kings," a phrase that could hardly have evoked more than a distant memory in the year 528.

The Uccakalpa family is likewise represented first by records of its fourth ruler Vyāghra(deva). His two undated stone inscriptions, both from the Nāchnā area, identify him as a feudatory of Pṛtivīṣeṇa, presumably

19. Fleet, *CII*, III, 93-112; *EI*, XXI (1931-1932), 124-26.
20. *EI*, VIII (1906), 284-90. Fleet, *CII*, III, 112-16.
21. *EI*, VIII (1906), 285-86 (identifying the donated villages with two near Bilhari, 9 km. west of Murwāra). Fleet, *CII*, III, 114, 116. Here, as elsewhere in this book, I use the term Bundelkhand to include areas sometimes distinguished as Bagelkhand.

the second, of the main branch of the Vākāṭaka family, about A.D. 470-490.[22] His son Jayanātha was ruling in A.D. 493/4 and 496/7, when he made Vaiṣṇava donations from Uccakalpa, usually identified with the modern town Uncahara.[23] Śarvanātha ruled from at least 510 until 533/4. One of his inscriptions refers to a village on the northern bank of the Tamasa (modern Ton) River, indicating influence to the north of the Parivrājakas.[24] The objects of Śarvanātha's dedications included Kumāra, Sūrya-Nārāyaṇa (Viṣṇu and the Sun), and twice a Vaiṣṇava goddess called Piṣṭapūrīka.[25] The Uccakalpa records do not refer to the Guptas, although after Jayanātha they use the Gupta era; otherwise, these land grants follow the same pattern as those of the neighboring Parivrājakas.

A crucial document linking these two families is an inscribed post found near Bhumara, dating from A.D. 508, which refers both to Hastin and to Śarvanātha.[26] Traditionally interpreted as a boundary stone, this has been recently reconsidered by D. C. Sircar, who suggests that it concerns a village within the Parivrājaka kingdom that was also a *jagir* (economic holding) of the Uccakalpa Śarvanātha. This would imply a somewhat subordinate status for the Uccakalpas at this point. Territorially, the boundary between the two kingdoms

cannot have been far from this spot, for Nāchnā lies some 25 kilometers to the west.

In summary, both families arose in the fifth century as minor governors under the Gupta and Vākāṭaka dynasties. By the early sixth century, the Parivrājakas had become independent and had extended their power to an area at least a hundred kilometers from north to south. The Uccakalpas meanwhile must have been released from Vākāṭaka overlordship and have come somewhat under the sway of the Parivrājakas. Their power apparently extended to the north of the Parivrājakas and may have survived longer. While it is possible that the violent destruction of Khoh represents a foreign invasion, I am not convinced that this need be ascribed to the Hūṇas rather than to a more local enemy. It is understandable that the Hūṇas should bypass this relatively isolated area in the lee of a mountainous plateau. The abundance of remains in this entire region from a time when less building survives from more central areas may reflect the protected position of this part of Bundelkhand. It seems to me probable that Nāchnā remained under Uccakalpa domination. It is likely that Maṛhiā was built at a time when the Parivrājakas governed here. The affinity between this shrine and that of Bhumara would support a contention that

22. Mirashi, *CII*, V, 89-92 (and ch. II on Vākāṭaka chronology). Neither inscription styles Vyāghra *mahārāja*, while later ones list him thus in genealogies, after independence from the Vākāṭakas.

23. Fleet, *CII*, III, 117-25.

24. Ibid., pp. 125-39; *EI*, XIX (1927), 127-31.

25. Fleet, *CII*, III, 116, 132, 138. Cunningham originally associated

the goddess with Pataini Devī of Pithaora (Uncahara District), who he felt was Jain (*ASI*, IX [1873-1875], 10); Mahendra of Piṣṭapura is one of the rulers described as captured and then freed in the Allahabad *praśasti* of Samudragupta (line 19).

26. Fleet, *CII*, III, 110-12. *EI*, XXXIII (1960), 167-72. For the astronomical calculation of the date, see *EI*, XXI (1931-1932), 125.

the latter lay within Parivrājaka control. But even this is conjecture, and the relationship between local styles and a refined picture of political power should not be stressed here.

Nāchnā

The village of Nāchnā, together with the nearby Kūtharā and Lakhorobagh, preserves such a wealth of late Gupta remains that one must conclude it formed an important regional center, perhaps the capital of the Uccakalpas (Fig. 10).[27] These remains span the period considered in this chapter, and provide a relative sequence to which the work of other sites can be related. At the same time, they show a continuing interplay between mainstream traditions, derived from the outside, and a local sculptural idiom that is at its worst clumsy and at its best vital in a slightly folkish way.

Nāchnā is the source of over a dozen images of Tīrthaṃkaras, which indicate a flourishing Jain community here, and which serve to introduce the yet more plentiful Brahmanical material. The figure in Plate 146 is sufficiently close to the 470s Buddhas of Sārnāth to indicate a roughly similar date.[28] Yet the low *uṣṇīṣa* and small curls suggest that the influence or perhaps

even the sculptor came from the region of Sāñcī at this point. A second image, now installed in a cave on the hill known as Siddh-ka Pahar, is still elegantly tranquil in its lines (Plate 147). The foliage on this halo is relatively simple and hence typologically early. At the same time, this sculptor introduces local mannerisms. The feet are proportionally larger than in the last example, as are the lips and eyes. Thus the face acquires an earthy warmth. The next image, a Pārśvanātha (Plate 148), is more slender than the previous two. Peculiar local proportions remain. The attendants' poses are rendered two-dimensionally, although the effect is not as exaggerated as in Nāchnā's latest phase. Thus these three Jain images punctuate the period from roughly 470 until 510.

The most complete early monument of the site is the Śiva shrine known as the Pārvatī Temple, although even this has been denuded in the twentieth century.[29] The temple faces west, as does the Viṣṇu temple at Deogarh, a fact I would interpret to mean that an eastward orientation had not yet become mandatory. A photograph of 1918 (Plate 149) demonstrates that the plan originally comprised a cella surrounded by a *pradakṣiṇa patha* or passage for circumambulation (Fig.

27. Cunningham provides a summary of legends indicating the importance of the place (*ASI*, XXI [1884-1885], 95).

28. A similar (perhaps earlier, at least more elegant) image is illustrated in plate 1 of Williams, "Jina Images." U. P. Shah publishes three more images from the second cave on the hill in *Jain Art and Architecture*, ed. A. Ghosh, I, pls, 62-64. I would place his Plate 62 close to our Plate 148, that is, slightly later than Shah's date. I would also assume that the hair of that image indicates Ṛṣabhanātha and

that the lions are simply a conventional part of the throne. Shah's plate 63 seems to me to follow soon after this group, while his plate 64 must be later sixth-century.

29. Cunningham, *ASI*, XXI (1884-1885), 95-97; *ASIPR, WC* 1918-1919, pp. 60-61, pls. XV-XVI. In this last report by Beglar, the directions are incorrect by 90 degrees: his south should in fact read west.

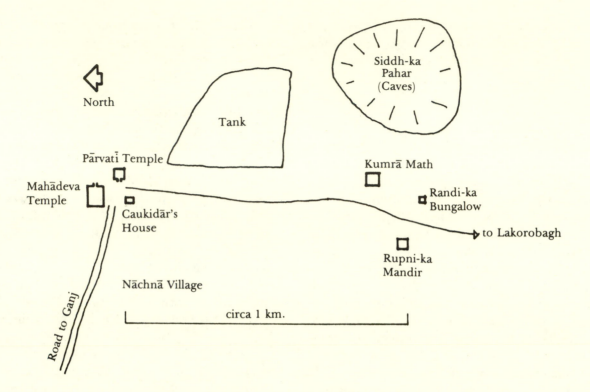

Fig. 10. Nāchnā, site plan

11). This is one of the earliest examples of such a plan, known in later texts as the *sāndhāra* type, and common among medieval temples. To include a passage of this kind does not seem a startling innovation, for circumambulation had long been the basic Indian pattern of worship.

Plate 149 also demonstrates that this temple origi-nally bore a second chamber above the main shrine. This was apparently topped by a flat roof. An *āmalaka* finial has been found at the site (Plate 163 left), and it is possible that such elements surmounted the roof, as in the one-story pavilion depicted in Plate 170. This double-chambered temple type is very rare even in later periods; it is not clear from the few other examples

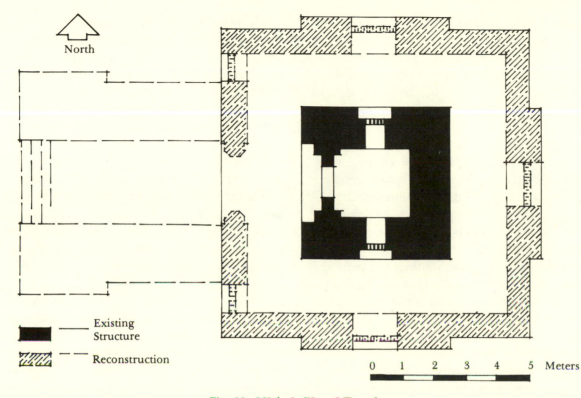

North

Existing
Structure

Reconstruction

0 1 2 3 4 5 Meters

Fig. 11. Nāchnā, Pārvatī Temple

whether the upper room could be entered and whether it served any religious purpose.[30] The surviving door of the Pārvatī indicates that the main cult was Śaiva. Conceivably a *liṅga* such as that in Plates 161 and 162 was enshrined here, in which case the upper chamber might have corresponded to the absent fifth head of the *liṅga*, the sky, usually not represented; this is clearly only a hypothesis, however.

30. The Meguti at Aihole, a Jain temple dated 634/5, and the Buddhist Temple 45 at Sāñcī, ninth-century or later, are the least questionable examples (Viennot, "Temples à toit plat," pp. 31-35). In the Lad Khan at Aihole, the upper shrine may represent somewhat

What appears as a separate plinth today (Plate 150) originally continued directly upward into the wall of the lower story. At the bottom is a more emphatic series of moldings than we have seen so far: the *khura* or "hoof," familiar from Tigowa; dentils, newly used in this position;[31] the *kumuda* or rounded form, seen at Mirpurkhas; and a small reversed-curve molding. Above this authoritative base line, the walls were rusticated in the long-standing Indian sculptural convention for depicting rocks. Clearly the entire temple was compared to a mountain, as in the words of a contemporary inscription of Mandasor: "A temple which, having broad and lofty spires, and resembling a mountain, and white as the mass of the rays of the risen moon shines, charming to the eye, having the similarity of being the lovely crest-jewel, fixed in its proper place."[32] This metaphoric vision of architecture is common later both in texts and in practice. Possibly the cave-like upper chamber enriched the image.[33] What is unique here is the vividness with which the Nāchnā architect carried out his metaphor, robing the rocky slopes with images of wild animals that call to mind the present fauna of this same region.[34] Mt. Himavan was brought to Bundelkhand.

The present condition of the shrine would not suggest its original opulent decor. The outer wall bore windows on all sides. No photo survives of the back, but Cunningham's description of the window there matches the frame in Plate 151.[35] Here for the first time a band of overlapping broad leaves appears. Again this motif may well have originated in Mathurā, for the rather flat, simplified form of this Nāchnā version suggests that it is derivative.[36] At least this can be added to the inventory of Gupta motifs from the last quarter of the fifth century on. Comparable windows in the side walls consisted of *vyālis* or leogryphs with riders flanking a central pilaster; these have been built into the porch of the neighboring Caturmukh Mahādeva Temple at some point since 1918. At either side, on the front wall of the Pārvatī Shrine, a family of *nāgas* formed a window; these also were built into the interior of the Mahādeva porch (Plate 152). No precedent exists for such elaborate forms used as window grills. The outer front door was flanked by pilasters, probably those now installed in a modern shrine immediately to the northwest. An old photograph shows images of *gaṇas* inset on the side walls. Although none of those preserved here or removed to other collections matches

later additions. This, while Śaiva today, has been identified as a Sūrya-Nārāyaṇa shrine (Balasubrahmaniyam, "Lad Khan," p. 41). The Meguti and Lad Khan at Aihole today have stone stairs leading up. One puzzling feature in Nāchnā is the slabs of stone set in at the corners, ca. 50 cm. above the floor. It is hard to explain these structurally; possibly they form a unique kind of bench. No socket for any image is found on the roof slabs today.

31. Williams, "Dentils."

32. Fleet, *CII*, III, 86; obviously that shrine at Mandasor is not to be identified with the Pārvatī Temple.

33. The *Bṛhat Saṃhita* of Varāhamihira describes a type called Guharāja, which might be related to this (ch. LVI, v. 25).

34. A peacock and deer are still in place. Others survive at the site, in the Ramban Museum near Satna, and in the Jayakar Collection (V. S. Agrawala, "Survey of Gupta Art," pl. VIII, fig. 6).

35. "On one side the trellis has four small pillars, with three openings, each pillar being ornamented with a human figure" (*ASI*, XXI [1884-1885], 97).

36. *Cf.* the Mathurā lintel in Plate 277. The most elaborate version of this motif of which I know is a triple-leaved form from Kau-

those in the photograph, it is probable that some belong to the Pārvatī Temple.[37] One example (Plate 153) shows a foreigner with what seems to be a rhyton, perhaps an amusing comment on the invading Hūṇas. The *gaṇa* troops of Śiva are of course a fitting enrichment of this temple.

The construction of the Pārvatī doorway is peculiar to the Nāchnā area: figures on lotuses at the ends of the lintel are actually carved from the same piece of stone as the jambs (Fig. 18c). We seem to stand at a point of transition in the conception of the doorway, in which the T-shaped pattern with prominent figures keyed in separately at the corners was no longer required. The early Nāchnā solution was to unite the vestigial figures with the jambs. The alternative solution, which predominated once these figures were more completely eliminated, was a simple post-and-lintel construction (Fig. 18e).

Other local peculiarities appear on this doorway (Plate 154). Like the second two Tīrthaṃkara images (Plates 147, 148), the figures follow a distinctive type, with thick lips, stick-like limbs, and heavy ankles. The doorkeepers, for example, appear almost club-footed. There is a clarity in the relationship between pilasters and a roof-like band (*śāla* molding) on the lintel, unusually architectonic for this or any period in Indian art. A clear sense of weight and support continues in many architectural remains at Nāchnā.[38] Likewise, the absence of foliage issuing from the vases that serve as capitals is a characteristic of the site. In general, such minor idiosyncracies would suggest the work of carvers out of touch with other areas.

At the same time, the Nāchnā doorway is not totally removed from others of the fifth century. The position of the River Goddesses below was to become the rule soon after this. It would seem that they had been demoted from their heraldic (and perhaps politically motivated) position atop the jambs, replaced there by the Yakṣīs who had preceded them. At the base of the portal they are in this case attendant upon the more prominent Śaiva personae of the doorkeepers. The organization of the lintel with the central divinity (Śiva

śambī (now in the Allahabad University Museum). This leaf has been termed acanthus in much previous literature, or more recently and convincingly a palm (by Viennot and Harle).

37. From the 1918 photographs, there would have been four on each side wall and the front, and perhaps another four on the rear, making a total of twelve. Three are preserved at the site, one built into the Mahādeva porch (four-armed, dancing), and two loose (one lion-headed, one with one of its two arms extended straight up). One with left hand aloft was photographed in 1958 by the Archaeological Survey (Temple Survey Negative 3034), but has since disappeared. Two musician *gaṇas* photographed by the American Institute of Indian Studies in the 1960s are also now missing; one with beard and mustache holds a rectangular object in the right hand. Of the seven in Panna in 1961, four dancing ones remain: Bajpai, "Gaṇa Figures from Panna." It is unlikely that all thirteen cited here belong on the Pārvatī shrine, nor do all of these match in dimensions (between 37 and 65 cm. high), although their broken condition makes it impossible to consider size systematically.

38. A particularly striking example is a column built into the *dharamśālā* known as Randi-ka Bungalow, which bears sixteen flutes from bottom to top, broken only slightly by two decorative bands. The Attic impression is misleading, for this is simply a clear version of Indian patterns, usually so complex that the architectonic effect of the column is lost.

with Pārvatī and worshipers) replaces earlier narrative treatments of this member. Doubled *candraśālā* arches appear on the lintel, a new element at the very end of the previous phase (Tigowa, Mirpurkhas). From the *pūrṇa ghaṭa* of the pilaster bases, foliage descends roughly half the height of the vase, as on those of Rājghat (Plate 101) and Tigowa (Plate 129).

In the matter of dating, clearly such comparisons point to a position in the last quarter of the fifth century. Within the Nāchnā sequence itself, the Pārvatī temple belongs to a second phase. It is not the work of outsiders, as might be the Tīrthaṃkara image in Plate 146, which I assign to about 470-480. Yet this temple is richly inventive beyond anything that followed at the site. A date between the years 480 and 500 seems reasonable, corresponding to the end of Vākāṭaka overlordship for the Uccakalpas.

Whereas the porch of the Mahādeva Temple at Nāchnā has been assembled since 1918, incorporating fragments from the Pārvatī, clearly another set of Gupta pieces was built into the main fabric of that ninth-century temple. A doorway (Plate 155) was constructed in the same peculiar manner as that of the Pārvatī Temple. The missing section of the lintel, today part of the caretaker's hut, bears an image of Śiva with twisted locks of hair (*jaṭā mukuṭa*) (Plate 156).[39] This iconic form of the divinity framed in a central panel (*lalāṭa bimba*) seems later in design than the continuous and casual frieze of the Pārvatī lintel. The outer band of the Mahādeva Gupta doorway consisted of overlapping leaves, first seen on the window in Plate 151; at the top this turned into a band of broader leaves arranged on a stem. This doorway seems on the whole to be based on that of the Pārvatī Temple but to be less precise in carving and design (*vide* the dissimilar treatment of the doorkeepers' backgrounds). A slightly later date (about A.D. 495-505) is indicated.

The Mahādeva shrine also includes within its original fabric three window trellises and six large couples now placed above them (Plate 157); although none of these is as ineptly carved as the door, it is likely that they were part of the same original temple, which this early medieval structure replaced. The large couples are inset into a medieval frame, and it is impossible to ascertain their original function. Their large-featured faces and rubbery legs with thick ankles are quite close to those of the figures of the Pārvatī doorway. The window grills below are likewise related.[40] A row of lion heads crown these, like the lion heads alternating with human faces at Eran (Plate 123), a motif that gains currency in the sixth century. The outer foliate band rises from female figures, both standing, undifferentiated, on *makaras*. On the doorway in Plate 156 as well, River Goddesses are absent, and the large female figures at the ends of the lintel stand upon dwarves with foliate tails (of which two other examples are known from the

39. The portion of this doorway in the temple is today covered by a frame of wood and metal, leaving only the inner foliate band visible. The form of Śiva in Plate 156 is probably not Lakulīśa, for it lacks a club.

40. The inner trellis on the west has been replaced by a medieval one. The lion heads there are replaced by plain dentils, and both this and the northern window lack female figures on *makaras* below.

area).[41] One is reminded of the multitude of Yakṣīs and Yakṣas with exotic vehicles at the nearby *stūpa* of Bharhut, albeit six centuries earlier in date. Perhaps the unorthodox treatment of the River Goddesses at Nāchnā is the result of competition from other locally worshiped divinities.

Roughly half a kilometer south of the Pārvatī and Mahādeva Temples lie two brick shrines of the fifteenth century or later. These, and particularly that known as the Kumrā Maṭh, are the subject of an article by Walter Spink.[42] While it is impossible to improve upon many of the observations in that article, I cannot accept Spink's assumption that the Gupta fragments built into the Kumrā Maṭh belonged to a single, four-doored temple.

The large door frame on the south side of this temple (Plate 158) appears to have surrounded a second pair of jambs and lintel, found on the west side of the Kumrā Maṭh but now removed to the compound of the Pārvatī Temple (Plate 159; Fig. 18d). The interior measurements of the first lintel correspond to the exterior of the second (190 cm. long), and the *candraśālās* of the two complete each other. On the whole the elements

of this impressive doorway indicate a date after the Mahādeva door (A.D. 500-520), as well as a loss of provincialism at Nāchnā at this point. The River Goddesses have assumed the form standard in the sixth century, dominating the smaller companions who shade them with parasols. The attendants of Yamunā on the left stand upon fishes, an aptly aquatic touch that occurs in one image from Mathurā (Plate 228). The T shape of the entire frame is minimized by the absence of large human figures at the ends of the lintel, although leogryphs serve as a decorative bracket and small scenes of religious importance are tucked within the inner band in Plate 158. The human figures on the jambs and the central *lalāṭa bimba* on the lintel are not framed on the side, as they had been previously.[43] The carving of the inner band of foliage is somewhat flatter and simpler than that of the Pārvatī doorway; yet it is still coherent and vibrant with energy. Although the poses of figures are no more three-dimensional than those of the Pārvatī, they are less mannered in proportions than those of intervening works. Thus the Nāchnā artists do not continue the ingrown process of building exclusively on local models.

41. An unpublished window in the Ramban Museum, near Satna, thought to come from Nāchnā; and a jamb in the Allahabad Museum, of the early Nāchnā structural type, from Nagod (P. Chandra, *Stone Sculpture in the Allahabad Museum*, fig. 207). A similar dwarf is the vehicle of the goddess to the left of the main doorway of Ajaṇṭā Cave 23.

42. Spink, "Nāchnā Kūṭhara." Spink refers to this shrine as the Temple on the South Hill. Pramod Chandra refers to it as the Teliyā Maḍh ("Vāmana Temple," pl. 16). The term Kumrā Maṭh was used by villagers in my visits in 1965, 1969, and 1974. The fragments on the north side do not belong to a doorway (Spink, "Nāchnā Kū-

ṭhara," fig. 326). They appear to me to date from ca. A.D. 500, and to be superior in quality to the Mahādeva pieces. Bands of broad, overlapping leaves built in on the north side (and one inside the Kumrā Maṭh) are clearly by a different carver from that of the south door, for the former have serrated central ridges, as at Deogarh.

43. The absence of frames is not consistent elsewhere; for example, in Orissa they linger until the tenth century, while at Sirpur, ca. 600, they disappear selectively. At least in central India, they lose currency after ca. A.D. 500. The carving of one leogryph on a continuation of the jamb below, while the other was a separate block of stone, may indicate a transitional status (Fig. 18d).

This composite doorway seems to belong to a Sūrya-Nārāyaṇa Temple, for the lintel bore the Sun God, Sūrya, in the center and two *avatārs* of Viṣṇu at either end. The former image is iconographically complex, including the wives of the Sun as archers above, the male attendants Daṇḍin and Piṅgala below, and Aruṇa as the charioteer in the center. Even the chariot with seven horses is more than a cliché, for the steeds are carved on the bottom to be visible overhead as the worshiper walked through the door. At the ends (Plate 158), the two forms of Viṣṇu both differ from earlier versions of the same events, suggesting that the artists were creating new narrative illustrations of the legends. On the left, Varāha holds an Earth Goddess as large as he is, and he squats upon the serpent in a unique and ungainly way. On the right, Narasiṃha collars a sprightly Hiraṇyakaśipu in one of the earliest illustrations of the role of the Man-Lion as a destroyer of demons. The parallel between the two scenes may have been suggested by the Caturvyūha images of Mathurā (Plate 74), in which leonine and boar heads are paired on the sides; it is also possible that the imagery of Nāchnā and Mathurā reflects the same religious sources. At any rate, there is a care and freshness in the treatment of every element here that make one regret the loss of the rest of the large temple to which this belonged.

A doorway now installed in the nearby shrine known as Rupnī-ka Mandir may have been carved by the same workmen as the last, but is clearly later, roughly 530-540 (Plate 160). The structure comprises a simple combination of jambs and lintel (Fig. 18e). The flying attendants on the lintel have become a repetitious series, each male figure forming a simple curve with the female tucked above, rather than overlapping his body as before. The T shape has been further reduced, with only the minor decorative form of a bird occupying each inner corner. The foliage of the inner band is shallower in execution than any seen so far, and is composed of a choppy series of curves that are not united by any apparent stem. Yet the River Goddesses demonstrate not merely a decline in skill (although that is true to some extent), but also a new aesthetic at work. The umbrella introduced in the last example (Plate 159) trails fluttering scarves. A new pair of attendants above the goddesses add to the rococo quality of the carving. Large stable units are lost in the all-over effect of line. The pole of the umbrella and the angled position of the River Goddess combine to create a strong diagonal thrust, impelling the worshiper inward. We are moving toward the religiosity of medieval temple design.

A number of isolated Hindu sculptures can be at least roughly connected with the sequence of doorways just discussed. The *liṅga* in Plates 161 and 162 has been mentioned as the type that might have been placed in the Pārvatī shrine, making the empty chamber above appropriate. In fact, this was found a kilometer away near Lakhorobagh and brought to the Pārvatī compound some time between 1965 and 1969. The four-faced *liṅga* represents Śiva as Maheśvara, the heads corresponding to Sadyojāta or Earth (Plate 161), the feminine Vāmadeva or Water, the angry Aghora or Fire (Plate 162), and Tatpuruṣa or Air. The differentiation of the forms of Śiva is clear here, and the associ-

ation with the elements, while not textually documented until later Purāṇic literature, is borne out by a few early images in which the fifth head appears, holding aloft sun and moon, emblems of the sky.[44] The decor of the Nāchnā *liṅga* is elaborate and carefully varied, the serpent threaded through one of Aghora's ears (Plate 162) representing a characteristic touch. At the same time, each face is based upon broad curves that echo and vary the shape of the *liṅga* itself.

The miscellaneous images in Plate 163 are undatable but point to the variety of divinities in worship at Nāchnā: a four-headed Brahmā, a Viṣṇu to the side, and Lakulīśa to the extreme right. The frieze in Plate 164 is of particular iconographic interest, for it is an early image of the seven planets together with Rāhu, the descending node of the month as a large head at one end. The planets sit in alternating poses, except for Sūrya at the extreme left, whose legs are crossed; a standing form for the planets soon becomes common in north India. New astronomical imagery appears in the fifth century, not only in this area but also in Mālwa and the Gangetic centers.[45]

Six *Rāmāyaṇa* scenes show the Nāchnā figural style in its fully localized form with awkward if expressive figures (Plates 165-170). These do not come from niches in the base of the Pārvatī Temple (to judge from their dimensions), and the less sophisticated treatment of rocks

than on the base of that temple would support a slightly later date, about 500-510. The subjects can be identified as follows.

Plate 165: Sītā and Lakṣmaṇa hear the Golden Deer calling out. Sītā rebukes Lakṣmaṇa for his unwillingness to leave. Lakṣmaṇa holds his ears in chagrin, and finally he departs.

Plate 166: Sītā is approached by Rāvaṇa disguised as a mendicant.

Plate 167: Hanuman approaches Rāma and Lakṣmaṇa at the behest of Sugrīva.

Plate 168: Vālin and Sugrīva fight, while Rāma and Lakṣmaṇa watch, unable to distinguish them.

Plate 169: Sugrīva is distinguished by a garland, and Rāma shoots at Vālin.

Plate 170: Hanuman is brought before Rāvaṇa in Laṅkā.

Two scenes represented here are unknown in other sculptural versions of the story: Lakṣmaṇa's departure from Sītā, a subtle moment in terms of human motivation; and the capture of Hanuman, a subject of popular appeal.[46] The treatment of the monkey rulers is simpler and more humorous than the crowned versions of Deogarh and the Allahabad area.[47] By comparison

44. For example, Rang Mahal (Harle, *Gupta Sculpture*, pl. 128) and Musānagar (N. P. Joshi, "Unique Figure").

45. The Nāchnā frieze was at the site in 1965, but was no longer there by 1967. Astronomical images from Udayagiri have been discussed in Chapter II. A fragment from Bhitari, now in the Indian Museum, Calcutta, shows Rāhu and three standing planets, whose

attributes may correspond to those on the Nāchnā piece; the style of the Bhitari fragment appears to me to be early sixth-century.

46. Stutterheim, *Rāma-Legenden*. The intervening four scenes are, however, chosen for representation at Lara Jonggrang in Java, and Hanuman's exploits are shown at length at Panataran.

47. For Deogarh, see Vats, *Deogarh*, pls. XV-XVII. For one piece

with other central Indian Gupta cycles of reliefs and scattered Gangetic examples, the Nāchnā figures are slender and relaxed. Informal concerns such as description of setting (plants, rocks, the palace in Laṅkā), comedy, and personal reactions (such as the puzzlement of Rāma and Lakṣmaṇa in Plate 168) take precedence over epic events.

On the whole, Nāchnā witnessed the continuation of Gupta traditions after the Gupta empire was no longer a political reality in this area. Beginning with an influx of sculptural forms (and perhaps sculptors) close to those of eastern Mālwa and the Gangetic centers, the area moved rapidly toward a local figural style around 490 A.D., perhaps with Uccakalpa independence from any overlord. At the same time, changes occurred that reflected currents we shall see in late Gupta art elsewhere. Nāchnā's position below the plateau on which most of the succeeding monuments of this area are located must have made it somewhat accessible to outside contact. One aspect of the Nāchnā style that went beyond a simple continuity in workshop traditions is the inventive treatment of subject matter. This implies on one

hand a receptivity on the part of the craftsmen to sophisticated guidance, and on the other hand a lively local intelligentsia. It is this combination of elements, from minor motifs to general aesthetic, derived from a prestigious heritage and yet developing in new ways, that makes the remains of Nāchnā a vigorous finale to Gupta art.

Khoh

The valley of Khoh is comparable to the Nāchnā area as an avenue to the Parasmaniya plateau, connecting this with the plains; this area was also something of a political and religious center, for a number of sculptural remains and copperplate inscriptions were found here.[48] Since these latter belong to both Uccakalpas and Parivrājakas, it is quite possible that the region changed hands between the two dynasties. The remains that survive are parts of a much larger whole, and it is difficult to date any piece. The finest complete work is a Śiva *liṅga* with one face, which epitomizes the harmony of the mature Gupta style (Plate 171).[49] By comparison with an earlier example of the same

from Shringwerpur, Allahabad District, see P. Chandra, *Stone Sculptures in the Allahabad Museum*, fig. 221. An example from Vārāṇasī (R. C. Agrawala, "Brahmanical Sculptures," fig. 340) shows the plebeian monkeys with some humor, although the entire composition is formal. Scenes at Pavnar, southwest of Nagpur, have been identified as illustrating the Rāmāyana (Mirashi, *CII*, V, lx-lxii), but these have more recently been identified as Krṣṇa subjects (see note 107 below).

48. Fleet, *CII*, III, 93-105, 112-16, 121-39. *ASIPR, WC* 1918-1919, pp. 105-107. The various Khoh sites extend over an area of several kilometers.

49. *ASIPR, WC* 1918-1919, pl. XXIX. P. Chandra, *Stone Sculpture in the Allahabad Museum*, p. 90, pls. LXVI, LXVII. The piece was found at the site Nakti-ki Talai, within the Khoh Valley. A *gaṇa* found nearby (ibid., pl. XXX) demonstrates the relationship with Nāchnā, for the great scholar V. S. Agrawala mistakenly ascribed this to the latter site ("Survey of Gupta Art," pl. VIII, fig. 4). A theriomorphic Varāha, without sages on his body, was found on the nearby mound Atariya Khera (*ASI*, IX [1873-1876], pl. III; *ASIPR, WC* 1918-1919, pl. XXIX). The *nāga* is now missing, but from the old photographs and from the evenly raised eyebrow of the boar itself, I suspect that the image is medieval.

type in Udayagiri Cave 4 (Plate 113), the Khoh image integrates the face of Śiva into the phallic form behind, and its skull bursts forth less abruptly. The elaborated headdress repeats the form of the *liṅga*, and the crescent moon is mirrored in the curve of the lips. The facial type is not far removed from the earthy warmth of Nāchnā figures from the end of the fifth century. At the same time, the exquisite balance and repose in such a masterpiece correspond to the principles that underly the great Buddha images of Mathurā and Sārnāth.

The importance of the Khoh ruins, spread over an area of 5 kilometers, goes beyond individual works that are preserved. Cunningham noted the remains of a large brick temple at Ataria Khera, indicating the use of that material in an area where stone was easily available in the neighboring hills, and explaining the failure of much Gupta architecture to survive. He also pointed out the remains of colossal stone images whose spalled condition suggested destruction by fire. Fragments of limbs twice life-size still abound there, along with one large, elegantly carved image base. A head of Narasiṃha or Hayagrīva and fragments of a conch, club, and discus indicate the Vaiṣṇava character of the foundation.

Nand Chand

The site of Nand Chand, some 50 kilometers to the south of Nāchnā across the Parasmaniya plateau, shows that the style of Nāchnā was not confined to its immediate vicinity.[50] The remains at Nand Chand are largely medieval, spanning at least four centuries. The seemingly isolated shrine dedicated to Śiva as Lord of the Dead (Mṛtangeśvara) is today the site of large *melas* or fairs twice a year. Perhaps even in the sixth century the role of Nand Chand was an episodic one. The only architectural member that goes directly back to our period (for some of the later temple is surely a medieval copy of Gupta work) is an unfinished capital with foliage descending over half the height of the vase, which implies a date soon after the Pārvatī Temple at Nāchnā. A single small doorkeeper (Plate 172) demonstrates the connection between Nand Chand and Nāchnā, for the heavy-ankled figure with slightly outsize hands and large facial features warmly confronting the viewer could be by the same carvers as the Pārvatī door (Plate 154). In that this type becomes less pronounced in the later monuments of Nāchnā itself, one might wonder whether its originators did not migrate to other sites such as Nand Chand.

Two colossal guardians show the fate of this style in an isolated and conservative locality (Plate 173). All the minor peculiarities of proportion at Nāchnā have been exaggerated to grotesque effect. The result is crude, the work either of sculptors whose vision waned in old age or of local workmen who copied the work of the Nāchnā masters. At the same time these gigantic fig-

50. Cunningham describes the site amply, *ASI*, XXI (1884-1885), 160-63. He refers to two broken octagonal pillars with heavy capitals of a rather early date, similar to those at Eran and Udayagiri; I have been unable to identify these. Among the other remains, a set of Mātṛkās may include some sixth-century fragments. The doorkeeper in our Plate 182 has been reproduced as from Bhanpura (indeed near Nand Chand), Mandasor District (incorrect, the district today is Murwāra). Bajpai, "Madhya Pradesh Sculptures," p. 35, fig. 17.

ures have great presence. Tusks emerge from the guardian's mouth, illustrating new currents of supernatural imagery and specifically the role of the horrifying and grotesque in tantric Śaivism. Thus the natural grace of the earlier Gupta style became irrelevant. The date of these remains can only be fixed in relationship to Nāchnā. An acceptable date for the first guardian (Plate 172) is about 510, and the later pair (Plate 173) must have been carved after some time, perhaps between 530 and 550.

Pipariya

The site of Pipariya lies upon the Parasmaniya plateau, roughly 300 meters in elevation, a poor farming area today, which one suspects was inhabited in the sixth century primarily as a refuge from the troubles of the plains. At Pipariya, the foundation of a single temple is known, and I will assume that the various fragments are all from the same structure.[51] The door frame that remains *in situ* (Plate 174) was probably surrounded by the bands of broad, overlapping leaves now removed to Sagar University (Plate 175). Thus while the simple foliage in inset panels would suggest an early date, this may well have been pitted against more developed forms like those found on the columns (Plate 176). The structure of what remains of the doorway is of the late post-and-lintel type, and nothing in the outer border suggests any further projection around the lintel. Thus only a vestige of the T profile remains in the female figures at the ends, which interrupt the relationship between pilasters and the rooflike molding on the lintel. A double *candraśālā* occurs in a form not found elsewhere in central India, with a horseshoe niche open below and a very small repetition above. A row of lion dentils surmounted the door (the central head human, and the two lions to the side facing inward, presaging the angled versions of these leonine rows in the early medieval period.[52] The presence of the double *candraśālā* and the general organization of the door suggest a position similar to the composite door of the Kumrā Maṭh, A.D. 500 to 520, although there is no marked resemblance in style between Nāchnā and Pipariya.

Yet the iconography of the lintel does repeat three themes found at the Uccakalpa center, only twenty kilometers to the west. In the first place, the seven planets are defined in precisely the same way as those of Nāchnā (Plate 164): seated with alternate legs raised, holding what seems to be a purse, and circumscribed by a plain aureole. Rāhu is of course lacking at Pipariya, a feature that makes this frieze unusual.[53] The planets are flanked by two scenes of Kṛṣṇa, the killing of the bull-demon Ariṣṭa on the left and of the horse demon Keśin on the right, both seen earlier at Mandor. In the second place, beyond these are the same two forms of Viṣṇu that flank the south door of the Kumrā Maṭh. Neither corresponds to the Nāchnā image in detail, however. The Varāha supports a more conventionally small Earth Goddess on his arm; and Narasiṃha appears in a standard iconic form with four arms, lacking a demon. An explanation for the iconographic

51. The site as a whole is unpublished; it was surveyed by Professor K. D. Bajpai of Sagar University.

52. Williams, "Dentils," fig. 8. I would reconstruct this doorway

on the analogy of Deogarh (Plate 203).

53. Mitra, "Study of Some *Graha*-Images."

connection between Nāchnā and Pipariya without any concrete formal ties might lie in the movements of some religious teachers between the two. Nothing in the treatment points clearly to which came first, although it seems likely that the grandiose Kumrā Maṭh portal and other remains at Nāchnā would make more of an impression than the small version at Pipariya.

The Pipariya remains include three columns that must originally have been over two meters high. These are closer to the norms of Nāchnā than is the doorway. Thus they rise from bases with lotus flowers on the top, their shafts are relatively continuous, and their capitals are vases without foliage (Plate 176). Here the crowning member bears a *kīrtimukha* or grotesque face, which is unique among all the Gupta versions of this stock motif. Its comical character is played against the subtle modeling of the face and the dispersed foliage, which reads as hair.

The main image was probably a much-worn Viṣṇu now in Sagar (Plate 177). A personified club and discus (one of which presumably flanked this) reveal a subtlety and contrapposto implied by the door figures as well (Plate 178). The Viṣṇu itself is unusual in the position of the locks of hair fanning out horizontally and in the subtle modeling of the drapery, resembling that of some of the Sārnāth Bodhisattvas of the fifth century (Plate 96) as well as the female figures at the ends of the Pipariya lintel. On the whole we see here an attempt to surpass the neighboring temples of Nāchnā by sculptors of real skill, perhaps from Magadha. The

unfinished condition of the Pipariya doorway suggests that their work was cut short before all its possibilities could be realized.

Śankargaḍh

Śankargaḍh, at the mouth of the Khoh valley, continues some of the peculiarities of Pipariya. A Gupta doorway here is built into a later shrine, which has been so often whitewashed and refurbished that little of the original is today visible.[54] At least it is clear that each jamb originally bore a single doorkeeper, like those of Pipariya.

A small niche cut into the natural rock of the Śankargaḍh hill bears a tiny, delicately carved image of Śiva and Pārvatī (Plate 179). This follows the relatively slender body type of the last site, with the same natural articulation of stance we saw in the personified discus (Plate 178). Pārvatī's drapery, its folds defined by double lines, seems to be a later version of the fluid style of the Pipariya lintel. This couple is more refined than any of the Gupta *ekamukhaliṅgas* associated with the site.[55] I would ascribe the relief, and perhaps the Śankargaḍh doorway to about A.D. 520.

Bhumara

The elegant temple of Bhumara lies 11 kilometers north of Pipariya on the same plateau. It seems to be a product of the Pipariya workshop, perhaps contemporary with work at Śankargaḍh. The plinth of a single shrine is known (Plate 180), although it is quite possible

54. *ASIPR, WC* 1919-1920, pp. 104-105, pl. XXVII. A Viṣṇu image from Śankargaḍh, now in Allahabad, generally resembles that from Pipariya (P. Chandra, *Stone Sculpture in the Allahbabad Museum,*

fig. 208).

55. *ASIPR, WC* 1919-1920, pl. XXVIII. V. S. Agrawala, "Survey of Gupta Art," figs. 1-2.

from the copious remains at the site that others await discovery. The plan of the Śiva temple is much clearer today than it was to its initial restorers (Fig. 12).[56] The large plinth upon which the main shrine rests is preceded by the bases of two smaller ones at ground level. These are similar in conception to the four subordinate shrines at Deogarh; apparently early in the sixth century this became one of several acceptable temple plans in the same way that different roof types coexisted. It is possible that these shrines were plain chambers, since their scale is too small for any of the jambs that survive. The upper temple consisted of a windowless cella set upon an open terrace. This was surrounded by a ridged parapet recently restored by the Archaeological Survey. In front, the jagged remains of walls perpendicular to the doorway demonstrate the existence of a maṇḍapa or porch, double-walled in construction like the shrine itself. If the many pieces removed to Allahabad and Calcutta were all part of this foundation, the porch may have had three doors, interior columns, and

perhaps floral friezes along the top. While this suggestion must remain conjectural, the superstructure of the shrine proper can be reconstructed with more security on the basis of the similar temple at Marhiā. Bhumara's long friezes of gaṇas alternating with ornament would seem to have formed bhūmis or upper stories resting on the flat roof. It is possible that candraśālās decorated each side, for these have been found in three sizes, corresponding to the three types of roof frieze.[57] Finally, at least two āmalakas have been found here, which, like that from Nāchnā, are round in profile, completely three-dimensional, with deep angular grooves.[58] It is possible either that four of these surmounted the top level of the roof or that these two formed the central ornament of the small shrines in front.

The iconography of the temple at Bhumara is ecumenical in a way that distinguishes it from the Pārvatī shrine at Nāchnā, whose decor refers to no divinity other than Śiva. The lintel announces the Śaiva character of the Bhumara shrine by its central bust with a

56. *ASIPR, WC* 1919-1920, pp. 107-108; Banerji, *Temple of Śiva.* Banerji is incorrect in showing the small shrines in front with doors on center, and in suggesting that a covered *pradkṣiṇa patha* surrounded the cella. The latter has been doubted by Viennot ("Temples à toit plat," p. 33) and P. Chandra ("Vāmana Temple," p. 144).

57. On the friezes, probably the taller pieces, ca. 33 cm. high, came first (Banerji, *Temple of Śiva*, pl. IX, except b top row center, Xa and b), followed by those ca. 23 cm. high (ibid., pls. IXb top center, Xc, in all of which the gaṇas are separated by plain keyhole niches), crowned by those ca. 20 cm. high (ibid., pl. XIa, b top, and c top, all with long separating panels). Pramod Chandra categorizes these fragments helpfully, although I am unable to follow his separation of types 3 and 4 (*Stone Sculpture in the Allahabad Museum*, pp. 79-87, pls. LVIII and LIX). There are four candraśālās ca. 74 cm. wide (Banerji,

Temple of Śiva, pls. XIIId and XICa-c), five ca. 46 cm. wide with foliate decor in the frame (ibid., pls. XIIa-c and XIIIa), and two ca. 30 cm. wide (ibid., pls. Xb top and XIIIb). That in pl. XIIIc appears to be of the first type, but I have been unable to confirm this with measurements. Since none of the roof friezes indicates a break in the design, it is possible that the candraśālās were attached to the top of the lower level and overlapped the frieze. Banerji categorizes both friezes and candraśālās somewhat differently, but gives no measurements and seems somewhat confused.

58. These are 25 cm. high, which to my mind is rather small for a roof whose top frieze alone was 20 cm. high. Two are illustrated in Banerji's *Temple of Śiva* (pl. IV b), and one of these again in P. Chandra's, *Stone Sculpture in the Allahabad Museum* (pl. LX).

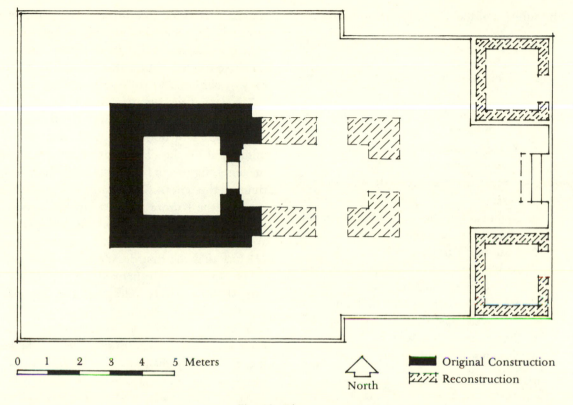

0 1 2 3 4 5 Meters

North

■ Original Construction
▨ Reconstruction

Fig. 12. Bhumara

third eye and flowing locks that bear the lunar crescent. Yet Śiva is represented only twice among the remaining fragments, in his dancing form (*tāṇḍava*) and seated upon his bull in two of the *candraśālā* arches. His con-

sort is the subject of one large *candraśālā*, as are his sons Kumāra and Gaṇeśa; of the latter a separate large image also survives.[59] One would expect two of these divinities to be the object of worship in the small shrines

59. Banerji, *Temple of Śiva*, pls. XIIa, XIIId, XIVb, and XVa.

in front. The subjects of the *candraśālās* are as follows:

Large 1. Kumāra, holding spear, seated on peacock

2. Mahiṣamardinī, four-armed, grasping the buffalo's tail

3. Sūrya, arms raised to hold lotuses, with Daṇḍin and Piṅgala

4. Yama, seated with legs pendant, stick across knees (Plate 184)[60]

Medium 5. Gaṇeśa, four-armed with axe and rosary

6. Brahmā, four-headed and four-armed, seated with ascetic's band, with lotus and curved stick[61]

7. Kubera, corpulent, legs pendant, with three pots, holding a lotus

8. Viṣṇu, two-armed with club and lotus flower, legs pendant, *kirīta mukuṭa*[62]

Small 9. Śiva dancing, six-armed

10. Dancing figure, possibly a *gaṇa*

Of these, Kumāra corresponds to the simple form described in the *Bṛhat Saṃhitā*, but Sūrya (with Daṇḍin and Piṅgala), Yama (with two male attendants, perhaps Kāla and Citragupta), and Gaṇeśa (four-armed, with rosary) are better explained by the more complex descriptions of the *Viṣṇudharmottara*. It is not a ques-

tion of discovering the precise textual source here, but rather of the generally evolved nature of the iconography. It would seem that there is no particular program for these subjects, but rather a broad reference to a variety of divinities as subsumed under Śiva.

The date of the Bhumara temple can be deduced from the relationship of its doorway (Plate 181) to the general sequence of doorways at Nāchnā. The T shape is minimized by the placement of couples at the ends of the lintel, figures only slightly larger in scale than those running the length of the jambs. This lies somewhere between the Kumrā Maṭh composite door and that of Rupni-ka Mandir. The jamb figures and central bust are not enclosed by frames, a feature we have seen at Nāchnā after the first decade of the sixth century. The River Goddesses are flanked by flying attendants and turn slightly inward, although the diagonal thrust is less than that of Rupni-ka Mandir and the umbrellas lack scarves. Finally, the overflowing foliage of some capitals extends the length of the vase and turns upward more decisively than any seen so far. All of these features point to a date around A.D. 520 to 530.

At the same time, it is clear that Bhumara is not a product of the Nāchnā workshops. Close as those two sites are (about 20 kilometers), Bhumara has far greater affinities with Pipariya. Nowhere is this more striking than in figural style. The *liṅga* face (Plate 182) differs

60. Generally identified as Indra, although the absence of his characteristic elephant and crown makes this unlikely.

61. The curved stick is problematic; it is hardly a mace as Banerji suggested (*Temple of Śiva*, p. 12). A ritual instrument, explaining its *yūpa*-like form, is more likely.

62. Banerji suggested that this represented Yama, a view that has been repeated by P. Chandra (*Stone Sculpture in the Allahabad Museum*, p. 76) and Harle (*Gupta Sculpture*, p. 51). Surely the crown and club (not a *daṇḍa*) point to Viṣṇu, for whom a two-armed form, not usually represented as object of worship, is permitted in early texts.

from the Nāchnā or Khoh versions (Plates 161, 171) not only in details of jewelry and headdress but also in the introverted effect of its slightly downcast eyes beneath a horizontal brow. A tiny *liṅga* in worship in the neighboring village Khamharia (Plate 183) shows the Bhumara characteristics in less elaborate form, despite its worn condition. It is also obvious that the Bhumara carving was not the product of the Nāchnā workshops in their most distinctly localized phase around 490-510 (the period of the Pārvatī, Mahādeva door, and Kumrā Maṭh north pillars). The graceful pose and articulation of the Bhumara River Goddesses contrast with the Nāchnā figures. The necks of Bhumara figures are shorter. The Bhumara door guardians (Plate 185) stand in complex poses; the flesh of the stomach is modeled with extreme subtlety, contrasting with the originally crisp areas of ornament in a manner that equals the finest Sārnāth Bodhisattvas. All of these characteristics add up to a graceful, elegant, if slightly characterless effect at Bhumara, as opposed to the earthy and fresh style of Nāchnā.

The architectural decorative elements of Bhumara also point to a workshop tradition different from that at Nāchnā. Obviously the plan of the temple differs radically from that of the Pārvatī. Nor does the early Nāchnā manner of door construction survive here, for two simple lintel slabs are superimposed on the jambs in Plate 181. The moldings of Bhumara lack the dentils of the Pārvatī, and are slightly more complex by vir-

tue of an indentation between the lower "hoof" (*khura*) and the torus (*kumuda*) as well as the asymmetrical curve of this latter. Trellised windows, so common at Nāchnā, do not occur at all here; presumably the shrine interior was therefore darker. *Candraśālās* are not doubled at Bhumara, although multiple projections resemble the form found at Tigowa before (Plate 130). The central arch of the lintel is open below as at Pipariya, a shape here used with particular effect to provide a *liṅga*-like crown above the central bust. Moreover, at Bhumara the *candraśālā* is elaborated in other ways: by the inclusion of group images on the interior, by the insertion of various decorative elements within the frame, and by the development of a crisply articulated finial that bears Śiva's crescent moon.[63]

The Bhumara sculptors seem to have thrown their talents into devising variant forms of vegetative borders. Moreover, they introduced a motif new to this region, a meandering band on the inner register of the doorway. This motif must have been in existence already at Mathurā, Mukundara, and Ajaṇṭā, although not in precisely the same form as here.[64] If Bhumara is derivative in this regard, this doorway nonetheless uses the element to masterful effect: the lintel employs two diagonal lines to frame the central bust, echoing the direction of the flying attendants above and unifying the entire doorway in its clear yet subtle geometrical framework.

On the whole, Bhumara is clearly the work of the

63. This is preserved in only one case (P. Chandra, *Stone Sculpture in the Allahabad Museum*, p. 131), but the similar pendant lotuses sur- viving on others would suggest a similar treatment.

64. Viennot, "Mukundara," pl. 70.

second workshop of northeastern Bundelkhand, whose appearance we have already hypothesized at Pipariya.[65] Although the latter temple is difficult to reconstruct as a whole, Bhumara demonstrates that these carvers, at an only slightly later stage, were extremely accomplished. It would seem that this workshop originated in the eastern Gangetic region very early in the sixth century, sharing some developments with the neighboring workshops of Nāchnā, but for the most part remaining aloof.

Maṛhiā

The newly discovered temple of Maṛhiā lies some 45 kilometers south of Bhumara (Plates 186-188). As Pramod Chandra has convincingly shown, the architectural design helps to clarify the dismantled shrine at Bhumara.[66] Both have plinths, although that at Maṛhiā is lower and supports a simpler, rounded parapet. No porch is indicated by the intact front wall at Maṛhiā. A square, windowless cella rises in the center in both cases. Two tiers above at Maṛhiā represent an intermediate stage between the single raised portion of Sāñcī 17 or Tigowa, and the triple levels of Bhumara, although this is not a chronological relationship. The

corners of the second level project slightly, articulating each face in a variant upon the *triratha* plan seen at Bhitargaon. Unlike Bhumara, Maṛhiā includes no *āmalakas* in its superstructure. Nor are there large *candraśālā* arches here; in their place small panels are inset in the lower roof level, bearing forms of Viṣṇu. On the north, Narasiṃha disembowels Hiraṇyakaśipu; the *avatār* is conceived as demon killer, as on the lintel of the Kumrā Maṭh composite doorway at Nāchnā (Plate 158). At Maṛhiā the demon is wrapped around one of the Man-Lion's legs in the type current later.[67] On the east face of Maṛhiā we see a standing, four-armed Hayagrīva, a form of Viṣṇu recognized as important already in the epic literature (Plate 187).[68] The Vaiṣṇava nature of the shrine is borne out by the image of Viṣṇu on Garuḍa above the door and by the legs of an image of Vāmana which may have stood in the sanctum.

Although simpler, it is clear that this temple did not precede Bhumara. The only vestige of the T-shaped doorway lies in a portion of the lintel that was not originally visible. Double *candraśālās* are repeated on the second level of the superstructure, while only the single form appears at Bhumara. The foliage of the inner band of the doorway is close to that of Bhumara in its slug-

65. It is impossible to be sure of the relationship between Bhumara and the very damaged doorway at Śankargaḍh. Possibly some of the Pipariya sculptors moved on to Bhumara, while one moved down to the other site, carrying the Pipariya door organization (with male guardians alone below) in purer form. All three sites share a narrowing of the jamb at its base (at Bhumara by the termination of the outer molding in Plate 181), which is found only in the Rupni-ka Mandir door at Nāchnā.

66. P. Chandra, "Vāmana Temple." See also Meister, "Note on the Superstructure." Meister takes issue with Chandra largely on the implications of this type in terms of the later evolution of the north Indian *śikhara*, pointing to vestiges of this roof type remaining side by side with the true *śikhara* (a point that I think Chandra would not have denied).

67. The interlocking legs of the two is an explicit feature of later texts.

68. N. P. Joshi, "Hayagrīva."

gishly undulating stem and dispersed tendrils, although these are less complex than at the latter, and far less deep in carving. The impression emerges that Maṛhiā was a product of the next decade after Bhumara, 530-540, and that its patron had less money to spend on the temple.

By contrast with Nand Chand in its relationship to Nāchnā, Maṛhiā does not represent a significantly transformed version of the Bhumara style. The iconography has some of the richness of the great Śiva Temple. There is a certain inventiveness in the way the Garuḍa's wings fan into frothy foliage in the center of the lintel. The guardian on the right is awkward in the placement of his arm on the attendant, but this is clearly not the effectively mannered style of the later Nāchnā workshops. On the whole, Maṛhiā stands at a moment when the earlier Gupta tradition had not seriously been questioned.

Sakhor

The last site in this region, Sakhor, lies at the western periphery, a position that may explain its receptivity to elements from both workshop traditions of eastern Bundelkhand. The plan of the much damaged temple seems again to represent a version of the Bhumara one:

large plinth, small cella (no superstructure remaining), and a porch projecting in front (Plate 189).[69] In this case, enough of the porch remains to show that it had a substantial unbroken wall of the same type as the shrine itself. Decoration survives only on the door to the sanctum (Plate 190). Here some elements are characteristic of the Nāchnā workshops. The outer band consists of a twisted garland very similar to that of the Pārvatī Temple at Nāchnā. This band seems to have risen from a vase placed at the level of the River Goddess's shoulder and resting upon the head of a *gaṇa*, still partially visible on the right. This is clearly not the configuration of the jambs found at Bhumara, where the outer member stops short to focus on the figure group immediately next to the door opening. The lintel bears in its center a Dancing Śiva (*tāṇḍava*) with at least eight arms, a type in vogue later in the sixth century in the western Deccan.[70] A frame surrounds this image, the *lalāṭa bimba* that we have seen to be abandoned after the Mahādeva lintel at Nāchnā. The unframed jamb figures below and the organization with couples at the top corners, however, point to a date closer to the Kumrā Maṭh composite door or to Bhumara.[71] In all these affiliations with the Nāchnā style, it is possible that the lost architectural remains at Nand

69. Sakhor (Sakhar) was visited by the Archaeological Survey in 1912, and photos of it were first published by Odette Viennot in "Temples à toit plat," figs. 28, 30, p. 34. Mme. Viennot's suggestion of a superstructure such as that at the Pārvatī Temple is entirely possible, although no stones at the site form part of such a superstructure. I cannot agree with her statement that the meander motif was of short duration, in view of its continuing use at Bodh Gayā. The Sakhor roof stone bears a later inscription dated v.s. 1361.

70. The image is particularly close to the Cave 14 version at Ellora (Gopinatha Rao, *Elements of Hindu Iconography*, II, pl. LXIII). A four-armed dancing Śiva from Nāchnā is now preserved in the National Museum, New Delhi (V. S. Agrawala, "Survey of Gupta Art," fig. 5).

71. The Kumrā Maṭh door is not precisely the same, in that its lintel ends bear forms of Viṣṇu rather than couples. Another possible source at Sakhor is Deogarh, which combines a framed *lalāṭa bimba*

Chand, only 20 kilometers east of Sakhor, would explain forms that go back to the first decade of the sixth century.

Yet connections between this shrine and Bhumara in particular are overriding. None of the figures on the Sakhor door is well preserved; from what survives it is clear that these are in the confidently three-dimensional and varied positions of the Bhumara school, as opposed to the stiff-legged poses of Nāchnā. The resemblance between the two meander patterns, together with the general configuration of the doorway, suggests a date for Sakhor of about 530, immediately following Bhumara.[72] The brilliant design of the earlier doorway fails at Sakhor. Whereas the Bhumara sculptors had employed modest foliage on the inner interstices of the meander to set off the geometrical band, the Sakhor sculptors repeated the rosettes of the meander proper. This motif is ill-adjusted to the varying inner spaces and competes with the band itself. The diagonal lines toward the center of the lintel here conflict sharply with the frame of the central image and do not relate successfully to the lines of his limbs. In short, we see motifs derived from the two traditions of design in eastern Bundelkhand. These idioms were combined at a point

when both were beginning to wane. The Sakhor sculptors are not inferior in sheer skill of carving, yet they lack the vision of design that had distinguished both schools at their inception. The result is eclectic. Yet this shrine is significant because it indicates that these two traditions were not irrevocably separated.

Kosala: Tala

Southern Kosala, the modern region of Chattisgaḍh, has an episodic history throughout the period of this book. A ruler of the area was said to have been captured and released by Samudragupta.[73] The Vākāṭaka rulers Pṛthivīṣeṇa II (Main Branch) and Narendrasena (Vatsagulma Branch) both claimed ascendancy over Kosala in the second half of the fifth century.[74] No local records support these claims, yet two fragmentary carvings from the Raipur area show some connection with the Vākāṭaka artistic idiom.[75] In the late fifth and sixth centuries, the dominant power in Kosala must have been the Śarabhapurīyas. Their first capital, Śarabhapura, built by the eponymous founder of the dynasty, has not been located.[76] Toward the middle of the century, Sudevarāja shifted the capital to Śrīpura, the modern Sirpur. His younger brother, Pravāra, ex-

and unframed jamb couples, although the latter are recessed behind the outer pilaster band, so that they seem to project less freely. Deogarh (150 km. to the west of Sakhor), seems in general a less likely candidate as a source at this point.

72. The moldings of the shrine also duplicate those of Bhumara and lack the dentils of the Pārvatī base. Yet because the latter is the only shrine complete with moldings at Nāchnā, and because its cella lacks moldings by virtue of the *sāndhāra* plan, this argument is in-

conclusive.

73. Fleet, *CII*, III, 12-13.

74. Mirashi, *CII*, V, 80-81, 107-10.

75. These are a doorway inset into the Ramacandra Temple at Rajim and recarved in places (Stadtner, "Sirpur to Rajim," figs. 22-24) and a pillar from Turturiya (Cunningham, *ASI*, XIII [1874-1876], pl. XVII).

76. Fleet, *CII*, III, 191-200. *EI*, IX (1907-1908), 170-73; XXIII (1935-

tended Śarabhapurīya power but was also replaced at Śrīpura by Tīvara of the Somavaṃśī dynasty, who ruled no later than A.D. 585.[77] The Śarabhapurīyas show no direct connection with the Guptas.[78] Yet another dynasty in Kosala, the Śūra family (known solely from one puzzling copper plate) did employ the Gupta era during this period.[79] The lack of earlier remains is more extreme than in Bundelkhand. Here, in the late Gupta phase, we are both at the outer periphery of Gupta influence and at the threshold of the use of the stone medium.

Thus some difficulty is to be expected in dating the first monuments of Kosala, which like Athena spring full-grown with only half their parentage visible. The major site in question is Tala, roughly halfway between the later centers of Mallar and Rajim, whose importance was first recognized by Donald Stadtner.[80] The

temple known locally as the Jeṭhānī is in ruins, perhaps because it had an unstable stone superstructure, indicated by fragments of large *āmalakas*. It appears to be roughly contemporary with the more complete Devarānī. Here fragments of brick that surround the base today suggest that a brick superstructure rested upon stone walls.

The unique nature of the Devarānī begins with its architectural form. The plan (Fig. 13) includes a porch or *maṇḍapa*, like those of Bhumara and Sakhor, but adds a smaller outer vestibule. The base moldings at the rear (Plate 192) appear to me to be straight-edged above a lower "hoof" (*khura*); they are exceptional among Gupta moldings for their complexity and at the same time for the absence of the round or reverse-curve members that begin to appear in the later fifth century.[81] The exterior walls of the shrine resemble none

1936), 18-22; XXXI (1955-1956), 103-108, 263-66; XXXIV (1961-1962), 28-31. Sircar and Śarmā, "Pipardula." Chhabra, Rao, and Husain, "Ten Years of Indian Epigraphy," p. 49. Śarabha cannot be the maternal grandfather of Goparāja of Eran, called *Śarabharāja dauhittraḥ*. That term is used only when a male heir is lacking, and Śarabha of Kosala had a son.

77. *EI*, XXII (1933-1934), 15-23; XXVI (1941-1942), 227-30; XXXIV (1961-1962), 51-52. Mirashi's early date for Tīvara was modified in the second article.

78. Sircar argued that they had an overlord on the Ganges: *EI*, XXXI (1955-1956), 267-68; but this appears improbable. Śarabhapurīya inscriptions are dated in regnal years of each king.

79. *EI*, IX (1907-1908), 342-45. Sircar, "King Durgarāja," p. 63. Mirashi, "Three Ancient Dynasties." I am unable to resolve the dispute between Sircar and Mirashi about the reading of the date, for the *akṣara* in question does not precisely resemble known versions of either 200 or 100 (that is, the date is either A.D. 601 or 501). In either case, this shows the use of the Gupta era in an area where we

do not know of its use before and have little reason to imagine direct Gupta power. The Śūra family, known from the Arang plate alone, is elusive. It is conceivable that they ruled in the Tala area when the temple was built, although we have more evidence for the Śarabhapurīyas in that locality (cf. the Mallar Plates, *EI*, XXXIV (1961-1962), 28-31.

80. Stadtner, "Sirpur to Rajim," pp. 18-25; "Sixth-Century Temple from Kosala."

81. Stadtner describes these as forming a typically Dravidian base of the type known as *pratibandha*, citing the authority of M. A. Dhaky ("Sirpur to Rajim," p. 23), and comparing them with the Dharmarāja Ratha at Mamallapuram ("Sixth-Century Temple from Kosala," p. 40). The *makara toranas* of the exterior, another seemingly south Indian element, are also found at Ajaṇṭā (Cave 6, lower). I would prefer to think of such forms as indigenous to Kosala in wood, rather than as resulting from influence from the south, where such forms are not known at this point.

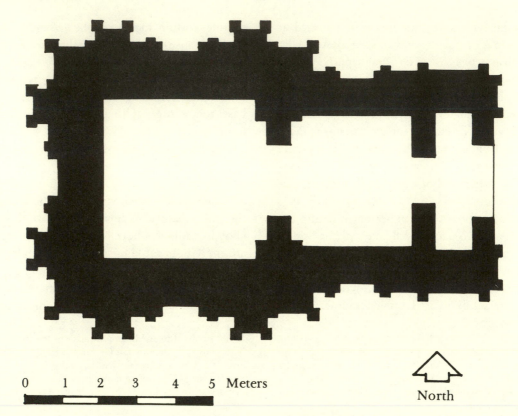

0 1 2 3 4 5 Meters

North

Fig. 13. Tala, Devarānī Temple

considered so far. Shallow niches are formed by pilasters. Unlike the pilasters of Mirpurkhas, Bhitargaon, and Deogarh, these are plain but in places support broad arches that rise from the mouths of large *makaras*. These forms are in a general way akin to slightly later buildings to the south, both Calukya and Pallava. I am inclined to ascribe all to a common origin in wooden buildings, for the Tala walls suggest an open pavilion with arches formed of pliable materials. At any rate, this is not the more lithic architectural vocabulary of Gupta India.

The Devarānī doorway tells a related story. Its

structure is significantly different from any pattern seen so far. The lintels are set into single, large jamb pieces whose outer bands continue straight up (Fig. 18f). These massive jambs appear to consist of a single slab, cut diagonally. This conceivably reproduces a kind of veneer, which might be appropriate to wood. As a stone form, it is unique.

The decor of the doorway is on the whole considerably closer to what we have seen already. A T-shaped profile is implied in the extension of the upper lintel (Plate 193), although the precise configuration of this reduced form is not found in any other case. River Goddesses are placed toward the bottom of the inner faces of the jambs, an aberrant position comparable to those of Bilsaḍh and Bhitargaon.

The details of carving comprise a catalogue of fifth-century Gupta motifs, but executed in extraordinarily high relief. Even the innocuous rosettes in Plate 194 project substantially. Next to these is a band of foliage, simple and early in type but more three-dimensional in its form than comparable examples in the previous chapter (for example, Plate 113). The conventional twisted garland is blown up beyond even the crisp version at Nāchnā (Plate 154) into a convincing and varied image. At the far left in Plate 194 (its top visible in Plate 195) is a remarkable foliate band, semicircular in cross-section and so deeply undercut that this has been more severely damaged than the rest. This plant originates on the lower lintel from two tree trunks growing

above the backs of elephants, and is animated with various birds and animals. The Tala band comes closer than any other example to representing literally the *śrī vṛkṣa* or Tree of Fortune mentioned as an auspicious doorway motif in the *Bṛhat Saṃhitā*.[82]

On the lateral faces of these doorjambs, two *kīrti-mukha* heads confront the visitor just above eye level, projecting 20 centimeters into space (Plate 196). These faces do not simply dissolve into foliage, the usual version of the motif, but are overlaid with leaves even on the eyeballs. It is characteristic that the crown is a double image, combining three additional creatures. These heads show the genius of artists surely not without previous experience, albeit in a different medium.

On this same doorway, the capitals (if it is proper to use that term for the element surmounting a group of floral bands) consist of a convex-lobed *āmalaka* that supports a festooned vase. In Plate 197, a related fragment from the Jeṭhānī Temple shows a similar *āmalaka* resting upon a vase. This position for the *āmalaka* was unprecedented. In this same Jeṭhānī fragment, the vase itself corresponds to a version seen at Uparkot and Udayagiri 19, bedecked with pearls that hang from small lions.

How are we to explain basically orthodox Gupta motifs executed and arranged in quite unorthodox ways? In this case the migration of artists from the north seems unlikely. At the same time, Tala goes beyond a patron's memory of Gupta forms or the generalized re-

82. Varāhamihira, *Bṛhat Saṃhitā*, Adh. LVI, S1. 25. I would not infer from this, however, that the term universally designates such

frothy foliage. Perhaps the Gupta artisans were as confused and inconsistent about its meaning as modern scholars.

production of such forms that one might expect from small, portable objects. It is most probable that the means of transmission was a pattern book, perhaps with some of the scholastic character of later Indian texts on architecture, including many possible motifs and not making their overall organization entirely clear. The three-dimensionality of the carving may indicate the training of the sculptors in a wood-working tradition, as indicated by some of the architectural forms as well. If this hypothetical situation did exist, the receptivity of the Kosala wood-carvers to tenuously transmitted Gupta influence is remarkable.

The figure style of the Devarānī Temple is hard to place as a result of damage, of localism, and of inconsistencies both in style and in skill. For example, the figures of the lower lintel (Plate 195) are as adeptly depicted in complex postures as those in the works of the Gaḍhwa master discussed below. In other areas, the figures are flattened and packed in contorted poses into narrow spaces. The iconography of these scenes is exceptional. On the upper lintel, a seated figure, presumably Lakṣmī, is flanked by two elephants and by an unusual array of attendants with offerings. The lower scene has been identified as Kaṅkālamūrti, Śiva in penance for the sin of killing a Brahman, a subject without precedent and later more characteristic of south India than of the north.[83] On the right doorjamb, Śiva

and Pārvatī sit on rocks with a running figure to one side, perhaps Rāvaṇa shaking Mt. Kailāsa.[84] Even what seems to be a simple Kubera on the opposite side is puzzling (Plate 196). Who are the carefully depicted sages in the background? What flattened objects does he hold? Are the rounded forms to the side bags of riches or small figures in rear view? On the lower surface of the lintel, just visible in Plate 195, a roundel is composed of crouching figures, jeweled and with bizarre headdresses, in what seems to be a kind of dance. Given the identity of Chattisgaḍh as a strongly tribal area today, it is tempting to credit some of the anomalies here to currents of belief outside the familiar Brahmanical world of Sanskrit texts.

To establish a precise date for temples of Tala is impossible, for nothing in the area is preserved to which they can be significantly related. The Gupta motifs upon which they draw span the second phase of Gupta art. The complexity of foliage and the stiffness of some figures would suggest a date well into the sixth century, yet these may be local characteristics rather than matters of chronological development. The position of about 480 to 530 is a reasoned guess.

Eastern Mālwa, Regional History

The area along the Betwa River does not have a coherent geographical identity.[85] It formed part of Mālwa at

83. Stadtner, "Sirpur to Rajim," p. 21; "Sixth-Century Temple from Kosala," pp. 44-46. Cf. Adiceam, "Images de Śiva, III-IV."

84. This subject had been represented in Mathurā: N. P. Joshi, *Mathura Sculptures*, pl. 83. The crouching figures on the lower face of the lintel invite comparison with the ṛṣis of Mukhalingam (Bar-

rett and Dikshit, *Mukhalingam*, pls. 4, 5).

85. Cunningham, in discussing the Candella inscription of A.D. 1097 on the Rajghati rock carvings by the Betwa River at Deogarh, suggests that the area may have been recovered from the Kalacuris of Cedi (*ASI.* X [1874-1877], 102-103).

times, whereas by the eleventh century it was ruled by the Candella dynasty to the east. Eran and Deogarh lie only 50 kilometers apart. Clearly the former was controlled by the Hūṇa Toramāṇa not long after the year 485, for the inscription on the great Varāha image is dated in the first year of his reign (Plates 198-200).[86] Yet this new overlord does not seem to have wrought any great change in political organization, religion, or artistic style. The year 510, the date of the Eran inscription of Goparāja, may mark either the termination or the establishment of Hūṇa power here.[87] While the former seems slightly more probable, it is prudent not to build upon this point. In 510 the ephemeral late Gupta ruler Bhānugupta was recognized as suzerain, and the area had been ruled by the deceased Goparāja, apparently of a lineage other than that of Mātṛviṣṇu and Dhanyaviṣṇu, the regional potentates twenty-five years before. It seems likely that the area was much fought-over by the Hūṇas and various local kings, none of whom left inscriptions until the later sixth-century record of Naharghati at Deogarh. In fact, the latter does not mention a ruler at all, but rather bestows its praise upon Svāmibhaṭa, a religious teacher.[88] At Deogarh one of the finest monuments of Gupta art was produced amid this apparent political confusion; details of its form,

if not its overall quality, may reflect such circumstances.

Eran

The great theriomorphic Varāha at Eran, whether executed close to 490 (as I think) or in 510, must have been a tremendously impressive work in its time (Plates 198-200).[89] In many ways the image builds upon precedents in the area. The position of the Earth Goddess hooked over a tusk is that of Udayagiri and the previous semi-anthropomorphic Varāha at Eran (Plates 37, 126), rather than the version of the Kumrā Maṭh at Nāchnā (Plate 158). Yet it is as if the patrons, lacking the opportunity for a rock-cut image but able to command a colossal block of stone, were determined to surpass the great relief of Udayagiri. The mighty beast is more than twice the height of a man, almost as large as the colossal Viṣṇu of Eran, and in its visionary form more profoundly stirring.

This appears to be the earliest representation of Varāha entirely as a boar, an iconographic type known elsewhere but favored in central India in the medieval periods. The type is referred to as an alternative to the Man-Boar in the *Viṣṇudharmottara Purāṇa*, although that text prescribes that the image be covered with de-

86. Fleet *CII*, III, 158-61. The Eran Boar inscription clearly follows that of the Garuḍa pillar in A.D. 485, for the co-donor of the latter, Mātṛviṣṇu, is identified as dead, although it is still within the lifetime of his younger brother, Dhanyaviṣṇu. Eran is described as his *viṣaya* or district, a term used in the late Gupta inscriptions of Bengal. Obviously the Hūṇas' proclivity for Śaivism did not prevent the dedication of a Vaiṣṇava monument.

87. Fleet, *CII*, III, 91-93. I would associate the crude carvings of a

couple and of horsemen on this post with the earlier Nāga inscription (Mirashi, *CII*, IV, pp. 605-11).

88. *EI*, XVIII (1925-1926), 125-27.

89. Cunningham (*ASI*, VII [1871-1874], 88-90) gives a somewhat inaccurate description of this image, corrected in X (1874-1877), 82-85. In the latter Cunningham speaks of remains of an enclosing shrine, but the column that he reproduces (pl. XXVII) appears to be early medieval.

mons.[90] As at Udayagiri, the incantational description of the *Matsya Purāṇa* in which the boar's body is identified with the parts of the sacrifice seems most relevant.[91] Yet neither these sacrificial metaphors nor the hosts of celestials seen at Udayagiri can be specifically identified here. It is impossible to differentiate the rows of sages (all bearded, with matted locks, holding holy-water jars) that cover most of the image. Only on the front does Sūrya stand out, for he wears a tunic and holds aloft lotuses (Plate 199, immediately to the right of the Earth's thigh). The succeeding six figures to the right of him (all of whom lack beards, wear low head-dresses, and stand in a single row with no intervening heads) presumably constitute the *saptagrahas* or seven planets, also present at Pipariya. The larger figure above these, superimposed on the sages, seems to represent Viṣṇu (with weapons below). The garland of twenty-eight completed figures, alternating male and female on the whole, one differentiated as a scorpion, remains unexplained.[92] At the top is a cube, on three faces of which are carved corpulent figures. This possibly represents the sacrificial post (which the *Matsya Purāṇa* equates with the Boar's head) or possibly the god Brahmā (who appears in this position as Udayagiri). A small female figure above the tongue may aptly represent the personification of speech, Vāc. Below are two *nāgas* (Plate 200), not rising independently as in other Varāhas (although possibly one has been broken off in front), but with coils intertwined in the manner of later doorways and undatable village shrines.[93] I suspect that this concept existed already in folk art and that the sculptors drew also upon village imagery. Corresponding to texts less literally than did the Udayagiri relief, the colossus at Eran shows a richness of imagination and forms a worthy successor to that evocative relief. The creative spirit that had impelled earlier Gupta art to develop and vary its forms within general aesthetic guidelines had not immediately disappeared here, despite the change in government.

Deogarh

Deogarh, rich in remains of the late Gupta and early medieval periods, is one of the rare cases in which we find some continuity at a single place from the sixth through the eleventh centuries. Its site, like that of Eran, must have been particularly important in an age of river transport, for the impressive Betwa flows past the caves of Deogarh, less than a kilometer from the Gupta Temple. This shrine, the first monument of the site, is a subject rife with controversy over both its reconstruction and its date.

The central structure rested on a large plinth, appar-

90. *Viṣṇudharmottara Purāṇa*, p. 212 (ch. 99, line 10).

91. *Matsya Purāṇa*, pp. 282-83.

92. I had suggested in an article on the lion capital from Udayagiri that the male figures and scorpion might represent the signs of the zodiac (Williams, "Recut Aśokan Capital," p. 238). I was, however, mistaken in the total number of completed roundels: twenty-eight rather than twenty-five. In some places, nonetheless, two female figures occur side by side, so that, if we allow for some that are indistinct, it is possible that the male figures together with the scorpion number twelve.

93. Zimmer, *Art of Indian Asia*, text pl. B2a.

ently with small shrines at each corner, corresponding to the *pañcāyatana* type of later texts (Fig. 14).[94] The cella, which faces west, is square and windowless, its walls articulated into three planes (*triratha*), which are also visible in the superstructure. This spire itself consisted of a series of stories bearing various forms of ornament, one of the best-preserved portions of which is visible on the east (Plate 202). From this section it is clear that the corners were rectilinear and successively stepped back, unlike the curve of the later *nagara śikhara*. Here we also see the remains of a beam that projects roughly a meter, broken at the end and supporting traces of a flat stone layer on top. From the edges that remain on all sides of the temple, I would reconstruct an awning.[95] It has been suggested by early writers that this member projected considerably farther than the present beam, and was supported by square pillars that were found at the site.[96] This is possible, in view of the stylistic correspondence between these pillars and the

latest parts of the sanctum. Yet columns were not necessary for support. Nor do those that survive correspond in height (ca. 3 m.) to the elevation of the awning (ca. 4 m.). The difficulties in reconstructing this section stem obviously from the lack elsewhere of any comparable wide awning perpendicular to the wall. While Bhitargaon and the Lakṣmaṇa Temple at Sirpur provide the closest analogies for some aspects here, both of these brick shrines have more complexly three-dimensional surfaces than the essentially lithic planes of Deogarh.

Discussion of the date of the temple has centered on an inscription engraved sideways on a pillar similar to that in Plate 209.[97] This record, however, can only be dated palaeographically, is carved on a member whose association with the temple is disputed, and may well be the work of a later visitor. In the past two decades of scholarship, the temple has been ascribed to dates ranging from the late fifth century through the early

94. The *pañcāyatana* plan was not recognized in the first two reports on Deogarh: Cunningham, *ASI*, X (1874-1877), 100-11; Mukherji, *Report on Lalitpur*, pp. 11-12. The smaller shrines were first recognized by D. R. Shani: *ASIPR, NC*, 1917-1918, p. 7. This was further clarified by M. S. Vats in his *Deogarh*.

95. My reconstruction differs from that by Vats (pl. 5) chiefly in suggesting the presence of the awning only above the central portion of the wall or *bhadra*. This is suggested by the finished portion of that block as on the north face. I am less certain than previous authors that the large semicircular indentations above the awning corresponded to ribs; these are very shallow for any cantilevering effect, and their size would suggest a rib that would add substantially to the awning's weight.

96. Cunningham suggested four pillars on a side; he recognized the problem of the height of the surviving ones and suggested additional

capitals and brackets to make up the difference. P. C. Mukherji, in his more fanciful reconstructions, added another pillar at each corner for a total of twenty; he supplied the missing height with both brackets and a lower verandah that looks very Candella (*Report on Lalitpur*, pls. 4-6). Percy Brown followed Cunningham but added a heavy cornice for height (*Indian Architecture* I, pl. XLI, p. 6). Only five three-meter pillars were found. There are also several round columns in the godown, as well as enough other fragments to suggest the existence of a second sixth-century shrine.

97. Vats, *Deogarh*, p. 29. I would accept the reading by B. Ch. Chhabra, "This is the name of the illustrious Bhāgavata Govinda, votary of the Lord of Keśāvapura," indicating a later graffito rather than a gift. Vats cites Chhabra's palaeographical dating as last quarter of the fifth or first quarter of the sixth century.

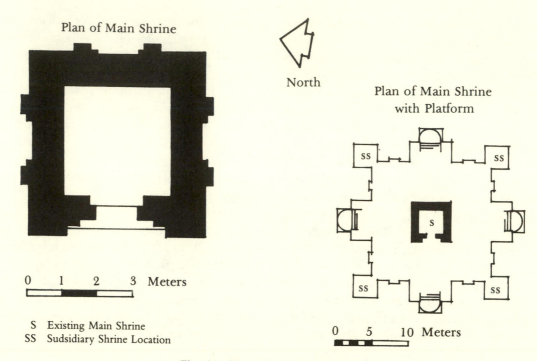

Plan of Main Shrine

North

Plan of Main Shrine
with Platform

0 1 2 3 Meters

S Existing Main Shrine
SS Sudsidiary Shrine Location

0 5 10 Meters

Fig. 14. Deogarh, Gupta Temple

seventh.[98] The proposal presented here is prompted by the unusually large number of unfinished portions in the sculpture of the temple. These suggest that there were two campaigns in the carving, with a hiatus perhaps occasioned by fighting during the Hūṇa presence in the area. In brief, the first phase at about 500 in-

cluded the jambs of the doorway and the commencement of the sides of the shrine. The second phase stretched over a longer period of time, roughly 520 to 550, perhaps for lack of major patronage. During this time the lintel, the rest of the walls, the plinth, and many of the *candraśālās* and pillars found near the

98. Pramod Chandra seems to suggest a late fifth-century date ("Vāmana Temple," p. 145). James Harle (*Gupta Sculpture*, p. 51) and Michael Meister ("Essay," p. 42) suggest first quarter of the sixth century, a date close to that of Vats. Odette Viennot implies a date

early in the second quarter of the sixth century ("Temples à toit plat," p. 52). Sheila Weiner argues strongly for a date of 600 or later ("Gupta to Pāla," p. 170).

temple were finished. Some of the separate pieces probably belong to adjoining temples that followed the original Gupta one. It may seem unlikely that the work on the doorway proceeded upward, for in carving as in painting a room, working downward makes sense. In fact, however, among the many unfinished temples in India there is no universal rule about the direction that work took. At Bhumara we see an unfinished section in the *candraśālā* above the central bust on the lintel. Likewise the Mohinī at Bhubanesvar has unfinished portions in the superstructure, while many of the wall motifs are complete. Thus it is possible that the Deogarh carvers proceeded in this way, as I think a detailed examination of the parts will show.

The door of the Deogarh Temple is constructed with separate blocks at the end of the lintel in the general manner of fifth-century portals (Fig. 18g). It is likewise designed with a clear T profile, enframed *lalāṭa bimba* in the center of the lintel, and with River Goddesses above, features that become rare in the sixth century.[99] The latest element is the lack of a frame around the couples on the jambs. This was noted on the Kumrā Maṭh doorway of Nāchnā, dated above to the years 500-520. Thus it is likely that the Deogarh door was put together and roughed out around A.D. 500.

Discontinuities between the jambs and the lintel indicate that at least some bands of carving were completed below at this point. Most striking is the treatment of the outer band of overlapping broad leaves: on the left jamb the interstices between leaves form rosettes with raised center, an ingenious double image found rarely elsewhere. The same band, however, once it reaches the River Goddesses, assumes a more conventional form with simple circular recesses between the leaves. Another unusual break occurs on the pilasters just at the top of the jamb blocks of stone; here the octagonal portion is followed by a sixteen-sided one with unusual abruptness. The *pūrṇa ghaṭas* from which the outer band rises are distinctly less advanced than the one example that survives above the pilaster on the proper left, where foliage extends the full height of the vase. Likewise, the *candraśālās* on the lintel are more advanced than those in the relatively complex architectural models on the jambs (Plate 204).[100] While these last two discrepancies occur elsewhere, there is an exceptional lack of consistency in the carving of this door. The disjunction may be the result either of uncoordinated work at one time or of an interruption followed by the importation of new craftsmen not entirely versed in local idioms. If we hypothesize the latter, we must admit that a real effort was made to "complete" the original.[101] Nor are all bands divisible into two phases. I should think that the figural carving was close to completion in the first campaign, to judge from the

99. Viennot, *Divinités*, pp. 37-64.

100. The pilasters that are inset above could easily have been included below. These two model buildings are not identical on the jambs, for the proper left adds small *candraśālās* flanking the central one on the upper level. The pearls are inconsistently carved on the

101. One unfinished portion seems to remain behind the *candraśālās* immediately above the dancing *gaṇa* on the proper left. The head of the Gaṅgā and the underside of her umbrella are also more roughly carved than those of the Yamunā.

four sides of these models.

three-dimensional stances of the figures. The entire inner foliate band, although slightly more diffused in structure and appearance than that of the Nāchnā Pārvatī, might well represent an advanced design of about A.D. 500. Thus the doorway owes most of its character to the first campaign, with some parts of the lintel executed around A.D. 520.

Turning to the sides of the temple, we find the inner scenes fully realized, whereas the foliage surrounding them is incomplete in different respects in each case, and the outer pilasters show a major lack of coordination. In Plate 206, the foliate inner frame has been but roughly cut on the left, presumably in the first phase. Where this foliage is finished, on the right, it differs from that of the doorway in its obtrusive lines, playing flattened areas with notched edges against pits of shadow. The outer pilasters do not match each other, and the carving continues around the corner on the left but not on the right. They clearly lack the careful planning of the inner image. The *pūrṇa ghaṭas* of these pilasters are similar to those at the top of the doorway, in that their foliage extends the height of the vase and curls up even more markedly, in this case in two sections. Finally, in the center of one of the top bands in Plate 206, a small figure grasps the ends of two pieces of the foliage; its leaves are, however, interrupted, and the body of the figure projects down into a recessed band of simpler striations. An unbroken band encloses comparable

figures on the other two sides (cf. Plate 205), and it is clear that the carver on the east face changed the original design, an alteration not likely to take place in a single, continuous process of decoration. Yet it is significant that the later impulse to decorate and articulate the wall is still balanced by the plain wall surfaces to the sides (*pratiratha* in later terminology), so that the great reliefs stand out and invite individual attention.

The iconography of these exquisitely composed reliefs is somewhat problematic and suggests a local mythological tradition not precisely identifiable. The most standard of the three is the famous scene of Viṣṇu reclining on his serpent Ananta (Anantaśayana), with his personified weapons below fighting the demons Madhu and Kaiṭabha. The combination has been seen already at Udayagiri (Plate 39), and, like that, the Deogarh version comes close to the *Devī Māhātmya* textual version.[102] The northern face shows Viṣṇu descending on Garuḍa to rescue the King of the Elephants (Gajendramokṣa) (Plate 205). This subject is exceedingly rare in sculpture, one possible version having been pointed out already at Mathurā (Plate 24). In both, the *graha* or "grasper" that threatens the Elephant King is interpreted as a *nāga*.[103] The third relief, on the east, represents Nara and Nārāyaṇa, the double incarnation of Viṣṇu in the form of two sages (Plate 206). Although this subject was not common later, we have at least one other version of this period from Nagarī (Plate 216).

102. The gods above at Deogarh are not explained by the *Devī Māhātmya*; nor does the Goddess seem to play any role in conquering the demons, for Śrī is shown docilely rubbing Viṣṇu's feet.

103. The term *graha* occurs, for example, in the *Vāmana Purāṇa*

(469, ch. 58, line 19; cf. Appendix 1, p. 9 of Kashiraj edition for other examples). The term is often translated crocodile, and indeed is later shown as one, or as a tortoise.

The Deogarh relief shows a central female figure flying upward, which has been identified as the nymph Urvaśī, born from Nārāyaṇa's thigh (*ūru*) in order to shame the other nymphs who were tempting him.[104] An early textual version of this story that explains the details of the relief remains to be found. The smaller scenes inset in the pilasters, such as the Gajalakṣmī in Plate 206, are more conventional. The central panel of the lintel, again perhaps at least laid out in the first phase, shows an unusual combination of Viṣṇu seated on the serpent Ananta, attended by his own Man-Lion and Dwarf *avatārs*. In the present state of our knowledge, we cannot be positive of the image on the interior shrine or of the overall program of the temple.[105]

The plinth of the temple originally bore a series of reliefs, treating Vaiṣṇava themes at greater narrative length. There was certainly an extensive Kṛṣṇa cycle, of which at least ten scenes survive.[106] Many of these scenes are events not represented elsewhere; for example, the panel in Plate 207 is unique if it shows both Balarāma and Kṛṣṇa as babies. Likewise, the *Rāmāyaṇa* was illustrated at length at Deogarh with at least eight panels. These bear comparison with a series of larger reliefs from the central Vākāṭaka site Pavnar, southwest of Nagpur, which have been identified as scenes from the *Rāmāyaṇa*, although this is questionable.[107] The Pavnar figures are more slender, and the dramatic content of those scenes appears to be elaborated. Yet both of these sets differ from the smaller, more folkish panels of Nāchnā (Plates 165-170). It is characteristic that the monkeys at Nāchnā are more purely simian than the crowned, regal versions at Deogarh.

In style these scenes from the Deogarh plinth span the various phases of the temple's carving. The scene of the Yadava babies with their foster parents in Plate 207 resembles the groups at the base of the jambs or the great scenes from the sides of the main temple in the refined carving of detail and the balancing of the two figures. Here Yaśodā recedes, supported by cows

104. The previous identification of this scene as the Dakṣiṇāmūrti form of Śiva was first corrected by D. R. Sahni, *ASIPR, NC*, 1917-1918, p. 8; this was elaborated by Shastri, "Identification." T. N. Ramachandran specified the *Devī Bhāgavata Purāṇa* as a source on the basis of the Urvaśī figure: "Fresh Light." This was questioned, however, by R. C. Hazra, "Devī-Bhāgavata." While much of Hazra's criticism has the air of expecting an unnaturally literal correspondence between relief and text, I admit that it is unlikely that the *Devī Bhāgavata* per se goes back to this period, in light of other features in the Purāṇa.

105. An interesting suggestion has been made by Susan Huntington that the temple at Deogarh was circumambulated counterclockwise; one of her strongest arguments is the placement of Gaṇeśa, usually worshiped first in Ċola Temples, to the proper right of the south face, where it is approached last in the normal clockwise path.

106. Of these identified by Vats (*Deogarh*, pp. 18-20), only the overturning of the cart corresponds to another Gupta carving, that at Mandor. The fragments that Vats identifies as later Gupta (ibid., pp. 25-27) include at least three additional Kṛṣṇa scenes. J. Hawley questions whether our pl. 207 may not represent Vasudeva (rather than Nanda) exchanging babies with Yaśodā, a subject common in past-Gupta cycles.

107. Mirashi, *CII*, V, lx-lxii. This has been questioned by Dr. A. Jamkhedkar, Director of State Archaeology in Maharashtra, who for example suggests that Mirashi's plate C represents the killing of Dhenuka rather than the fight between Vālī and Sugrīva. I am grateful to Dr. Devangana Desai for informing me about this.

in the background, whereas the male figure advances, his feet projecting subtly over the edge of the niche. Other reliefs from this same row are less adept. The smaller band that decorated the plinth at an upper level belongs to the latest phase, for the figures are mannered and unstable. For example, the woman on the right in Plate 208, seemingly a reproduction of the attendant to the left door guardian (Plate 203), teeters on a foot placed too far to the left, with the lower leg inadequately fore-shortened. The pilasters of the base are later versions of those on the walls of the main shrine. Even the complex example in Plate 207 shows a misunderstanding of the lower *pūrṇa ghaṭa*, for the lotus flowers are separated from the corner foliage by an unexplained band. Thus the plinth suggest a rather long duration for the second campaign of work on this temple, about 520 to 550.

A number of miscellaneous fragments at the site point to the existence of at least one additional temple contemporary with the second phase of work. The large pillars, rejected above as a necessary part of the main shrine, are certainly similar to the wall pilasters in their carving. Two panels from the base of jambs show River Goddesses with slightly larger male guardians, indicating the rapid abandonment of the by then old-fashioned composition of the earlier door.[108] Possibly some friezes of *gaṇas* separated by keyhole niches represent the tiered superstructure of this same shrine, on the analogy of Bhumara and Marhiā. One *āmalaka* with convex lobes still at the site should belong to this period, although there is no clear place for it on the sur-

viving superstructure, and it appears to be very small for the top. While the only *candraśālā* arches surviving on the temple are devoid of figures, a number on the ground bear various divinities. These latter, moreover, show diagonal projections at the lower corners, unlike any *in situ*. Thus alternative architectural forms seem to have coexisted here in the first half of the sixth century.

Concomitant processes make the remains of Deogarh hard to disentangle. On the one hand, there is the interruption and discontinuity of patronage hypothesized above. On the other hand, an unusual fidelity persists in the copying of earlier forms as late as the medieval period, to be considered in the epilogue. Some images cut into the cliffs of the River Betwa illustrate this process already in the middle of the sixth century. One inscription here, in the area known as Naraghāṭī, has been ascribed palaeographically to the end of that century.[109] This records the dedication of a set of *mātṛkās* that is preserved; these can in turn be related to an earlier set at the adjoining Rājghāṭī area (Plate 210). Hence a date of about 550 for the Rājghāṭī relief. Here the mothers hold their children and lack vehicles, early characteristics. Only Cāmuṇḍa is distinguished by her emaciated ribs and by a corpse below, attributes employed already at Badoh Pathari nearby.[110] The simple, rounded body-type of the Rājghāṭī set does not constitute a major departure from the figural style of the Gupta temple. The adjoining niches perpetuate several motifs from that model: rosettes connected by oval leaves, and doubled *candraśālā* arches. Despite its disjointed and unfinished character, the great Vaiṣṇava

108. Viennot, *Divinités*, pl. 17a.

109. *EI*, XVIII (1925-1926), 125-27. Viennot, "Mahiṣāsuramar-

dinī from Siddhi-ki-Guphā."

110. Harle, *Gupta Sculpture*, pl. 29.

temple provided a rich source of designs employed in these modest excavations.

Western Mālwa, Regional History

To use the ancient term Mālwa to designate not only the area of Mandasor but also adjacent parts of Rajasthan may seem misleading, for Mālwa is usually identified roughly with the modern state of Madhya Bharat.[111] In fact, however, inscriptions suggest that the control of Mandasor extended to the north, and the artistic remains of that center form a continuum with those of both the Chitor and the Kota regions in Rajasthan. Until A.D. 467, the Mandasor area was ruled by a dynasty who called themselves *aulikaras*, and who at times recognized the Guptas as their overlords.[112] From 473 we have an eloquent description of a Sun Temple built thirty-six years previously by a group of silk weavers who had come from Gujarat.[113] This indicates substantial fifth-century architecture in the area, quite possibly of wood, as well as the movement of a collective patron across a considerable distance. This temple had, however, been destroyed and required refurbishing in the 470s. At that same time, the late Vākāṭaka ruler Pṛthivīṣeṇa claimed to be honored by the lords of Mālwa.[114] While this may represent a false boast, it comes at a plausible moment. Moreover, minor contact with the Vākāṭakas in the 470s is indicated by the first

sculpture of the area. There is a gap in our knowledge of the actual rule of Mālwa until 491, when we hear of a king named Gauri, and again until 533, when Yaśodharman appears, perhaps his descendant.[115] Yaśodharman is the paradigmatic successor to the Guptas. His vainglorious inscriptions announce that he defeated the mighty Hūṇa Mihiragula, that he ruled from the Himalayas to the "western ocean," and that he surpassed the prowess of the Guptas. One may doubt the last two claims and yet be struck by his emulation of that imperial dynasty both in the substance and in the style of his claims. At the same time, his inscription refers to the dignity of his own lineage with the *aulikara* crest, demonstrating the rising independence of a family of local rulers who had in the fifth century functioned under the Guptas. Thus it is not surprising that stone sculptural remains should begin to appear from the period of this growing independence, both drawing upon the Gupta imperial styles and increasingly localized in minor ways.

Mukuṅdara

Mukuṅdara (also known commonly as Darra) lies on an uninhabited but strategic pass leading from the planes of Mālwa through the Dwāra Hills to the north. The availability of stone from these surrounding hills may explain the use of that material here for the first

111. For example in Jain, *Malwa through the Ages*. S. R. Goyal has, however, argued that early references to Mālwa refer to the Tonk-Mewar regions: "Did the Vākāṭakas Invade Rajasthan?"

112. For a summary of these inscriptions and complete references, see Williams, "Sculpture of Mandasor." References to Gupta overlords occur in the Mandasor inscription of M.E. 524 and that of 530 (going back to Kumāragupta's reign).

113. Fleet, *CII*, III, 79-88; Sircar, *Select Inscriptions*, pp. 299-307.

114. V. V. Mirashi, *CII*, V, 79-81.

115. Fleet, *CII*, III, 142-58. Viṣṇuvardhana is not a separate person, as Fleet thought, but another name of Yaśodharman himself, suggesting his descent from Gauri, whose ancestors had also used the suffix -varman.

time in this region. The temple at this site, dated below to about 480, might belong in the previous chapter, were it not for its direct connections with the later monuments of western Mālwa.

The plan of the Mukuṅdara temple can be reconstructed on the basis of suggestions by Odette Viennot and Michael Meister, although my version is not identical with that of either of these authors.[116] As Figure 15 indicates, there was a series of eight bays, each roofed with flat slabs of stone, surrounding the slightly higher sanctum. An old photograph of four columns attests to the existence of a porch or *maṇḍapa*, although nothing remains today; fragments of doorjambs and a Gaṅgā figure must have belonged to the front door. The general configuration is similar to that of Bhumara; interior columns have been seen at Udayagiri Cave 19. The walls of the temple probably consisted of brick, inset with stone pilasters on the interior.[117] The temple itself rested upon a large plinth with lateral stairs leading up on either side of the front. The superstructure must remain conjectural, although it seems likely that mold-

ings with lion dentils formed a cornice. Seven *āmalakas* remain at the site, of two slightly different types, perhaps placed originally at the corners of sanctum and porch.[118] Bands of foliage alternating with checkered panels may have edged the roof in the manner of Marhiā, and two *candraśālās* may also have decorated that area (Plate 214). The use of a bay structure appropriate to wooden architecture or to caves, but here ill-adapted to so ambitious a project in stone and brick, may account for the ruined condition of the shrine.

In dating the temple at Mukuṅdara, two elements are critical. In the first place, the moldings of the exterior, both of the temple proper and of the plinth, show a simple "hoof" curve (*khura*), a type found at Tigowa and Marhiā, but elaborated in all the later north Indian temples of which I know; on the basis of these, a date well into the sixth century becomes unlikely. The central pillars do show a *kumuda* or rounded molding at their base, seen already at Udayagiri Cave 19; but at Mukuṅdara this comprises a separate socle of stone into which the shaft is set.[119] Such a technique might stem

116. Viennot, "Mukuṅdara"; Meister, "Darrā."

117. The proximity of the columns to the shrine, indicated by Fergusson, *Picturesque Illustrations*, pl. 5, suggests an attached *maṇḍapa* rather than a separate Nandi pavilion. The brick structure is suggested as a possibility by Meister in passing. I find this most plausible in light of the fragments of bricks at the spot and the total absence of stone interstices, whereas the majority of the columns and pilasters survive. Mme. Viennot suggests a *pradakṣiṇa patha* between the outer molding and the engaged pilasters (C and D in her fig. 1). This seems improbable to me in light of the narrow passageway (50 cm.) and the fact that this implies extremely thin walls for the Gupta period (ca. 20 cm.).

118. Three *āmalakas* have a socket 54 cm. in diameter and have

pointed edges between their convex facets, and three are 45 cm. in diameter across the socket and have a flattened edge between the facets. In general a variation of 9 cm. might be expected in the measurement of such an architectural member, but it does appear that the *āmalakas* fall into two distinct groups.

119. The Udayagiri bases are better preserved on faces other than that in Plate 118. Viennot compares these moldings only to Deogarh ("Mukuṅdara," p. 122) and does not consider the prevalence of plain *kumbha* moldings. Meister ("Darrā") describes the insetting of pillars into square ring stones as an early technique of stone construction. He also points to other more elaborate moldings as part of the cornice.

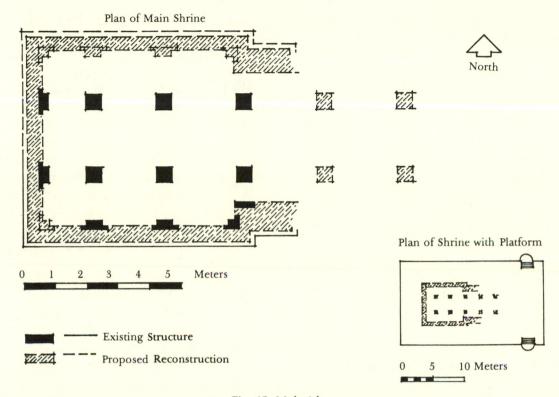

Plan of Main Shrine

North

0 1 2 3 4 5 Meters

Existing Structure

Proposed Reconstruction

Plan of Shrine with Platform

0 5 10 Meters

Fig. 15. Mukundara

from wood construction, suggesting the background of the craftsmen. In the second place, the architraves between the pillars and pilasters of the shrine show a twisted band curved at each side, as if to suggest a flying piece of cloth attached to the end of a garland. The hooked configuration is related to that seen most recently at Bhumara and Sakhor, as Mme. Viennot points out.[120] It is, however, different from these as well as

120. Viennot, "Mukundara," p. 126. The Mathurā version in Viennot's pl. 70d need not belong to the second half of the sixth century, as she suggests. It includes simple lotus foliage, a broad and unarticulated *candraśālā*, and dentils stepped three-dimensionally, all clearly placed in our second general phase (Chapter III), particularly in the avant-garde workshops of Mathurā. Viennot admits the origin of the "unfinished medallion" motif at Junnar and Kanheri (pp. 122-24).

from western Deccan examples, and comes closest to a Mathurā example that cannot be later than the third quarter of the fifth century. Moreover, the Mukuṅdara form is taken one stage further at Chār Chomā, to which I ascribe a date of ca. 490-500, implying a position before that for Mukuṅdara.[121]

Other elements in the carving of Mukuṅdara support a date of about 480 for the temple. The lotus ceilings that survive are more elaborate than those of either the early Udayagiri Caves or of Tigowa. The foliage extending across the architraves and the bracket capitals is rather broad in leaf and simple in organization (Plate 212), although some detached fragments are typologically later (Plate 213). None shows the notched edges that become common in the sixth century. The *candraśālā* filled with foliage (Plate 214), on the other hand, appears in later examples from Bhumara and Mathurā (Plate 229), although the simple form of the arch itself at Mukuṅdara should probably precede these. A fragmentary Gaṅgā from the base of a doorjamb now in the Rajputana Museum, Ajmer, need not indicate a date later than Udayagiri Cave 19, where similar figures appear in this position. Finally, the carving of pillar and pilaster shafts is of little chronological significance. Simple semicircles (with an additional ribbonlike strand on the central pillars in Plate 212) have been called the "unfinished medallion motif," although it is clear that the effect is completed and deliberate here. While the motif becomes common in examples of the sixth and

seventh century, it also goes back to the second or third century in the western Deccan, and has been noted already at Uparkot. On the whole, a position immediately following Tigowa is reasonable.

The temple at Mukuṅdara shows an unusual freshness and simplicity of design, whatever its position within the history of Gupta art. This character can in part be explained by the presumption that its sculptors were working for the first time in stone, although the impact of another medium is less visible here than at Tala. Rock-cut models, and in particular the caves of the western Deccan, may explain the "unfinished medallion" and the foliage on bracket capitals.[122] Whatever its source, Mukuṅdara initiated a flavor that was to continue in Mālwa.

Nagarī

The village of Nagarī lies in the modern Rajasthan, near the citadel of Chitor. Five inscriptions from the site show that it flourished from the third century B.C. through the fifth A.D.[123] The last of these records the dedication of a Viṣṇu temple by three brothers of Vaiśya *varṇa* (usually merchant castes), documenting the breadth of patronage in this period. This inscription is dated in the Mālwa Era, like those of Mandasor to follow, which demonstrates a sense of regional identity.

The most impressive carvings at Nagarī are the remains of a gigantic gateway or *toraṇa* that must belong to the early sixth century on the basis of its relationship

121. Williams, "Char Choma."
122. Stern, *Colonnes indiennes*, fig. 74, etc.
123. Bhandarkar, *Nagari*, pp. 118-22. One inscription mentioning

an Aśvamedha sacrifice suggests that this was the seat of a powerful ruler.

to works from Mandasor. The decorative side face of the post in Plate 215 bears fluted bands and medallions, which elaborate upon forms found at Mukuṅdara (Plate 212). The figural style of the Nagarī gateway seems also to continue the free three-dimensionality of the previous site. The top half of the double-*candraśālā* arches in Plate 215 have diagonal projections from their lower corners, a detail mentioned as characteristic of pieces found at Deogarh. Since the form is less emphatic at Nagarī, this may represent an early version of a motif that was to spread in western India and eventually beyond.[124]

The iconography of the Nagarī gateway also indicates some connection with Deogarh. In Plate 216 we begin at the left with a scene of Nara and Nārāyaṇa seated in the wilderness, a simple version of the great Deogarh relief.[125] Nara and Nārāyaṇa are forms of Arjuna and Kṛṣṇa, respectively; hence it is not surprising to find the rest of the lintel devoted to the story of the encounter between Arjuna and the *kirāta* or hunter. In the next panel to the right, Arjuna stands on one leg with arms raised in the pose of penance (*tapas*), presumably before Śiva. Then we see Arjuna confronting a boar, with Śiva and Pārvatī in the background in

the form of a homely hunter and his wife. The arrow projecting from behind the boar must indicate that both Arjuna and the *kirāta* have shot the animal. Next, in a broken panel, the two draw bows upon each other in jealousy, followed by a scene in which Arjuna, his supply of arrows exhausted, uses the end of his bow on the head of the *kirāta*. These last two scenes seem to intervene between the previous two, but straightforward narrative sequence is not a necessity in Gupta art.[126]

The subjects of the reverse of this same crossbar remain to be identified. The third panel from the right (not the center of the lintel) shows a seated figure with twisted locks in meditation, surrounded by four worshipers; despite the lack of a club, this might represent Lakulīśa.[127] If so, the remaining scenes are presumably Śaiva. Unlike the earlier cycle of Mandor, discussed in Chapter II, the Nagarī scenes do not have immediate counterparts in Mathurā or elsewhere (even the illustrations of the Arjuna story at Rajaona, discussed below). While lost sources can never be ruled out, given the fragmentary preservation of early Indian art, the Nagarī images do not seem to be part of a widespread network of iconographic conventions. Thus in figural style and decorative motifs, such a peripheral area had

124. Viennot, *Temples*, pp. 11ff.

125. The resemblance includes the lion below and the poses of the two ascetics as well, perhaps, as the four-armed version of Nārāyaṇa, although this is unclear at Nagarī. It is possible that the relief reproduces the impressive model of Deogarh, that it forms the source of the Deogarh composition, or that the two spring from a common source, whether in the form of lost sculpture or of iconographic sketches.

126. It is conceivable that Arjuna is shown doing *tapas* before Indra·

rather than Śiva, which would permit a "normal" chronological reading. But elsewhere the penance is clearly before Śiva (Ramachandran, "Kirātārjunīyam"). The Sārnāth Kṣantivādin lintel (Plate 233) and the paintings of Ajaṇṭā demonstrate a comparable disregard for temporal order.

127. Cf. Plate 229. One set of Śaiva scenes possibly related to this face of the Nagarī lintel are the Ahicchatrā terra cottas (V. S. Agrawala, "Terracottas of Ahichchhatrā").

at this point absorbed central forms that were ill-digested in the first phase of Gupta art. And at the same time, these forms were now being used for new kinds of content.

Mandasor

By the second quarter of the sixth century, the area of Mandasor was clearly the center of western Mālwa, under the proud Yaśodharman. Works associated with him provide a relatively firm pivot for the chronology of late Gupta art. One Viṣṇu image from Mandasor itself may represent an earlier phase and perhaps the initiation of the stone medium in this immediate area (Plate 218). The small scale and slightly clumsy execution of this piece explain the large heads of the personified weapons. The headdresses and Viṣṇu's twisted sash are common in the fifth century. Yet the flattened pose of the weapons and the slick modeling of the main figure's legs suggest a date of 510-520, slightly before the more firmly dated works.

These last lie six kilometers from Mandasor at Soṇḍni, the site of Yaśodharman's eloquent if pretentious inscription, engraved in duplicate on two pillars.[128] Presumably this is not far in date from another inscription of this ruler dated Mālwa Era 589 or A.D. 533; and presumably the similarities in carving between the Soṇḍni columns and the two colossal guardians at the site (Plate 219) indicate an association in time, as well. These figures stand convincingly, and yet the lower hand

has been pressed against the thigh in a mannered position. A new elaboration creeps into the forms, even into the modeling of the body, which has become superficially sensitive. Complex drapery folds, vermicular headdress, and the explosive lines of notched foliage above complicate the effect. Here in the second quarter of the sixth century, we are at a turning point between the Gupta style and a more florid idiom that was to follow.

The tall post found at Khilchipura, 3 kilometers from Mandasor (Plate 220) invites comparison with the Nagarī fragments of a similar gateway. So strong are the resemblances that these could well be the work of the same carvers. At the same time, it is clear that the Khilchipura piece is later. The Gaṅgā at the bottom here is flattened, her head bent, unlike the more credible stance of the Nagarī figures. The folds between the legs, which at Nagarī fell with horizontal repose, here exaggerate the fluttering quality of the entire panel. The complexity of overall effect resembles that of the Soṇḍni Guardians, and the date must be close. As in the Rupnika Mandir doorway at Nāchnā, the worshiper's movement is directed inward, opening the way to the functional use of sculpture in medieval architecture.

A colossal stele of Śiva found at Mandasor Fort must also be contemporary with the Soṇḍni Guardians, illustrating the extension of that style to a more iconic subject; hence greater rigidity in form.[129] Finally, an isolated Śaiva figure (Plate 221) resembles the *gaṇas*

128. Fleet, *CII*, III, pp. 143-50. Williams, "Sculpture of Mandasor," pp. 51-58, for complete references and discussion of other Soṇḍni sculptures.

129. Williams, "Sculpture of Mandasor," pp. 60-61. The facial features are particularly rigid, due either to the recutting of eyes and brows (my suggestion) or to the addition of the entire face (James Harle's suggestion, personal communication).

and attendants in other examples from the area associated with Yaśodharman, which suggests a roughly similar date.[130] This image is comparable to the *gaṇas* of Nāchnā (Plate 153). Yet by contrast with the humor and earthiness characteristic of that region, Mandasor shows an elaboration of form and an interest (undoubtedly explained by iconography) in the frightening and the grotesque.

Mālwa demonstrates the same continuing transformation of the Gupta style that we have seen in Bundelkhand. The two move in different if related directions. Moreover, in Mukundara this area finds a more isolated and exceptional beginning for its tradition of stone carving, albeit a less abrupt start than that of Kosala.

Western India: Śāmalājī and Related Sites

Whereas the Gupta presence was very real in Gujarat as late as A.D. 458, it must have waned soon after, for the Maitraka dynasty had emerged as the local power by 502.[131] The first ruler of this family, Śrī Bhatārka (known only from later inscriptions), is identified as *senāpati* or general, possibly under the Guptas, and the early sixth-century inscriptions refer to an overlord. But external overlordship is no longer mentioned after 556, and at the end of the sixth century *senāpatis* are named as subordinates to the Maitrakas themselves. Like the Parivrājakas, the Maitrakas used the Gupta era, later designating it the Valabhi era from the name of their own capital. Unlike any other of the successors to the Guptas, however, the Maitrakas formed a continuous lineage for a period of three centuries. This explains in part the continuity of sculptural traditions after the year 550, which elsewhere forms a dividing point in terms of style.

One of the first stone sculptures from western India is a small Viṣṇu image from Bhinmal in the desert part of Rajasthan (Plate 222). This has generally been ascribed to the fourth century.[132] Comparison with the Mandasor Viṣṇu of Plate 218 implies that the Bhinmal piece also belongs around the year 500. The latter is very similar in iconography, but lacks an elaborate crest ornament on the headdress. The rough definition of drapery, broad eyes, and slightly flattened shoulders may be indications of provincialism within the Mandasor style rather than of a Kushan date.

The source of the greatest number of late Gupta images is Śāmalājī, near the Devnimori *stūpa*, toward

130. This image is built into a later Śiva temple. While four-armed *gaṇas* are known, I am tempted to identify this as Bhairava (with animal in the lower right hand) or possibly Vīrabhadra. Sara Schastok suggests that it may represent Kubera, on the basis of a jar beneath the seat ("Sixth-century Kubera Image").

131. Majumdar, *Classical Age*, pp. 60-63; Virji, *Saurashtra*.

132. Shah, "Abu and Bhinmal," pp. 51-53. This image shares with the one from Mandasor small flames that issue from the sides of the crown, and retains a bar for additional support of the upper arms, perhaps the sign of a sculptor new to the stone medium. Shah indicates that this version of the *kirīṭa mukuṭā* or mitre is limited to the late Kushan period; it continues with elaborated crest, however, in Gujarat, in works that he ascribes to the late fifth century and that I would place a century after that (Shah, "Śāmalājī and Roda," pls. 48, 49). A sixth-century date was suggested by Sara Schastok in an unpublished paper delivered at the College Art Association meetings, 1978.

the border between Rajasthan and Gujarat. Some of the Śāmalājī sculptures have been attributed to a date in the fifth century, and again I must demur. None precedes the year 500, if we compare them with figures from Mandasor. For example, the standing guardian with trident in Plate 223 is quite similar to the colossal guardians from Soṅdni in the general disposition of his body and in drapery.[133] The slightly more three-dimensional poses in the Śāmalājī piece and the less elaborate treatment of detail imply a date earlier by at most a decade. The rocks in the background are comparable in their stylization to those of the rock-cut relief at Śaṅkargaḍh in Plate 179. A date of 510 to 520 for the Śāmalājī piece may deprive it of its primacy in the development of style, but this does not deny the elegance and intensity of these relatively small-scale carvings. It seems reasonable that this phase should appear under the early Maitrakas, before the overbearing reign of Yaśodharman immediately to the east.

The sculptures of Śāmalājī and of related sites in Rajasthan form a continuum leading into the seventh century. One example ascribable to the end of our period, ca. 550, is the torso in Plate 224, part of a set of Mātṛkās, of which several groups exist.[134] At this point the previous style, which, but for the stone, could almost be mistaken for a late Gupta work from some

other area, is turned into something more distinctively local. On the one hand, detail is elaborated in a rich and unusually meticulous way, as in the specifically defined leaves in the woman's headdress. On the other hand, there is a spontaneity in pose and expression, which imparts to the image a naturalistic and seemingly Western quality. In fact, the half-knit brows of the mother and the playful gesture with which the baby grabs her earring are in no sense copied from some Mediterranean-derived work. Rather the attitude seems to parallel that of the Hellenistic sculptor. It is no more necessary to credit an early date to these natural works than it is to the terra cottas of Fondukistan and other sites in Afghanistan, where a taste for the spontaneous survives as late as the seventh century.

The Punjab and Haryana: Murti, Agroha

The Punjab, including what is today the northern plains of Pakistan, was probably occupied by the Hephthalites during the late Gupta period. If Toramāṇa of the Kurā inscription from the Salt Range is the same as the Hūṇa ruler of Eran, his power was recognized over a distance of at least sixteen hundred kilometers.[135] When the Chinese pilgrim Sung-yun traveled to India in 519, he reported that the Hephthalites had their capital in the mountains to the north, and that their tributaries were

133. Shah ("Śāmalājī and Roḍa," pl. 21, p. 46) publishes a companion piece still in situ. The pairing suggests dvārapālas. The Prince of Wales Museum dates the piece illustrated here to the seventh century.

134. This was published in Shah. "Śāmalājī and Roḍā," pl. 23, ascribed to the early fifth century. It certainly precedes the derivative example in Shah's plates 29 and 30 from Koṭyarka, which shows a

medievalizing distortion of the mother's arms and a loss of the earlier spontaneity of expression. The identification of these as Kṛttikās or foster mothers of Kumāra was proposed by Pal, "Rajasthani Sculptures."

135. Sircar, Select Inscriptions, p. 422, denies earlier arguments that this was not the same Toramāṇa.

extensive.[136] In fact, the political realities of the northern areas were undoubtedly determined by unrecorded Central Asian rulers, on the one hand, and by the continuing momentum of the old urban centers, on the other. The former introduced a few images that are non-Indian in religious subject matter and in the costume of secular figures. The urban merchants, however, are most likely to have continued the sponsorship of Buddhist art of late Gandhāran derivation. A few potstone images found at sites such as Taxila may result from receptivity to Hinduism after the Hūṇas' forays into India.[137]

In this complex mixture, a few remains stand out as pure examples of late Gupta style transported far to the north. Most notable is a group of architectural fragments from Murti in the Salt Range, pieces small but hardly portable (Plate 225).[138] In style these belong to the first half of the sixth century, and they cannot be connected with Samudragupta's putative conquest of the area. In Plate 225 the foliage is divided into small lobes with notched edges, a late Gupta type. The *pūrṇa ghaṭa* shows advanced, complexly curling leaves, although the high neck of the vase is unusual. The female figure above would suggest a date not long after 500, for the pose is assured and the drapery modeled with

fluidity. A single *candraśālā* from Murti is similar in contour to those of Bhumara.[139]

Agroha, 200 kilometers northwest of Delhi, on the Haryana plains, preserves both stone and terra-cotta fragments of the same kind.[140] The decor of a fragmentary doorjamb in Plate 226 is indistinguishable from that of Sārnāth. The interest of these pieces lies in their entirely orthodox Gupta style. Clearly they are the work of carvers from the central plains of north India. Artists must have traveled north as the result either of disturbances at home or of the positive inducement of patronage. Whatever the nature of this patronage, it is apparent that this style was acceptable at least in a limited way. Thus the Salt Range was part of an area for which the Gupta style had a direct appeal just at the moment when the Gupta empire had disappeared.

Mathura

The two previous chapters have begun with Mathurā, in tribute to the central role of its workshops. In this period, that position itself begins to crumble. Some Mathurā works continue to stand out as the most sophisticated versions we know of particular types. The sheer quantity of production diminishes at this point, however. And the impact of Mathurā models upon

136. Hsüan-tsang, *Buddhist Records*, p. xci.

137. *ASIAR* 1934-1935, pl. VIIIf; Banerjea, "Sūrya," pl. XIII. Some of the works attributed elsewhere to the subsequent Shāhi period may in fact be associated with the Hephthalites.

138. These were first published by Sir Aurel Stein, *Archaeological Reconnaissances*, pp. 52-57. Some of the Murti pieces are clearly medieval (Stein, pl. 20, 2).

139. Stein, *Archaeological Reconnaissances*, pl. 20, 3.

140. H. L. Srivastava, *Excavations at Agrohā*. While the remains discussed here extend back to the second century B.C., they do not include the Gupta works now in the Lahore Museum. More Gupta and early medieval pieces from Agrohā are kept in the Chandigarh Museum. Important collections of related terra-cotta pieces from Haryana are housed in the Gurukuls of Narela and Jhajjar, near Delhi.

artists in other areas must also have decreased, if gradually. This situation might be credited to the Hūṇas, who probably occupied the city.[141] More important than simple invasion, however, is the break-up of communications throughout the former Gupta empire. Security, roads, and in particular the habit of looking to such a prestigious center did not vanish in a night. But the lack of dated works of this phase from both Mathurā and Sārnāth makes it impossible to chronicle the process precisely.

A long lintel illustrated in Plate 227 shows that building did not cease at Mathurā late in the fifth century. On the bottom a fragment of lacy foliage survives, its margins indented with small notches, which in type follows the broader leaves of the previous period. A single *candraśālā* arch sketched at the left end is complex in both outer and inner profile.[142] The outer band of overlapping leaves has not been seen so far in Mathurā, although it appeared by the end of the fifth century in both Bundelkhand and eastern Mālwa. The form here must be close to the origin of the motif, for each leaf and seed pod is crisply defined. It would be hard to imagine that the conventional versions of Nāchnā or even Deogarh influenced Mathurā in this case. The general organization of the lintel accords with developments elsewhere: the T shape is not emphasized, and flying figures converge on the central emblem with the

focus of the Pārvatī Temple at Nāchnā. A date of 480-490 seems reasonable here.

A pillar bearing the sole image of the goddess Yamunā known from this great center on that holy river also belongs to a late Gupta phase (Plate 228). The *pūrṇa ghaṭas* of both top and bottom show foliage falling the length of the vase, and the foliage itself has the slightly fussy quality of the last example. The figure of Yamunā sways two-dimensionally, and the rather crude modeling of face and waist suggests a hasty execution. Her attendant stands upon the smiling head of a fish, like that of the Kumrā Maṭh at Nāchnā in Plate 159.

The *candraśālā* fragment in Plate 229 should be placed around the year 500 on the basis of its foliage, still three-dimensional but minutely fragmented.[143] Such an arch filled with foliage has been seen at Mukundara, and continues both in Mālwa and in northwestern Bundelkhand.[144] Again it would seem probable that both areas derive the form from Mathurā. Within this example sits Lakulīśa, the incarnation of Śiva, whose worship at Mathurā goes back at least to A.D. 380 (the inscription of Plate 16). This form of the divinity is identified by the club that he holds and by the ascetic's pose, with a band holding the legs. Only two disciples appear to surround the teacher, rather than the four who are canonical later and who may appear already at Nagarī (Plate 217). The coherence of design between

141. V. S. Agrawala ("Brahmanical Images," p. 128) illustrates a potstone image of Sūrya very similar to works more plentiful in the northwest, probably a Hūṇa import.

142. The opposite end has been left plain, apparently unfinished. It is possible that a second half of this *candraśālā* has been broken off below.

143. N. P. Joshi, *Catalogue of Brahmanical Sculptures*, p. 130 (also p. 108, fig. 36, a similar Lakulīśa figure on a Mathurā lintel).

144. In Mālwa the form survives at Char Choma. In Bundelkhand it appears at Bhumara and in an unpublished piece in the Ramban Museum, Satna, said to come from Nāchnā. Several other examples are known from Mathurā, as well.

this image and its surrounding frame surpasses most of the *candraśālās* of Bhumara.

Although it is difficult to date any Buddha images within this latest Gupta phase at Mathurā, two Jain figures may tentatively be ascribed to the end of this period. The Ṛṣabhanātha in Plate 230 resembles the sixth-century carvings of Nāchnā, especially the Rupnīka Mandir doorway, in the cursory forms of the attendants and the fluttering quality of design.[145] The flying figures above are framed by clouds, a characteristic of medieval images later. All the faces show an exaggerated arc in the eyebrows; the ears point outward and detract from the spherical unity of the head. A second Tirthaṃkara in Plate 231 carries the linear execution of details even further. The tubular limbs and the repetitive effect of the surrounding twenty-three patriarchs might suggest a medieval date. Yet the forms of the central body are not entirely schematic. The abraded inscription has been attributed to the fifth century on palaeographic grounds, and while that may be slightly too early, it does support a position in the middle of the sixth century.[146] These two images represent the contrasting poles toward which late Gupta figural style moved: exaggerated movement and exaggerated rigidity.

Finally, Plate 232 illustrates an attractive if unsophis-

ticated image of Kṛṣṇa lifting Mt. Govardhana. This piece has generally been ascribed to a late Kushan or early Gupta date on the grounds of the crisply rounded face and stocky body.[147] These qualities are possible in the early sixth century, as well. The sharp definition of the face resembles that in Plate 230. Moreover, the flattened realization of Kṛṣṇa's traditional stance, with his right leg bent to the side rather than forward, characterizes the subtle contortion that begins to appear at this point. This image represents, therefore, a perpetuation of an iconographic type that had earlier been widely diffused outside Mathurā.

Eastern India, Regional History

It would seem that imperial Gupta power lingered longest in the Gangetic basin, for late inscriptions are found here. At the same time, we hear of several dynasties in this area arising at the end of the fifth century and apparently functioning initially as feudatories. The first of these is the Maukhari dynasty, a name known from the third century A.D.[148] Maukhari presence stretched from Kanauj to Magadha by the year 500. Iśvaravarman in the second quarter of the sixth century seems to have opposed the Hūṇas, possibly in alliance with Yaśodharman of Mandasor.[149] His successor Iśanavarman had adopted the imperial title Ma-

145. Smith, *Jain Stupa*, pl. XCI.

146. Smith, *Jain Stupa*, pl. XCIV. The Lucknow Museum currently identifies the image as ninth-century. The traces of letters that survive are clearly not that late, and I feel that a sixth-century date is possible.

147. N. P. Joshi, *Mathurā Sculptures*, fig. 87. V. S. Agrawala suggested a seventh-century date, however ("Catalogue," XXII, 119).

148. The inscribed *yūpas* from Badva in Kota district (Rajasthan), attributed to the third century A.D. on palaeographic grounds, use the name Maukhari.

149. For the history of the dynasty in general, see Pires, *Maukharis*. Majumdar, *Classical Age*, pp. 67-71. Goyal suggests that Iśvaravarman and Yaśodharman jointly came to the aid of the Gupta ruler Bālāditya II (*Imperial Guptas*, p. 350).

hārājādhirāj by 554. Thus the Maukharis attained independent status just at the end of the Gupta period, slightly later than the rulers of other areas considered thus far. The Maukharis remained a power in Magadha until the reign of Harṣa, early in the seventh century. Although the sole dated inscription of the dynasty used the Vikrama Saṃvat, coins appear to be dated according to the Gupta era and certainly continued Gupta silver types.[150]

The second successor dynasty in the east is that known as the Later Guptas from the use of -gupta as a suffix to almost all of their names.[151] In fact, however, there are no connections in the epigraphic or numismatic records of this family to indicate any continuity with the Imperial Guptas. They appear to have arisen alongside the Maukharis in Magadha late in the fifth century, and to have fought with that dynasty throughout the second half of the sixth century. At times the Later Guptas were in control of Mālwa, ruling from Ujjain, and it is possible that they may have been one of the factors in the problematic history of that area, although the lack of Later Gupta inscriptions in Mālwa makes this dubious.[152] We have no reason to associate any of the artistic centers of eastern India considered here with either the Maukharis or the Later Guptas. Both were probably limited in power by rivalry with each other and with the Hūṇas. Thus while there is a conservatism both in Imperial Gupta claims and in artistic style in this area, it may in fact have been more chaotic than some outlying regions.

Sārnāth

The great Buddhist center of Sārnāth preserves no inscription after the 470s that reveals its political history in the next century. Unlike Mathurā, however, Hūṇa presence here is unlikely, and the large quantities of Sārnāth sculpture do not suggest a slackening of production in the late Gupta phase. It might be expected that the Buddhist shrines would have flourished in the continuing political turbulence. The absence of dated material and the strongly conservative nature of artistic traditions here (borne out by considerably later and relatively well-dated works) make it particularly difficult to trace developments. Works of the mid-fifth century were apparently still in worship and available as models for craftsmen. Hence decorative motifs changed less rapidly than in outlying regions. Moreover, despite the growth of tantric cults, the nature of Buddhist ritual would not seem to have changed significantly here. Thus no changing architectural function for Buddhist sculpture led to new forms, as was often the case in Hindu centers. In short, we are left with an unusually subtle and gradual evolution of style.

The colossal lintel in Plate 233 provides a useful comparison with the Mathurā example in Plate 227; it is significant that large shrines were still built in both

150. The Harāhā inscription is dated v.s. 611 (*EI*, XIV [1917-1918], 110). For a survey of the coins, see Devahuti, *Harsha*, p. 244.

151. For general surveys of the Later Guptas, see Majumdar, *Classical Age*, pp. 72-75; Devahuti, *Harsha*, pp. 18-24.

152. The question of a possible Mālwa origin for the dynasty has been much discussed. For a strong if not entirely convincing statement of the case, see Sircar, "Maukharis and Later Guptas."

cities at this point. The two lintels are bounded by overlapping leaves shown with carefully represented detail. Although the Sārnāth work solves the problem of turning a corner in the same way as the Kumrā Maṭh of Nāchnā (Plate 158), it would be impossible to decide in which of the great centers this motif originated. Traces of foliage on the bottom band of the Sārnāth lintel seem earlier than that of the Mathurā piece, the edges of each tendril remaining smooth and undivided. The architectural forms of the Sārnāth piece are not only more prominent but also apparently more developed in the elaborate excrescences of the doubled *candraśālās*. Flanking the center are two complete replicas of the superstructure of a building. A large *candraśālā* projects from what appears to be a simple *śikhara*, topped by an *āmalaka*. The figural style points to a date distinctly following the Sārnāth works of the 470s (Plates 89, 90) and hence places the piece in the first quarter of the sixth century. For example, the couple at the far right shows a stiff angularity in the legs and in the way the woman's head is bent.

The great lintel from Sārnāth differs from other doorways of the Gupta period in its episodic composition, a pattern perhaps fostered by the long-standing Buddhist tradition of narrative art. The subject here is the Jātaka story of the Buddha's birth as Kṣantivādin, the "Speaker of Patience."[153] The scenes do not follow a single sequence, but begin in the center with the ladies of the harem entranced by the preaching of the ascetic Kṣantivādin. His dismemberment by the king

is shown on the left, his apotheosis on the right. Didactic clarity was subordinated to the desire to create a pleasing and auspicious design, but the story-telling impulse survives.

A second architectural fragment illustrates the difficulty in defining a boundary between this and the previous phase at Sārnāth (Plate 234). The foliage here may well be the work of the sculptor who executed that on the great First Sermon of Plate 94. Both broad lines and details are indistinguishable in the two. Only the greater depth of carving on the second piece makes the notched edge of small curls stand out in more fragmented effect. As on the Sārnāth lintel, the figures at first seem to have lost only slightly their previous credibility. The thrust of hips is exaggerated, and a figure such as the man in the second major panel from the top stands unstably. These figures lack a surrounding frame, moreover, as in the early sixth century at Nāchnā (Plate 159). This jamb is clearly later than those in Plate 99. More important, it seems to belong to a point at which Sārnāth was in the forefront of stylistic developments, rather than in the ranks behind Mathurā, as before.

The placement of Buddha images in the sixth and seventh centuries is particularly ticklish because of the lack of any dated standard of comparison within this conservative and active center itself. The example in Plate 235 represents the Buddha's Temptation by Māra, following closely the iconographic conventions of earlier steles (Plate 95).[154] The positions of the two standing figures are made agitated by the tilt of their heads.

153. Williams, "Sārnāth Gupta Steles," pp. 174-75.

154. Māra stands to the left holding a bow, his daughter to the

The hands, both of Māra's daughter on the right and of the Buddha as he touches the earth, show the mannered bending back of fingers that characterized the works of Mandasor under Yaśodharman. Heads are enlarged, as are the features within them. There are sinuous curves in the lips, in the drapery ends, and in the edge of the robe across the chest, although the latter was to become more serpentine in centuries to come. A sweetness of expression results, which makes even the slightly folkish image in Plate 93 seem reserved by comparison. At the same time, the eyebrows are defined by a raised line, and a new sharpness invades the features.

So small a sample undoubtedly does not represent the only direction that change took in sixth-century Sārnāth. The earlier naturalism was gradually abandoned. The result might be either the intrusion of hard-edged, ornamental line or the simplification of the entire image. The size and importance of the work might determine whether the effect is one of slightly desiccated elegance or of hasty sketchiness. The iconography of this period does not seem to have changed significantly, and it is only in later centuries that tantric currents emerged.

Bihar: Patna, Bodh Gayā, Rajaona

During the late Gupta period, sculptural ateliers to the east came into their own. The difference between isolated works produced here and the more sophisticated products of the central schools no longer persisted from the early Gupta phase. Works of art, moreover, became more plentiful than before. The Buddha found at Telhara near Patna exemplifies the changes in this region (Plate 236). Were it not for the shiny black stone, one would connect this piece with Sārnāth versions of the First Sermon such as that in Plate 93, so close are the proportions of the figure and the pert facial expression. Only the simplified background and the asymmetrical position of the standing Buddhas suggest a certain provincialism. An inscription is dated palaeographically no earlier than the sixth century.[155] Perhaps the Patna area inherited Sārnāth sculptors who dispersed after A.D. 500.

The conservatism of the Buddhist milieu at this point is demonstrated by additions to the much earlier railing surrounding the great shrine of the Buddha's Enlightenment at Bodh Gayā. A sandstone original of the first century B.C. was extended with granite posts; this unusual and intractable stone was perhaps chosen because the added parts were repairs—hence the donors' desire for durability. If so, it is conceivable that the Gupta sculptors were directly copying broken works of the first century B.C. Many medallions are occupied by heads that duplicate those of the original, although the Gupta carver demonstrated greater proficiency in modeling and in representing volume. In Plate 237, the lower figures

right, with two grotesque members of his host above. Below are the remains of the Earth Goddess, called to witness, and probably of a problematic striding female figure (who occurs not only in eastern U.P. but also in Cave 11 at Ellora). The upper group in Plate 235 corresponds to that in an early medieval stele of the Buddha's life,

where, however, the figures below the Buddha have been eliminated (Williams, "Sārnāth Gupta Steles," fig. 3).

155. P. L. Gupta (*Patna Museum Catalogue*, p. 55) suggests a seventh-century date. Susan Huntington suggests a sixth-century one (*Bihar and Bengal*, p. 34).

show an assurance in their foreshortened and varied poses, which is radically different from the stiff postures in earlier panels. This scene illustrates the Jātaka tale of a tortoise carried through the air by two friendly birds, only to fall to the ground at the taunts of spectators. The subject is a favored one in late Buddhist art.[156] The Bodh Gayā railing additions can be ascribed to the late Gupta period on the basis of the dispersed quality of the small fragments of foliage that occur in these carvings.

The interesting shrine known as Maṇiyār Maṭh at Rajgir may also belong to the late Gupta period; yet because so little of its terra-cotta decor survives, adequate discussion is difficult. The finest remaining Brahmanical pieces of this phase from Bihar are a pair of pillars found at Rajaona, 60 kilometers east (and slightly north) of Rajgir (Plates 238-240).[157] Again it is foliage that suggests a date of ca. 500 on the basis of its diffused and rather small curls, still organically related to larger and rather three-dimensional leaves. The spacious compositions and the use of scenic props are comparable to the *Rāmayaṇa* reliefs from Nāchnā (Plates 165-170). The figures are, however, quite different from the distinctive type of Nāchnā, both in their squat proportions and in their more convincingly

foreshortened poses. If we compare these with the earlier narrative steles from Sārnāth (Plate 95), the movement toward a local Bihari style is slight.

The subject matter resembles that of the Nagarī lintel (Plates 216, 217), with the story of Arjuna and the *kirāta* on one pillar, and on the other scenes from the life of Śiva and Pārvatī. The Arjuna sequence begins in the middle of one face (Plate 238) with the penance of the Pandava prince, who stands on one leg among flames. In Plate 239 we see the ambidextrous Arjuna from the rear (identified by the two quivers), perhaps using his bow upon a lost figure of Śiva as the *kirāta* hunter. The hand-to-hand combat between the two follows. The remaining face (Plate 240) shows Śiva seated with Pārvatī on his mountain, while in front Arjuna kneels before the chubby four-armed personification of the Pāśupatāstra, the weapon that has been his goal throughout the story.[158] Finally, returning to the first face we see him in his chariot (Plate 238). The literary source here could well be a version close to the *Mahābharata*, although the Śiva scenes on the other pillar imply that the original story had a somewhat different context. Neither the individual scenes of the composition nor the events depicted for illustration suggest any relationship with Nagarī, direct or indi-

156. Pali Jātaka, No. 178 (Kacchapa Jātaka). In addition to the example from Nālanda Temple Site 2, it occurs on an isolated pillar from Mallar (Stadtner, "Sirpur to Rajim," fig. 18), and at Chandi Mendut, and five centuries later at Chandi Jago in Java.

157. These pillars were first described by Cunningham in situ at Rajaona (*ASI*, III [1871-1872], 154-55). At that time the first pillar was more complete, including a scene of "two figures fighting to the left beside a prostrate figure" (of which a corner still remains), as well as the now-missing face with "a seated goddess, with an attend-

ant holding an umbrella over her, and two standing and one kneeling figure with joined hands before her." The pillars were subsequently published and misascribed to Chandimau in Patna District, the first pillar at that point being split in two (*ASIAR* 1911-1912, p. 161). This was corrected by Banerji, *Age of the Imperial Guptas*, pp. 192-93.

158. Ramachandran, "Kirātārjunīyam," pp. 16-21. I differ from Ramachandran in the identification of Arjuna as the larger figure in Plate 239 on the basis of the two quivers.

rect. Although the same stories are current in both areas, there is no pattern of shared iconographic conventions, as there had been for the Kṛṣṇa cycle in earlier periods. The Rajaona carvings demonstrate the skill and inventiveness of sculptors working in what had previously been a provincial area.

Gaḍhwa

The Gupta sculptures of Gaḍhwa are as difficult to place as any body of material included in this book. Even geographically, this is a nonesuch. Though the site lies 40 kilometers south of Allahabad, the Gaḍhwa images share little with those of Kauśāmbī or other sites in the Sangam area. Equidistant from Nāchnā and Sārnāth, Gaḍhwa lacks the regional style of the former and the conservatism of the latter. At most there is enough in common between these carvings and those of Bhumara to suggest that Gaḍhwa may represent a source for one of the Bundelkhandi idioms. The distinctiveness of this style is in itself a growing characteristic of our third major period within Gupta art. The uniqueness of Gaḍhwa does not, I believe, result from previous local experience on the part of the sculptors in woodcarving, as seems the case at Mukuṅdara and Tala. Rather, the incipient regionalism of the period must

have been accentuated by the individual talents of at least one master carver who worked here.

The site of Gaḍhwa is today surrounded by a wall, which encloses Gupta and more numerous medieval carvings.[159] Three inscriptions dated A.D. 408 to 418 were found here, but these were not physically associated with any images. They seem to me to predate the Gupta works.[160] Nor are any substantial architectural remains that might aid in their dating associated with these works.[161] I once suggested a mid-sixth century date on the basis of a sole image of what seems to be a River Goddess of late type (Plate 242, to the side).[162] Since advancing that opinion, however, I have come to recognize the diversity with which the River Goddesses were treated in the fifth century, and this element no longer seems a substantial reason for so late a date. Figure style suggests that the Gaḍhwa carvings belong at the commencement of the period considered in this chapter, that is, late in the fifth century. Their inclusion here rather than in the previous chapter is the result of my desire to stress localizing divisions of style at this point.

A first example from Gaḍhwa, the frieze in Plate 241, is not preserved in its original condition.[163] The reverse bears medieval architectural elements; reuse of the stones

159. Cunningham, *ASI*, III (1871-1872), 53-61; X (1874-1877), 9-15; Knox, "Excavations at Gaṛhwa."

160. Fleet, *CII*, III, 36-41. These inscriptions refer to an almshouse, which need not, however, be identified with the structure from which the Gupta carvings come. Perhaps such an almshouse (conceivably wooden) is represented in one of the carvings (Cunningham, *ASI*, X [1874-1877], pl. VII E).

161. One fragment of a row of lion heads seems to me to belong to the late fifth century (Williams, "Dentils," fig. 10).

162. Williams, "Recut Aśokan Capital," p. 237. The image is illustrated in Viennot, *Divinités*, pl. 19a. A female figure without any vehicle, but with similar measurements, survives at the site on the lateral face of the base of Plate 261; if the two are a pair, they would not seem to represent River Goddesses. In any case, such figures appear at the base of jambs at Tumain (Plate 119) and Udayagiri XIX (Plate 115).

163. The scene is misattributed to Garhwal in Ions, *Indian Mythology*, pp. 70-71. For a fuller discussion see N. P. Joshi, *Catalogue*

in a later period may explain the destruction of most of the Gupta shrine. The lower edge of the frieze has been eroded and clumsily restored, making it impossible to discern the original stance of the figures. These figures seem closer to the Sārnāth type of the second half of the fifth century (e.g., Plates 95, 233) than do the willowy, complexly turned bodies in the other Gaḍhwa carvings discussed here. The foliage points toward a late fifth-century date, its long leaves creating almost unattached curves with edges as broken and ebullient as those of the Pārvatī doorway at Nāchnā.

The subject of the scene to the left has been correctly identified as the fight between Bhīma, the second Pandava brother, and Jarāsandh, king of Magadha, as described in Book II of the *Mahābhārata*.[164] The wrestler to the rear who lifts his opponent in order to destroy him must be Bhīma. To the left stands Kṛṣṇa with four hands holding three of the standard Vaiṣṇava attributes (discus, conch, and club), and encouraging Bhīma in the fight. To the left of this is Arjuna with bow, arrow, and two quivers, which indicate his ambidextrousness.

Two posts, each carved on three sides, show the sec-

ond and more distinctive style that I attribute to a "Gaḍhwa master" (Plates 242-244).[165] A difference between this and the previous frieze is visible even in the foliage. Although the general structure of the two plants is similar, in the second, detail obtrudes far less, not only on the worn surface planes, but also on the contours of the forms. Figures move in counterpoint to the principal stem, without yielding to complete regularity. At times they are separate from the plant, but at others they emerge directly from a tendril. The figures themselves are relatively slender and appear in a wide variety of poses, some deliberately foreshortened, some turned at unusual angles, such as the rear view. There is a sense of credible ponderation that is unique in Indian art. A posture such as that of the central female figure in the bottom of Plate 244 epitomizes the problems of placing these images chronologically. The mannered and exaggerated shrinking is that of the medieval period. Yet, unlike the contorted couple at the far right in the Sārnāth lintel of Plate 233, this figure holds her head above the weight-bearing foot with a subtle adjustment of the axis of each limb to the re-

of Brahmanical Sculptures, pp. 89-90. This panel is close in height (26 cm.) to the long Viśvarūpa frieze from Gaḍhwa, also in Lucknow. I see these as friezes from the base or wall of a temple (cf. Williams, "Char Choma,") rather than as *toraṇa* bars or lintels, which seems improbable for the long, divided Viśvarūpa panel.

164. N. P. Joshi, *Catalogue of Brahmanical Sculptures*, pp. 89-90. *Mahābhārata*, tr. van Buitenen, II, 7-73 (Sabhaparva 20-21). I am unable to explain the elephant-headed figure (Gaṇeśa?) in what survives of the scene to the right.

165. Cunningham (*ASI*, X [1874-1877], pl. VI) thought of the portion illustrated in our Plates 243 and 244 as continuous, the former being the lower one. The carving of the two, while similar,

would not match without supposing the loss of several inches of stone. It thus seems more likely that the two are matched posts, perhaps comparable in position (being carved on three sides) to those of Bilsaḍh, discussed above. The River Goddess(?) illustrated in Viennot, *Divinités* pl. 19 occupies a separate fragment of similar dimensions, and one more split fragment bearing a monastic figure and foliage survives at the site. Harle (*Gupta Sculpture*, pl. 79) illustrates one of two similar fragments removed to the Lucknow Museum, which may be related, as well as the Viśvarūpa frieze (Harle, *Gupta Sculpture*, pls. 71 to 78), which seems clearly to be the work of the Gaḍhwa Master.

quirements of anatomical plausibility. In almost every figure, new risks are taken that make even the Sārnāth carvings of the previous phase seem formulaic.

The iconography of this master's work is as baffling as its form.[166] The corpulent figure atop the panel in Plate 244 presumably represents Jambhala or Kubera, as at the end of the great Sārnāth lintel (Plate 233) or the Devarārnī jambs from Tala (Plate 196). The bust below has one equally enigmatic counterpart among the unpublished fragments of the Jeṭhānī Temple at Tala. The lower panels might be identified as court scenes, like those on the Khilchipura pillar. Yet the indisputable identification of the Bhīma-Jarāsandh fight in the frieze discussed above suggests the possibility of subjects drawn from other parts of the Mahābhārata. For example, the second post (Plate 243) shows two seated men playing a board game.[167] Might this represent Yudhiṣṭhira gambling disastrously with Duryodhana? Might the lower panel in Plate 244 represent Draupadī being led to her humiliation before the Kauravas after she was gambled away by her senior husband? This surely is not a conventional amorous group, for the woman withdraws reluctantly from the grasp of one man and

is accompanied by a soldier. The center of a long frieze from Gaḍhwa is occupied by Viṣṇu as Viśvarūpa. This all-embracing form is vividly described in the Bhagavad Gītā, and plays a particular role in the final version of the great epic.[168] The identification of Bhīma and Jarāsandh's fight is not a logical basis for these other hypotheses, based also on the Mahābhārata; that would be to assume a common program. Rather it is possible to say that if such suggested iconography is borne out by further research, this would form an additional basis for associating the two groups of carvings in time. Hence the formal differences between the two would clearly be a matter of the "hand" of the carvers rather than of date. It would also be appropriate that the inventiveness which these carvings show in composition had its counterpart in the exploration of new literary subject matter.

Finally, the lower half of an image of Viṣṇu as Varāha (Plate 245) seems also late Gupta, for it is radically different from the hard-edged, contorted medieval images of other avatārs that survive at the site. The sinuous toes of Varāha and the complex, rhythmic coils of the serpent demonstrate the kind of subtlety that one

166. Although the central Viśvarūpa and the Sūrya have been mentioned, I know of no account of the entire frieze or of the posts. Bourdillon discussed some considerably later scenes from the site ("Krishna Obelisks at Garhwa").

167. This is obviously not the original form of gambling with vibhīdaka nuts described in the Mahābhārata (tr. van Buitenen, pp. 127-155). Possibly, however, the gambling was reinterpreted in light of contemporary practice in the fifth century. The board suggests a form of parchisi.

168. The type is discussed in Chapter III in connection with Ma-

thurā. This image is located in the center of the long frieze that bore Sūrya, the Sun, at one end and Candra, the Moon, at the other (Harle, Gupta Sculpture, pls. 71, 72). To the left, four figures stand out, possibly four of the five Pandavas: Nakula and Sahadeva (immediately to the right of Sūrya), Bhīma (fourth figure to the right, tall, with bushy hair), and Yudhiṣṭhira (third figure beyond to the right, with parasol held above him). This is, or course, highly speculative unless the rest of the frieze can be explained and the dramatic situation identified.

would expect in a large work of the Gaḍhwa master. Here the ponderous thrust of previous versions of this same subject is replaced by a lighter and more graceful movement.

Conclusion

It is more difficult to summarize the general currents of artistic development from 480 to 550 than for previous periods. The center did not hold. Regionalism began to appear, founded upon different grounds in various cases. An established school such as Sārnāth had its own rich tradition of the previous phase upon which to build. Sārnāth, in turn, may have competed with Mathurā as a source of influence. In some peripheral areas, local workshops must gradually have drifted away from forms associated with the great urban centers. In others, this was a period of beginning from scratch, at least in the medium of stone. And yet there were unifying threads, beyond the common impulse to diversity.

There is a broadly shared conservatism, both in the general aesthetic goals and in the vocabulary of motifs. Even the band of wide, overlapping leaves, an element new at the end of the fifth century, is a logical extension of leaf forms seen already. To what extent was this conservatism the result of simple inertia on the part of the artisan workshop, and to what extent was it deliberate on the part of the patron? Only in the case of Kosala am I led to deny continuity of sculptors themselves, trained in the earlier fifth-century Gupta traditions. There the introduction of these forms seems a very deliberate choice. In general, it is wisest to imagine both forces at work. Clearly the patrons found such

styles acceptable. A parallel presents itself between the choice of an artistic idiom linked to the imperial past and the attempts of various small dynasties who succeeded the Guptas to legitimatize themselves by ties to those predecessors. The attempts took the form of minor gestures such as dating their inscriptions "in the year of Gupta rule," as well as of bold claims to surpass Gupta prowess. Yet in areas where no such political force existed, some elements within the populace also felt a nostalgia for forms associated with the previous stability. None of these contributing motivations, however, should be thought of as a necessary cause for the conservatism of artistic style.

A second unifying force lies in the nature of what artistic change did occur. Small alterations have been pointed out as distinguishing the works in this chapter from those of the last, and these alterations are clearly not haphazard. Throughout most areas there is a loss of naturalism, particularly striking in the poses of the human body. Some elements may be simplified, but on the whole the lines of composition are elaborated. This in turn leads increasingly to a loss of unity within the image as a whole. Three *liṅgas* from Khoh, Nāchnā, and Bhumara (Plates 171, 161, 182) illustrate this process but need not, however, form an actual chronological progression. It appears to me that explanations for such change should be sought in the situation of the artist himself. The problem of working in a style thought already to have attained perfection is not peculiar to the late Gupta sculptor. The term "mannered" has been used for works such as those of Mandasor, with recognition of the analogy between the situation here and

in sixteenth-century Italian painting. The mechanism that conveys a sense of the artist's inadequacy in the two cases may differ, but the psychological situation is similar. And yet such a sense of inadequacy was not inevitable, either at the end of the Renaissance or at the end of the Gupta period, as the venturesome works of the Gaḍhwa master reveal.

Finally, one might expect to find shared religious themes affecting the patrons and eventually the images of many parts of late Gupta India. The quantity of temples and images does increase in every area except perhaps Mathurā. In that these works are religious, one might infer a wave of religiosity. In that these works are made of stone, one might infer a desire for permanance in a transitory world. Yet inscriptions only hint

at that motivation in this period, whereas it becomes common after the year 600.[169] Certainly Mahāyāna Buddhism and various *bhakti* movements within Hinduism were on the rise, but I hesitate to ascribe changes in artistic form to such a source. As in the earlier phases of Gupta art, when new subjects were seen as available or necessary, the artist continued to rise to the challenge. At the same time, he had a growing number of conventions upon which to draw. This and the gradualness of change make it difficult to draw a clear line between this phase and the previous one. By contrast, the next period marks a more abrupt break in the very conception of the temple and the image, which takes us out of the Gupta world.

169. One clear Gupta inscriptional reference of this kind is from Bihar Kotra in the Mandasor area. A.D. 404/5, which says, "this living creation is transitory like a mirage" (*EI*, XII [1914], 315-21). The Kahaum pillar inscription discussed in Chapter III describes the donor as "alarmed when he observed the whole of the world passing through a succession of changes" (Fleet, *CII*, III, 67-68). Cf. Majumdar and Altekar, *Vākāṭaka-Gupta Age*, p. 378.

Chapter V
THE BEGINNING OF THE MEDIEVAL, A.D. 550-650

Aesthetics and History

It is traditional to conclude any discussion of Gupta art with the reign of Harṣa Vardhana in the first half of the seventh century. That is not my intention. In aesthetic terms alone, the middle of the sixth century, not of the seventh, marks a turning point. In architecture, the break is not merely a matter of elaboration and development of the superstructure; those tendencies were visible in the earlier chapters of this book, although they become more marked and consistent at this point. After the middle of the sixth century, temples develop a new kind of focus and coherence. These terms may not seem at first appropriate to the complex medieval shrine as opposed to a simple building such as that at Tigowa. Yet it is precisely the increasingly complex elements of the later shrine—radically differentiated spaces, contrasts between expansive exterior and constricted interior, and hierarchically articulated wall surfaces—that create a focused and dramatic religious experience.

In sculpture, the break at 550 is more apparent. Before this point, the individual unit, whether relief panel, doorway, or object of worship, forms a self-contained composition and tells a self-contained story. Sculpture

thus comes closer in the Gupta period than ever before in India to playing the role of the work of art. In shrines of the end of the sixth century, as in the great medieval temples of later centuries, independent units are impossible to define; and the sculpture is woven compositionally into the fabric of the building. The River Goddesses, which turn and direct the worshiper inward through the portal, are still symbolically significant, but now serve to integrate the doorway with the interior spaces and ultimately with the shrine itself. In this process, the human body loses that sense of credibility that the independent Gupta image usually retained. We are asked to regard the figures no longer as human beings whose bodies move as ours do, but rather as analogies to human anatomy governed by laws of design that apply to the architecture as well. Whether contorted or static, the poses no longer evoke empathetic reactions. Details of the body likewise break the previous balance between abstraction and visual reality. Thus while some specific motifs, notably the ebullient Gupta foliage, remain current, the spirit with which they are handled changes.

Finally, in both architecture and sculpture, a new

157

pluralism of regional styles appears, which means that some of the above generalizations are not fully borne out in certain areas. We no longer see the old *koine* of style, including both motifs and their treatment, that had stretched from Gujarat to Bengal and from the Salt Range to the Vindhya Mountains. The development of regional styles, familiar in later medieval architecture, is also apparent in the less plentiful and less well-preserved structures of the late sixth and seventh centuries.

In surveying the history of this next century, it seems appropriate to focus on aspects that relate to this aesthetic change. Among the kaleidoscopic twists of political history, Harṣa deserves consideration despite the fact that little surviving art is associated with him. His rule poses some of the same problems that we have confronted in art: is he the last outpost of the Gupta order, or does he exemplify a new political system? These questions are related to our estimate of Harṣa's actual power, and here the very nature of the primary historical sources is critical. Harṣa has fared very well— by what would seem to be accident. His early years were chronicled by the poet Bāṇa in the *Harṣacarita*; and he was later visited by the great Chinese Buddhist pilgrim Hsüan-tsang, whose various records give a sense of specificity generally lacking in Indian history to our reconstruction of the first half of the seventh century.[1]

Harṣa probably came to power in A.D. 606, ruling Thaneśvar in the eastern Punjab. Early in his career he assumed control of Kanauj on the Ganges, after the last of the Maukhari rulers there (who had been married to Harṣa's sister) had been killed by a ruler of Mālwa in alliance with Śaśāṅka of Gauḍa on the east. Harṣa then launched a *digvijaya* or victory tour. It is here that we are plunged into controversy about the actual extent of his conquests. Clearly he was a formidable antagonist for the rulers of Valabhi in Gujarat and for the Calukyan ruler Pulakeśin of the present Karnataka. At the same time, it would seem that he was not decisively victorious on either of these fronts, and there is little evidence for his actual control over regions outside the eastern Punjab, Uttar Pradesh, Magadha, and parts of Orissa.[2]

The question of the extent of Harṣa's power leads to that of the nature of political organization under him, for it could be said of the Guptas as well that temporary victories did not result in a unified political system with the modern connotations of an empire. In lands outside the central core, we hear of *mahārājas*, *rājas*, and *samāntas*. Undoubtedly these rulers were influenced by Harṣa in a Machiavellian system of alliances, but they were sufficiently independent that they are not given a secondary administrative title, as had the *mahārāja uparikas* of the latest Gupta period in Bengal. These are also very different from the governor of Gujarat under

1. Majumdar, *Classical Age*, pp. 96-123; Devahuti, *Harsha*.
2. Inscriptions of the Gurjaras of Broach describe Dadda II as protecting the king of Valabhi, who had been overcome by Harṣa. (R. C. Majumdar "Gurjara-Prattharas" p. 18). The Calukya stalemate is mentioned in Pulakeśin's own inscription (*EI*, VI [1900], 10) and by Hsüan-tsang (*Buddhist Records*, p. 450). I must concur in Majumdar's deduction from Hsüan-tsang that most of the peripheral areas were sufficiently independent not to be linked with Harṣa's "empire" (*Classical Age*, pp. 110-13).

Skandagupta, who was the son of a previous governor and yet felt obliged to recite his own merit and to explain that he has been chosen for the position. Within the core of Harṣa's actual kingdom, many officials such as *uparikas* and *kumāramatyas* continued titles and functions that had existed under the Guptas. Other officials were new, however. Two that are of interest are both judicial officers: the *pramatara*, who interpreted the *dharmaśāstras*,[3] and the *akṣapaṭalika*, who was responsible for the legal aspects of land transactions.[4] These demonstrate a need for specialists to interpret the increasingly complex codifications of law. Such officers, whether at the court or at the village level, represent a proliferation of the semireligious civil service, potentially independent of the ruler himself. While Gupta administration may have contained the germ of such a system, there seems to be a qualitative difference between the two. Harṣa's failure to bequeath his power to any successor within his dynasty suggests that this rule was not as coherently institutionalized as that of the early Guptas.

In terms of some criteria, Harṣa's reign indeed revived qualities of the Gupta period. The writing of the time suggests general economic prosperity. Trade flourished both internally (undoubtedly aided by political contacts across north India) and abroad, although I know no realistic means of assessing its extent. The literary climate of Harṣa's court would seem to have resembled that of Samudragupta or Candragupta II, for

the ruler himself was a dramatist as well as a patron of writers. The picture of cultural richness and popular contentment that Hsüan-tsang paints is not very different from that presented by Fa-hsien.

A coherent political survey of other dynasties of this period is hindered by the fragmentation that lies behind the diversity of artistic style. Nonetheless, certain social and religious generalizations can be made that differentiate this century from previous ones and that unite it with the following medieval period. The sheer quantity of economic expenditure devoted to building stone temples increases. It is, of course, unfair to make comparisons of size, for Bhitargaon testifies to the existence of large structures under the Guptas, and small shrines equivalent to Sāñcī 17 continued to be built in later periods. Yet an impression emerges that more of society's resources were channeled into temple building as time progressed, an impression that is surely the result of more building as well as the better preservation of the later temples and of the longer duration of the medieval period as a whole. The apparent decline of Buddhism presents only a partial diversion of the energies that had gone into sites such as Ajaṇṭā and Sārnāth to Hindu enterprises. The Buddhist caves of Ellora, the *stūpa* at Gyaraspur, and the continuing activity at Sāñcī and Sārnāth demonstrate intermittent periods of religiosity at a limited number of Buddhist sites.

But primary reasons for the changes lie within Hindu society. This is the period of a rise of the sacerdotal

3. Devahuti, *Harsha*, p. 185. The institution was not limited to Harṣa's court.

4. Devahuti, *Harsha*, p. 197. The term appears in Samudragupta's

spurious Gayā plate; even if this is a copy of a genuine plate, it is possible that this term is changed, not being found in other Gupta records.

classes, when the Brahmans played an increasingly clear role and sought to maintain their position.[5] Certainly other groups changed their role and sometimes rose. The Śūdras, for example, seem to have extended their activities and differentiated themselves from the Untouchables beneath them. The new status of the Śūdra is reflected, however, precisely in his admission to important Brahmanical sacrifices.[6]

Within Hinduism, moreover, it would seem that the nature of ritual changed in a manner profoundly significant for the history of art. The image played a more consistent role in worship.[7] The importance of *pūjā* or worship was recognized at this point, when the subject began to be included in Purāṇic literature.[8] The motivation for the increase in temple building may be traced largely to the ever more assertive presence of sacerdotal customs. Inscriptions demonstrate a comparable change in ideology, for donors consistently refer to their desire to find permanence in a world of transitory glory. There was, moreover, a growth in concern for astrological proprieties, and most religious grants were made on auspicious days.[9] The temple is a keystone in this process, providing a setting for the requisite rituals, insuring the donor's immortality, being completed according to a priestly calendar, and reflecting the nature of worship in its very design.

In the following discussion of this period, selection rather than comprehensiveness is appropriate. We will focus upon areas and examples that pose possibilities of continuity with the Gupta past. Were one to look at the emerging architecture of the Pallavas, Calukyas, or even of Orissa, all in areas where there were no Gupta monuments, the contrast with the past would be yet more obvious. We will also consider examples that can be dated with some certainty, since the chronology of the early beginning for medieval styles proposed here is an obvious issue.

Sirpur

The brick Lakṣmaṇa Temple at Sirpur takes us back to the problematic and peripheral region of Kosala, where Tala showed an isolated introduction of Gupta forms. Sirpur was probably the capital of the two latest Sarabhapurīya kings, but no remains here significantly precede the reign of the great Somavaṃśī king, Śivagupta, who probably ruled during the first half of the seventh century.[10] The Lakṣmaṇa Temple (Plate 246) was dedicated by the ruler's mother, Vāsaṭā, at the

5. Hazra, *Purāṇic Records*, part II, ch. IV.
6. R. S. Sharma, *Śūdras*, p. 278.
7. Thapar, *History of India*, p. 157.
8. Hazra, *Purāṇic Records*, p. 189.
9. Majumdar and Altekar, *Vākāṭaka-Gupta Age*, pp. 377-78. Altekar presents the interesting statistic that only two Gupta-period grants were made on the occasion of eclipses and one on the Uttarāyana, whereas about 80 percent of grants after the year 600 were made on such astronomical occasions.

10. V. V. Mirashi, "Three Ancient Dynasties," p. 55. As usual, however, the inscriptional evidence is not conclusive. M. G. Dikshit assumes an eighth-century date for Śivagupta (Barrett and Dikshit, *Mukhalingam Temples; Sirpur and Rajim*, p. 18). Vidya Dehejia has recently proposed to place this ruler around 740-800 (*Early Stone Temples of Orissa*, pp. 160-63). In these scholars' favor, one must admit that Mirashi's assumption of an early seventh-century position rests in essence on historical plausibility. The conjunction of a solar eclipse and the new-moon day of Āṣāḍha early in Śivagupta's reign,

occasion of her husband's death, indicating the foundation of the shrine early in the seventh century. Vāsaṭā was the daughter of a ruler of Magadha named Sūryavarman, and it is possible that influence from her homeland is in part responsible for the innovations that we see at this point. Aside from several nearby ruins and two Buddhist *vihāras* at Sirpur, we have no other Somavamśī monuments, yet later seventh-century architecture in Kosala grows logically out of this initial phase.[11] Although the beginnings of the regional style are murky, its development is clear.

In architectural terms, the Lakṣmaṇa Temple contrasts with the past Gupta traditions. This is the first case of an elaborated porch or *maṇḍapa* with interior columns (Fig. 16). The only possible Gupta prototypes are Bhumara and Mukundara, which may have had porches supported by columns on the inside. Neither of those, however, could have had the axial plan of the Lakṣmaṇa. Tala, the only previous temple in the region, had two small porches, but their cellular effect without columns must have been radically different. Developments at Elephanta and Ellora Cave 29 in the second half of the sixth century indicate that the idea of using columns to create an approach to the shrine was by no means peculiar to Kosala.[12] It is possible that in both areas we see the translation of wooden forms into stone and the combination of the *maṇḍapa/garbhagṛha* plan of the traditional temple with the columnation that was standard for *caitya* halls. The elaborate, axial *maṇḍapa* remains distinctive of Kosala architecture for a century, and columns with large figural carving come to rival the doorway in decorative richness.

Sirpur contrasts with even the most complex Gupta temples such as Bhitargaon and Deogarh in other ways, as well. The *pañcaratha* plan, with five major planes on shrine and superstructure, represents a logical elaboration of the *triratha* type seen so far. One of the nearby and contemporary ruined shrines shows a modified

sometimes cited as a firm date, might in fact have occurred in A.D. 606, 616, 633, 643, or at various later points: *EI*, XXIII (1935), p. 119. Dehejia, moreover, correctly points out that the retardataire palaeography of Kosala Somavamśī copper plates is less helpful for dating than that of the more advanced stone inscriptions of the same rulers.

On the other hand, her late date seems to be based on equally questionable evidence. The writing of the stone inscriptions of Śivagupta appears to me to be quite close to the 619/20 inscription of the Śailodbhava Madhava, a vassal of Śaśāṅka (illustrated in Dehejia's tables or *EI*, VI [1900], 143-46; *EI*, XI [1911-1912], 182-92; *EI*, XXXI [1955-1956], 197-198). In all, "ja" loses its upper arm, "ma" is square in configuration, and "ya" is not tripartite. "Ra," "la," and "sa" are similar at least in the first inscription of Śivagupta's mother. Dehejia's equation of the Tivara mentioned in inscriptions of the Śailodbhava Madhava's grandson with the Somavamśī Tivara who was a great-uncle of Śivagupta is open to doubt. At least equally possible is the equation of Śivagupta's maternal grandfather, Sūryavarman of Magadha, with Sūryavarman the son of the Maukhari Iśanavarman (c. 550-576). This latter argument has been used to date the Lakṣmaṇa Temple at Sirpur around 600 (Krishna Deva, "Lakshmana Temple at Sirpur"), despite R. C. Majumdar's rejection of the equation (*EI*, XVII [1937], 284).

I conclude that the foundation of the Lakṣmaṇa Temple by Śivagupta's mother probably falls in the first half of the seventh century, but would hesitate to specify a year.

11. For a discussion of later sites such as Kharod and Palāri, see Donald Stadtner, "Sirpur to Rajim."

12. Spink, *Ajanta to Ellora*, pp. 18-21.

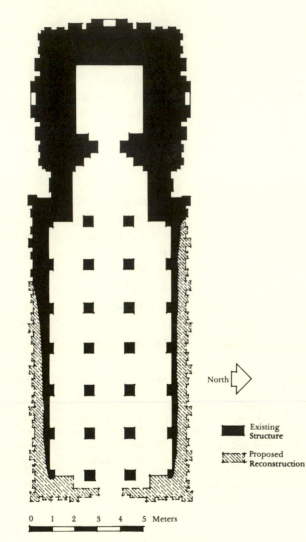

North →

■ Existing
 Structure

▨ Proposed
 Reconstruction

0 1 2 3 4 5 Meters

Fig. 16. Sirpur, Lakṣmaṇa Temple

stellate plan; this constitutes a further attempt to break up the wall plane that the Gupta architect had been content to leave intact as a surface for the sculptor. Details are elaborated with the same effect. Base moldings extend higher on the wall, forming an *adhiṣṭhāna* or basement equal to the *jaṅgha* or wall above.[13] The traditional round molding has been given the bold, upward-swelling curve of the *kalaśa* or water jar; this textual term is literally illustrated by leaves that drape over the molding, a detail peculiar to Kosala and later Orissa. *Candraśālās* appear both on the upper cornice, as heretofore, and on the base moldings. The latter position lacks structural logic, in that the motif suggests a window, but this serves visually to unify the walls with the superstructure. The interplay between large and small *candraśālās* observed at Bhitargaon here becomes a systematic diminution upward. Only a few details of decor are rooted in earlier Kosala traditions, of which we have seen one example at Tala.[14]

In general the doorway seems to follow earlier Gupta patterns (Plate 247). At the same time, this doorway neatly embodies the new concerns of the later period. The number and variety of decorative motifs have been reduced at the Lakṣmaṇa, so that curling foliage of constant scale produces a uniform effect across the door-

13. The brick temple at Bhitargaon may have had such an *adhiṣṭhāna*. At least we can say that it was not a feature of Gupta stone temples.

14. Tala does not explain the treatment of moldings or of exterior walls. The Vākāṭaka-influenced tradition of a doorway in the Rāmacandra Temple at Rajim represents another possible local source. The false doors resemble those of Sārnāth (*ASIAR* 1914-1915, pl. LXIVc) and Muṇḍeśvarī, conceivably indicating Magadha influence.

way. Figures become contorted. For example, in Plate 248 all the complex action of the woman standing on the side of her upturned foot takes place stiffly, in a single plane. Elements of religious significance dominate, with Viṣṇu Anantaśayana on the lintel and his *avatārs* and scenes of Kṛṣṇa's life on the outer bands. The entire doorway is designed to propel the viewer inward to the shrine. The dramatic setback of the bands proceeding inward, the circular carving of several foliate borders, and the carving on the lateral sides of the jambs are all features already seen at Tala. There, however, the carving invites admiration in its own right, whereas here it serves to introduce the worshiper to the shrine. The doorway has been turned from a structural unit or a discrete element of design into an aperture within the architectural whole.

Mahua

With Mahua we return to the general area of central India that had been so productive in the Gupta period, although the closest Gupta site is Deogarh, 50 kilometers to the southeast. The smaller Śiva Temple at Mahua (Plates 249, 250) bears an inscription on its lintel that provides a terminus ante quem of at least A.D. 800; to my mind a date of 650 is most probable on palaeographic grounds.[15] Viennot assigns the temple to the mid-sixth century,[16] Krishna Deva to the mid-seventh century.[17] For our purposes it is enough to say that the building is definitely post-Gupta, and that for all its apparent conservatism it shows a clean break with the Gupta aesthetic.

The plain, windowless cella and open porch of Mahua continue the early plan of Sāñcī 17. The use of two, rather than the previously standard four, columns at the front of this porch lightens the effect of the outer entrance and focuses attention upon the door behind. The central panel on each side wall forms a raised plane continuing into the first cornice, resembling the *triratha* plan seen at Bhitargaon and Deogarh. All these characteristics are found in yet simpler form in a temple near Udayapur, which must, however, belong to the eighth century or later.[18] It is possible that the presently flat roof at Mahua originally supported a small superstructure, although this is borne out neither by any markings on the roof slab nor by a substantial number of fragments at the site.[19] The shrine is the first complete example of the monolithic type of construction, for its walls are composed of upright slabs. Mukundara initiated this method with its monolithic pilasters, although there the wall interstices may well have been brick. On the whole, Mahua represents a recasting of the Gupta format.

15. *EI*, XXXVII (1967), 53-55. Earlier notes had suggested a seventh-century date; Sankaranarayan and Bhattacharya suggest the eighth century without much discussion. Two forms of the subjoined "ya" occur, but even the later of these does not resemble that in the Apsaḍh inscription of the late seventh century.

16. Viennot, "Temples à toit plat," p. 52. I find this date excessively early.

17. Quoted in Meister, "Note on the Superstructure," p. 88.

18. Goetz, "Imperial Rome," p. 153. P. K. Agrawala, *Gupta Temple Architecture*, pl. XVb. Goetz considered the Udayapur temple to be very early Gupta; Agrawala labels it "about A.D. 700 (?)." Although simple in carving, every element is medieval in character.

19. Viennot, "Temples à toit plat," pp. 40-42.

The decorative carving makes the change yet clearer. Although the molding elements have all been seen individually in the sixth century, their combination has not. A rounded band (*kumuda*) had been used above a row of dentils at Nachnā, but here the one element interrupts the other. *Candraśālas* are applied to base moldings in the same way that they have appeared before on lintels and cornices. The *candraśālas* above the exterior images (Plate 250) are at first glance reminiscent of Bhumara. Elephant heads between the lower excrescences and foliage above, however, break the integrity of the contour here. The prominent "unfinished medallion" motif on pillars and pilasters might suggest some direct relationship to Mukundara. Yet a detailed comparison of Plates 212 and 250 indicates that at most this is a matter of later copying and not of continuity within one workshop, so different is the subtly rounded cutting at Mukundara from the regular, angular forms at Mahua. Likewise, the bracket capitals at these two sites are radically dissimilar in the curve of the edges in the profile of the bracket. The *pūrṇa ghaṭa* capitals of the porch pilasters show foliage extending beneath the foot of the vase and filling out the corners of the block to produce a square effect beyond that of any late Gupta example. The foliate panels of the walls are ingeniously varied and are carved with real skill. Yet the surface is flat, as if pressed against a pane of glass, and bias cutting is minimal. Here the vegetative logic of the design is lost; the explosive forces already visible at Bhumara have destroyed any central stem.

The main exterior images are medieval in style but not completely in iconography, perhaps the result of copying a much earlier model. On the rear wall Mahiṣamardinī wrenches the buffalo's head upward, a pose generally thought to have been abandoned after the Kushan period.[20] The Varāha on the north (Pl. 249), however, holds aloft a rather large Earth Goddess as earlier at Bhitargaon and later at Māmallapuram, unlike the nearby versions at Eran, Udayagiri, and Badoh Pathari. Figures such as the *gaṇa* holding Gaṇeśa's bowl of sweetmeats in Plate 250 are shown with bodies bent two-dimensionally. None of these images is as complex and complete in design as the Deogarh panels. The three play a comprehensible religious role: Gaṇeśa as the remover of obstacles first worshiped; Durgā as the consort of the main deity, Śiva; and Varāha as a Vaiṣṇava attendant upon Śiva. They are conceptually subordinate to the whole in the same way that their design is part of a network on the increasingly elaborate wall.

Gyaraspur

The ancient center of Gyaraspur, 40 kilometers east of Vidiśā and located on what was probably a trade route that led north along the Betwa River, is best known for its Hindu and Jain remains of the medieval period. The Buddhist *stūpa* on a hill 3 kilometers to the northwest of those temples must be earlier in date. An inscription on the base of one Buddha image (Plate 252) points palaeographically to a position in the late sixth or early seventh century.[21] Only a portion of the Bud-

20. R. C. Agrawala, "Goddess Mahiṣāsuramardinī"; Viennot, "Goddess Mahiṣāsuramardinī."

21. Huntington, "Gyaraspur." I am grateful to Dr. Huntington for sharing this manuscript and for correcting some of my erroneous

dhist creed is preserved, and this provides no historical or iconographic information.

Architecturally, the Gyaraspur *stūpa* is in certain ways distinct from the much earlier monuments of Sāñcī. The high, vertical base differs from the more hemispherical profile of previous *stūpas* (Plate 251). There is a surrounding *medhi* or terrace for circumambulation, with projecting platforms (except on the side that abuts on the hill) and Buddha images facing roughly the points of the compass. Remains of upright posts indicate that a simple railing of traditional type existed here.

Sculpturally, the contrast with the fifth-century works of Sāñcī (Plate 110) is striking.[22] This is true even in the conservative figure of the Buddha himself. The crossed legs are bent downward with various dislocations of the feet.[23] The distinction between parts of the body, such as neck and chest, is more abrupt and less organic at Gyaraspur. The head forms a less unified ovoid volume. The attendant figures stand in mannered poses, the bends of the body being exaggerated while the whole remains two-dimensional. Headdresses and drapery are elaborated in a florid way, reminiscent of those at Mandasor. The northern image (Plate 253) might be dated later than the others at Gyaraspur. But by the same token, this image, coherent and elegant in its distortions, radically stylizing the drapery in contrast with the overly fleshy modeling of the body, is the most successful of the four. The format of the back of the

slab is similar for all four images. I would therefore regard these as a contemporary group by different carvers, among whom the sculptor of the northern image was certainly most progressive.

Iconographically, the Gyaraspur images reveal new concerns. All the Sāñcī Buddhas must have held their hands in *dhyāna mudrā*, the position of meditation, and all show similar thrones and attendants. At Gyaraspur, the Buddhas are differentiated as follows:

west: *dharmacakra mudrā, cakra* below flanked by deer; Bodhisattva on left holds *kamaṇḍalu* or jar, on right holds lotus, has Buddha in hair

north: *dhyāna mudrā*, large lotus below flanked by Nāgas; Bodhisattva on left damaged, on right holds lotus, wears antelope skin, has Buddha in hair

east: *dhyāna mudrā, cakra* below flanked by deer(?); Bodhisattva on left has Buddha in headdress in *dhyāna mudrā*, on right holds fly whisk, hair in *jaṭa mukuṭā*, possibly with emblem in front (Plate 252)

south: *varada mudrā*, nothing below; Bodhisattva on left holds lotus, wears antelope skin,

information about the site. To my knowledge, the inscription is not published. The script compares most closely with the Maukhari and Apsaḍh inscriptions, and is definitely not as late as those of the eighth century. It appears to read ". . . *prabhavā hetum teṣaṃ tathāgato hyavadatteṣāñca yo ni* . . ." up to the central break.

22. The Buddha in Sāñcī Temple 31 may be contemporary with the Gyaraspur *stūpa* (Marshall and Foucher, *Monuments of Sāñchī*, pl. CXVc).

23. Foreshortened poses survive in later images: Irwin, "Sanchi Torso," fig. 11.

has Buddha in *dhyāna mudrā* in head-dress, on right has jewel in headdress (Plate 253)

One might expect the Buddhas to represent four of the five Jinas, but the gestures do not completely correspond to the later form for this group.[24] The northern image seems to represent the Great Miracle at Śrāvastī, identified by the serpents Nanda and Upananda below.[25] The deer on the base of the eastern figure would suggest the First Sermon, although this is difficult to reconcile with the *dhyāna mudrā*.[26]

Clearly the attendant figures at Gyaraspur represent Bodhisattvas, unlike those at Sāñcī, which had continued the earlier tradition of Brahmā and Indra.[27] One in each group of Gyaraspur bore a Buddha in the head-dress. Conceivably these attendants represent the so-called Dhyāni Bodhisattvas that correspond to the central Jinas.[28] It seems to me more likely that the Bodhisattvas with Buddha in headdress are, however, forms of Avalokiteśvara. Two of the miniature Buddhas (east

and south) are in *dhyāna mudrā*, and the Bodhisattvas on the south and north wear an antelope skin, all pointing to Avalokiteśvara.[29] Whatever the iconography, it is certainly more complex than anything we have seen so far in Gupta Buddhist art, and it is plausible that some overall program linked the four images in the same way that coherent religious planning came to dominate Hindu architecture in the sixth century.

Muṇḍeśvarī

Eastern India, particularly Buddhist centers such as Sārnāth, forms the most conservative guardian of Gupta traditions. We will consider the innovative Hindu remains of Muṇḍeśvarī first, however, because these are associated with a dated inscription. A slab found near the present temple bears the date 30, probably of the Harṣa era, which would correspond to A.D. 636; it mentions two temples, Vinīteśvara and Śrī Maṇḍaleśvara.[30] Fragments at the site extend from the sixth century until the eighth or later.[31] On stylistic grounds the surviving octagonal shrine should belong to the first

24. The hand positions should include *bhūmisparśa mudrā* rather than the repeated *dhyāna*; moreover, the directions do not correspond to the standard placement of the Jinas. De Mallmann, *Tântrisme bouddhique*, pp. 130-31.

25. Williams, "Sārnāth Gupta Steles," p. 183. Again, the remaining *mudrās* do not indicate the standard groups of four major events in the Buddha's life.

26. I follow Susan Huntington's assurance that these are in fact deer, although on the site I had taken them to be bulls, which (as the emblem of Ṛṣabhanātha) might suggest Jain influence.

27. The *jaṭa* of Brahmā and *kirīṭa mukuṭa* of Indra are clear on the southern image (Marshall and Foucher, *Monuments of Sāñchī*, pl. LXXc). It is conceivable that the remaining attendants represent

Bodhisattvas; a *vajra* in the hand of the right figure on the east might indicate either Indra or Vajrapāṇi.

28. The fact that the western main image is in *varada mudrā*, whereas the headdress Buddha is in *dhyāna mudrā*, would seem to militate against this suggestion.

29. The antelope skin may of course be worn by Maitreya, but he should not have a Buddha in the headdress as well.

30. *EI*, IX (1907), 289-90. N. G. Majumdar, "Muṇḍeśvarī Inscription," pp. 21-29. The dedication records the dedication of a *maṭha* (shrine) of Vinīteśvara (a form of Śiva). It also provides for upkeep from the storeroom of Śrī-Maṇḍaleśvarasvāmipada (also Śaiva) of the temple of Nārāyaṇa. The present shrine is Śaiva.

31. Asher, *Bihar*, pp. 73-77; Patil, *Antiquarian Remains*, pp. 291-93.

half of the seventh century. Hence this may correspond to the major temple of the inscription (perhaps already founded by 636), although the substantial unfinished portions and additions indicate that its carving was underway for a considerable period of time.

The octagonal plan of Muṇḍeśvarī may illustrate the same search for variety that takes the form of *pañcaratha* and stellate plans at Sirpur (Fig. 17). While the Śaṅkarācārya in Kashmir is the only other extant octagonal temple, the type, along with many others of which we have no examples, is described in the later texts.[32] The central niches (Plate 254) were presumably reflected in the articulation of the now-missing superstructure, as on the Lakṣmaṇa at Sirpur. The bold moldings form an *adhiṣṭhāna* or basement as well. Here, however, their relationship to the flat wall elements shows a deliberate inconsistency or complexity. The doors are set directly into the *adhiṣṭhāna* at ground level. The major niches rest upon this, using the upper base molding (*khura* or "hoof") as its own base. The minor niches rise yet higher on the *jaṅgha* or wall

The boulder described here with a six-armed "Yakṣī" in relief (more likely a very worn Mahiṣamardinī), does not appear to me to be Gupta. There are remarkable inconsistencies in old accounts of Muṇḍeśvarī, perhaps the result of the remoteness of the site from modern transport, thus requiring that visits be short.

32. For the Śaṅkarācharya, see *ASIAR* 1915-1916, pp. 72-73. For all the variety of temples described in the *Bṛhat Samhitā*, it does not explicitly mention an octagonal type. There are ten octagonal temples in the *Samarāṅgana Sūtradhāra* (Kramrisch, *Hindu Temple*, p. 281). In a recent article, Michael Meister argues that this plan results, not from a simple quest for variety but rather from a desire to reconcile opposing geometrical and cosmological systems ("Muṇḍeśvarī").

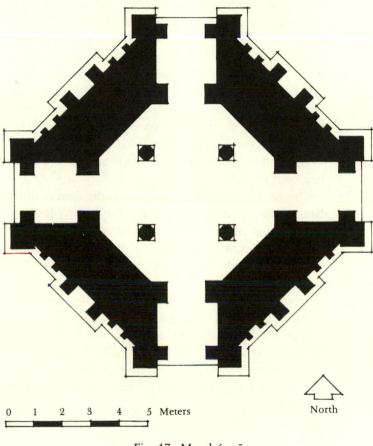

0 1 2 3 4 5 Meters

North

Fig. 17. Muṇḍeśvarī

proper. Moreover, the moldings themselves are interrupted and are rendered inconsistently on the doorway and projecting *bhadra* faces. The insertion of dentils into a rounded molding is comparable to Mahua. The very form of this round molding is the *kalaśa*, or "vase," which was seen at Sirpur. The insertion of small bits of foliage just above this, and the intervening bands of pearls represent a violation of the chastity of Gupta moldings. Other motifs are late in specific form. *Candraśālās* display both elaborate excrescences, which interrupt virtually the entire contour, and a three-lobed pattern on the inside.[33] *Pūrṇa-ghaṭa* capitals with foliage extending below the vase are topped with angular brackets, as at Mahua.

The eastern door (Pl. 255) follows the format of the latest Gupta portals, such as the Rupnī-ka Mandir at Nāchnā, but minor differences lead to a totally altered effect. The entire design is simplified by the emphatic frame around the guardians at the base and by the recessions within the bands above. The outer register of overlapping leaves is hardly recognizable, their broad form flattened and impinged upon by coarsely curling foliage that echoes the innermost band. The use of a relatively large (ca. 15 cm.) unit of design creates a regular, repetitive effect for the entire frame. The small figures, *gaṇas* on the side and flying attendants above,

are varied only in minor ways and form a serial band. The guardians lack the elaboration of the early medieval style elsewhere and remain squat in proportions; yet they stand two-dimensionally and hold their hands in flattened positions.

The sculpture from Muṇḍeśvarī, in part removed to the Patna Museum, is not exclusively associated with the surviving temple. One small four-sided carving at the site combines images that are very close to the guardians of the eastern door with a Gaṇeśa, which one might at first take to be earlier (Plate 256).[34] Yet the seemingly natural pose of this figure is as flattened as those of the guardians. The corpulent body and elephant head induce slightly more sensitive modeling than the usual human figure, as was also the case with the Mahua Gaṇeśa (Plate 250). In fact, the latter relief is very similar in sentiment and in iconography, supporting a contemporary date for Mahua and Muṇḍeśvarī.[35]

Sārnāth

The period from 550 to 650 is not one from which we have any clearly dated remains at Sārnāth, although this remained an important Buddhist center when Hsüan-tsang visited it in the seventh century. The Dhamekh Stūpa (Plate 257) has often been assigned to

33. The side projections appear in Mālwa as early as Nagarī, and their oblique angle indicates that they depict a slanting roof from which the *candraśālā* projects as a dormer window.

34. The other faces show Viṣṇu (four-armed); Pārvatī (four-armed) with lion and antelopes, holding rosary, long bud (?), and other unclear emblems (two fires below); and Sūrya. The Pārvatī most closely resembles Orissan images (Panigrahi, *Bhubaneswar*, figs. 109, 110).

Such a post should probably be described as a *dhvaja stambha*. Cf. an earlier one from Kutari, Harle, *Gupta Sculpture*, pp. 59-60. A second and probably later example from Muṇḍeśvarī (now in the Patna Museum) shows Durgā, Sūrya, Hari-Hara, and a damaged figure with spear.

35. For another, later, Gaṇeśa at Muṇḍeśvarī, see Meister, "Preliminary Report," fig. 19.

the fifth century on the basis of an unsupported assertion by John Marshall.[36] Its decor would make a date in the first half of the seventh century more likely. The interlocking merlons at the bottom of Plate 258 are transformed into large floral triangles, as is common in medieval temples.[37] Toward the top, garlands of pearls with bells and lions' heads between represent a motif not observed before Muṇḍeśvarī. While the large band of vegetation is more botanically accurate than others of this period, and while scale alone may explain the sparseness of the composition, the foliage itself is quite different from that of fifth-century Sārnāth. These fronds are relatively flat, their edges deeply notched with indentations, which produce a lacy pattern of light and shadow. The ingeniously varied geometric patterns are unusual in scale and effect, but they seem to be enlargements of similar swastika-derived bands at Muṇḍeśvarī. The high, vertical base of the Stūpa resembles that at Gyaraspur. The eight niches may have enshrined the seven Buddhas of the past and, on the west, Maitreya, who is supposed to have been assured here by Śākyamuni of his future Buddhahood. Thus both the Dhamekh and the Gyaraspur *stūpas* suggest a new complexity of program.

A lintel fragment in Plate 259 seems modeled upon the Kṣantivādin lintel (Plate 233), although the altera-

tion of details reveals a date as much as a century later. The band of broad, overlapping leaves has been conventionalized. Below, a row of interlocking triangles with superimposed flowers simplifies the merlons of the Dhamekh Stūpa. The architectural forms, which represent miniature temple superstructures, differ from those of the earlier lintel principally in detail. The *candraśālās* that project from these consist of a single rather than a split and doubled arch; yet the outer contour is considerably elaborated, particularly above, producing a more vertical effect. The figures reveal their early medieval date in the way their limbs are disposed in complex positions on a single plane. Thus the attendants upon the right-hand Buddha exceed any member of the Kṣantivādin lintel in the irrationality of their flattened curve. Both of the preserved fragments of this later lintel substitute formulaic scenes of worship for the narrative concerns of the earlier work.

Undoubtedly many of the large images of Sārnāth and of Nālanda belong to this same post-Gupta phase, but I shall leave the refined discriminations here to specialists in eastern Indian art. One example dated on palaeographic grounds to the seventh century is the Bodhisattva shown in Plate 260.[38] The Buddha in the headdress in *bhūmisparśa mudrā* represents Akṣobhya; this should in turn identify the Bodhisattva as Mañ-

36. *ASIAR* 1904-1905, p. 72 n. 2. Marshall wrote in this footnote that new evidence had come to light proving conclusively that the Dhamekh Stūpa belonged to the Gupta period rather than to the eleventh century, as Oertel, the author of the report, had asserted (indeed too late a date). This evidence has never been published. Cunningham's original excavations into the mound produced a tablet with an inscription of the sixth or seventh century, usually assumed

to be a later insertion but in fact quite possibly contemporary with the present form of the monument.

37. For example at Osian (*ASIAR* 1908-1909, pls. XXXVIIb, XLIIB) and at Auwa (Meister, "Preliminary Report," fig. 24).

38. *ASIAR* 1904-1905, pp. 81-82. D. R. Sahni (Sahni and Vogel, *Catalogue*, pp. 120-21) specifies that the inscription is late seventh-century; I do not feel that we can be that precise.

juśrī, his youthful offspring, in the form known as Siddhaikavīra.[39] If this image is mid-seventh century, it, together with one in Cave 12 at Ellora, constitutes a very early example of this specialized form of Mañjuśrī.[40] Perhaps there were originally four female attendants in the Sārnāth image as well.[41] Although the western Deccani form is not visually related to that at Sārnāth, iconographically the two are comparable, illustrating the progressive subdivision of standard Bodhisattva types and the systematic differentiation of their attributes.

Stylistically, the Sārnāth Siddhaikavīra seems superficially close to the Bodhisattvas discussed in Chapter III. There is still restraint in the composition, as well as elegance in the carving of details such as the *yajñopavīta* looping over the complex belt of linked construction. Yet the body of the Bodhisattva bends within a single plane, pliant as the lotus stalk that echoes the curve of the hip. Anatomical articulation is minimal, and the dumpy attendants are simple versions of the main figure. While jewelry does not totally overwhelm the smooth surfaces of the body, there is a certain sameness throughout the ornament. Hair, necklace, armbands, waistband, and *dhotī* all form looping curves, unlike the contrasting decorative effects of Gupta sculpture. The head no longer maintains a unifying oval vol-

ume: ears protrude, and the face becomes square from the central placement of the eyes and the double-edged eyebrows. In an image not radically different in function from the earlier Sārnāth versions of the same type, we see here the shift to a medieval style at its most subdued. The change should not be interpreted merely as a decline in skill. Taste had surely changed since the fifth century, and possibly the earlier images would have been regarded as too simple, both in visual and in religious terms.

Tezpur

One monument from the easternmost province of India deserves attention here because it is frequently classed as Gupta and might be used in testimony to Samudragupta's conquest of Assam. This is the doorway at Dah Parbatiyā, five kilometers from Tezpur (Plate 261).[42] Here the T shape and the genuine three-dimensionality of the River Goddesses might imply an early date. Yet closer inspection suggests that these are atavistic features surviving in an outlying area that drew upon a variety of traditions formed elsewhere. The small figures on the jambs stand in poses less anatomically credible than the Gaṅgā and Yamunā. Both women immediately above the bottom *pūrṇa ghaṭa* twist their heads backward even as they move forward on stiff

39. De Mallmann, *Mañjuśrī*, pp. 32-33. The absence of his customary youthful locks of hair and tiger-claw amulet is puzzling.

40. Gupte, *Buddhist Sculptures of Ellora*, pp. 85-87, pl. 8d.

41. Sahni identified these as Bhṛkuti and Mṛtyuvañcana Tārā (Sahni and Vogel, *Catalogue*, p. 121), on the basis of their attributes. These forms of Tārā are not particularly associated with Mañjuśrī. The

Sādhanamālā does, however, prescribe Candraprabha, Jāliniprabha, Keśinī, and Upakeśinī surrounding Siddhaikavīra (*Sādhanamālā*, p. 145). None is specified as holding the *akṣamālā* visible to the right in Plate 260, but at Ellora the attributes do not precisely follow the *Sādhanamālā*, either.

42. *ASIAR* 1924-1925, pp. 98-99.

legs. The frame around the River Goddess groups, while less obtrusive than at Muṇḍeśvarī, is similar in its compartmentalizing effect. The Garuḍa in the center of the lintel, grasping the tails of the *nāgas* that emerge at the bottom of the jambs, does not occur before the early seventh century.[43] The outer and middle bands of foliage are unique as configurations of rigidly axial structure. The innermost band has a strongly Gupta flavor in its bold leaves, but the pattern of repeated circular forms shows the regularity of Orissan foliage of the eighth century and later.[44] The iconography, with Gaṇeśa and Kumāra (much damaged) at the top of the jambs, Lakuliśa in the center of the lintel, flanked by Sūrya on his right and an unidentified male figure (perhaps Viṣṇu) on the left, follows patterns current in Bhuvaneśvar in the seventh and eighth centuries.[45] The coarse pearl borders of the top *candraśālās* are strongly Orissan in flavor. Surely this isolated example of early stone carving in Assam is less likely to be connected to Samudragupta's conquest than to Śaśāṅka's hegemony early in the seventh century.

Gop

In the far west, the Maitraka dynasty of Valabhi bridges the gap between the period of dissolving Gupta power and the eighth century. The Gupta era remained in use here, although by A.D. 556 references to an overlord vanished, and soon feudatories appeared under the Maitrakas. In the second quarter of the seventh century, Hsüan-tsang reported that Valabhi was ruled by a king named Dhruvapata; inscriptions of a Maitraka ruler by that name are known from A.D. 606 to 612.[46] The Chinese pilgrim described Saurāṣṭra as a separate kingdom but dependent upon Valabhi. He reported that the country was at this time rich, chiefly on the basis of sea trade; this observation is borne out by the position of the later Maitraka and Saindhava temples, clustered along the coasts.

Our first structural temple in this region, perhaps the only one relevant for discussion here, is the inland site of Jhināvārī Gop (Plates 262-63). Its construction represents a technical tradition different from that of the stone shrines in central India, for the walls are thinner and apparently lack the double structure characteristic of Gupta buildings. The *jagatī* or plinth, divided into two separate terraces, invites comparison with the simpler ones at Nāchnā and Deogarh. The cella of Gop today rises starkly with unusual height. It is clear from old photographs, however, that the base was originally surrounded by a wall forming a balustrade or possibly an enclosed passageway, which would have broken the present vertical lines.[47] Moreover, deep, regular holes

43. Viennot, *Temples*, p. 128.

44. Panigrahi, *Bhubaneswar*, fig. 13 etc.

45. Ibid., ch. VIII, figs. 96, 106, 124, etc. The small intervening *candraśālās* at Tezpur appear to be occupied by animal-headed musicians.

46. *Buddhist Records*, p. 267.

47. Burgess, *Kâthiâwâḍ and Kachh*, pl. LI. It is clear in Burgess's photo that some of the stones piled along the top of the *jagatī* wall are not in their original positions. From the western face it appears that four courses of stone surmounted the present surface of the upper terrace, forming a balustrade with slightly higher sections at the corners and in the center of each side.

along the top of the cella wall indicate support for the end of beams that might have supported an awning or roof above a circumambulatory passage. The severe pent roof of the temple at Gop is unique at this point, if related to the tapered and layered effect that must have existed at Bhumara. The roof of Gop "explains" the particular form of candraśālā with triangular projections to the side (such as at Nagari), for these additions seem to reproduce the form of the pent roof from which the arches project like dormer windows. The temple at Gop represents an ambitious and innovative beginning for stone architecture in Gujarat. It is possible that the source was a local wooden architectural tradition, although forms derived from wood are not particularly striking. It is also possible that the sources were verbal, for Gop corresponds rather closely to texts, albeit later ones.

The date of the temple at Gop has been most carefully discussed by M. A. Dhaky, and his placement at ca. A.D. 600 seems acceptable.[48] The moldings, if not identical with those of buildings treated already in this chapter, are elaborate and clearly later than those of the

Gupta temple at Deogarh or the Parvatī at Nāchnā. A garland appears above some of the lower niches, comparable to the looped bands of pearls at Muṇḍeśvarī and Sārnāth. The moldings are not continuous across the central projecting plane. Candraśālās appear on the base in the same way that they appear on the lower wall at Sirpur and Mahua. At Gop, however, these arches rise above the kapota or cornicelike molding, rather than being set into it; the total effect is to replicate an actual shrine in relief on the base. The form of the candraśālās is traditional and backward-looking, except for the interior articulation with lobed arches and a pendentive above.[49] These are analogous to the trilobate candraśālās of Muṇḍeśvarī (Plate 254). Moreover, some niches on the base at Gop (Plate 263) show multiple pendentives like those that grow in importance in seventh-century Kosala (Plate 246). All these comparisons suggest a general position in the last quarter of the sixth century A.D. or the first quarter of the seventh.

Finally, the gap that separated Gop from the main body of Maitraka temples in the area supports a rela-

48. Nanavati and Dhaky, *Maitraka and Saindhava Temples*, pp. 33-40. Dhaky writes that the *jagatī* has a basic similarity to that at Deogarh, a matter that I fail to see except in its very presence. He notes a "strong family likeness" between the moldings and those of the Anandaprabhā Vihāra at Sirpur. While a similar sequence does occur at the bottom of the upper section of the Gop *jagatī*, *candraśālās* are not found on the Gop *kapota* (cornice) molding; without this, the section is not very distinctive. The Sirpur *vihāras* (like Gop) lack any *kalaśa* or vase moldings such as those of the Sirpur Lakṣmaṇa, a feature current in the seventh century. Finally, Dhaky notes a resemblance between the niche of the Lakṣmaṇa *prahāra* (spire base) and that of the Gop *jagatī*. I cannot see this in any detail, for pilasters are

very differently attached to the upper moldings in the two. These reservations are not intended to deny the great worth of Dhaky's thoughtful discussion. Nor would one expect complete analogies of detail between regions so far apart as Saurāṣṭra and Chattisgaḍh at a single point in time.

49. Odette Viennot considers this motif in her book, *Temples*, pp. 13-14. I cannot agree with her contention that the triangular wings are a new feature at Gop; surely Nagari and Mandasor show this feature earlier in the sixth century. Nor can I accept her suggestion that the disposition of such arches on the roof in alternating rows is an innovation here, for Bhumara seems to me considerably earlier and to have shown this arrangement.

tively early date. The later temples, like those of medieval India in general, use *candraśālās* of diminishing size on the roof. Here the Bileśvara shrine is transitional between Gop and the bulk of Maitraka-Saindhava architecture, and its analogies with the Rajivalocana Temple at Rajim indicate a late seventh-century position.[50] Gop is considerably earlier than that.

The figural sculpture of Gop has not survived in a condition that permits extended stylistic analysis, although it may well have been related to the sculpture of sites in northern Gujarat, 350 kilometers to the northeast.[51] A seated Durgā from Udaipur illustrates one aspect of late sixth-century style (Plate 264). The break between this and the earlier Mātṛkā of Plate 224 is minimal, aside from the accidental difference between a symmetrical and a hip-shot pose. Yet if we look closely, it is clear that the foliage beneath Durgā's feet has been reduced to a smooth plane with grooves on its surface. The elaborate headdress shows a certain dryness and fussiness of execution. The soft irregularity of modeling that gives the earlier Mātṛkā a sense of spontaneity has disappeared. Arms and legs are tubular, and their raised positions make them less credible than those of earlier Gujarati figures. In sculpture one sees a

continuation of an earlier regional style, whereas in architecture Gop seems rather to initiate a regional idiom.

Marwar: Mandor

Mandor in northwestern Rajasthan became the capital of the Gurjara kingdom toward the middle of the sixth century, and its political importance from that point on is clear. Yet paradoxically, the carvings that begin in this period are no better documented in historical terms than were the earlier slabs of Mandor, discussed in Chapter II. These last were thought to represent stylistically fresh and provincial versions of iconography derived from Mathurā. This is clearly not the case with the panel of the Saptamātṛkās or Seven Mother Goddesses in Plate 265.

This relief is located 25 meters from an inscription of the year 685.[52] Although the bearing of the inscription on the images is moot, it supports a seventh-century date for them in a general way. And that is clearly the position which their style would indicate in light of developments elsewhere. The figure type is still relatively heavy, and the legs are not repetitively splayed, as are those of later Pratīhāra examples from Rajasthan.[53] Yet three Mātṛkās (Māheśī, Kaumarī, and

50. Nanavati and Dhaky, *Maitraka and Saindhava Temples*, pp. 55-56, pls. 28-30. For the dating of the Rajivalocana at ca. A.D. 700, see Stadtner, "Sirpur to Rajim."

51. Two standing images found within the temple at Gop are very weathered but resemble figures from Śāmalājī (Shah, "Śāmalājī and Roḍa," pls. 41 and 47). The Gaṇas of the base at Gop bear comparison with a set from Devnimori (Shah, "Śāmalājī and Roḍa," pls. 55-59).

52. *Report*, Jodhpur, year ending 30 Sept. 1934, VIII (Jodhpur, 1935), p. 5. D. C. Sircar asserts in this report that the images were made at the time of dedication of the well. R. C. Agrawala has assigned the images to the early seventh century, perhaps influenced by the distinctions between them and medieval works published in the same article: "Mātṛkā Reliefs," p. 86.

53. Agrawala, "Mātṛkā Reliefs," fig. 18.

Aindrī) stand on the side of one foot with the same disregard for anatomical credibility that we have seen at Sirpur (Plate 248). The legs of the dancing Śiva in the center of the panel are spread farther apart than the mid-sixth century version in the central panel of the Sakhor lintel (Plate 191). Thus these figures are fully abreast of general early medieval stylistic developments.

The standing position of these figures had been known earlier in Mathurā, although the major Gupta sets (Udayagiri, Besnagar, Badoh Pathari, and Deogarh) were all seated.[54] The Mandor Mātṛkās are, however, more clearly differentiated than any previous group by their animal vehicles and by their attributes. This is one of the first examples, moreover, in which Śiva takes the form of a dancer in the company of the goddesses. The later Rajasthani conception of the entire set is a bacchanalian troupe, perhaps with tantric overtones. Mandor hence opens the way to very distinctive regional iconography. In short, this relief shows the artists of Rajasthan using pan-Indian stylistic forms to represent local currents of belief, whereas the early Gupta artists of the same site had followed the iconographic lead of Mathurā within the limits of provincial style.

Conclusion

After the year 550, the pace of regional differentiation quickened. At that point, the counterforce of conservatism, which functioned even in the late Gupta period, was gone. Carvers no longer perpetuated a past tradition that had been imperially defined. The growth

of regional styles accounts for the sense that examples in this chapter are plucked out of their proper context. We conclude in medias res. Most of these temples and images figure in recent monographs on various early medieval styles. One scholar's postscript is another's introduction.

The changes that the present work emphasizes by way of contrast with the Gupta were surely deliberate. Gupta norms were altered, but not from a decline in skill or a misunderstanding of their import. A change of taste had occurred, part of a change in the very conception of the role of art. Thus architecture became more complex and coherent as a religious experience, and sculpture was integrated into that larger purpose. This new role led to the patterning of detail, linking different parts of the temple's decor. It also led to the depiction of less credible human anatomy, the creation of less self-sufficient sculptural compositions, and the organization of imagery in more inclusive iconographic programs. Such distinctions are stressed here precisely because seventh-century works have often been included under the rubric of Gupta style.

The explanation for such change does not lie primarily within the production of art. General religious and social currents that correspond to this shift have been indicated at the beginning of this chapter. The evidence lies mainly in inscriptions and in the art itself. Outside those areas, we have little basis for asserting the aesthetic foundation of the visual arts in the Gupta period. Texts that focus upon the production of images and

54. Ibid., p. 86.

temples begin with the *Bṛhat Samhitā* of the sixth century. Thus the status they project for art is post-Gupta, and the authors are generally, like Varāhamihira, learned Brahmans rather than participants in the visual arts.[55] The inarticulateness of the artist is not peculiar to India. Yet here it seems that other sources have too consistently been allowed to speak for him.

Hence the fundamental assumption in this book that aesthetic concerns motivate the development of Gupta art and distinguish it from what follows. This flies in the face of the long-held tenet in the history of Indian art, that religious concerns are consistently central and that a formal approach by Western critics is doomed to ethnocentrism. I would concur in this estimate to the extent that the aesthetic basis of Gupta art has made it particularly attractive to Western audiences. Yet this is not to deny the reality of that basis. A false dilemma may seem to be created if form and content or aesthetic and religious goals are conceived as mutually exclusive. Throughout the history of Indian ideas, a balance between *dharma* and more practical concerns was evoked. That balance shifted in different periods, but art and religion were never competing systems of values. More precisely put, the ritualistic aspects of religion did not condition the work of art in the Gupta period to the extent that they did the works of the early medieval age.

55. Among the *śilpa śāstras*, the *Samarāṅgaṇa Sūtradhāra* purports to be the work of the ruler Bhoja, who actually designed buildings as an architect, although its concerns are on the whole as scholastic and classificatory as those of most texts. The *Śilpa Prakāśa* and other illustrated Orissan texts come closest to the practical concerns of the carvers and planners.

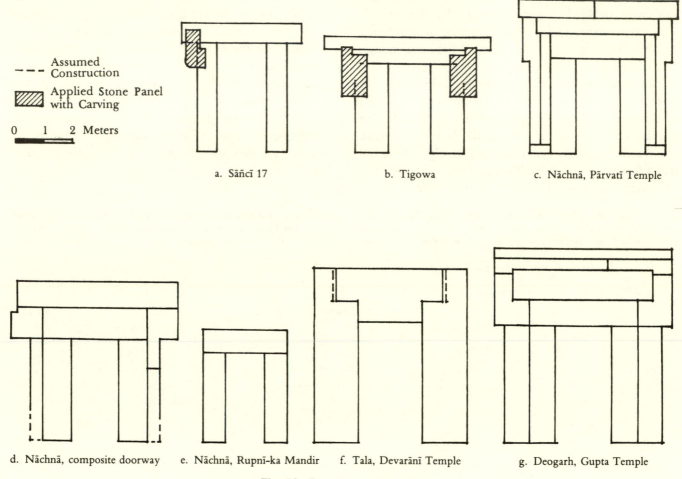

Assumed
Construction

Applied Stone Panel
with Carving

0 1 2 Meters

a. Sāñcī 17 b. Tigowa c. Nāchnā, Pārvatī Temple

d. Nāchnā, composite doorway e. Nāchnā, Rupnī-ka Mandir f. Tala, Devarānī Temple g. Deogarh, Gupta Temple

Fig. 18. Doorway construction

EPILOGUE

In the new world of medieval India, how can we reconcile the demise of Gupta traditions with the designation of the Gupta as a Golden Age? The situation in art is analogous to the Vikramāditya legend.[1] For medieval writers, Vikramāditya was the model ruler. He was a conqueror (the literal meaning of the name), a man of wisdom, and a patron of the Nine Jewels—a group of savants that included the poet Kālidāsa and the astronomer Varāhamihira. This legend is clearly composite. The ruler was identified as founder of the Vikrama Saṃvat, an era beginning in 58 B.C. That era was, however, known as the Mālwa era as late as the sixth century A.D., in the inscriptions of Mandasor. Stories about Vikramāditya, including his instruction by a ghost, are preserved in various works such as the *Kathāsaritsāgara* of eleventh-century Kashmir. These identify him both as a contemporary of the Sātavā-

hana king Satakarni (probably first century A.D.) and as Harṣa of Kanauj (seventh century A.D.). Such irreconcilable facts cannot fruitfully be reduced to a core of historical truth. Rather they illustrate the inventive way in which Indians have found models both in the historical past and in what we distinguish as myth. In the words of the eminent historian, Arthur Basham, questions of historicity are irrelevant.[2] The epithet *vikramāditya* itself, the patronage of Kālidāsa, and the exploits against the Śakas are important Gupta elements in the composite whole. At most, one can say that the growth of the Vikramāditya legend after the year 600 is part of the identification of the Gupta period as a model age.

Likewise in Indian art, the Gupta style does not occupy an exclusive place as an ideal.[3] The emblematic pillars considered in Chapter III are in the same way

1. Sircar, *Ancient Malwa and Vikramāditya*.
2. Basham, "Ancient Indian Ideas of Time," especially pp. 62-63. My ideas are much indebted to this essay.
3. The role of Gupta art as an international model is a subject for another book. Although the relationship is sometimes close, as for example in the earliest Dvāravatī sculpture of Thailand, it seems to me to have been overemphasized. On the one hand, local variations are far greater than among the incipient regional styles of late Gupta India. On the other hand, it is worth distinguishing direct Gupta influence from that of later, conservative Indian styles, particularly because such conservatism was entrenched in the Buddhist centers that were accessible as sources for the so-called International Gupta style(s) of Buddhist Asia.

one link in a chain that goes back to the Maurya age and that extends on to sixteenth-century Nepal. For the role of Gupta art in particular as a model, some medieval images based directly on Gupta works are of interest. Such apparent copies admittedly constitute a limited sample of medieval art, yet they serve to focus on the attitude of artists in later ages to this portion of their past.

The first example, a Sārnāth Preaching Buddha of the ninth century or later (Pl. 266), invites comparison with the great First Sermon of Plate 94.[4] The differences here are obvious enough. The foliage has been reduced to a flat pattern that only distantly evokes vegetation. Some of the nonhuman metaphors implicit in the body are lost or altered; for example, the stove-pipe symmetry of the upper arms no longer suggests the trunk of an elephant. The balanced geometry of the Gupta image yields to a centrifugal organization. Thus it is peculiarly unjust to take the later work out of its architectural context, whereas the earlier work permitted such excerpting. In the case of this example, one may wonder whether this particular Gupta image was the model, and indeed whether the medieval work is not simply the extension of those conservative habits that had long characterized the workshops of Sārnāth.

In a second example, it is easier to assert that a Gupta work provided a specific model for the later sculptor, without intervening links. This is the case of a *linga*, probably of the eighth century, now installed in the Mahādeva Temple at Nāchnā (Pl. 267), which follows iconographically the *linga* of about the year 500, found a kilometer away (Pls. 161, 162).[5] In the later work, again, lines harden and detail elaborates itself. The phallic form in the center lengthens to make the composition less compact. This subject illustrates, moreover, the way in which the dramatic content of the Gupta work changes. The differentiation of the four heads had been primarily a formal matter of lines and specific attributes in the earlier image; the later one achieves this by means of facial expression. This is striking in the fierce (Aghora) heads, where the Gupta snarl rises to a medieval shriek. The process runs parallel to the changing conception of *rasas* or moods in dramatic literature: a standard set of eight of these distilled emotional states became progressively formulaic and central to the structure of the poem, and characters were often equated with the *rasa* or state that they embodied. The visual arts followed their own logic in depicting these dramatic states, but the goal was related to that in literature.

4. Sahni and Vogel, *Catalogue*, pp. 89-90 (noting that the Buddhist creed is inscribed on the rim in characters of about the ninth century A.D.). Susan Huntington ascribes this and two closely related pieces to the reign of Mahīpāla, early in the eleventh century (*Bihar and Bengal*, p. 102). Both Vogel and Huntington note the probability that the sculptor came to Sārnāth from Bihar. In this case, I would not like to stress a direct relationship to the version of Plate 94, for many intermediaries are possible either at Sārnāth or Bihari centers such as Bodh Gayā.

5. Kramrisch, *Art of India*, pl. 108. Odette Viennot places the Mahādeva Temple in her sixth period, that is, in the ninth century, but she appears to ascribe the *linga* to an original core, which I find improbable. (Viennot, *Temples*, p. 109.)

Finally, Deogarh provides an example in which the distinctive iconography and compositions of the Gupta temple are clearly the model for the nearby Varāha Temple, built probably in the eight century.[6] In the medieval version of the Delivery of the Elephant King (Pl. 268, cf. pl. 205), natural distinctions of texture are lost. The Garuḍa's wing, the elephant's ear, and the foliage below form a unifying net of related patterns. The composition is organized, but not in terms of the self-sufficient interlocking triangles of the Gupta panel. Aside from the pivotal angle of the legs of Viṣṇu and the Garuḍa, lines radiate outward in a seemingly irregular way. The principal characters are isolated and abstractly conceived, each confronting the viewer and evoking its own counterpart emotion. Thus the stiffness of the elephant may in fact be justified as an image of captivity, suggesting pity, or the *karuṇa rasa*. This differs from the convincing interaction between the participants in the Gupta tableau. While it may take some effort on our part to convince ourselves that these are not the inevitable mistakes of the copyist, surely such changes are deliberate.[7]

Are these three examples of archaism, the use of the language of the past? It appears to me that this term is not appropriate, precisely because no previous language or formal idiom is borrowed. The distinction is not a matter of degree, for rarely is archaism complete. It is a distinction of kind to say that both the forms and the full content of Gupta art are not imitated in these apparent "copies." Archaism must be defined against the mainstream of art that it rejects. Here medieval style is neither rejected nor altered. This is Picasso "repainting" Velasquez, not a sculptor of fifth-century Greece reviving an archaic idiom.

Nor would one expect in India the self-conscious revival of the past that is implicit in the term archaism. For the medieval Indian, the past provided a continuum of models stretching backward in cosmic duration. Remains of the Gupta period were accessible by their proximity in time and hence their relatively copious survival—greater than what remains today, as we are reminded by destruction in the last century. Gupta remains were accessible by their extent across a large part of north and central India. Yet the conception of the past did not permit distinctions between various periods any more than it did between the real and the

6. Although the Varāha Temple (ca. 1 km. from the Gupta temple) was mentioned as early as 1899 in Mukherji's *Report on Lalitpur* (pp. 11-12), the first detailed account with illustrations is that of N. R. Banerjee, "New Light on the Gupta Temples." Viennot appears to accept the latter's placement as preceding the better-known Gupta temple at Deogarh (*Temples*, pp. 82, 246). Banerjee provides no strong arguments that the Varāha Temple is the prototype. He notes that the figures are stiff, and he compares the Varāha image with that of Udayagiri. Admittedly, this temple is based so thoroughly on the Gupta version that it is difficult to point to exclusively medieval motifs. My comparison of the two Deogarh reliefs may take the place of a detailed chronological discussion.

7. In the case of the two Nara-Nārāyaṇa panels, there may be one misunderstanding or reinterpretation of subject matter. The medieval version shows a central nymph undifferentiated in scale from the rest. If this figure represented Urvaśī in the Gupta version, the significance was perhaps lost in the second.

unreal. The medieval sculptor was in need of a variety of exempla, but that need was very different from the purpose for which Gupta images in particular were created. To pragmatic Western eyes, the relationship between Gupta art and the art of later periods that described this as a Golden Age is superficial. This may in turn discredit claims for the wide extent of such forms in their own period. The works themselves indicate that in the fifth century, however, Gupta art was neither myth nor haphazard collection of local styles, whatever its role for ages to come.

Appendix: Ajaṇṭā and the Art of the Vākāṭakas

The discussion of the caves of Ajaṇṭā in an appendix deserves some explanation, for these are often cited as masterpieces of Gupta art. The reason for their omission in the text does not lie in the fact that this part of the Deccan was ruled by other dynasties; I have tried to separate Gupta hegemony from Gupta style. One primary explanation lies less in the caves than in the scholarship about them. As Wayne Begley has put it, the study of Ajaṇṭā has become a field within a field.[1] To do justice to the topic would require another book. It seems possible here only to summarize other scholars' opinions and to evaluate these briefly. This process leads to a secondary explanation for the omission of the caves of Ajaṇṭā from a book on Gupta art: the fact that they seem to represent a separate phenomenon.

In the controversy about the dates of the Ajaṇṭā caves, the suggestions of Walter Spink are focal. For him, the "Mahāyāna" caves[2] correspond to the late years of the Vatsagulma or western branch of the Vākāṭaka dynasty (whose main branch figures in Chapter II), and specifically to the reign of Hariṣeṇa, whose minister Varāhadeva was the donor both of Cave 16 at Ajaṇṭā and of the nearby cave at Ghaṭotkaca.[3] If these two caves represent the earliest and latest phases of work in the region, and if the carving at both is roughly correlated with the inscriptions, it would follow that the excavations span no more than one generation. The general sequence among the caves is based upon several suppositions taken together: the general expansion of the site outward from a core around Cave 16; the general succession of the unfinished caves after the finished ones; and the development of ground plans to place the Buddha in the shrine against the rear wall (as opposed to a free-standing position) as well as to use more numerous and more complexly designed cells. For refinements in his chronology, Spink also considers Buddha images (introduction of the "European pose," substitution of attendant Buddhas for Bodhisattvas, introduction of flying couples, and the growing use of birds in throne backs), doorways (introduction of structural references), and pillars (replacement of octagonal by square bases with complex shafts, introduction of diagonal

1. Begley, Review of Weiner, p. 570.
2. The term "Mahāyāna" is a conventional way of distinguishing the later excavations at Ajaṇṭā from those of the first centuries B.C. and A.D. (Caves 9, 10, 12). The one overtly sectatian inscription among the later caves is of the Mahāsaṃghikas, an advanced Hīnayāna sect.
3. This was first suggested at a conference on Gupta art organized by John Rosenfield at Harvard University in 1961. See Spink, "Ajaṇṭā and Ghatotkacha"; "Ajaṇṭā's Chronology: The Problem of Cave Eleven"; "Ajanta: A Brief History."

flutes). In recent articles, Spink has made certain changes in his sequence, notably the division of the carving of Cave 16 into two distinct phases. It is worth pointing out at this point that both Begley and Stern arrived independently at a similar ordering of the caves. Up to 1972, Spink had accepted the dates that V. V. Mirashi assigned to Hariṣeṇa, providing an absolute range of ca. 465 to 502 for the caves.

In publications since 1974, Spink has pushed back his estimate of the absolute dates to the period from ca. 462 until 485, corresponding to a revision in his opinion about the years of Hariṣeṇa's rule.[4] This is based in the first place on epigraphic evidence. In the inscription from the Ajaṇṭā Cave 16, Hariṣeṇa is said to have conquered Trikūṭa, apparently early in his reign.[5] By A.D. 490, Traikūṭaka plates indicate that this dynasty was in independent control of the western coast.[6] From this, Spink infers that 490 is a terminus ante quem for the collapse of the Vākāṭaka empire. The inscription of Cave 16 claims also, however, that the western Vākāṭakas controlled Kaliṅga (southern Orissa) and Andhra, which is not likely to have been the case. Thus the ascendancy of the Traikūṭakas on the coast in 490 may be part of a gradual gnawing away at Vākāṭaka territory, rather than indicating the sudden collapse of the older dynasty.

In the second place, Spink's most recent dates are based on the tale of Viśruta in the *Daśakumāracarita* (Story of Ten Princes) by the seventh-century poet Daṇḍin. In this account, the rulers of Aśmaka (a dynasty whose ministers are mentioned in the inscription of Cave 26 at Ajaṇṭā) are said to have spread dissent in the area, suggesting Vākāṭaka decline even before 490 and the emergence of the Traikūṭakas. Moreover, a prince of the dynasty overthrown by the ruler of Aśmaka is said to have fled to his uncle at Māhiṣmatī on the Narmada River, an event that Spink infers must precede A.D. 486, when we have an inscription that identifies Subandhu as ruler of Māhiṣmatī with no reference to the Vākāṭakas.[7] Yet it seems dangerous to build upon the negative evidence of this last plate, for in ancient India claims to overlordship are often made without being borne out in the vassals' inscriptions. Furthermore, the relationship between the *Daśakumāracarita* and what must have been a complex political situation a century earlier is extremely speculative. In fact, the Vākāṭakas are not mentioned by name, and their role can only be inferred from that of the Aśmaka family and from geographical references.[8] In short, I find this recent hypothesis by Spink difficult to accept, and would prefer to think of Vākāṭaka patronage at Ajaṇṭā as extending roughly from 460 to 505. The

4. "The Splendours of Indra's Crown"; *Ajanta to Ellora*; "Ajanta's Chronology: The Crucial Cave."

5. Mirashi, *CII*, V, 107-10.

6. Mirashi, *CII*, IV, 25-32.

7. Mirashi, *CII*, IV, 18-19. This interpretation of the date assumes that it refers to the Gupta Era, which seems to me probable in terms of palaeography and content. Mirashi and Weiner, however, refer the inscription to the Kalacuri-Cedi Era, yielding a date of A.D. 417.

8. This was ingeniously proposed by V. V. Mirashi in "Historical Data," which differs, however, in details from Spink's version. In his 1974 article, p. 760, Spink identified Subandhu as the Vākāṭaka heir's uncle, whereas subsequently he identifies Subandhu with Viśruta, a separate successor to the Vākāṭakas from Magadha.

question remains at this point whether this includes all of the excavations at the site.

Philippe Stern, working since 1935, arrived at a general arrangement similar to Spink's, although this was not published in detail until 1972.[9] Stern was concerned with relative rather than absolute chronology. He indicated in passing that Spink's range appeared too narrow, but subsequently Odette Viennot, associated with Stern's research, has accepted the earlier version of Spink's dates and has assigned the Ajaṇṭā caves to the second half of the fifth century.[10] Stern divides the excavations into three phases primarily on the basis of columns, with some reference to the progress outward from the center of the site. In Period I (Caves 11, 7, 15, lower 6), we see simple octagonal columns without capitals, as well as forms modeled upon wooden prototypes. In Period II (Caves 16, 4, and 17), an enrichment of these forms begins, along with a hierarchical differentiation of columns within one cave. By Period III (Caves 19, 21, 1) the octagonal column without capital is gone, and other details are elaborated, remaining harmonious and hierarchical in their deployment. In Period IV (Caves 20, 21, 23, 24, and 26), the overflowing vase appears, figurative details sometimes invade the column, and elaboration continues. While the sequence is in general that of Spink, small differences point

to a different frame of reference. The treatment of Cave 16 is illustrative: for Stern, this belongs to Period II. For Spink, both very early and late forms occur here, some of which Stern does not discuss at all; these lead Spink to suggest that work continued here from the beginning of Hariṣeṇa's reign until almost the end, interrupted briefly in the middle.[11] Stern's picture is certainly clearer but does not take into account as much of the cave as Spink's in terms even of columns, let alone of other features.

Wayne Begley has defended most vigorously a long chronology of ca. 150 years for the Ajaṇṭā excavations, although his relative sequence is close to those of Spink and Stern.[12] Begley divides the caves into four groups: I (11, 7, lower 6); II (16, 17, 14, 15, 5); III (1, 2, 19, 20); and IV (26, 21, 23, 24, 14). For Group II, he accepts an association with Hariṣeṇa on the basis of the Cave 16 inscription, and hence he attributes these caves to the last quarter of the fifth century.[13] Begley places Group IV around 575, a date assigned on palaeographic grounds to the inscription of Cave 26. He sees the cave at Ghaṭotkaca as spanning the entire period of work at Ajaṇṭā, as does Spink; but Begley questions Spink's use of the inscription here to establish the date of the latest phase as still falling within Hariṣeṇa's reign. It is true that the reading of Varāhadeva's name as donor

9. Stern, *Colonnes*.

10. Ibid., pp. 137-38; Viennot, *Temples*, p. 204.

11. Spink, "Ajaṇṭā's Chronology: The Crucial Cave." Cf. Spink's review of Stern.

12. Begley, "Chronology"; "Identification of the Ajaṇṭā Fragment." One point of disagreement between Begley and Spink is the relative position of Caves 17 and 19. Spink identifies the reference to

a *gandhakūti* to the west in the Cave 17 inscription with Cave 19, which he therefore takes to be well under way at that point. Begley correctly points out that this identification of the shrine is completely speculative. It appears to me, however, that Cave 19 does not significantly follow 17.

13. Begley, "Chronology," pp. 83-86. Begley accepts Mirashi's dates for Hariṣeṇa.

in this inscription is speculative. Yet at least the *Va* is reasonably clear, and the formula describing the donor's family (which includes Hastibhoja, Varāhedeva's father) resembles that in the inscription of Ajaṇṭā Cave 16. Begley also questions the connection between the Ghaṭotkaca inscription and the conclusion of the cave. Yet it seems unlikely that it belongs to the early stages of carving, by analogy with the usual relationship between inscription and excavation at Ajaṇṭā.[14] Thus probability but not certainty is on Spink's side here. For his long chronology, Begley leans heavily on the palaeography of inscriptions. In this matter, I cannot agree that the differences indicate a span of a century and a half as opposed to fifty years. But again, this is only a judgment of probability.

Two issues underly Begley's chronology, neither of which is to be taken lightly. The first is one's intuitive reaction to the length of time necessary, not for the simple excavation of the caves, a mechanical issue, but rather for the development of their forms. Begley stresses the differences between his groups, whereas Spink stresses the overlapping elements. The second background issue lies in the relationship between the Ajaṇṭā caves and developments elsewhere. If one accepts the association of Elephanta, the later caves at Aurangabad, and Ellora Caves 21 to 29 with the Kalacuri dynasty, as Spink has argued elsewhere, it is difficult to place any part of Ajaṇṭā in the second half of the sixth century, contemporary with those nearby and certainly related excavations. At the same time, the strength of Begley's arguments is to question the increasingly rigid historical framework into which Spink fits the Ajaṇṭā developments. It is certainly possible that work here extended after the collapse of the Vākāṭakas, into the first few decades of the sixth century.

Sheila Weiner has worked on these problems at roughly the same time as Spink and Begley.[15] Not only does she present a longer absolute chronology than even Begley, but she also differs markedly from other scholars in her relative chronology. In the first place, she uses inscriptions to suggest a beginning at Ajaṇṭā around A.D. 400. I find her interpretations improbable for the two main pieces of evidence here: a Rāṣṭrakūṭa inscription from Cave 26, which she assigns to the early fifth century, and the copper plates of Subandhu, whom she assigns to A.D. 416.[16] In the second place, she uses the inscriptions of Cave 16 and a Traikūṭaka plate of 493 to reach a conclusion opposed to Spink's, dating Cave 16 after that year rather than well before, and hence reversing much of Spink's relative chronology.

14. Begley suggests that Cave 4 provides an example of an unfinished cave with dedicatory inscription ("Chronology," p. 39). Cave 4 was not abandoned at an initial stage but was rather nearing completion and was clearly in use.

15. Weiner, *Ajaṇṭā*. Cf. Reviews by Begley, Stadtner, and Williams.

16. I see no reason to connect the Cave 26 Rāṣṭrakūṭa inscription (published by Chhabra in Yazdani, *Ajaṇṭā*, IV, 121-24) with the early as opposed to the later Rāṣṭrakūṭas on the basis of either palaeography or content. Cf. the Pandurangapalli plates, *Mysore Archaeological Report* I (1929), 197-208. For the Subandhu plates, it appears to me that the evidence in favor of the Kalacuri as opposed to the Gupta era is inconclusive (cf. my review of Weiner).

Clearly neither interpretation is compelling, and both authors seem to me to place excessive trust in such records.

In sculpture, Weiner sees a general reductive urge in form, corresponding to a growth of docetic concern in content. One specific case of the latter is the introduction of Buddhas with legs pendant (*pralambapādāsana*) as a late feature at Ajaṇṭā. This indeed appears to be valid, and correlates with details that Spink has suggested are late, such as the introduction of dwarves issuing from the throne and of pearls festooning leogryphs. Thus Weiner's theory here has led Spink to revise his picture of the progress of Cave 16, where he now sees the plan as early and the carving of the shrine of Buddha as late. Begley had maintained an early (Group II) position for this shrine on the basis of the half-visible attendants behind the Buddha's throne, since he correctly observes that these figures in general increase in prominence. It might be possible to reconcile these contradictory lines of argument if one imagines that the initial roughing out of the shrine image was more complete at the top, precluding full, protruding attendants but permitting the pendant leg position for the Buddha.

Weiner builds her picture of the development of the *vihāra* at Ajaṇṭā largely on the assumption that shrines with a Buddha image engaged against the rear wall precede those with a circumambulatory passage around the image, and that the antechamber associated with the former shrine type is an early feature, later to be eliminated. In both cases, I find the reverse to be more probable. To begin with the second point, Weiner cites Haḍḍa as a source for the early antechamber; this site in Afghanistan seems remarkably distant in space and probably in time. The assumption that the elimination of the antechamber is a late feature rests on the observation that both *vihāras* with *pralambapādāsana* Buddhas (16 and 22) lack an antechamber. Yet this absence in Cave 16 becomes an early feature if Spink's two-stage hypothesis is correct; Cave 22 is small and astylar in general, its exceptional simplicity rather than its late date perhaps explaining the lack of an antechamber. In the case of Weiner's contention that circumambulation of the shrine image is a late feature, there seems to be an implicit connection between this pattern and that of Aurangabad Cave 7, which all would agree follows the latest caves at Ajaṇṭā. Yet in the plan of Aurangabad 7, the image is engaged against its shrine wall, and it is the entire central unit that is circumambulated. For Weiner, a force motivating the development of plans is a desire to make the Buddha image more prominent, whereas Spink and Begley hypothesize a replacement of the traditional Buddhist circumambulation of *stūpas* by the practice of worship or *pūjā* directed toward the image itself. While it is worth explaining such a shift in plan, whichever direction it went, in religious terms, our knowledge of the history and import of religious practices seems even less secure than our knowledge of the development of architectural forms. Thus it is dangerous to use such a motivation as an argument for chronology.

In general, the relative sequence presented by Spink and Begley seems to me preferable to Weiner's. Of the former two, I would accept the sequence in Spink's

article of 1975; yet an absolute range of c. 460 to 530 seems to be most probable.

My view of the relationship between the art of Ajaṇṭā and that discussed in the body of this book is that the two are different, if in ways related.[17] In the first place, some elements at Ajaṇṭā do not occur to the north: petals and bands of lozenge-shaped gems on doorways, or bulbous, fluted capitals. These would suggest that the workshops of this area were more isolated from those of the old Gupta Rāj than were those of Nāchnā, to take a contemporary and somewhat provincial example. The figural canon of the Ajaṇṭā Buddha images is on the whole heavier than that of Gupta Buddha images, which distinguishes them more than do the hallmarks that other schools of Buddhist sculpture imposed on their work. Perhaps these differences in themselves should not be oversimplified; I would be content to think of Ajaṇṭā as representing the most distinctive Gupta regional substyle of the late fifth and early sixth centuries.

Moreover, the borrowings from the Gupta mainstream that do occur are largely intrusive and late. For example, the main doorway to Cave 23 provides the only example I have noticed in the sculpture of Ajaṇṭā of a doubled *candraśālā* arch or of the overlapping band of broad leaves; in fact, this doorway might be the work of an outside carver, so different is it from others at the

site. *Pūrṇa ghaṭa* capitals occur relatively late according to Spink, Stern, and Begley; thus the earlier caves must be contemporary with monuments elsewhere in which this motif is common. Diagonal fluting was, I believe, known early in the fifth century at Uparkot and Mathurā, although it is introduced late in the sequence at Ajaṇṭā. The only allusion to the differentiated River Goddesses at the site occurs on the outer shrine doorway of Cave 20, where one goddess is attended by a figure standing upon a tortoise. The avoidance of the motif is understandable if it had political connotations, which might make a specifically Gupta motif unacceptable under a strong rival power.[18] Clearly these impressions of the retardataire and in part derivative status of forms at Ajaṇṭā in relation to Gupta art proper are based on the chronological picture that I have tried to develop independently for the two areas, without assuming a relationship one way or another between them. For Sheila Weiner and Odette Viennot, Ajaṇṭā initiates much that influences the Gupta.

To leave the impression that Ajaṇṭā was an isolated pocket on the periphery of Gupta art may be misleading. It is possible that a more central Vākāṭaka tradition had some bearing on the western Deccani style. One might expect this to be associated with the main branch of dynasty, ruling from Vidarbha, the area of Nagpur. The evidence from this part of northern Maharastra and southern Madhya Pradesh is very frag-

17. These suggestions are developed in detail in an essay "Vākāṭaka Art and the Gupta Mainstream," in the forthcoming volume of Gupta Studies edited by Bardwell Smith.

18. The Cave 20 example is illustrated in Spink, *Ajanta to Ellora*,

p. 36, fig. 6. It is worth noting that the River Goddesses are not differentiated in the western Deccan until Ellora Cave 21, which must belong to the second half of the sixth century or later.

mentary, but two masterpieces suggest that Vidarbha was the center of a sophisticated and individual style. One is a Śiva image found at Manasar, near the central Vākāṭaka capital, Ramtek.[19] This figure resembles the corpulent Yakṣas of Ajaṇṭā Cave 19, but it is more subtle in the way every detail is treated. It is likewise more specifically modeled than any comparable Gupta figure. Another fine image from Vidarbha is a large Gaṅgā figure found at Pavnar, probably the latest central Vākāṭaka capital.[20] This image shows a similar sense of natural detail in the modeling of flesh and drapery. Its cannons are inevitably different from those of the Manasar dwarf-Śiva and are slightly more elongated than those of most Gupta female images. The result is a somewhat south Indian flavor, although this hardly bears comparison with any specific southern style. Other damaged remains from Pavnar, Ramtek, and Panchmarhi may fill out this picture.[21] Finally, the caves of

Bāgh present a complex series of chronological and stylistic problems in their own right.[22] To my mind, they are contemporary with Ajaṇṭā in the second half of the fifth century and form a transition between mainstream Gupta forms (doubled *candraśālā*, diagonal fluting, etc.) and more distinctly Vākāṭaka ones.

Thus on the whole, areas to the west of Ajaṇṭā may have housed a more distinctive and developed local artistic idiom, which to some extent acted as a countervailing force to the Gupta. There was undoubtedly exchange between the Vākāṭaka and the Gupta, perhaps going both ways, for a few Gupta images show the specificity and elongation of the Vidarbha masterpieces (Plates 73 and 242-44). Yet the scattered nature of remains from what may be the center of this style makes the role of Vākāṭaka art mere hypothesis for the time being.

19. Illustrated in Sivaramamurti, *Śatarudrīya*, Frontispiece. Walter Spink in a forthcoming study suggests that this piece is early sixth-century, perhaps associated with Viṣṇukundin presence in Vidarbha.

20. Mirashi, *CII*, V, lxii, pl. D.

21. Mirashi, *CII*, V, lx-lxii. Cf. my forthcoming essay, "Vākāṭaka Art."

22. For a recent discussion with full bibliography, see Spink, "Bāgh."

Bibliography

Adiceam, Marguerite E. "Les images de Śiva dans l'Inde du Sud; III et IV—Bhikṣāṭanamūrti et Kaṅkālamūrti." *Arts Asiatiques* XII (1965), 83-102.

Agrawala, Prithvi Kumar. *Gupta Temple Architecture.* Varanasi: Prithvi Prakashan, 1968.

Agrawala, R. C. "Brahmanical Sculptures from Bharat Kala Bhavan." *Chhavi,* edited by A. Krishna. Varanasi: Bharat Kala Bhavan, 1971, pp. 173-77.

———. "The Goddess Mahiṣāsuramardinī in Early Indian Art." *Artibus Asiae* XXI (1958), 123-30.

———. "Goddess Ṣaṣṭhī in Mathura Sculptures." *Bulletin of Museums and Archaeology in U.P.* IV (1969), 1-6.

———. "Mātṛkā Reliefs in Early Indian Art." *East and West* XXI (1971), 79-89.

Agrawala, Vasudeva Sharana. "Brahmanical Images in Mathurā." *Journal of the Indian Society of Oriental Art* V (1937), 122-30.

———. "Catalogue of the Mathurā Museum." *Journal of the United Provinces Historical Society.*
 1. "Buddha and Bodhisattva Images." XXI (1948), 43-98.
 2. "Images of Brahmā, Viṣṇu, and Śiva, etc." XXII (1949), 102-210.
 3. "Jaina Tīrthaṅkaras and other Miscellaneous Figures." XXIII (1950), 35-147.
 4. "Architectural Pieces." XXIV (1951), 1-160.

———. *Devī-Māhātmyam.* Varanasi: All-India Kashiraj Trust, 1963.

———. "Rajghat Terra-cottas." *Journal of the Indian Society of Oriental Art* IX (1941), 7-111.

———. *Solar Symbolism of the Boar.* Varanasi: Prithvi Prakashan, 1963.

———. *Studies in Indian Art.* Varanasi: Vishwavidyalaya Prakashan, 1965.

———. "A Survey of Gupta Art and Some Sculptures from Nachna Kuthara and Khoh." *Lalit Kalā* IX (1961), 16-26.

———. "The Terracottas of Ahichchhatrā." *Ancient India* IV (1947-48), 104-79.

Allan, John. *Catalogue of the Coins of the Gupta Dynasties and of Śaśāṅka, King of Gauḍa (in the British Museum).* London: British Museum, 1914.

Altekar, Anant Sadashiv. *The Coinage of the Gupta Empire and Its Imitations. Corpus of Indian Coins,* IV. Varanasi: Numismatic Society of India, 1957.

Anderson, John. *Catalogue and Hand-Book of the Archaeological Collections in the Indian Museum.* Calcutta: Trustees of the Museum, 1883.

The Arts of India and Nepal: The Nasli and Alice Heeramaneck Collection. Boston: Museum of Fine Arts, 1966.

Asher, Frederick M. "Bodhgayā Image of the Year 64: A Reconsideration." *Journal of the Bihar Research Society* LVIII (1972), 151-57.

———. "The Sixth through Eighth Century Sculpture of Bihar." Ph.D. Dissertation, University of Chicago, 1971.

Bajpai, K. D. "Identification of Ramagupta." *Journal of Indian History* XLII (1964), 389-93.

———. "Identification of Vaṅga and Vāhlīka in the Mehrauli Iron Pillar Inscription." *Dr. Mirashi Felicitation Volume,* edited by G. T. Deshpande. Nagpur: Vidarbha Samshodan Mandal, 1965, pp. 355-61.

———. "Madhya Pradesh Sculptures." *Mārg* XXVI (June 1973), pp. 27-48.

———. "A New Inscribed Image of a Yaksha." *India Anti-*

qua, edited by F.D.K. Bosch, et al. Leyden: Brill, 1947, pp. 8-9.

————. *Sāgar through the Ages*. Sagar: Department of Ancient Indian History, Culture, and Archaeology, University of Saugar, 1964.

————. "Some Interesting Gaṇa Figures from Panna." *Lalit Kalā* X (1961), 21-24.

Balasubrahmaniyam, S. R. "The Date of the Lad Khan (Sūrya-Nārāyaṇa) Temple at Aihole." *Lalit Kalā* X (1961), 41-44.

Banerjea, Jitendra Nath. *The Development of Hindu Iconography*. 2nd ed. Calcutta: University of Calcutta, 1956.

————. "Sūrya." *Journal of the Indian Society of Oriental Art* XVI (1948), 47-100.

Banerjee, N. R. "New Light on the Gupta Temples at Deogarh." *Journal of the Asiatic Society of Calcutta* V (1963), 37-49.

Banerji, Rakhal Das. *The Age of the Imperial Guptas*. Varanasi: Banaras Hindu University, 1933.

————. *The Temple of Śiva at Bhumara*. Memoirs of the Archaeological Survey of India XVI. Calcutta, 1924.

Bareau, André. *Les Sectes bouddhiques du Petit Véhicule*. Saigon: Publications de l'École Française de l'Extrême-Orient XXXVIII, 1955.

Barrett, Douglas. *Sculptures from Amarāvatī in the British Museum*. London: British Museum, 1954.

————. "A Terracotta Plaque of Mahiṣāsuramardinī." *Oriental Art* XXI (1975), 64-67.

————, and M. G. Dikshit. *Mukhalingam Temples; Sirpur and Rajim*. Bombay: Bhulabhai Memorial Institute Heritage of Indian Art Series, No. 2, 1960.

Basham, Arthur L. "Ancient Indian Ideas of Time and History." In *Prācyavidyā-taraṅgiṇī: Golden Jubilee Volume of the Department of Ancient Indian History and Culture*, edited by D. C. Sircar. Calcutta: University of Calcutta, 1969, pp. 49-63.

————. *The Wonder That Was India*. New York: Grove Press, 1954.

Bedekar, V. M. "Legend of the Churning of the Ocean in the Epics and the Purāṇas: A Comparative Study." *Purāṇa* IX (1967), 7-61.

Begley, Wayne E. "The Chronology of Mahāyāna Buddhist Architecture and Painting at Ajaṇṭā." Ph. D. Dissertation, University of Pennsylvania, 1966.

————. "The Identification of the Ajaṇṭā Fragment in the Boston Museum." *Oriental Art* XIV (1968), 25-33.

————. Review of Sheila Weiner, *Ajaṇṭā*, in *Journal of Asian Studies* XXXVII (1978), 570-71.

————. *Viṣṇu's Flaming Wheel: The Iconography of the Sudarśana-Cakra*. Monographs on Archaeology and Fine Arts sponsored by the Archaeological Institute of America and the College Art Association of America XXVII. New York: New York University Press, 1973.

Berkson, Carmel. "Some New Finds at Ramgarth Hill, Vidisha District." *Artibus Asiae* XL (1978), 215-32.

The Bhagavad Gītā. Translated by Franklin Edgerton. New York: Harper Torchbooks, 1964.

Bhandarkar, Devadatta Ramkrishna. *The Archaeological Remains and Excavations at Nagari*. Memoirs of the Archaeological Survey of India IV. Calcutta, 1920.

Bharadwaj, Surender Mohan. *Hindu Places of Pilgrimage in India*. Berkeley and Los Angeles: University of California Press, 1973.

Bhattacharji, Sukumari. *The Indian Theogony*. Cambridge: Cambridge University Press, 1970.

Bhattacharya, Brindavan Chandra. *The Jaina Iconography*. Delhi: Motilal Banarsidass, 1974.

Bhattacharyya, Benoytosh. *The Indian Buddhist Iconography*. Calcutta: Mukhopadhyay, 1958.

Bhattacharyya, Dinesh Chandra. "A Newly Discovered Copperplate from Tippera." *Indian Historical Quarterly* VI (1930), 45-60.

Bourdillon, B. H. "Krishna Obelisks at Garhwa," *Journal of*

the United Provinces Historical Society I, part II (1918), 35-40.

Bosch, Frederik D. K. *The Golden Germ*. Indo-Iranian Monographs II. The Hague: Mouton, 1960.

Brown, Percy. *Indian Architecture (Buddhist and Hindu Periods)*. 4th ed. Bombay: Taraporevala, 1959.

Burgess, James. *Report on the Antiquities of Kâthiâwâḍ and Kachh*. Archaeological Survey of Western India II. London, 1876.

Chandra, Moti. "A Study in the Terracottas from Mirpurkhas." *Bulletin of the Prince of Wales Museum* VII (1959-1962), 1-22.

Chandra, Pramod. "Some Remarks on Bihar Sculpture from the Fourth to the Ninth Century." *Aspects of Indian Art*, edited by P. Pal. Leiden: Brill, 1972, pp. 59-64.

————. *Stone Sculpture in the Allahabad Museum*. Poona: American Institute of Indian Studies, 1970.

————. "The Study of Indian Temple Architecture." In *Studies in Indian Temple Architecture*, edited by Pramod Chandra. New Delhi: American Institute of Indian Studies, 1975, pp. 1-39.

————. "A Vāmana Temple at Maṛhiā and Some Reflections on Gupta Architecture." *Artibus Asiae* XXXII (1970), 125-45.

Chatterji, Sm. Bandana. "The Story of Samudramanthana." *Journal of Ancient Indian History* V (1971-1972), 56-77.

Chhabra, Bahadur Chand; N. L. Rao; and N. A. Husain. "Ten Years of Indian Epigraphy (1937-46)," *Ancient India* V (1949), 46-61.

Coomaraswamy, Ananda K. *La Sculpture de Bodhgaya*. Ars Asiatica XVIII. Paris: Editions d'art et d'historie, 1935.

Crane, Robert I., ed. *Regions and Regionalism in South Asian Studies: An Exploratory Study*. Duke University, Monograph Series V. Durham, N.C., 1967.

Cunningham, Alexander. *Archaeological Survey of India Reports*, vols. I-XXIII (1862-1884). Reprinted Delhi and Varanasi: Indological Book House, 1972.

————. *Mahābodhi*. London: Allen, 1892.

Czuma, Stanislaw. "Mathura Sculpture in the Cleveland Museum Collection," *Bulletin of The Cleveland Museum of Art*, 1977, pp. 83-114.

Dehejia, Vidya. *Early Stone Temples of Orissa*. New Delhi: Vikas, 1979.

Desai, Kalpana S. *Iconography of Visnu*. New Delhi: Abhinav, 1973.

Desai, Madhuri. *The Gupta Temple at Deogarh*. Bombay: Bhulabhai Memorial Institute, 1958.

Devahuti, D. *Harsha, A Political Study*. Oxford: Clarendon Press, 1970.

Dhavalikar, M. K. "New Inscriptions from Ajantā," *Ars Orientalis* VII (1968), 147-53.

Dikshit, Sadanand Kashinath. *A Guide to the Central Archaeological Museum, Gwalior*. Gwalior: Department of Archaeology and Museums, Government of Madhya Pradesh, 1962.

Divakaran, Odile. "Les temples d'Ālampur et de ses environs au temps des Cāḷukya de Bādāmi." *Arts Asiatiques* XXIV (1971), 52-101.

Donaldson, Thomas. "Doorframes on the Earliest Orissan Temples." *Artibus Asiae* XXXVIII (1976), 189-218.

Faccenna, Domenico. *A Guide to the Excavations in Swat (Pakistan) 1956-1962*. Rome: Instituto per Medio e Estrema Oriente, 1964.

Fa-Hsien. *A Record of Buddhistic Kingdoms*. Translated by James Legge. Reprint New York: Dover, 1965.

Fergusson, James. *Picturesque Illustrations of Ancient Architecture in Hindostan*. London: J. Hogarth, 1848.

————, and James Burgess. *The Cave Temples of India*. London: W. H. Allen 1880.

Filliozat, Jean. *La doctrine classique de la médicine indienne*. Paris: Imprimerie nationale, 1949.

————. "New Researches on the Relations between India and Cambodia." *Indica* (Bulletin of the Heras Institute, St. Xavier College, Bombay) III (1966), 95-106.

Filliozat, Jean. "Représentations de Vāsudeva et Saṃkar-saṇa." *Arts Asiatiques* XXVI (1973), 113-21.

Fleet, John Faithfull. "The Coins and History of Toramana." *Indian Antiquary* XVIII (1889), 225-230.

———. *Inscriptions of the Early Gupta Kings and Their Successors. Corpus Inscriptionum Indicarum*, III. 2nd ed. Varanasi: Indological Book House, 1963.

Frauwallner, Erich. *On the Date of the Buddhist Master of the Law, Vasubandhu*. Rome: ISMEO, 1951.

Gai, G. S. "Three Inscriptions of Rāmagupta." *Journal of the Bhandarkar Research Institute* XVIII (1969), 245-51.

Ghirshman, Roman. *Persian Art, the Parthian and Sassanian Dynasties*. New York: Golden Press, 1962.

Ghosh, A., ed. *Jaina Art and Architecture*. New Delhi: Bharatiya Jnanpith, 1974.

Glynn, Catherine. "Some Reflections on the Origin of the Type of Gaṅgā Image." *Journal of the Indian Society of Oriental Art* N.S. V (1972-1973), 16-27.

Göbl, Robert. *Dokumente zur Geschichte der Iranischen Hunnen in Baktrien und Indien*. Wiesbaden: Harrossowitz, 1967.

Goetz, Hermann. "The Earliest Representations of the Myth Cycle of Kṛṣṇa Govinda." *Journal of the Oriental Institute of Baroda* I (1951), 51-59.

———. "Imperial Rome and the Genesis of Classical Indian Art." *East and West* X (1959), 153-82, 261-68.

Gopinatha Rao, T. A. *Elements of Hindu Iconography*. Reprint, Delhi: Motilal Banarsidass, 1968.

Goyal, Shriram. "Did the Vākāṭakas Invade Rajasthan in the Middle of the Fifth Century?" Paper delivered in Jodhpur, 1974.

———. *A History of the Imperial Guptas*. Allahabad: Central Book Depot, 1967.

Griswold, Alexander B. "Prolegomena to the Study of the Buddha's Dress in Chinese Sculpture." *Artibus Asiae* XXVI (1963), 85-131; XXVII (1965), 335-40.

Gupta, Parmeshwari Lal. *The Imperial Guptas*. Varanasi: Vishwavidyalaya Prakashan, 1974.

———. *Patna Museum Catalogue of Antiquities*. Patna: Patna Museum, 1965.

Gupte, Ramesh Shankar. *The Iconography of the Buddhist Sculptures (Caves) of Ellora*. Aurangabad: Marathwada University, 1964.

Hackin, Joseph. "Le monastère bouddhique de Fondukistân." *Diverses recherches archéologiques en Afghanistan*. Mémoires de la Délégation Archéologique Française en Afghanistan VIII (1959), 49-58.

Härtel, Herbert. "Excavations at Sonkh (Mathura District), 1969-70." *Bulletin of Museums and Archaeology in U.P.* V-VI (1970), 1-4.

———. "A Kuṣāṇa Nāga Temple at Sonkh." *Bulletin of Museums and Archaeology in U.P.* XI-XII (1973), 1-6.

Harle, James C. *Gupta Sculpture*. Oxford: Clarendon Press, 1974.

———. "Late Kuṣana, Early Gupta: A Reverse Approach." In *South Asian Archaeology*, edited by Norman Hammond. London: Duckworth, 1973, pp. 231-40.

———. "On a Disputed Element in the Iconography of Early Mahiṣāsuramardinī Images." *Ars Orientalis* VIII (1970), 147-53.

———. "On the Mahiṣāsuramardinī Images of the Udayagiri Hill (Vidiśā) Caves." *Journal of the Indian Society of Oriental Art* N.S. IV (1971-1972), 44-48.

———. "The Post-Gupta Style in Indian Temple Architecture and Sculpture," *Journal of the Royal Society for the Encouragement of Arts, Manufactures, and Commerce*, August 1977, 570-89.

Hazra, Rajendra Chandra. "Is the Devī-bhāgavata the Source of the Deogarh Relief of Nara-Nārāyaṇa?" *Indian Historical Quarterly* XXIX (1953), 387-92.

———. *Studies in the Purāṇic Records on Hindu Rites and Customs*. 2nd ed. Delhi: Motilal Banarsidass, 1975.

Hein, Norvin. *The Miracle Plays of Mathurā*. New Haven: Yale University Press, 1972.

Hsüan-tsang (Hiuen Tsiang). *Si-yu-ki: Buddhist Records of the*

Western World. Translated by Samuel Beal. London: Kegan Paul, 1900.

Huntington, Susan L. "The Buddhist *Stūpa* at Gyaraspur." In *Chhavi* II, edited by A. Krishna. Varanasi: Bharat Kala Bhavan, forthcoming.

————. "Origin and Development of Sculpture in Bihar and Bengal, ca. 8th-12th Centuries." Ph. D. Dissertation, University of California, Los Angeles, 1972.

Indian Archaeology—A Review. New Delhi: Department of Archaeology, Government of India, 1957—.

Ingalls, Daniel H. H. "Kālidāsa and the Attitudes of the Golden Age." *Journal of the American Oriental Society* 96 (1976), 15-26.

Ions, Veronica. *Indian Mythology*. London: Hamlyn, 1967.

Irwin, John. "The Heliodorus Pillar: A Fresh Appraisal," *AARP* 6 (1974), 1-13.

————. "The Sanchi Torso." *Victoria and Albert Museum Yearbook* III (1972), 7-28.

Jain, Kailash Chand. *Malwa through the Ages*. Delhi: Motilal Banarsidass, 1972.

Jain, Purushottam Chandra. *Labour in Ancient India (from the Vedic Age up to the Gupta Period)*. New Delhi: Sterling Publishers, 1971.

Jayaswal, Kashi Prasad. "Candragupta and His Predecessor." *Journal of the Bihar and Orissa Research Society* XVIII (1932), 17-36.

————. "History of India, c. 150 A.D. to 350 A.D. (Nāga-Vākāṭaka Imperial Period)." *Journal of the Bihar and Orissa Research Society* XIX (1933), Parts I and II, 1-222.

————. *An Imperial History of India in a Sanskrit Text (c. 700 B.C.—c. 770 A.D.) with a Special Commentary on Later Gupta Period*. Lahore: Motilal Banarsidass, 1934.

Joshi, M. C. "Śiva Temple at Nibiyakhera." *Bhāratī* (Varanasi) VIII (1964-1965), 66-75.

————. "Two interesting Sun Images from Nachna," *Journal of Indian History* XLVIII (1970), 80-87.

Joshi, Nilakanth Purushottam. *Catalogue of the Brahmanical Sculptures in the State Museum, Lucknow*. Lucknow: State Museum, 1972.

————. "Hayagrīva in Brahmanical Iconography." *Journal of the Indian Society of Oriental Art* N.S. V (1972-1973), 36-42.

————. "On the Iconography of Balarāma in the North India." *Bulletin of Museums and Archaeology in U.P.* X (1972), 15-25.

————. "Kuṣāṇa Varāha Sculpture." *Arts Asiatiques* XII (1965), 113-17.

————. *Mathura Sculptures*. Mathura: Archaeological Museum, 1966.

————. "A Unique Figure of Śiva from Musānagar." *Bulletin of Museums and Archaeology in U.P.* III (1969), 25-30.

Kala, Satish Chandra. *Terracotta Figurines from Kauśāmbī*. Allahabad: Municipal Museum, 1950.

Kalhaṇa. *Rājataraṅginī*. Translated by Mark Aurel Stein. Reprint Delhi: Motilal Banarsidass, 1961.

Kalidasa. *Kumārasambhava*. Translated by H. H. Wilson. Reprinted Varanasi: Indological Book House, 1966.

Khan, Abdul Waheed. *An Early Sculpture of Narasiṃha*. Andhra Pradesh Government Archaeological Series No. 16. Hyderabad: Government of Andhra Pradesh, 1964.

Knox, George Edward. "Excavations at Gaṛhwa," *Journal of the United Provinces Historical Society*, I (1917), 20-33.

Kramrisch, Stella. *Art of India*. London: Phaidon, 1965.

————. "Die figurale Plastik der Guptazeit." *Wiener Beiträge zur Kunst- und Kulturgeschichte Asiens* V (1931), 15-39.

————. *The Hindu Temple*. Calcutta: University of Calcutta, 1946.

Krom, Nicholaas J., and T. van Erp. *Beschrijving van Barabuḍur*. The Hague: Martinus Nijhoff, 1920.

Lamotte, Étienne. *Histoire du Bouddhisme indien, des origines à l'ère śaka*. Louvain: Université de Louvain, 1958.

————. *Le Traité de la Grande Vertu de Sagesse*. Louvain: Université de Louvain, 1944.

van Lohuizen-de Leeuw, Johanna Engelberta. "The Date of

Kaniṣka and some Recently Published Images." *Papers on the Date of Kaniṣka*, edited by Arthur L. Basham. Australian National University Centre of Oriental Studies, Oriental Monographs Series IV. Leiden: Brill, 1968, pp. 126-33.

——. "The Dhyāni-Buddhas of Barabudur." *Bijdragen tot de Taal-, Land- en Volkenkunde van Ned.- Indie* CXXI (1965), 389-416.

——. "Gandhāra and Mathura: Their Cultural Relationship." In *Aspects of Indian Art*, edited by P. Pal. Leiden: Brill, 1972, pp. 27-43.

——. "The Kuṣṭarajagala Image: An Identification." *Paranavitana Felicitation Volume*. Colombo, 1965, pp. 253-261.

——. *The "Scythian Period."* Leiden: Brill, 1949.

Longhurst, Albert Henry. *The Buddhist Antiquities of Nāgārjunakoṇḍa*. Memoirs of the Archaeological Survey of India LIV. Delhi: Government Press, 1938.

Lopez, Robert. "Hard Times and the Investment in Culture." In *The Renaissance: Basic Interpretations*, edited by Karl Dannenfeldt. 2nd ed. Lexington, Toronto, London: D. C. Heath, 1974, pp. 82-101.

Lüders, Heinrich. "Epigraphical Notes, No. 41." *Indian Antiquary* XXXIII (1904), 155-56.

——. "List of Brāhmī Inscriptions from the Earliest Times." *Epigraphia Indica* X (1912), Appendix, 1-226.

——. *Mathurā Inscriptions. Unpublished Papers Edited by Klaus Janert*. Abhandlungen der Akademie der Wissenschaften in Göttingen. Phil.-hist. Klasse. 3rd. ser., No. 47. Göttingen: van Denhoech and Ruprecht, 1961.

Lyons, Islay, and Harald Ingholt. *Gandhāran Art in Pakistan*. New York: Pantheon, 1957.

Macdonald, Ariane. *Le Maṇḍala du Mañjuśrīmūlakalpa*. Paris: Adrien Maisonneuve, 1962.

Maenchen-Helfen, Otto J. *The World of the Huns, Studies in Their History and Culture*. Berkeley and Los Angeles: University of California Press, 1973.

Mahābhārata. Translated by J.A.B. van Buitenen. 3 vols. Chicago: University of Chicago Press, 1973-1979.

The Mahābhārata. Translated by Pratap Chandra Roy. 3rd ed. New Delhi: Munshiram Manoharlal, 1972-1975.

Maity, Sachindra Kumar. *Economic Life in Northern India in the Gupta Period*. Calcutta: World Press Private Ltd., 1957.

Majumdar, M. R. *Chronology of Gujarat*. Baroda: Maharaja Sayajirao University of Baroda, 1960.

Majumdar, N. G. "The Muṇḍeśvarī Inscription of the Time of Udayasena: The Year 30." *Indian Antiquary* XLIX (1920), 21-29.

Majumdar, Ramesh Chandra, ed. *The Classical Age. History and Culture of the Indian People*, III. 2nd ed. Bombay: Bharatiya Vidya Bhavan, 1962.

——. "The Gurjara-Pratīhāras." *Journal of the Department of Letters. Calcutta University* X (1923), 1-76.

——, and Anant Sadashiv Altekar. *The Vākāṭaka-Gupta Age (circa 200-550 A.D.)*. 2nd ed. Delhi: Motilal Banarsidass, 1967.

de Mallmann, Marie-Thérèse. *Les enseignements iconographiques de l'Agni-Purana*. Annales du Musée Guimet LXVII. Paris: Presses Universitaires de France, 1963.

——. *Étude iconographique sur Mañjuśrī*. Publications de l'École Française d'Extrême-Orient LV. Paris: Presses Universitaires de France, 1964.

——. *Introduction à l'iconographie du tântrisme bouddhique*. Paris: Bibliothèque du Centre de Recherches sur l'Asie Centrale et la Haute Asie, 1975.

Mārkaṇḍeya Purāṇa. Translated by F. E. Pargiter. Delhi: Indological Book House, 1969.

Marshall, Sir John Hubert, and Alfred Foucher. *Monuments of Sāñchī*. London: Probsthain, 1940.

Matsya Purāṇa. Translated by "A Taluqdar of Oudh." Allahabad: Indian Press, 1916.

Maxwell, Thomas S. "Transformational Aspects of Hindu Myth and Iconology: Viśvarūpa." *AARP* 4 (1973), 59-79.

Mehta, Ramanlal Nagarji, and S. N. Chowdhary. *Excavation at Devnimori*. Baroda: Department of Archaeology and Ancient History, Faculty of Arts, M. S. University of Baroda, 1966.

Meister, Michael. "Darrā and the Early Gupta Tradition." In *Chhavi* II, edited by A. Krishna. Varanasi: Bharat Kala Bhavan, forthcoming.

———. "An Essay on the Interpretation of Indian Architecture." *Roopa Lekha* XLI (n.d.), 35-47.

———. "Kṛṣṇalīlā from Wadhwān and Osian." *Journal of the Indian Society of Oriental Art* N.S. V (1972-1973), 28-35.

———. "Muṇḍeśvarī: Ambiguity and Certainty in the Analysis of a Temple Plan." In *Kalādarśana: American Studies in the Art of India*, edited by Joanna Williams. New Delhi: Oxford and IBH, 1981, pp. 77-89.

———. "A Note on the Superstructure of the Maṛhiā Temple." *Artibus Asiae* XXXVI (1974), 81-88.

———. "Phamsana in Western India." *Artibus Asiae* XXXVIII (1976), 167-88.

———. "A Preliminary Report on the Śiva Temple at Kusumā." *Archives of Asian Art* XXVII (1973-1974), 76-91.

Mirashi, Vasudev Vishnu. "Devnī Morī Casket Inscription of the Reign of Rudrasena, Year 127." *Hoshiarpur, Vishveshvaranand Indological Journal* III (1965), 101-104.

———. "Historical Data in Daṇḍin's Daśakumāracharita." *Annals of the Bhandarkar Oriental Research Institute, Poona* XXVI (1945), 20-31.

———. *Inscriptions of the Kalachuri-Chedi Era. Corpus Inscriptionum Indicarum* IV. Calcutta and Allahabad: Journal Press, 1955.

———. *Inscriptions of the Vākāṭakas. Corpus Inscriptionum Indicarum* V. Ootacamund: Archaeological Survey of India, 1963.

———. "Three Ancient Dynasties of Mahākosala." *Bulletin of the Deccan College Research Institute* VIII (1946-1947), 47-56.

Mitra, Debala. "Śaṅkar-Maḍhā at Kunda, District Jabalpur." *Journal of the Asiatic Society of Calcutta* VII (1965), 79-81.

———. "A Study of Some *Graha*-Images of India and Their Possible Bearing on the *Nava-Devās* of Cambodia." *Journal of the Asiatic Society of Calcutta* VII (1965), 13-37.

———. "Varāha-Cave of Udayagiri—an Iconographic Study." *Journal of the Asiatic Society of Calcutta* V (1963), 99-103.

Mukherji, Poorno Chander. *Report on the Antiquities in the District of Lalitpur, N. W. Provinces, India*. Roorkee: Tomason Engineering College, 1899.

Mukhopadhyay, Samir K. "Terracottas from Bhīṭā." *Artibus Asiae* XXXIV (1972), 71-94.

Nanavati, J. M., and M. A. Dhaky. *The Maitraka and the Saindhava Temples of Gujarat*. Artibus Asiae Supplementum XXVI. Ascona: Artibus Asiae, 1969.

Nath, R. "Bhitargaon," *Mārg* XXII (1969), 24-35.

O'Flaherty, Wendy Doniger. "The Image of the Heretic in Gupta Purāṇas." In the Carleton Gupta Colloquium papers, edited by Bardwell Smith and Eleanor Zelliot. Delhi: Motilal Banarsidass, forthcoming.

Pal, Pratapaditya. *The Ideal Image*. New York: Asia House Gallery, 1978.

———. "Some Rajasthani Sculptures of the Gupta Period." *Bulletin of the Allen Memorial Art Museum, Oberlin College* XXVIII (1971), 104-18.

———. *Vaiṣṇava Iconology in Nepal*. Calcutta: Asiatic Society, 1970.

Panigrahi, Krishna Chandra. *Archaeological Remains at Bhubaneswar*. Bombay: Orient Longmans, 1961.

Pargiter, Frederick Eden. *The Purāṇa Text of the Dynasties of the Kali Age. Chowkhamba Sanskrit Studies* XIX. Varanasi: Chowkhamba Sanskrit Series Office, 1962.

Patil, Devendrakumar Rajaram. *The Antiquarian Remains in Bihar*. Patna: Kashi Prasad Jayaswal Research Institute, 1963.

Patil, Devendrakumar Rajaram. *Monuments of the Udayagiri Hill.* Gwalior: Archaeological Department, 1948.

Philips, C. H., ed. *Historians of India, Pakistan and Ceylon.* London: Oxford University Press, 1961.

Pingree, David. "The Indian Iconography of the Decans and Horās." *Journal of the Warburg and Courtauld Institute* XXVI (1963), 223-54.

Pires, Edward A. *The Maukharis.* Madras: Paul, 1934.

Puri, Kidar Nath, and Klaus Fischer. *Kunst aus Indien, Ausstellung November 1959 bis February 1960.* Zürich: Kunsthaus, 1959.

Ramachandran, T. N. "Fresh Light on the Deogarh Relief of Nara-Nārāyaṇa." *Indian Historical Quarterly* XXVII (1951), 191-96.

————. "Kirātārjunīyam or 'Arjuna's Penance' in Indian Art." *Journal of the Indian Society of Oriental Art* XVIII (1950-1951), 1-110.

————. *Nāgārjunakoṇḍa, 1938.* Memoirs of the Archaeological Survey of India No. 17. Delhi: Government of India Press, 1953.

Rapson, Edward James. *Catalogue of the Coins of the Andhra Dynasty, the Western Kṣatrapas, the Traikūṭaka Dynasty and the "Bodhi" Dynasty.* London: British Museum, 1908.

Report of the Administration of the Archaeological Department and Sumer Public Library, Government of Jodhpur, 1935.

Rosenfield, John M. *The Dynastic Arts of the Kushans.* Berkeley and Los Angeles: University of California Press, 1967.

————. "On the Dated Carvings of Sārnāth." *Artibus Asiae* XXVI (1963), 10-26.

Rowland, Benjamin. *Art and Architecture of India: Pelican History of Art.* 3rd ed. Harmondsworth: Penguin Books, 1970.

Roy, Udai Narain. *Studies in Ancient Indian History and Culture.* Allahabad: Lokbharti Publications, 1969.

Sādhanamāla. Edited by Ben Bhattacharyya. Gaekwad Oriental Series, Baroda, XXVI (1925), XLI (1928).

Sahni, Daya Ram. With an introduction by J. Ph. Vogel.

Catalogue of the Museum of Archaeology at Sārnāth. Reprint, Delhi: Indological Book House, 1972.

Salomon, Richard. "The Kṣatrapas and Mahākṣatrapas of India." *Wiener Zeitschrift für die Kunde Südasiens und Archiv für Indische Philosophie* XVIII (1974), 5-25.

Sastri, Hirananda. *Nālandā and Its Epigraphic Material.* Memoirs of the Archaeological Survey of India No. 66. Delhi, 1942.

Sastri, T.V.G. "The Antiquity of Nagari and Its Torana." *Journal of the Oriental Institute of Baroda* XVI (1967), 336-41.

Schastok, Sara R. "The Sculpture of Gujarat in the Sixth and Seventh Century." Ph. D. dissertation, University of Michigan, 1979.

————. "A Sixth-Century Kubera Image from Mandasor." In *Chhavi* II, edited by A. Krishna. Varanasi: Bharat Kala Bhavan, forthcoming.

Shah, Umakant Premanand. "Central India: Monuments and Sculpture A.D. 300 to 600." In *Jain Art and Architecture* I, edited by A. Ghosh. New Delhi: Bharatiya Jnanpith, 1974, pp. 127-32.

————. "Sculptures from Śāmalājī and Roḍā." *Bulletin of the Museum and Picture Gallery* (Baroda) XIII (1960), 1-136.

————. "Some Early Sculptures from Abu and Bhinmal." *Bulletin of the Baroda Museum and Picture Gallery* XII (1955-1956), 43-56.

————. "Some Medieval Sculptures from Gujarat and Rajasthan." *Western Indian Art: Journal of the Indian Society of Oriental Art Special Number* (1965-1966), pp. 52-91.

————. "Terracottas from Former Bikaner State." *Lalit Kalā* VIII (1960), 55-62.

Sharan, Mahesh Kumar. *Tribal Coins—A Study.* Delhi: Abhinav, 1972.

Sharma, Govardhan Raj. *Excavations at Kauśāmbī, 1949-50.* Memoirs of the Archaeological Survey of India No. 74. Delhi: Manager of Publications, 1969.

————. *The Excavations at Kauśāmbī, 1957-59.* Allahabad: Institute of Archaeology, Allahabad University, 1960.

————, et al. *Allahabad through the Ages.* Allahabad: 27th Session of the Indian History Congress, 1965.

Sharma, Mathurā Lal. *Kotā Rajya ka Itihas.* Kota: v.s. 1996 (A.D. 1941).

Sharma, Ram Sharan. *Śūdras in Ancient India.* Delhi: Motilal Banarsidass, 1958.

Shastri, B. Ch. "Identification of a Relief Belonging to the Gupta-Temple of Deogarh." *Acta Orientalia* XII (1934), 116-25.

Singh, R. C. "Bhitargaon Brick Temple." *Bulletin of Museums and Archaeology in U.P.* I (1968), 9-14; II (1968), 30-35.

Singh, Udai Vir. "Excavation at Eran." *Journal of the Madhya Pradesh Itihasa Parishad* IV (1963), 41-44.

Sircar, Dines Chandra. *Ancient Malwa and the Vikramāditya Tradition.* Delhi: Munshiram Manoharlal, 1969.

————. "Date of the Mankuwar Buddha Image Inscription of the Time of Kumāragupta I." *Journal of Ancient Indian History* III (1970), 133-37.

————. "King Durgarāja of the Śarabhapurīya Dynasty." *Indian Historical Quarterly* XXII (1946), 62-63.

————. "The Maukharis and the Later Guptas." *Journal of the Royal Asiatic Society of Bengal* XI (1945), 69-74.

————. "Sectarian Differences among the Early Vaiṣṇavas." *Bhāratīya Vidyā* VII (1946), 109-11.

————. *Select Inscriptions Bearing on Indian History and Civilization, from the Sixth Century B.C. to the Sixth Century A.D.* 2nd ed. Calcutta: University of Calcutta, 1965.

————. "Two Pillar Inscriptions." *Journal of the Royal Asiatic Society of Bengal* XV (1949), 5-7.

————. "Vidiśā Jain Image Inscriptions of the Time of Rāmagupta." *Journal of Ancient Indian History* III (1970), 145-51.

————, and L. P. Pandeya Śarmā. "Pipardula Copper-Plate Inscription of Narendra of Śarabhapura Year 3." *Indian Historical Quarterly* XIX (1943), 139-46.

Sivaramamurti, C. "Amaravati Sculptures in the Madras Government Museum." *Bulletin of the Madras Government Museum* IV (1956), 1-376.

————. "Geographical and Chronological Factors in Indian Iconography." *Ancient India* VI (1950), 21-63.

————. *Śatarudrīya: Vibhūti of Śiva's Iconography.* New Delhi: Abhinav Publications, 1976.

Smith, Vincent A. *Coins of Ancient India: Catalogue of the Coins in the Indian Museum, Calcutta.* Reprint Delhi, Varanasi: Indological Book House, 1972.

————. "Indian Sculpture of the Gupta Period, A.D. 300-650." *Ostasiatische Zeitschrift* III (1914), 1-27.

————. *The Jain Stūpa and Other Antiquities of Mathurā.* Archaeological Survey of India, New Imperial Series XX. Allahabad: Government Press, 1901.

————. "Observations on the Gupta Coinage." *Journal of the Royal Asiatic Society* (1893), pp. 77-148.

————, and A.F.R. Hoernle. "Inscribed Seal of Kumāra Gupta II." *Journal of the Royal Asiatic Society of Bengal* LVIII (1889), 84-105.

Soper, Alexander C. "Recent Studies Involving the Date of Kaniṣka. A Review Article." *Artibus Asiae* XXXIII (1971), 339-50; XXXIV (1972), 102-13.

Soundara Rajan, K. V. "The Typology of the Anantaśayī Icon." *Artibus Asiae* XXIX (1967), 67-84.

Spink, Walter M. "Ajanta: A Brief History." In *Aspects of Indian Art*, edited by P. Pal. Leiden: Brill, 1972, pp. 49-58.

————. "Ajantā and Ghatotkacha: A Preliminary Analysis." *Ars Orientalis* VI (1966), 135-55.

————. *Ajanta to Ellora.* Bombay: Mārg Publications, 1967.

————. "Ajantā's Chronology: The Crucial Cave." *Ars Orientalis* X (1975), 143-69.

————. "Ajantā's Chronology: The Problem of Cave Eleven." *Ars Orientalis* VII (1968), 155-68.

Spink, Walter M. "Bāgh: A Study." *Archives of Asian Art* XXIX (1975-1976), 53-84.

————. Review of Philippe Stern, *Colonnes*, in *Journal of the American Oriental Society* 94.4 (1974), 483-87.

————. "The Splendours of Indra's Crown: A Study of Mahāyāna Developments at Ajaṇṭā." *Journal of the Royal Society for the Encouragement of Arts, Manufactures, and Commerce* (1974), 743-67.

————. "A Temple with Four Uchchakalpa(?) Doorways at Nāchnā Kuṭharā." In *Chhavi*, edited by A. Krishna. Varanasi: Bharat Kala Bhavan, 1971, pp. 161-72.

Srinivasan, Doris. "Early Kṛṣṇa Icons: The Case at Mathurā." In *Kalādarśana: American Studies in the Art of India*, edited by J. Williams. New Delhi: Oxford and IBH, 1981, pp. 127-36.

Srivastava, H. L. *Excavations at Agrohā, Punjab*. Memoirs of the Archaeological Survey of India LXI. Delhi, 1952.

Srivastava, V. N. "Buddha Pedestal Inscription of Kumāra Gupta." *Bulletin of Museums and Archaeology in U.P.* I (1968), 15-17.

Stadtner, Donald M. "From Sirpur to Rajim: the Art of Kosala during the Seventh Century." Ph. D. dissertation, University of California, Berkeley, 1976.

————. Review of Sheila Weiner, *Ajaṇṭā*, in *Revue d'art canadienne* V (1978), pp. 86-87.

————. "Sārnāth Architectural Remains." M. A. Thesis, University of Michigan, Ann Arbor, 1972.

————. "A Sixth-Century Temple from Kosala." *Archives of Asian Art* XXXIII (1980), 38-48.

Stein, Marc Aurel. *Ancient Khotan*. Oxford: Clarendon Press, 1907.

————. *Archaeological Reconnaissances in North-Western India and South-Eastern Iran*. London: Macmillan, 1937.

Stern, Philippe. *Colonnes indiennes d'Ajantā et d'Ellora*. Publications du Musée Guimet, Recherches et documents d'art et d'archéologie XI. Paris: Presses Universitaires de France, 1972.

Stutterheim, Willem. *Rāma-Legenden und Rāma-Reliefs in Indonesien*. Munich: George Müller, 1925.

Suryavanshi, Bhagwan Singh. "Exploration at Bilsad." *Journal of the Asiatic Society of Bombay* XXX (1955), 56-65.

Takakusu, Junjiro. "A Study of Paramartha's Life of Vasubandhu and the Date of Vasubandhu." *Journal of the Royal Asiatic Society* (1905), p. 44.

Thapar, Romila. *Communalism and the Writing of Indian History*. Delhi: People's Publishing House, 1969.

————. *A History of India*. Vol. 1. Harmondsworth: Penguin, 1966.

Trautmann, Thomas R. "Licchavi-Dauhitra." *Journal of the Royal Asiatic Society* (1972), pp. 1-15.

Trivedi, Harihar Vitthal. *Catalogue of the Coins of the Nāga Kings of Padmāvatī*. Gwalior: Department of Archaeology and Museums, Madhya Pradesh, 1957.

The Vāmana Purāṇa with English Translation. Edited by A. S. Gupta. Varanasi: All India Kashiraj Trust, 1968.

Varāhamihira. *Bṛhat Samhitā*. Translated by P.V.S. Śastri. Bangalore: V. B. Soobiah, 1947.

Varma, K. M. "The Role of Polychromy in Indian Statuary." *Artibus Asiae* XXIV (1961), 117-32.

Vats, Madho Sarup. *The Gupta Temple at Deogarh*. Memoirs of the Archaeological Survey of India LXX. Delhi, 1952.

Viennot, Odette. *Les Divinités fluviales Gaṅgā et Yamunā aux portes des sanctuaires de l'Inde*. Publications du Musée Guimet, Recherches et Documents d'art et d'archéologie X. Paris: Presses Universitaires de France, 1964.

————. "The Goddess Mahiṣāsuramardinī in Kushana Art." *Artibus Asiae* XIX (1956), 368-73.

————. "The Mahiṣāsuramardinī from Siddhi-ki-Guphā at Deogarh." *Journal of the Indian Society of Oriental Art*. N.S. IV (1971-1972), 66-77.

————. "Le Problème des temples à toit plat dans l'Inde du Nord." *Arts Asiatiques* XVIII (1968), 23-53.

————. "Le temple ruiné de Mukuṅdara, entre Mâlwa et Râjasthân." In *South Asian Archaeology 1973*, edited by

J. E. van Lohuizen-de Leeuw. Leiden: Brill, 1974, pp. 116-27.

———. *Temples de l'Inde centrale et occidentale*. Publications de l'École Française d'Extrême-Orient, Mémoires Archéologiques XI. Paris: École Française d'Extême-Orient, 1976.

Virji, Krishnakumari Jethabha. *Ancient History of Saurashtra*. Bombay: Konkan Institute of Arts and Sciences, 1955.

Viṣṇudharmottara-Purāṇa Third Khanda. Edited by Priyabala Shah. *Gaekwad Oriental Series*, Baroda, 1958, 1961.

Vogel, Jean-Philippe. *La Sculpture de Mathurā*. Ars Asiatica XV. Paris: van Oest, 1930.

Wayman, Alex, "Contributions Regarding the Thirty-Two Characteristics of the Great Person." In *Sino-Indian Studies, Liebenthal Festschrift*, edited by Kshitis Roy. Santiniketan: Visvabharati University, 1957, pp. 243-260.

Weiner, Sheila L. *Ajaṇṭā: Its Place in Buddhist Art*. Berkeley and Los Angeles: University of California Press, 1977.

———. "From Gupta to Pāla Sculpture." *Artibus Asiae* XXV (1962), 167-82.

Williams, Joanna, "Char Choma and the Late Gupta Period in Mālwa." In *Chhavi* II, edited by A. Krishna, Varanasi: Bharat Kala Bhavan, forthcoming.

———. "Dentils and the Question of Wooden Origins for the Gupta Temple." *Kalādarśana: American Studies in the Art of India*, edited by J. Williams. Oxford IBH, 1981, pp. 159-63.

———. "A Mathura Gupta Buddha Reconsidered." *Lalit Kalā* 17 (1974), 28-32.

———. "New Nāga Images from the Sāñcī Area." *Oriental Art* XXII (1976), 174-79.

———. "A Recut Aśokan Capital and the Gupta Attitude towards the Past." *Artibus Asiae* XXXV (1973), 225-40.

———. Review of James C. Harle, *Gupta Sculpture,* in *Art Bulletin* LIX (1977), 119-21.

———. Review of Odette Viennot, *Temples de l'Inde Central,* in *Artibus Asiae* XL (1978), 75-81.

———. Review of Sheila Weiner, *Ajaṇṭā,* in *Art Bulletin* LXII (1980), 177-80.

———. "Sārnāth Gupta Steles of the Buddha's Life." *Ars Orientalis* X (1975), 171-92.

———. "The Sculpture of Mandasor." *Archives of Asian Art* XXVI (1972-1973), 50-66.

———. "Two New Gupta Jina Images." *Oriental Art* XVIII (1972), 378-80.

———. "Vākāṭaka Art and the Gupta Mainstream." In the Carleton Gupta Colloquium Papers, edited by Bardwell Smith and Eleanor Zelliot. Delhi: Motilal Banarsidass, forthcoming.

Yazdani, Ghulam. *Ajaṇṭā*. London: Oxford University Press, 1930, 1933, 1946, 1955.

Zimmer, Heinrich. *The Art of Indian Asia*. Bollingen Series XXXIX. 2nd ed. Princeton: Princeton University Press, 1960.

Index

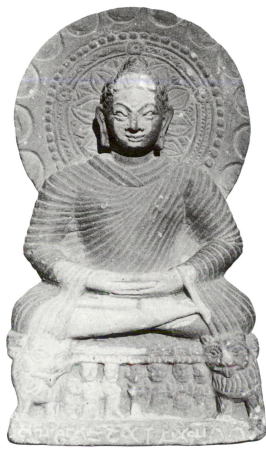

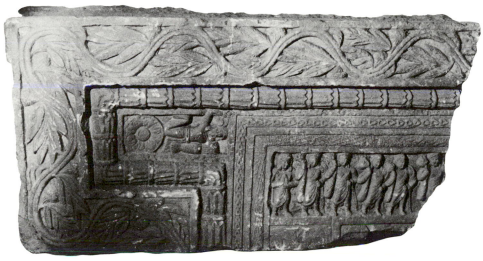

2. Mathurā, findspot Jamalpur. Lintel fragment, 2nd–3rd c. 63 × 121 × 22 cm.

1. Mathurā. Seated Buddha, dated K.E. (1)36. 28 × 15 × 6.4 cm.

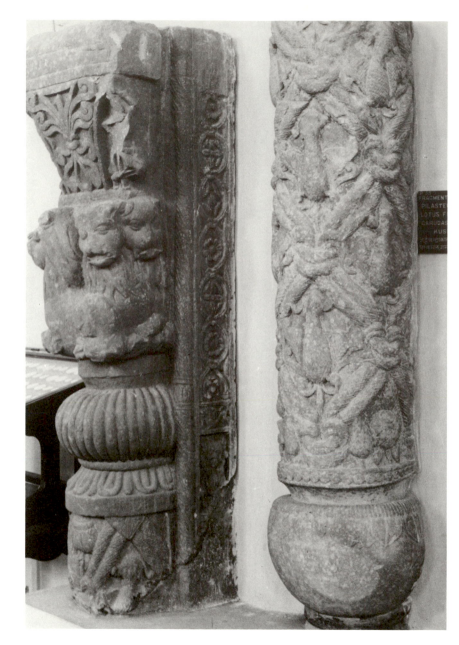

4. Mathurā, findspot a well in Mathurā
 Cantonment. Doorjamb, 3rd-4th c. 254 ×
 41 × 21 cm.

3. Mathurā, findspot possibly
 Jamalpur. Pilaster
 fragments, 3rd c. Top 107
 × 31 × 28 cm.; bottom
 104 × 31 × 28 cm.

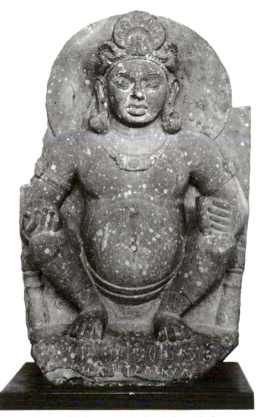

5. Mathurā, findspot Maholi. Yakṣa, 3rd c.
 70 × 40 × 15 cm.

6. Sārnāth. Standing Buddha, 2nd–3rd c.
 106.7 × 35.6 cm.

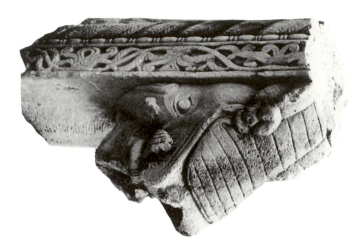

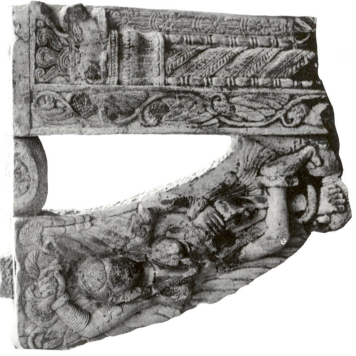

7. Jankhat. Door jamb, 3rd c.
76.5 × 21.5 × 26 cm.

9. Plate 8, reverse.

8. Jankhat. Top of door jamb and Yakṣī bracket. 78.6 × 20.3 × 72.3 cm.

c.

f.

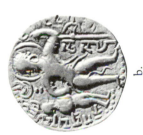

b.

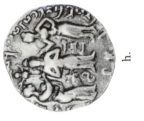

e.

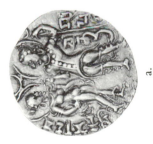

a.

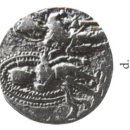

d.

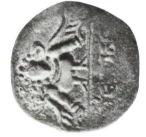

g.

h.

10a. Candragupta I and Kumāradevī, gold (obv.).
10b. Samudragupta, gold, Battleaxe type (obv.).
10c. Samudragupta, gold, Aśvamedha type (obv.).
10d. Candragupta II, gold, Cakra Puruṣa type (obv.).
10e. Candragupta II, copper, Garuḍa type (rev.).
10f. Candragupta II, copper, Pūrna ghata type (rev.).
10g. Kumāragupta I, gold, Kārttikeya type (rev.).
10h. Kumāragupta I, gold, Apratigha type (obv.).

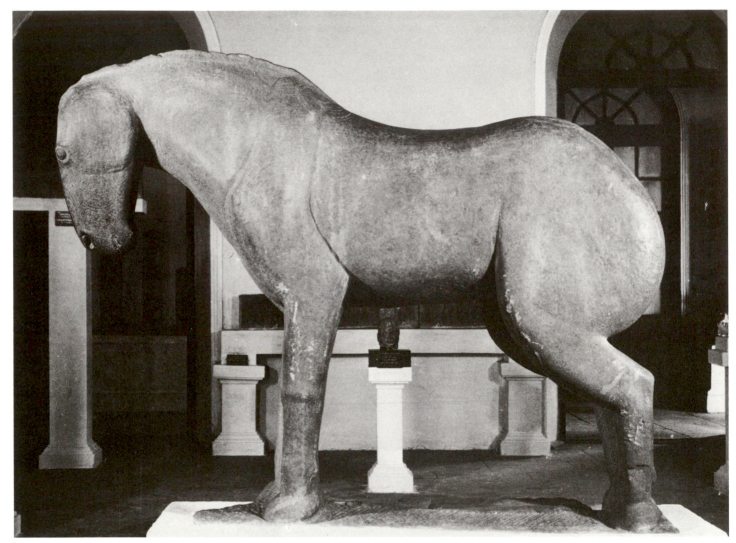

11. Khairigaṛh, Kheri District. Horse of Samudragupta (?), 365-375 (?). Ca. 200 × 159 cm.

12. Durjanpura, Vidiśā District. Candraprabha of Rāmagupta, ca. 370-375. Ca. 60 cm. high.

13. Durjanpura, Vidiśā District. Candraprabha of Rāmagupta, ca. 370-375. Ca. 60 cm. high.

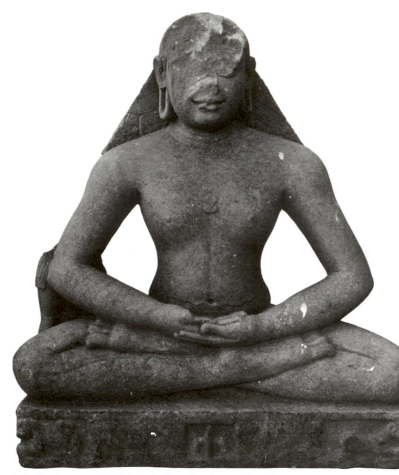

14. Durjanpura, Vidiśā District. Candraprabha of Rāmagupta, ca. 370-
375. Ca. 60 cm. high.

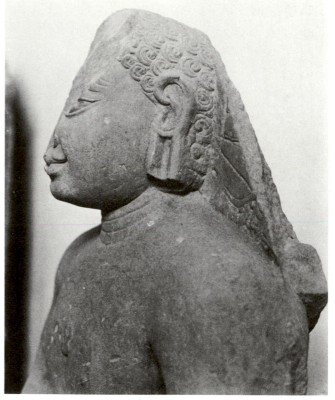

15. Plate 14, detail.

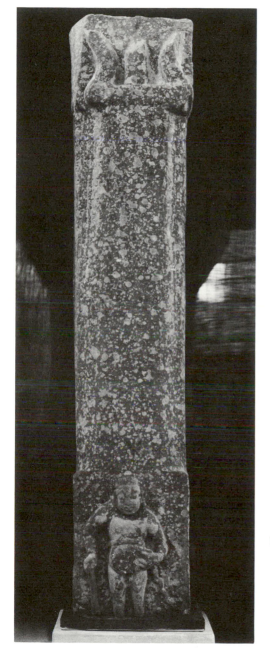

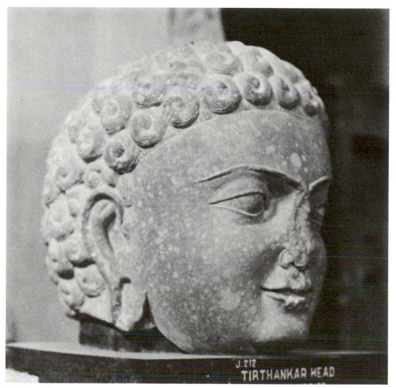

17. Mathurā. Tīrthaṃkara head, ca. 360–370. 32 cm. high.

16. Mathurā, findspot
Cāṇḍūl–Māṇḍūl Garden,
near Rangeśvara
Mahādeva. Śaiva pillar,
380. 124 cm. high, 25
cm. square at base.

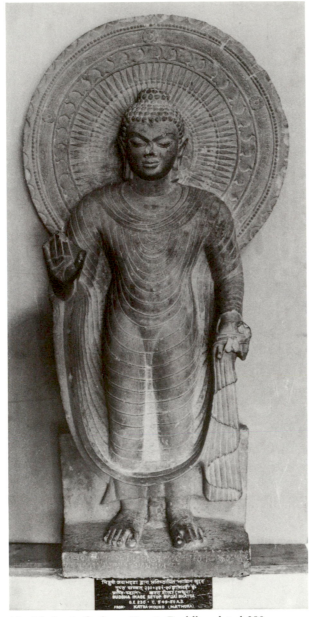

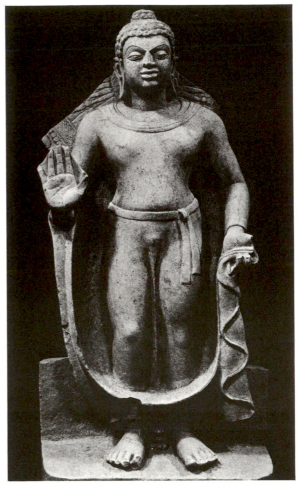

19. Mathurā, findspot Govindnagar. Buddha, ca. 390–400. Ca. 70 cm. high.

18. Mathurā, findspot Katrā. Buddha, dated 280, ca. 390–395. 130 × 43 cm.

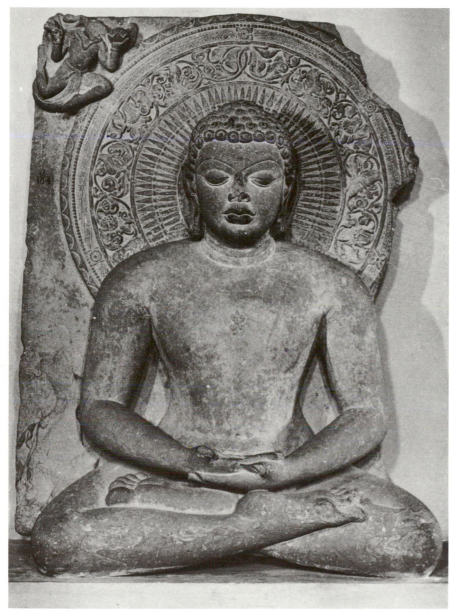

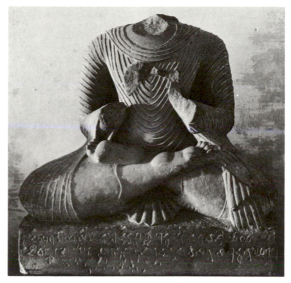

21. Mathurā, findspot Yamunā River. Dīpaṃkara Buddha, ca. 395–405. 57 × 50 × 20 cm.

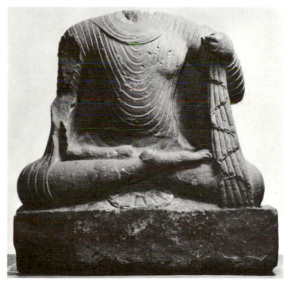

20. Mathurā, findspot Kaṅkālī Ṭīlā. Tīrthaṃkara, ca. 400–415. 124 × 99 × 40 cm.

22. Mathurā. Buddha, ca. 400–410. 61 cm. high.

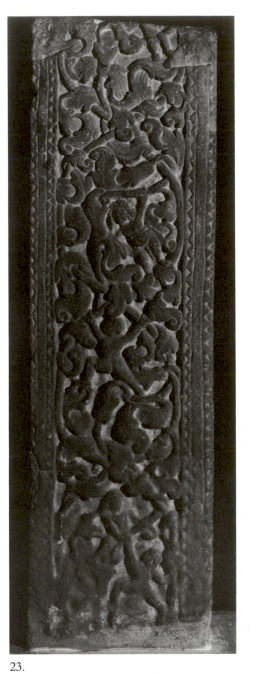

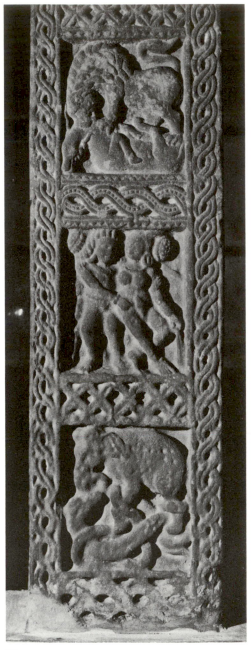

23. Mathurā. Pillar, ca. 400–415.
24. Plate 23, side view.

23. 24.

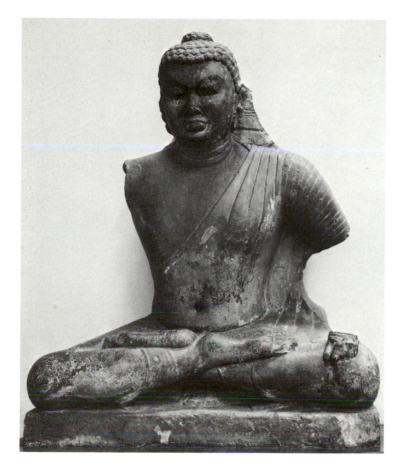

25. Bodh Gayā. Buddha, 384/5.
118 × 94 × 32 cm.

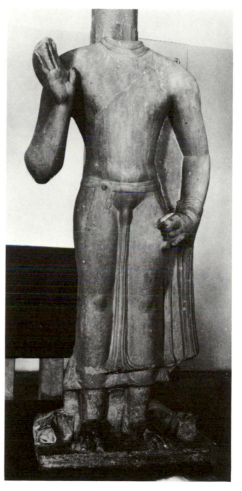

26. Sārnāth. Buddha, ca. 380–410.
Figure: 118 × 94 × 32 cm.

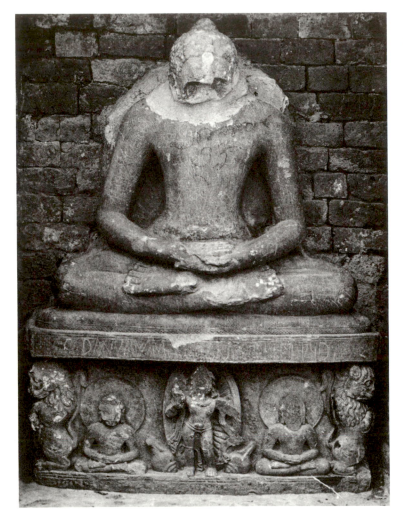

27. Rajgir, Vaibhara Hill. Nemīnātha, ca. 400–415.
82 cm. high (shoulder), 73 × 16 cm.

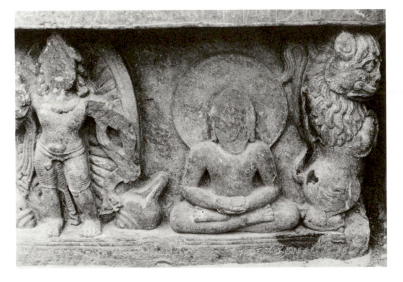

28. Plate 27, detail.

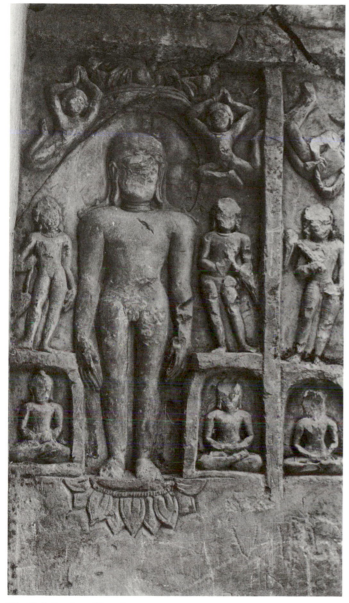

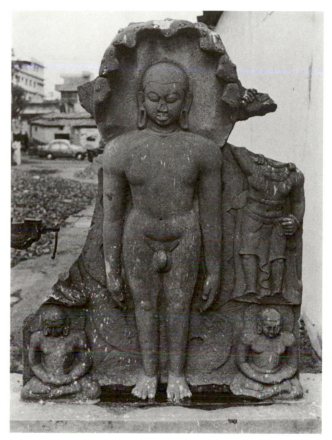

30. Patna, Gulzar Bagh. Pārśvanātha, ca. 400–
415. 181 × 130 cm.

29. Rajgir, Sonabhandar Cave. Ṛṣabhanātha, ca. 400–415.
73 × 36 cm.

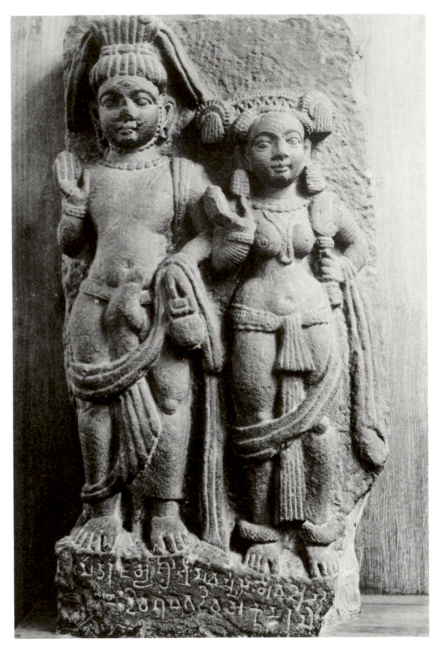

31. Kauśāmbī. Śiva and Pārvatī, 387/8? 70 × 35 × 12 cm.

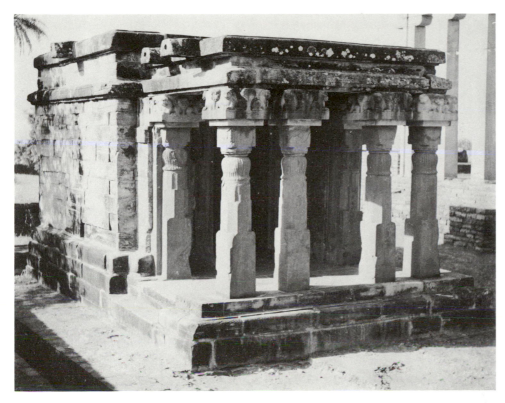

32. Sāñcī, Shrine 17, ca. 400.

33. Sāñcī, Shrine 17. Doorway.

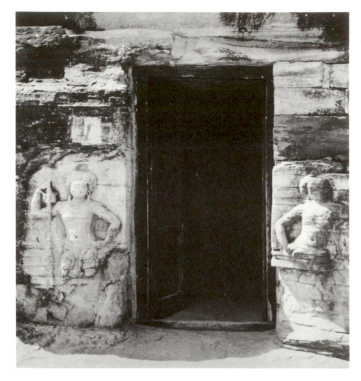

34. Udayagiri, Cave 7, doorway, ca. 400.

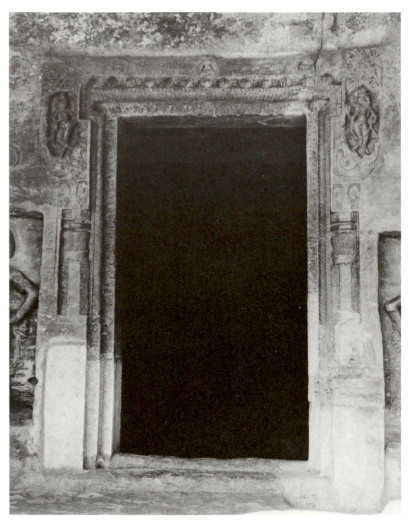

36. Plate 35, detail of doorway.

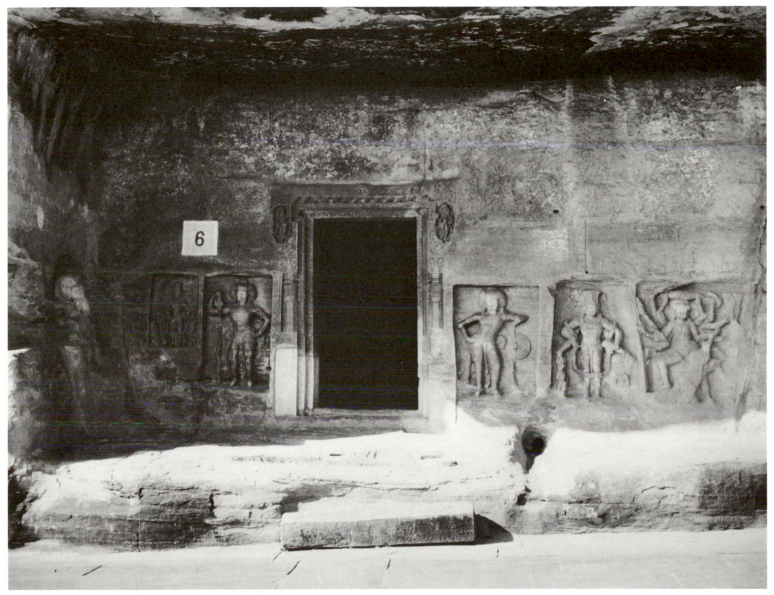

35. Udayagiri, Cave 6, façade, ca. 401/2. 7 m. long.

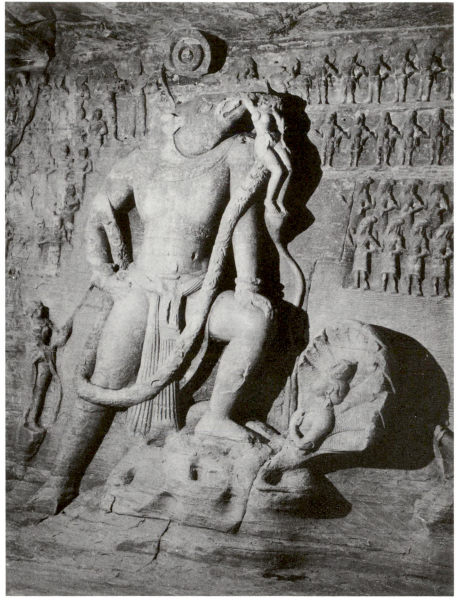

37. Udayagiri, Excavation 5. Varāha, central portion, ca. 401-405. 390 cm. high.

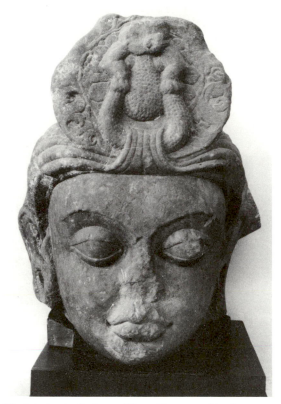

38. Mathurā, findspot River Yamunā. Head, 400-415. 53 × 43 × 38 cm.

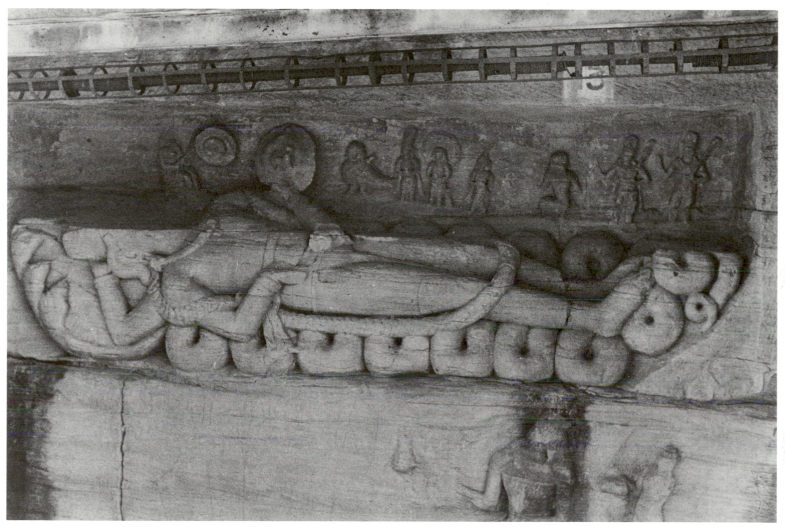

39. Udayagiri, Excavation 13. Viṣṇu Anantaśayana, ca. 401–405. 70 cm. long.

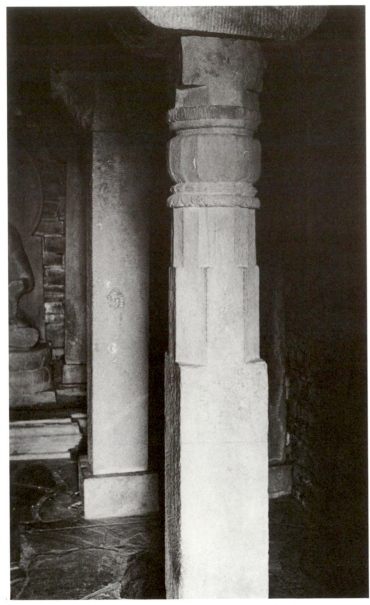

40. Sāñcī, Shrine 31. Pillar, ca. 405-415. 192 × 29 cm. square (base), 26 cm. square (top).

41. Udayagiri hilltop. Door jamb, ca. 405-415. 140 × 94 × 49 cm.

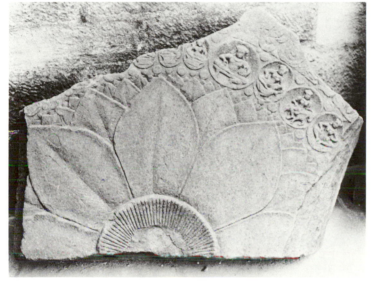

42. Udayagiri hilltop. Fragment of lotus ceiling, ca. 415–425.
Ca. 125 cm. wide.

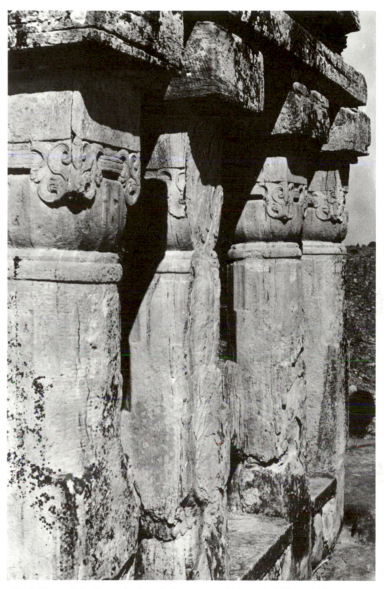

43. Udayagiri, Cave 1. Porch front, ca. 410–415. Pillars 194 cm.
high to abacus, 31 cm. square at top.

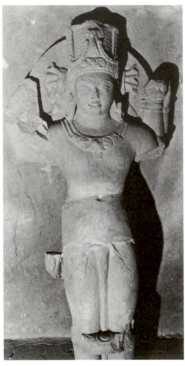

44. Besnagar. Balarāma, ca. 400–
 415. 103 × 48 cm.

46. Besnagar. Fragment of Goddess
 from doorway, ca. 405–415.

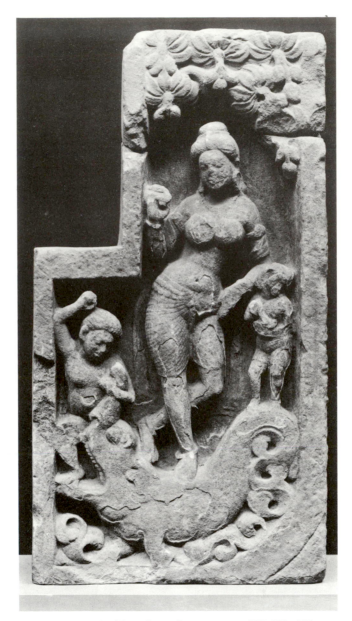

45. Besnagar. Goddess from doorway, ca. 405–415. 150
 × 60 cm.

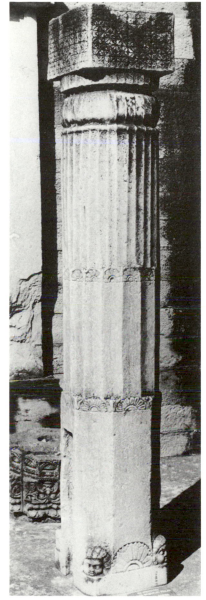

47. Besnagar. Pilaster, ca. 405–415.
 206 cm. high, 35 cm. square
 top and bottom.

48. Besnagar. Mātṛkā, ca. 400–415. Ca. 130 cm.
 high.

49. Pawaya. Terra-cotta panel, ca.
 400–410. 24 × 23 cm.

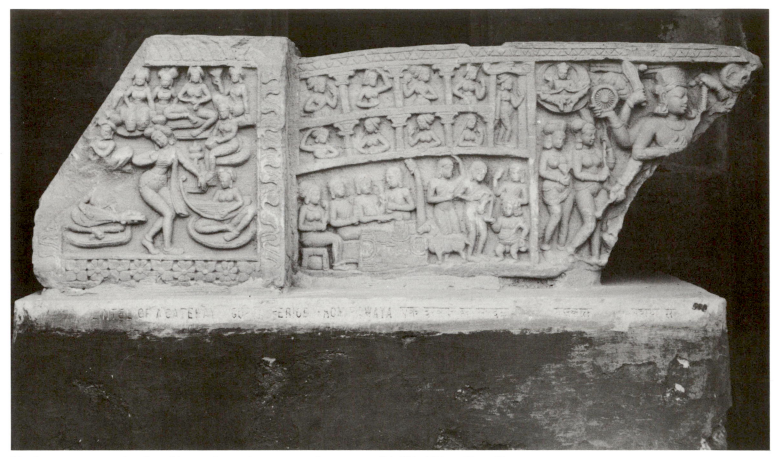

50. Pawaya. Toraṇa lintel, Bali's sacrifice and Viṣṇu Trivikrama, ca. 400–410. 195 × 67 × 69 cm.

51.

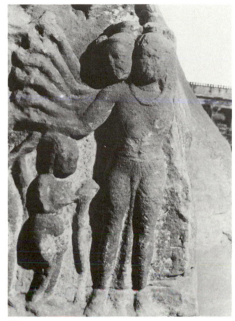

52.

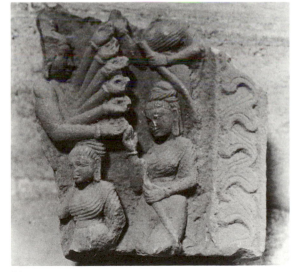

53.

51. Plate 50, reverse, center. Churning of
 the Ocean of Milk.
52. Plate 50, reverse, end. Kumāra.
53. Pawaya. Fragment from same lintel.
 Ṣaṣṭhī. 33 cm. high.

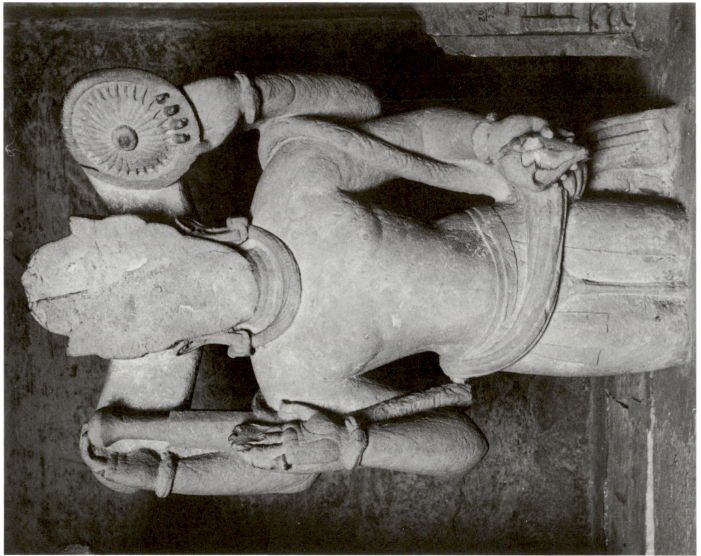

54. Pawaya. Viṣṇu, ca. 400–410. 96 × 65 cm.

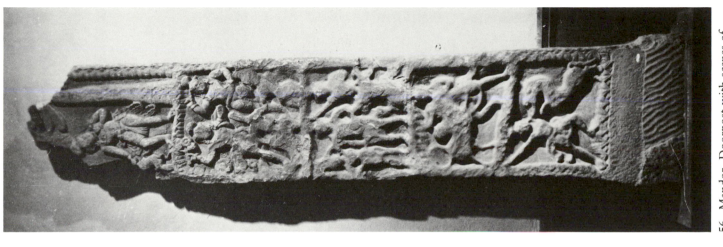

56. Mandor. Doorpost with scenes of Kṛṣṇa's life, ca. 380-415. Ca. 400 × 60 × 20 cm.

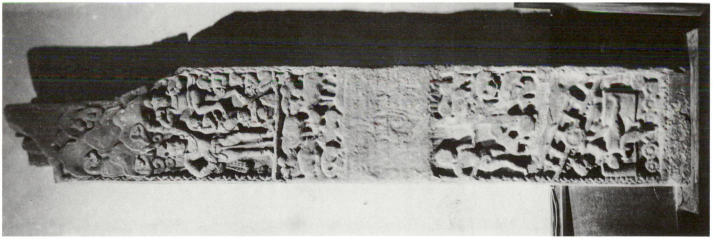

55. Mandor. Doorpost with scenes of Kṛṣṇa's life, ca. 380-415. Ca. 400 × 60 × 20 cm.

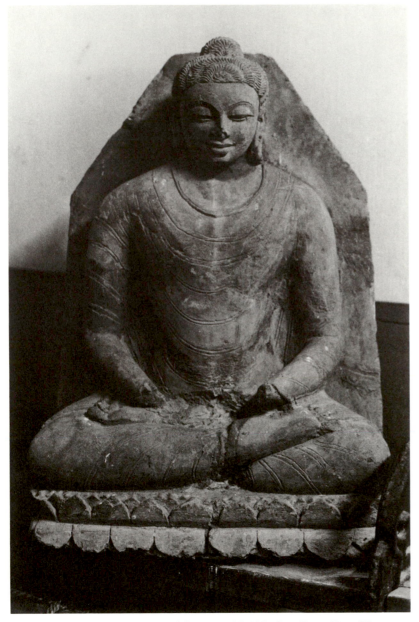

58. Devnimori. Terra-cotta medallion, ca. 400–415. Ca. 40 cm. high.

57. Devnimori. Terra-cotta Buddha, ca. 400–415. Ca. 60 × 45 × 25 cm.

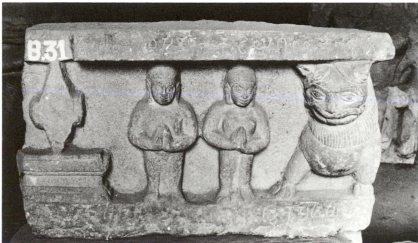

59. Mathurā. Pedestal of Jain image, 417. 26 × 44 × 11.5 cm.

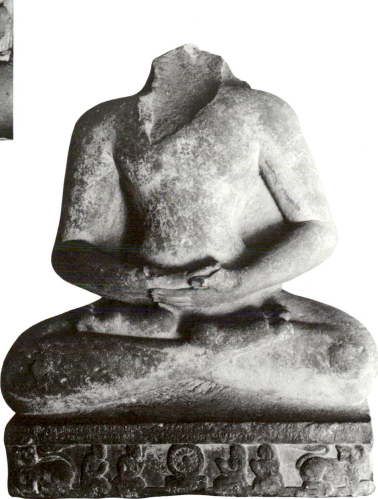

60. Mathurā. Tīrthaṃkara, 432/3.
107 × 80 × 35 cm.

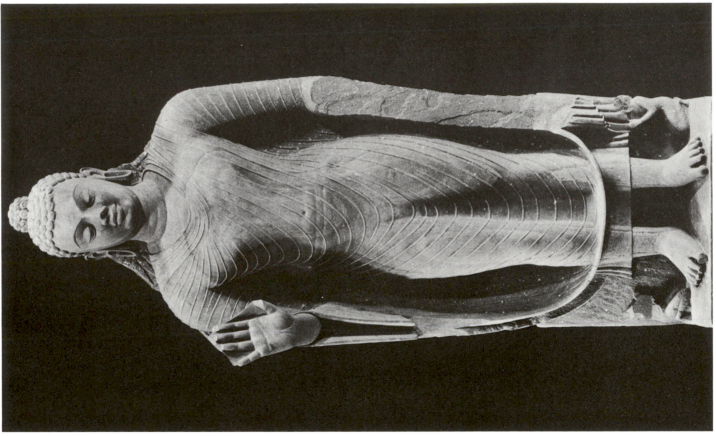

61. Mathurā, findspot Govindnagar. Buddha, 434/5. 147 × 52 cm.

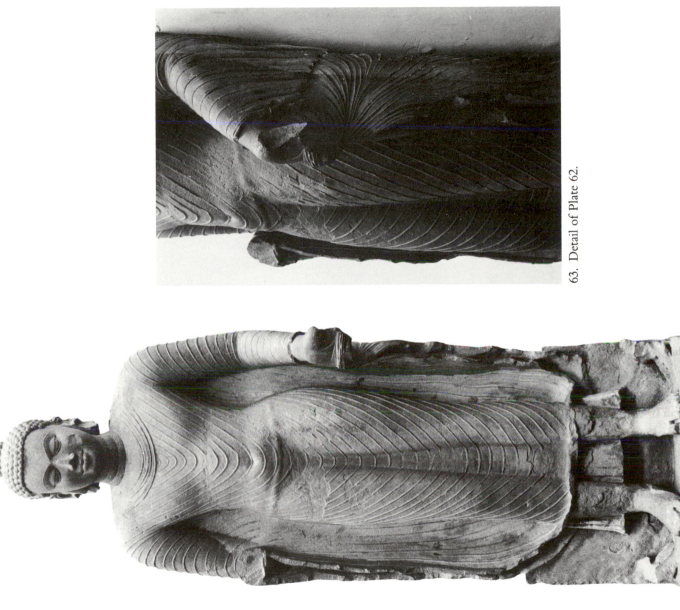

63. Detail of Plate 62.

62. Mathurā. Buddha, ca. 430-435. 147 × 50 × 26.5 cm.

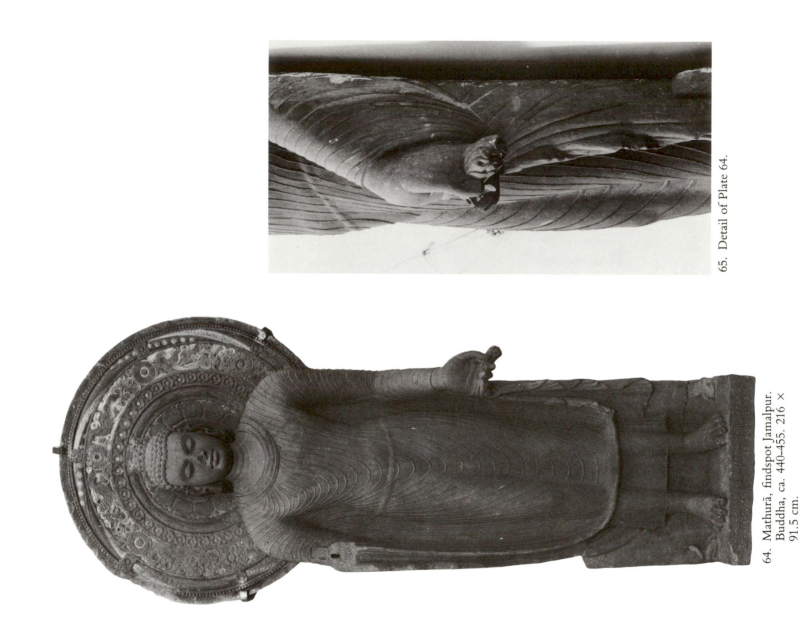

65. Detail of Plate 64.

64. Mathurā, findspot Jamalpur. Buddha, ca. 440–455. 216 × 91.5 cm.

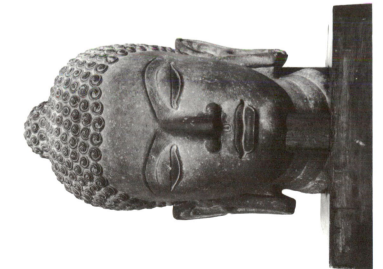

66. Mathurā, findspot Cāmuṇḍā Tīlā.
Buddha head, ca. 435-455. 59 × 37 ×
29 cm.

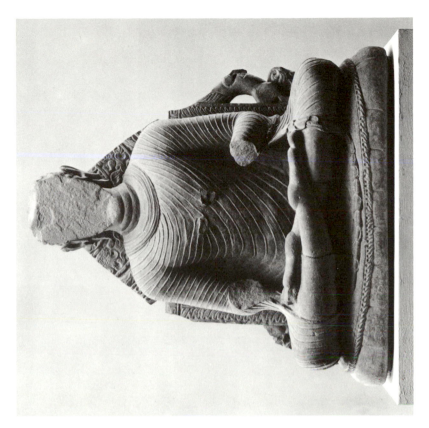

67. Mathurā. Buddha, ca. 435-455. 82
cm. high.

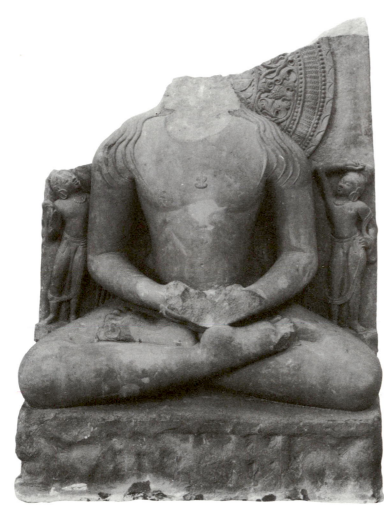

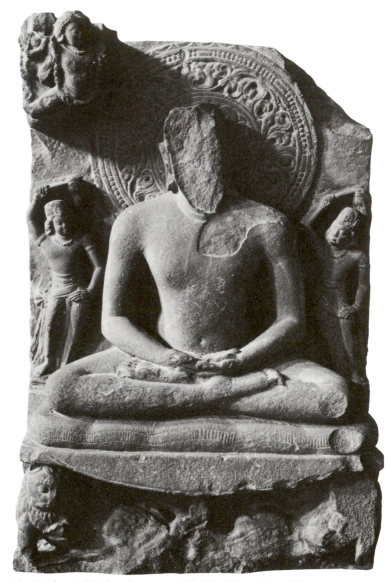

68. Mathurā, findspot Kaṅkālī Ṭīlā. Rṣabhanātha, ca. 440–455. 120 × 89 × 30 cm.

69. Mathurā. Tīrthaṃkara, ca. 440–455. 57 × 41 × 15 cm.

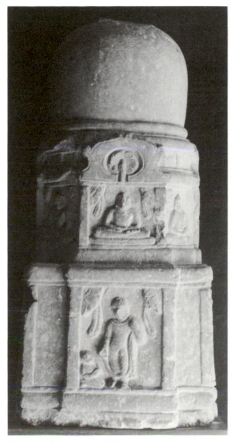

70. Mathurā. Model *stūpa*, ca. 420–440.
55 × 23 cm.

71. Mathurā, findspot Swāmighat.
Pilaster capitals, ca. 430–460. 64 × 34
(top width) cm.

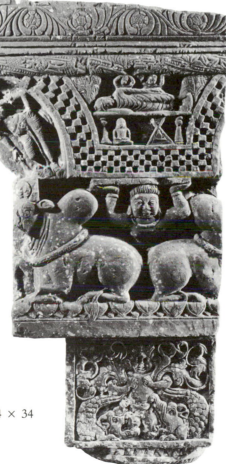
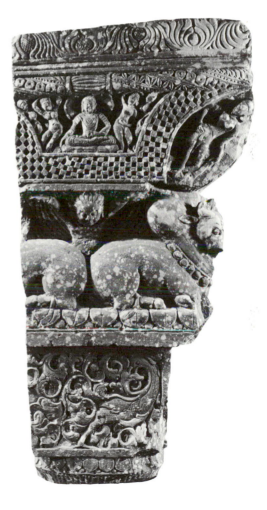

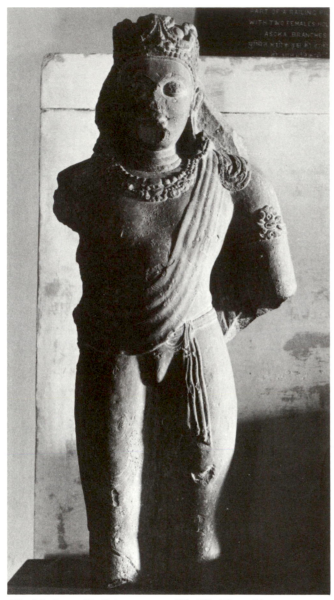

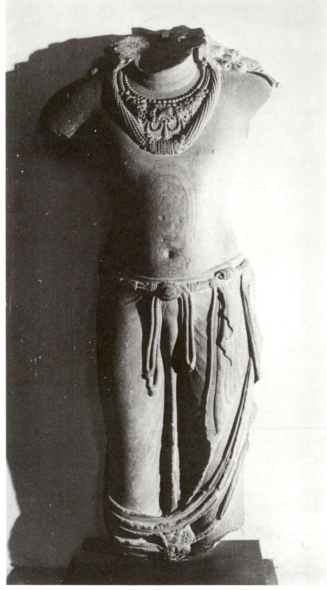

72. Mathurā. Bodhisattva, ca. 430–460. 73 × 34 cm.

73. Mathurā, findspot Jaisinhapura. Viṣṇu, ca. 430–460. 94 × 45 × 16 cm.

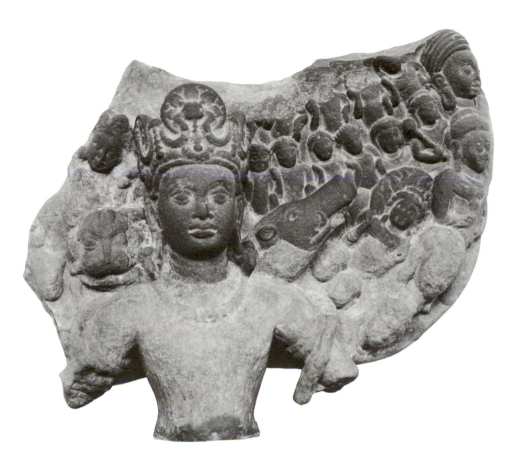

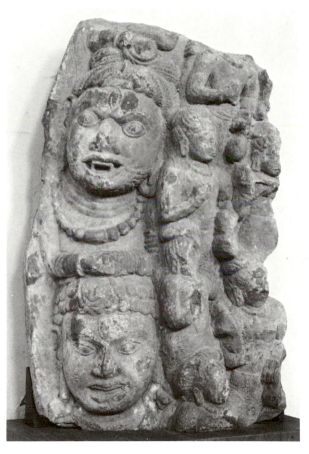

74. Bhankari, Aligarh District. Viṣṇu Viśvarūpa, ca. 430–460. 47 × 38 cm.

75. Mathurā, findspot Katra Kesavdev. Fragment of Viṣṇu Viśvarūpa, ca. 430–460. 46 × 30 cm.

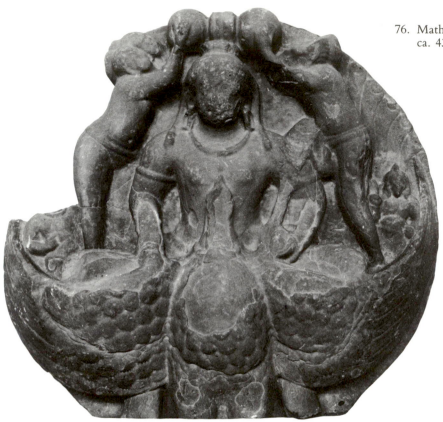

76. Mathurā. Anointing of Kumāra,
ca. 430–460. 74 × 83 × 15 cm.

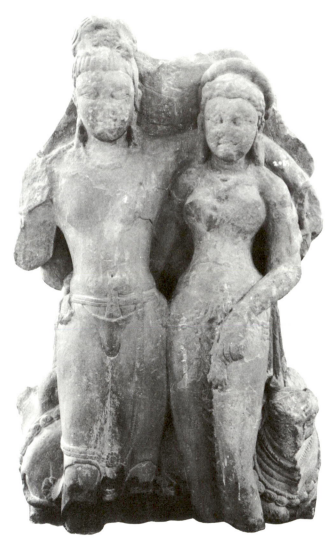

77. Mathurā. Śiva and Pārvatī,
ca. 430–460. 92 × 57 × 34 cm.

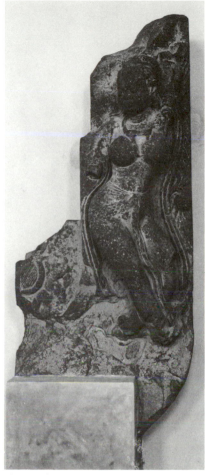

78. Mathurā. Goddess from doorway, ca. 430–460. 133 × 55 × 30 cm.

79. Mathurā, Column, ca. 430–460. 140 × 30 cm.

80. Mathurā. Durgā, ca. 430–460. 47 × 35 × 12 cm.

81. Bilsaḍh, south pillar, west face, ca. 420. Pillar 63 cm. square.

82. Bilsaḍh, north pillar, east face.
Pillar 63 cm. square.

83. Bilsaḍh, north pillar, south face. Pillar 63 cm. square.

84. Bilsaḍh, north pillar, west face. Pillar 63 cm. square, 137 cm. high above ground level.

85. Sārnāth. Buddha, ca. 430–450. 97 × 50
 × 25 cm.
86. Sārnāth. Buddha, ca. 450–460. 104 × 36
 cm.
87. Sārnāth. Buddha, ca. 455–465. 97 × 44
 × 20 cm.

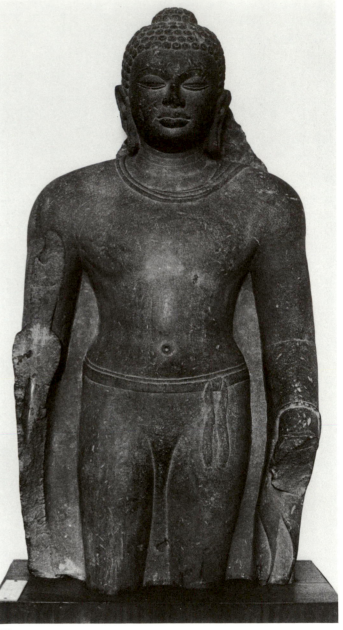

85.

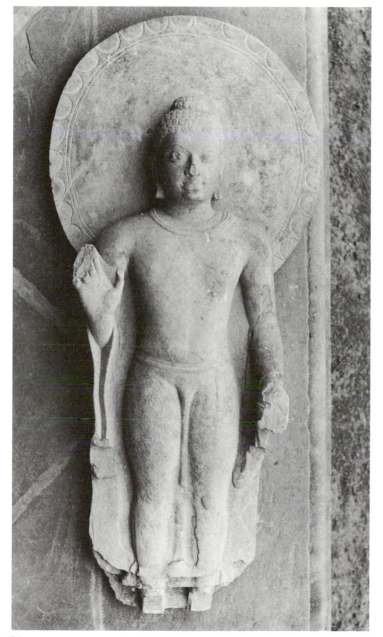

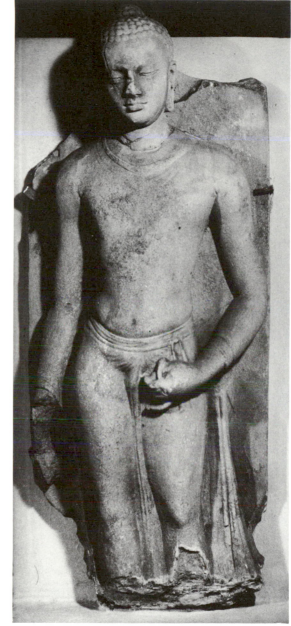

86.

87.

88. Kahaum. Pārśvanātha, 460/1.
 Image at base 77 × 34 cm.

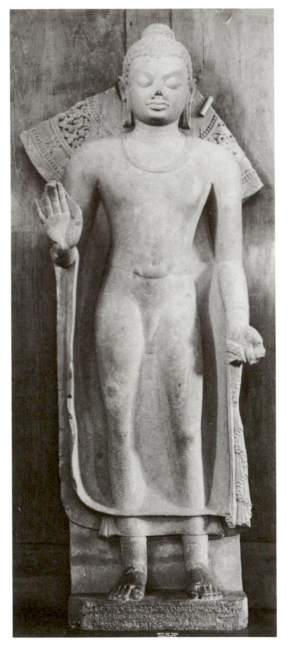

89.

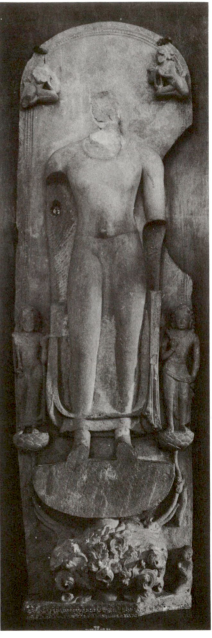

90.

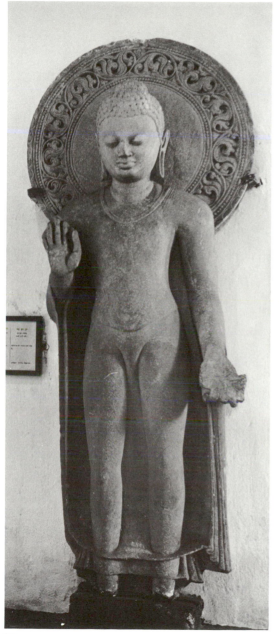

91.

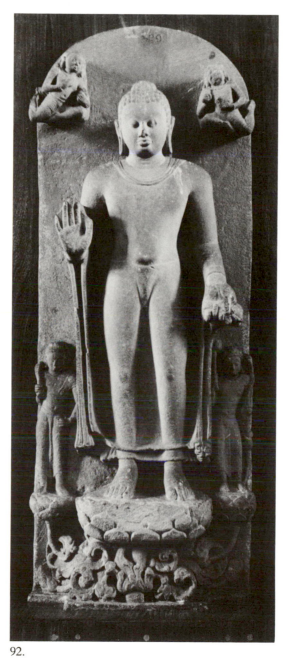

92.

89. Sārnāth. Buddha, 474. 193 × 45 cm.

90. Sārnāth. Buddha, 477. 190 × 43 cm.

91. Sārnāth. Buddha, ca. 465–480. 126 × 57 × 20 cm.

92. Sārnāth. Buddha, ca. 465–480. 112 × 48 × 24 cm.

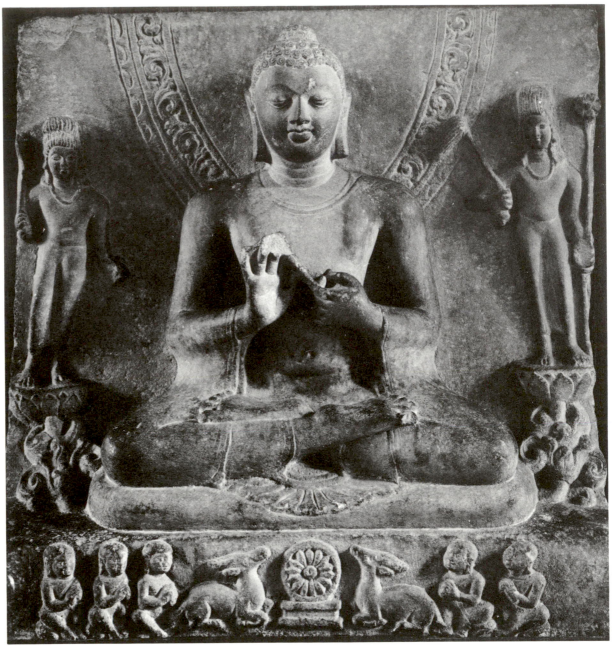

93. Sārnāth. Buddha, First Sermon, ca. 465–475. 74 × 74 × 22 cm.

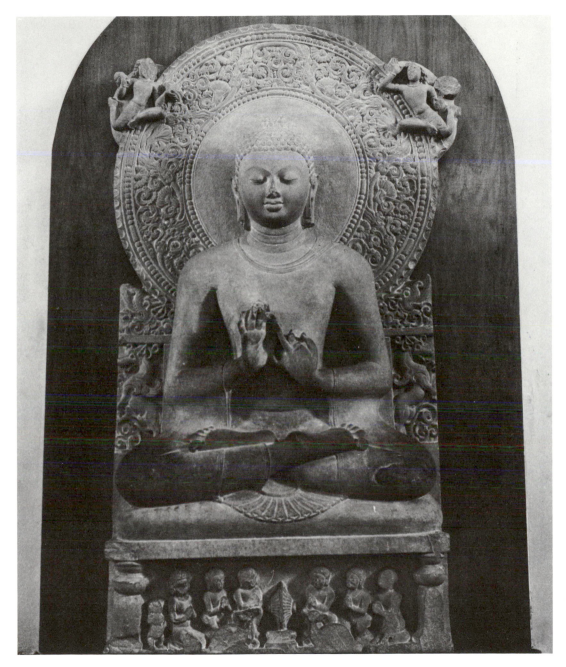

94. Sārnāth. Buddha, First Sermon,
ca. 475–485. 160 × 79 cm.

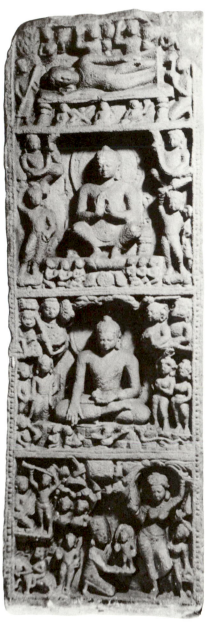

95. Sārnāth. Scenes from the
Buddha's Life, ca. 475-485. 93
× 31 10 cm.

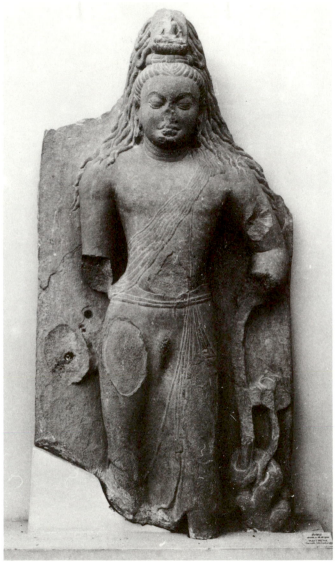

96. Sārnāth. Maitreya, ca. 450–460. 135 × 66 cm.

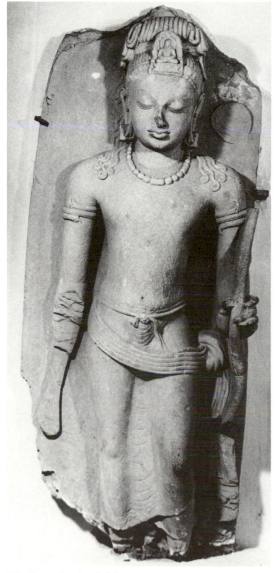

97. Sārnāth. Avalokiteśvara, ca. 465–485. 98 × 39 × 14 cm.

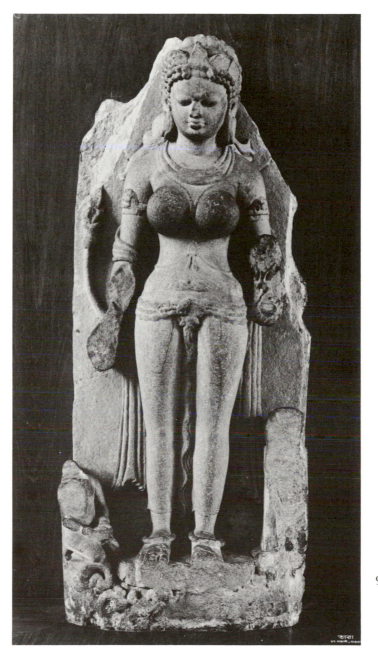

98. Sārnāth. Tārā, ca. 455–465. 98 × 39 × 14 cm.

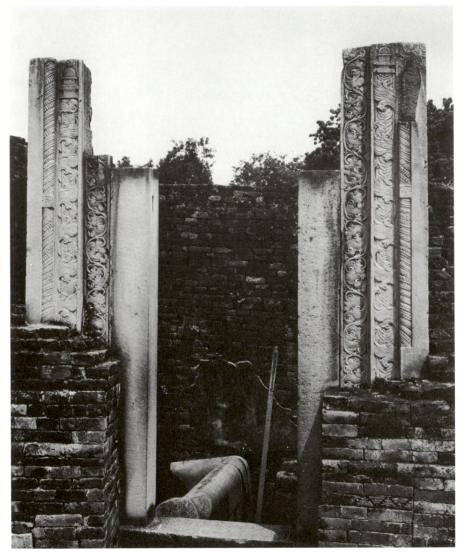

99. Sārnāth. Main shrine, door jambs, ca. 460–480. 50 × 93 cm.

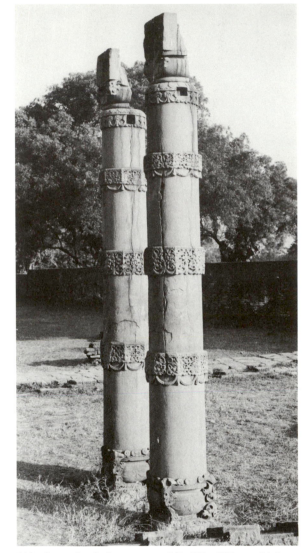

100. Sārnāth. Columns, ca. 460–480. 325 cm. high × 36 cm. square at base.

101. Vārāṇasī, Rajghat. Pillar.
Nārāyaṇa face, 478. 131 cm.
high, 33 cm. square at base.

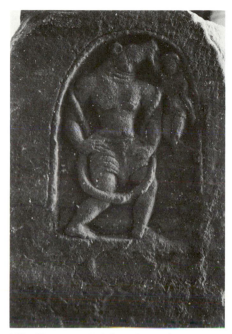

102. Vārāṇasī, Rajghat. Second
pillar, Varāha face, ca. 478.

103. Vārāṇasī, findspot Gayāghat.
Kumāra, ca. 470-485. 38 ×
48 cm.

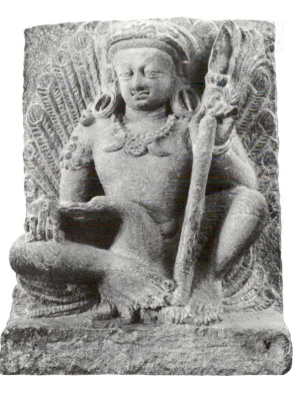

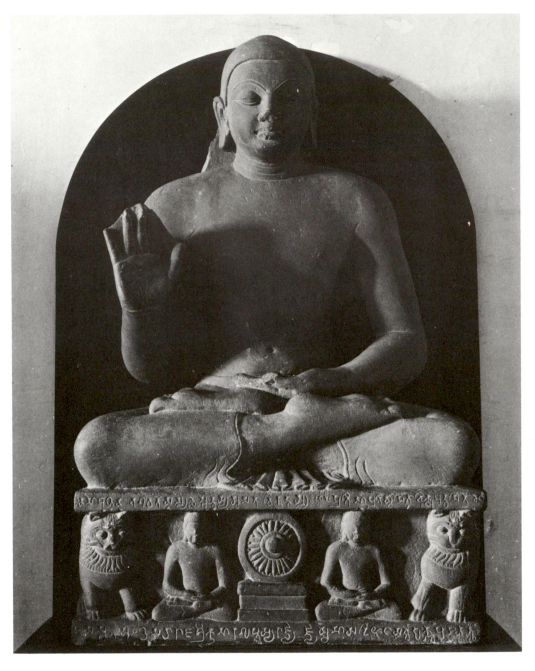

104. Mankuwar. Buddha, 429. 88 × 50 × 22 cm.

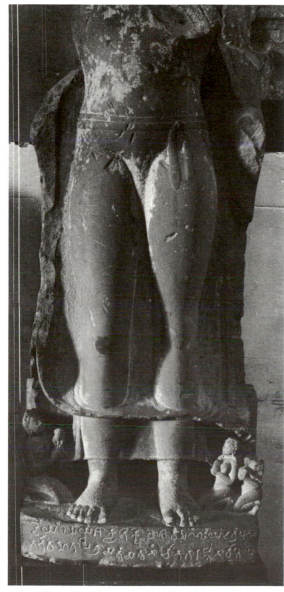

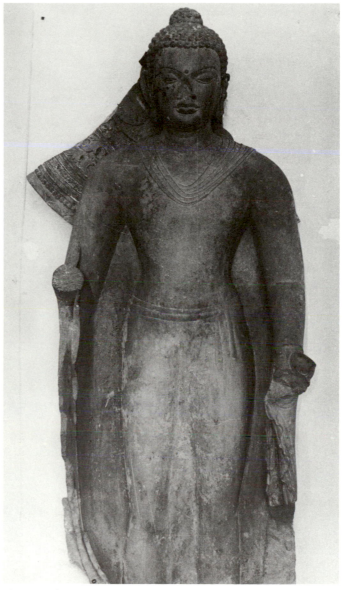

105. Bhīṭā. Buddha, ca. 430–450. 130 × 40 cm.

106. Bazidpur, Kanpur District. Buddha, ca. 430–450. 131 × 60 cm.

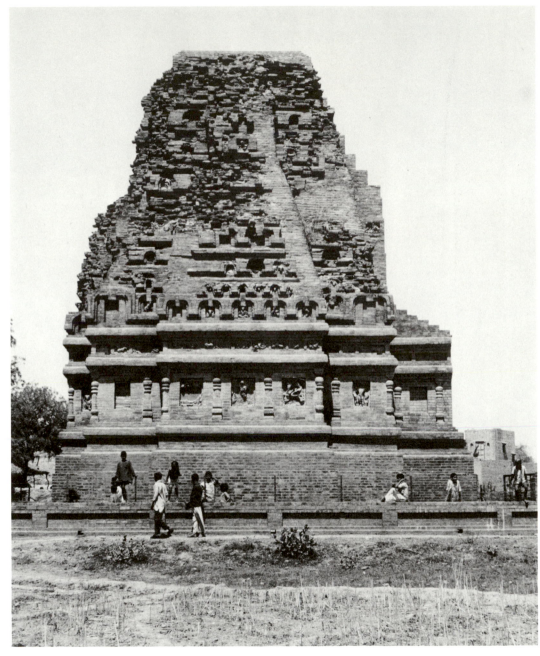

107. Bhitargaon. Brick temple, south face, ca. 425–460.

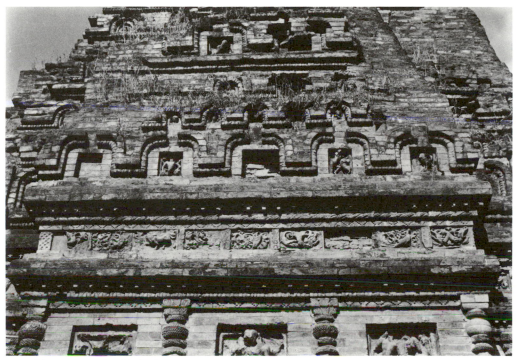

108. Bhitargaon, detail of Plate 107.

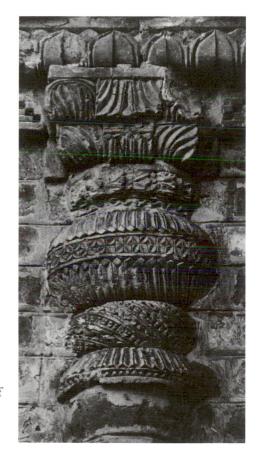

109. Bhitargaon, detail of pilaster capital.

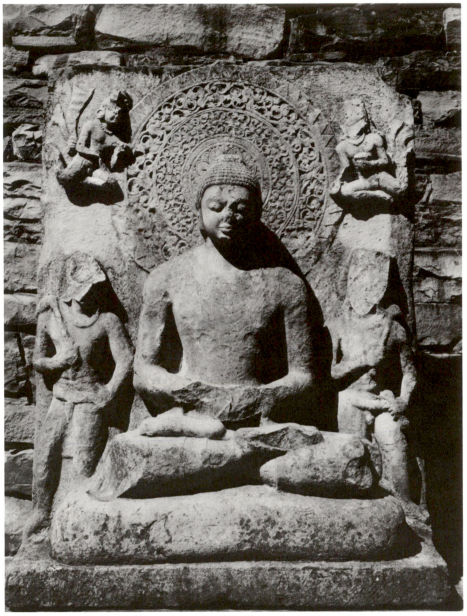

110. Sāñcī, Stūpa I. Buddha on east, ca. 435–450. 162 × 121 × 68 cm.

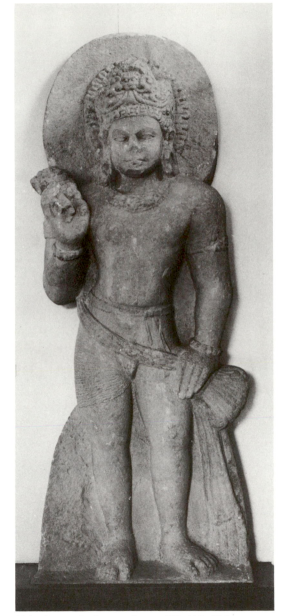

111. Sāñcī. Padmapāṇi, ca. 450–460. 209 × 83 × 34 cm.

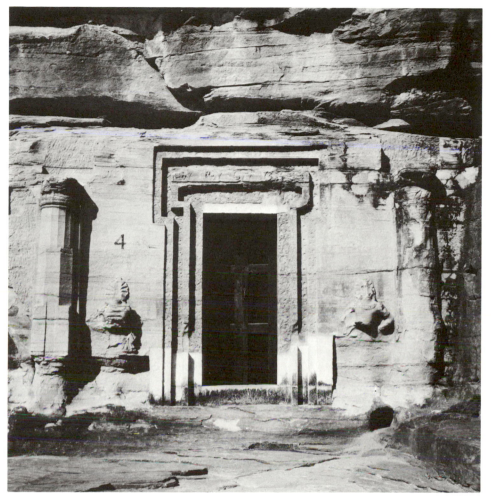

112. Udayagiri. Cave 4, façade, ca. 415–425. Door 160 × 70 cm.

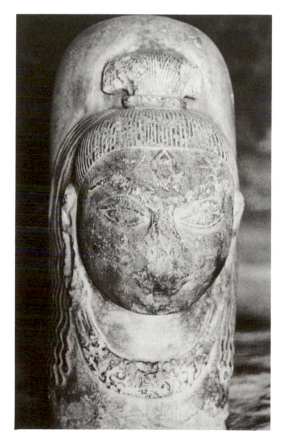

113. Udayagiri. Cave 4, *liṅga*, ca. 415–425. 75 cm. high, 25 cm. square at base.

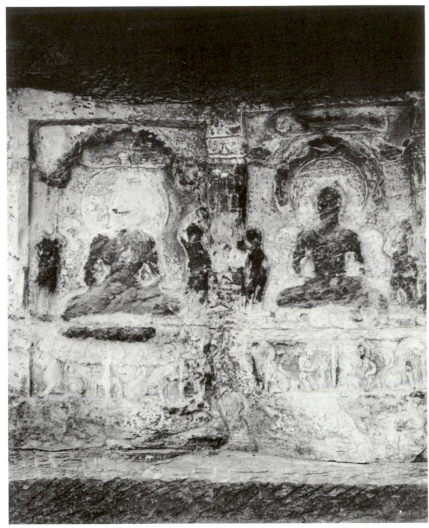

114. Udayagiri. Tīrthaṃkaras, ca. 425. 70 × 106 cm.

115. Udayagiri. Tīrthaṃkaras, ca. 425. 53 × 77 cm.

116. Udayagiri. Cave 19, façade, ca. 430–450.

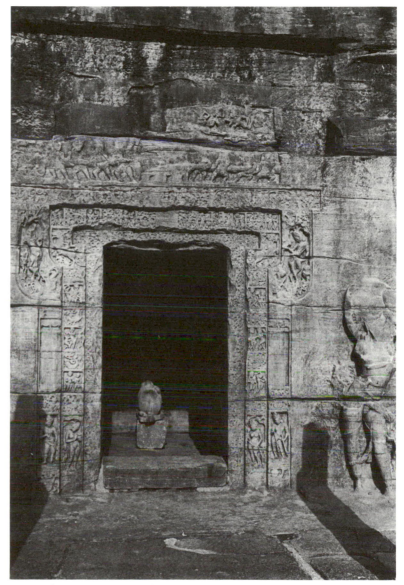

117. Udayagiri. Cave 19, doorway. Opening 214 × 109 cm.

119. Udayagiri. Cave 19, front column, detail. Ca. 55 cm. diameter at top.

120. Udayagiri. Cave 19, column immediately in front of door. Ca. 40 cm. square.

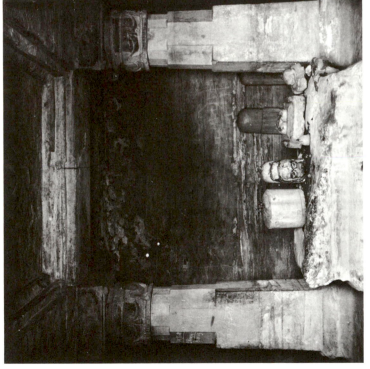

118. Udayagiri. Cave 19, interior.

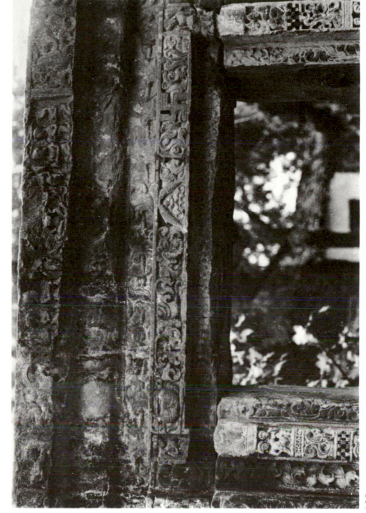

121. Tumain. Doorway, ca. 435/6.
Opening 202 × 83 cm.
122. Tumain, detail of Plate 121.

122.

121.

123. Eran. Lintel fragment, ca. 430–
450. 210 × 49 × 61 cm.

124. Eran. Capital, ca. 430–450. 80 ×
40 cm.

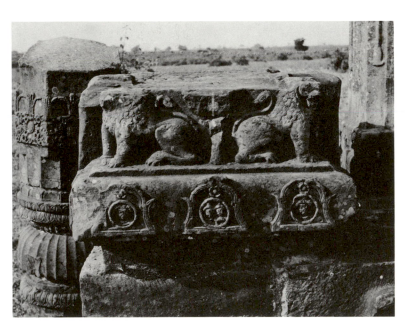

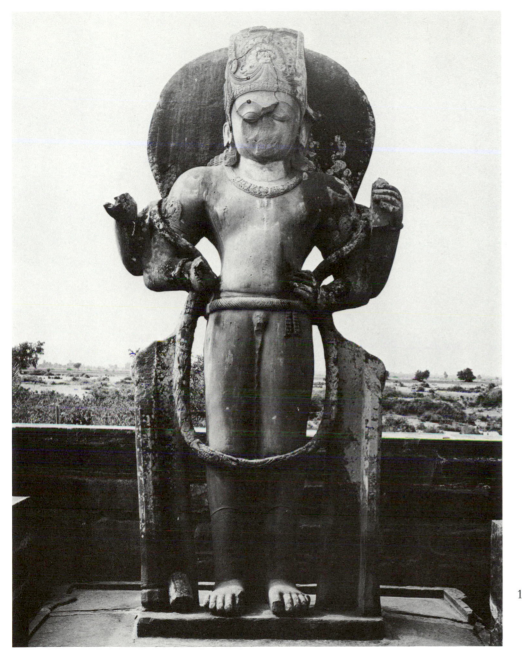

125. Eran. Viṣṇu, ca. 450–480. 411 cm. high.

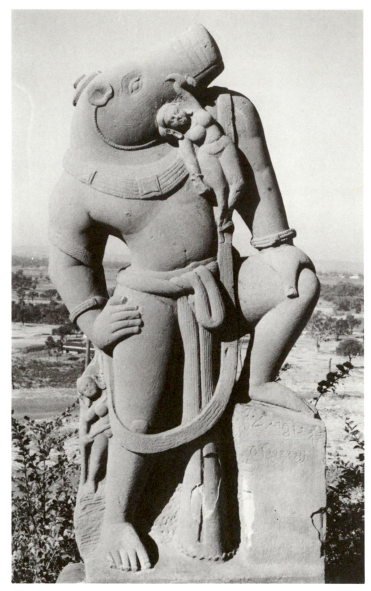

126. Eran. Varāha, ca. 450–480. 189 × 76 × 37 cm.

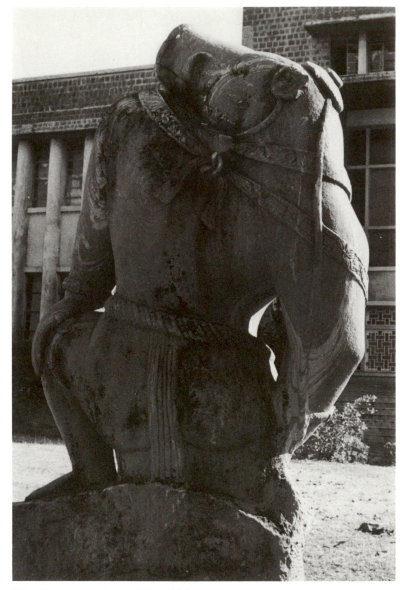

127. Eran, rear view of Plate 126.

128. Tigowa. South face, ca. 445–470.

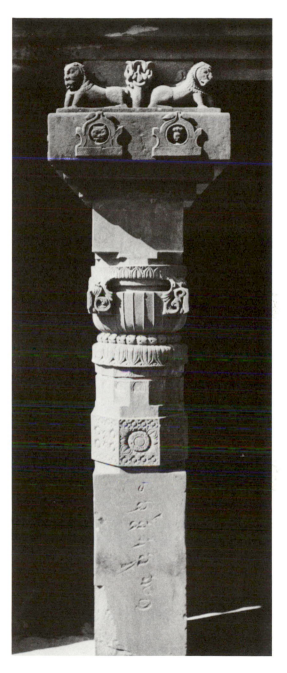

129. Tigowa. Central column. 221 × 33.5 cm. square at the base.

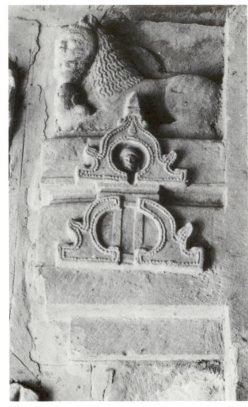

130. Tigowa. Pilaster capital.

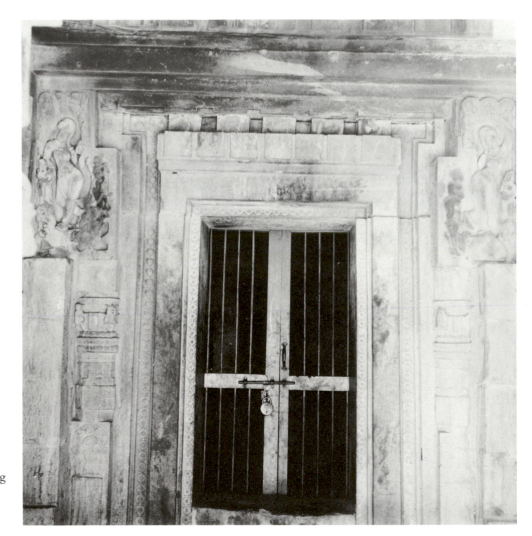

131. Tigowa. Doorway. Opening
75 × 166 cm.

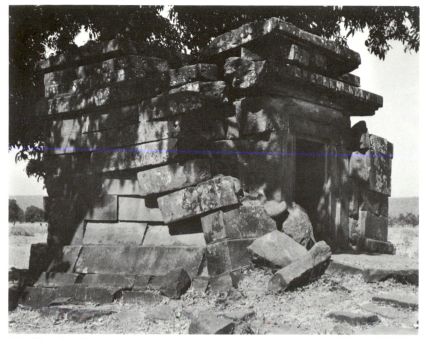

132. Kunda. Temple, ca. 450-475.

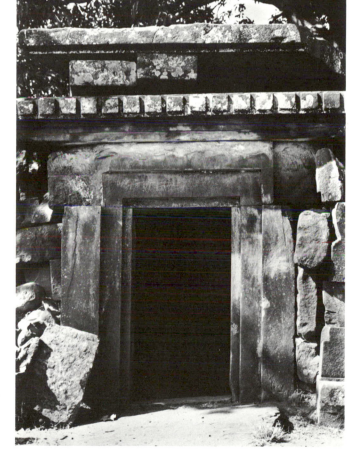

133. Kunda. Doorway. Opening 68 × 133 cm.

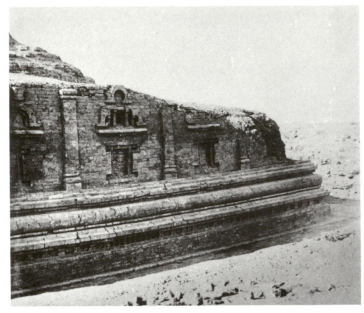

134.

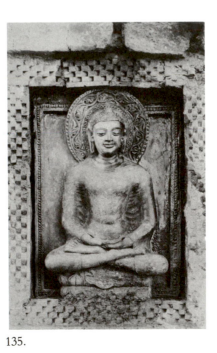

135.

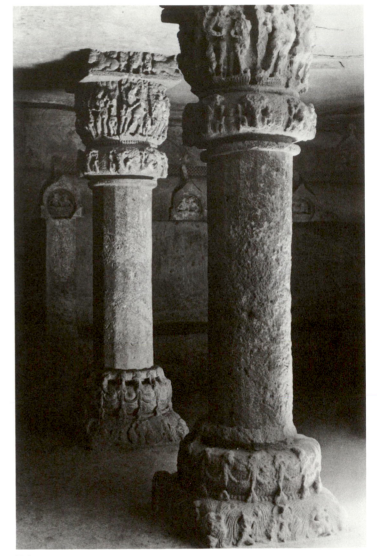

136.

134. Mirpurkhas. *Stūpa* base, ca. 440–470.

135. Mirpurkhas. Terra-cotta Buddha in situ.

136. Uparkot. Cave 2, columns in lower story, ca. 440–470. Ca. 200 cm. high.

137. Uparkot, detail of Plate 136.
138. Uparkot. Cave 2, top story columns.
139. Uparkot. Cave 1, pilaster.

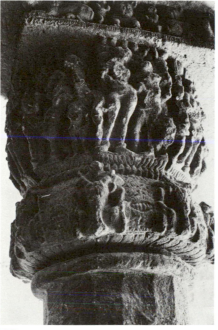

137.

138.

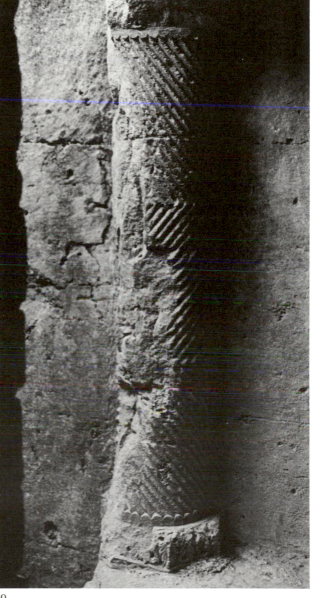

139.

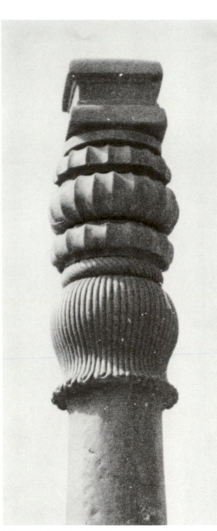

140. Mehrauli. Iron Pillar, ca. 415.

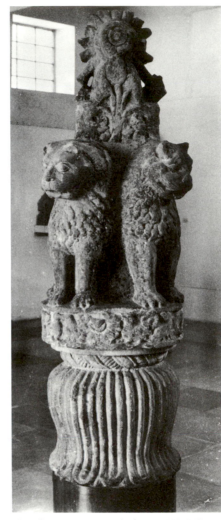

141. Sāñcī. Lion capital, ca. 415–450.
163 cm. high, ca. 48 cm. diameter
base.

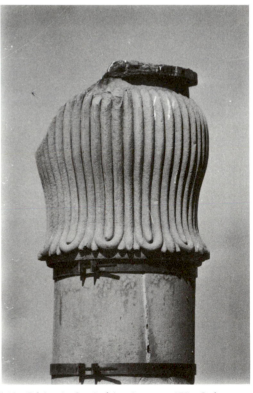

142. Bhitari. Capital in situ, ca. 455. Column
7.72 cm. high, 76 cm. square at base.

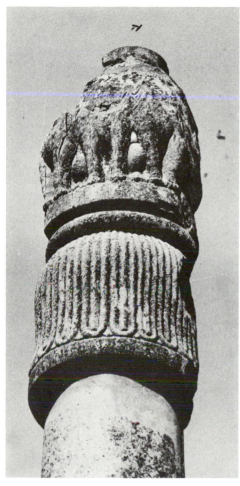

143. Latiya. Capital in situ, ca. 450–460.

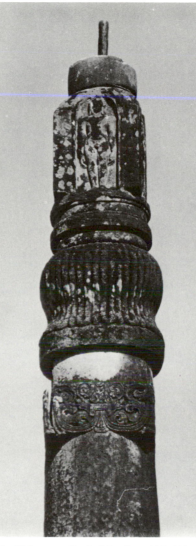

144. Kahaum. Capital in situ, 460–461.
Column 736 cm. high, 56 cm.
square at base.

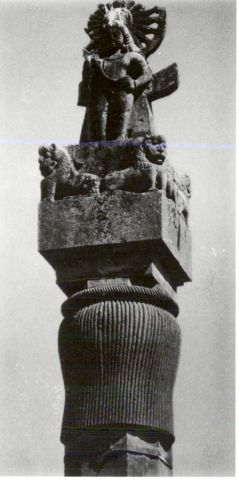

145. Eran. Capital in situ, 485. Column 1311
cm. high, 86.4 cm. square at base.

146. Nāchnā. Tīrthaṃkara, ca. 470–480. 147 × 86 × 39 cm.

147. Nāchnā. Cave on Siddh-ka Pahar. Tīrthaṃkara, ca. 480–490. 153 × 100 × 39 cm.

148. Nāchnā. Pārśvanātha, ca. 500–510. 78 × 57 × 20 cm.

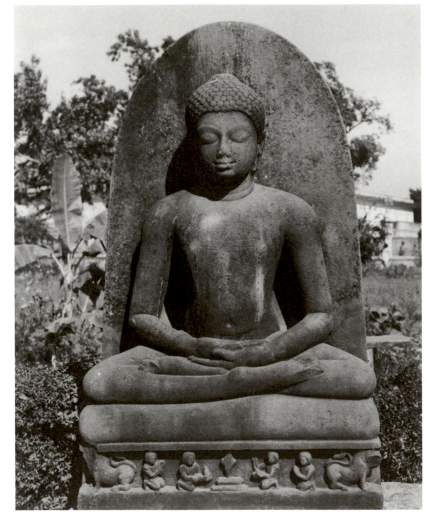

146.

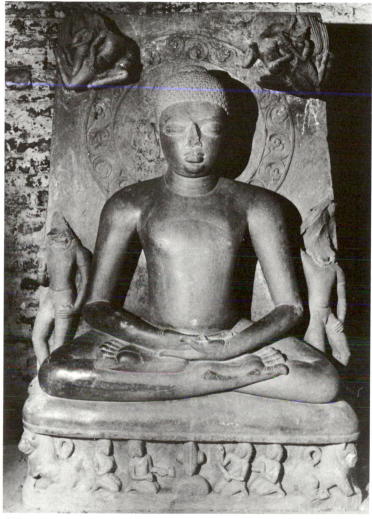

147.

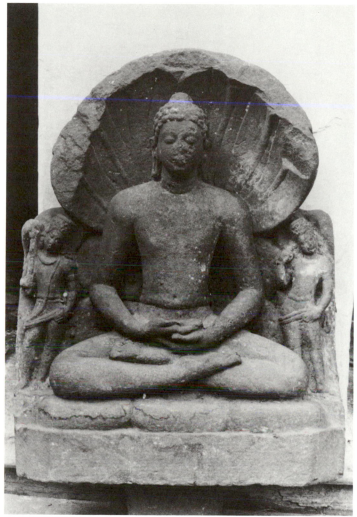

148.

149. Nāchnā. Pārvatī Temple,
ca. 480–500.

150. Nāchnā. Pārvatī Temple.

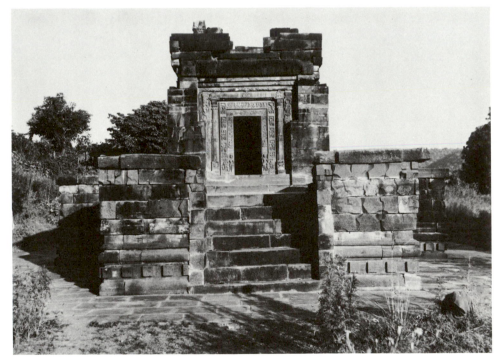

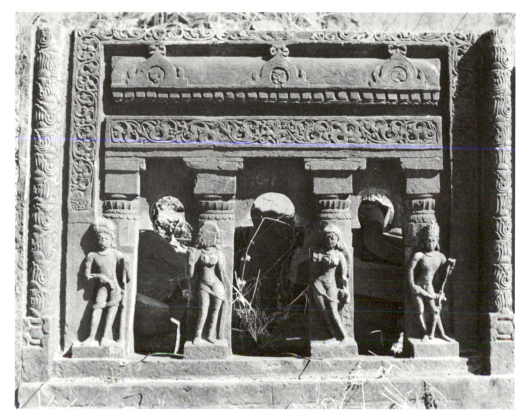

151. Nāchnā. Pārvatī Temple, rear window. 152 × 120 cm.

152. Nāchnā. Pārvatī Temple, *nāga* window (now in Mahādeva Temple). 89 × 85 cm.

153. Nāchnā. Pārvatī Temple (?), *gaṇa*. 61 × 41 × 22 cm.

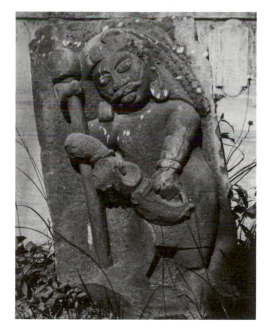

154. Nāchnā. Pārvatī
Temple, doorway.
Opening 170 × 81
cm.

155. Nāchnā. Doorway built into Mahādeva Temple, ca. 495–505. Opening 105 × 95 cm.

156. Nāchnā. Lintel fragment from doorway in Plate 155 (now in *caukidār*'s house). 106 × 31 cm.

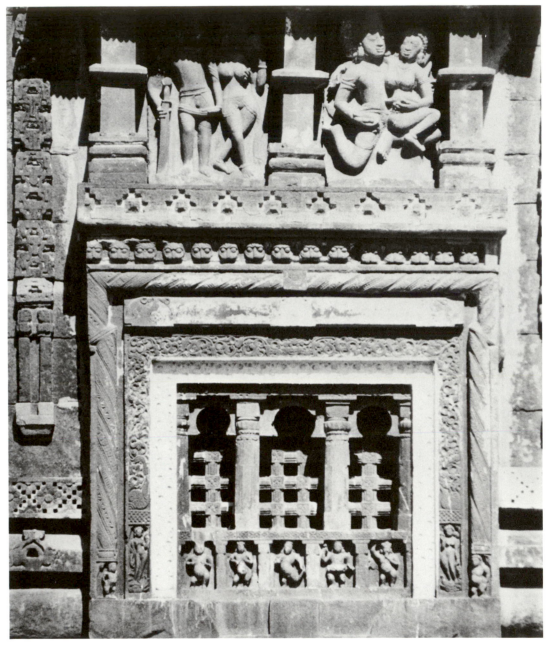

157. Nāchnā. Window inset
in Mahādeva Temple, ca.
500. Ca. 150 cm. square.

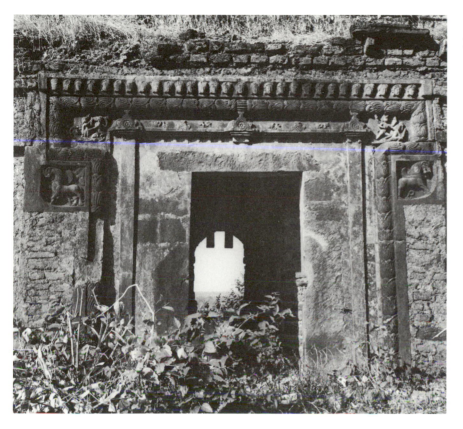

158. Nāchnā. Kumrā Maṭh, south doorway, ca. 500–520. Lintel 292 × 50 cm.

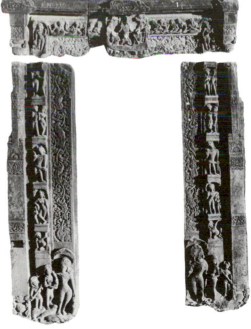

159. Nāchnā. Kumrā Maṭh, doorway found on west side, ca. 500–520. Opening 184 × 84 cm.

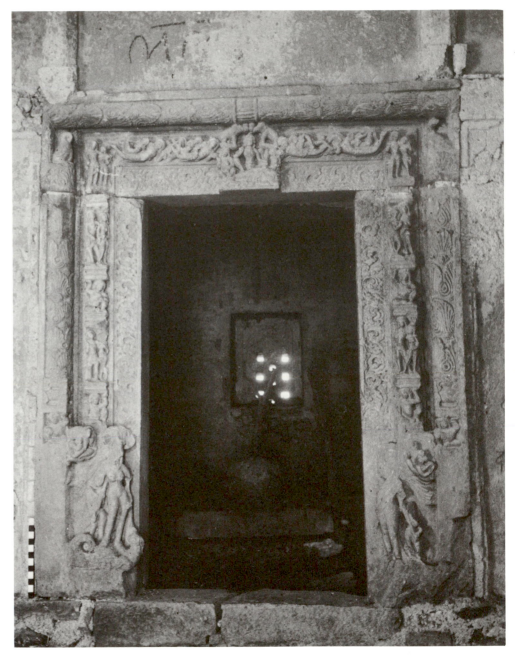

160. Nāchnā. Rupnī-ka Mandir,
 interior doorway, ca. 530–540.
 Opening 157 × 97 cm.

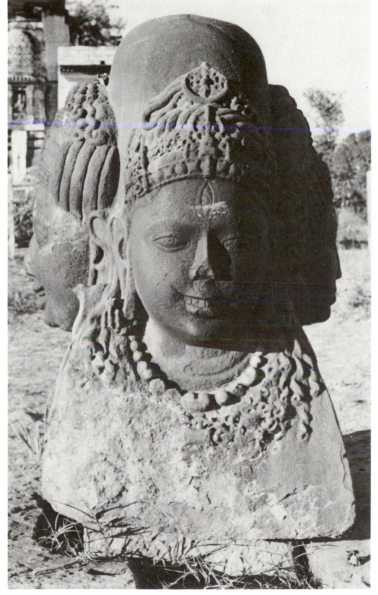

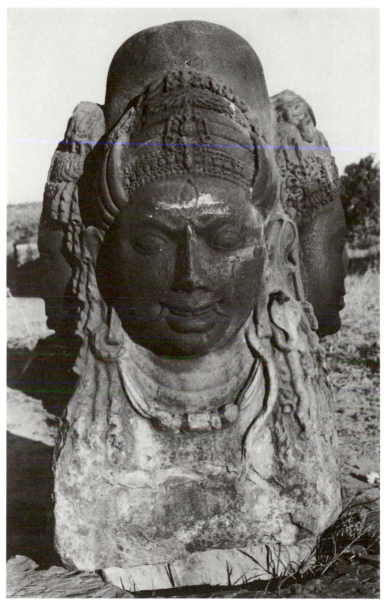

161. Nāchnā. *Liṅga*, ca. 500. 97 × 47 cm.

162. Plate 161, second view.

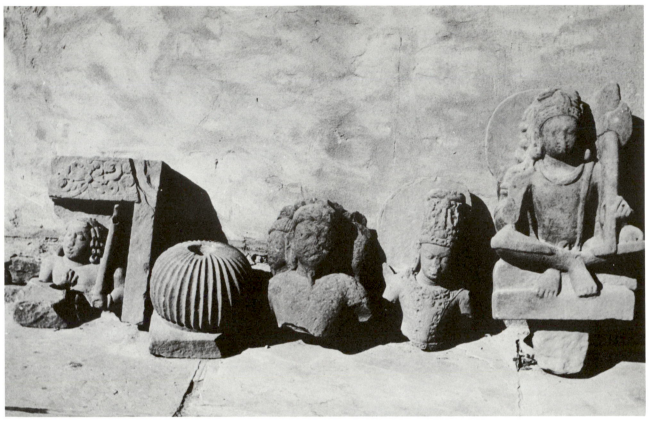

163. Nāchnā. *Āmalaka* stone and miscellaneous images at site, 1965. *Āmalaka* ca. 40 cm. high.

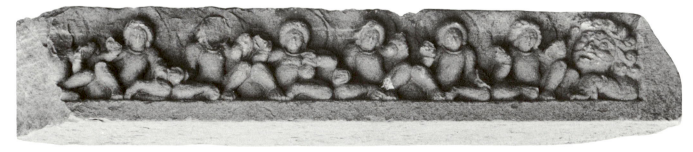

164. Nāchnā. Planetary frieze at site, 1965, ca. 500. Ca. 100 × 20 cm.

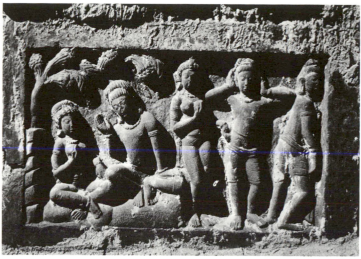

165.

165. Nāchnā. *Rāmāyaṇa* scene (Sītā and Lakṣmaṇa), ca. 500–510. 68 × 43 cm.

166. Nāchnā. *Rāmāyaṇa* scene (Sītā and Rāvaṇa). 68 × 43 cm.

167. Nāchnā. *Rāmāyaṇa* scene (Hanuman, Rāma, and Lakṣmaṇa). 68 × 43 cm.

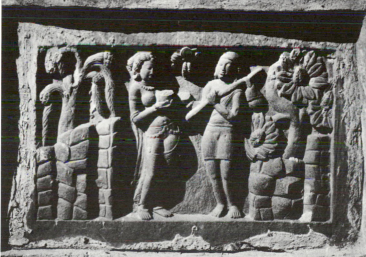

166.

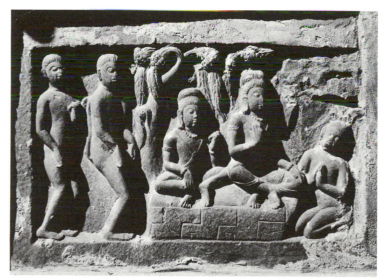

167.

168. Nāchnā. *Rāmāyaṇa* scene (Vālin and Sugrīva's fight). 68 × 43 cm.

169. Nāchnā. *Rāmāyaṇa* scene (Rāma shoots at Vālin). 68 × 43 cm.

170. Nāchnā. *Rāmāyaṇa* scene (Hanuman in Laṅkā). 68 × 43 cm.

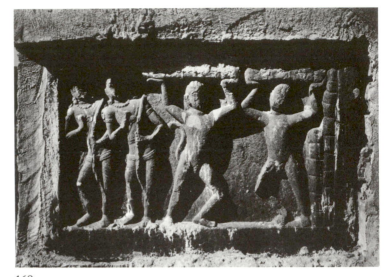

168.

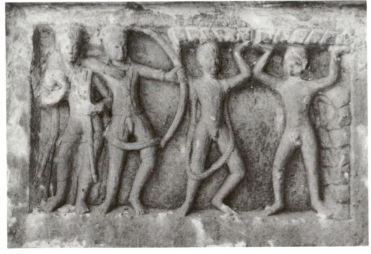

169.

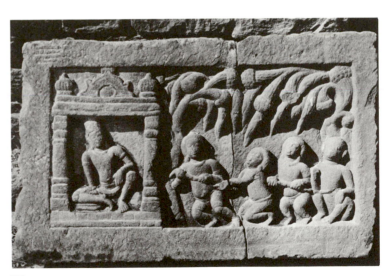

170.

171. Khoh. *Liṅga*, ca. 500. 64 cm. high.

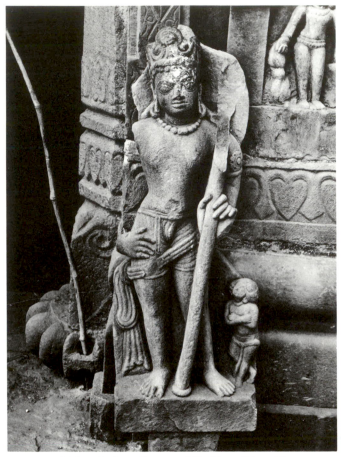

172. Nand Chand. Guardian, ca. 510. 80 × 27 × 11 cm.

173. Nand Chand. Guardian, ca. 530-550. 245 × 98 × 30 cm.

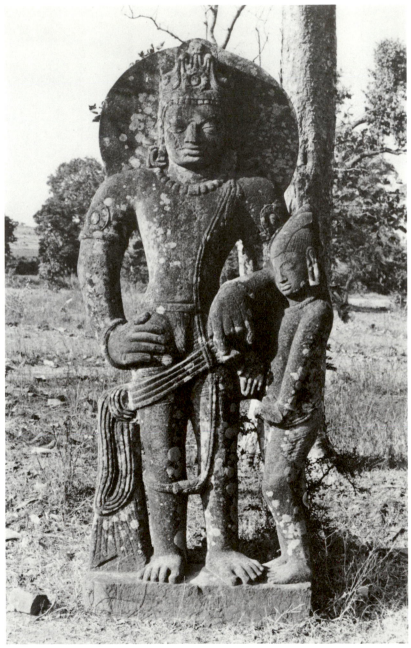

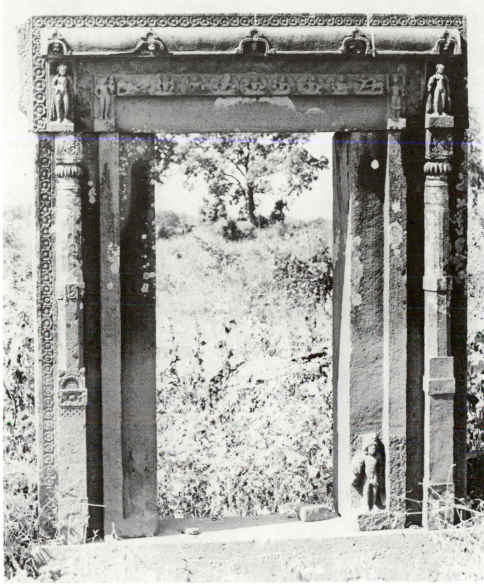

174. Pipariya. Doorway, ca. 510–520. Opening 194 × 83 cm.

175. Pipariya. Bands from doorway, ca. 510–520. 24 cm. wide.

176. Pipariya. Column, ca. 510–
520. Top 35 cm. square.

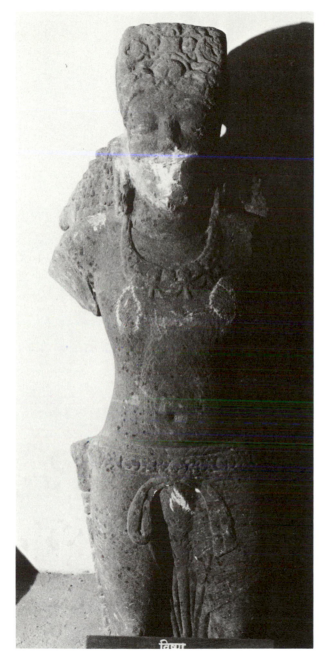

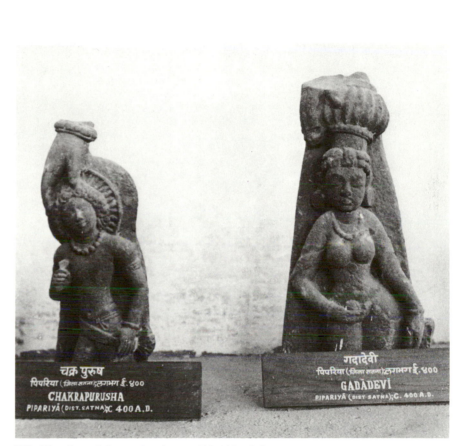

177. Pipariya. Viṣṇu, ca. 510–520.
107 × 35 × 23 cm.

178. Pipariya. *Cakra* and *gadā*, ca. 510–520. *Cakra* 43 × 14 cm.

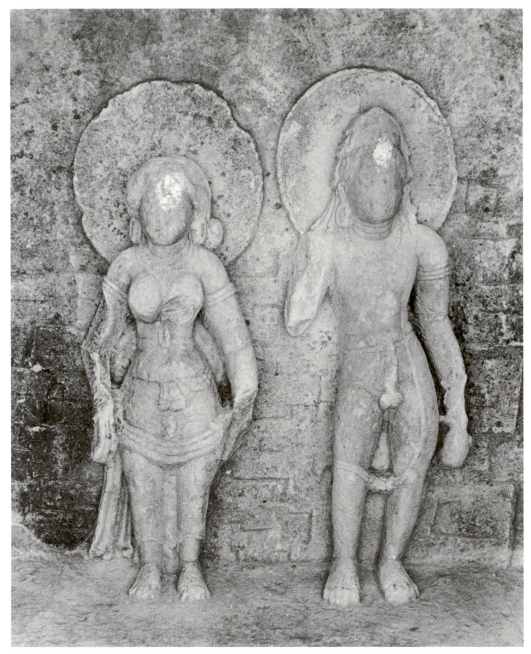

179. Śaṅkargaḍh. Śiva and Pārvatī,
rock-cut, ca. 520. 50 cm. high.

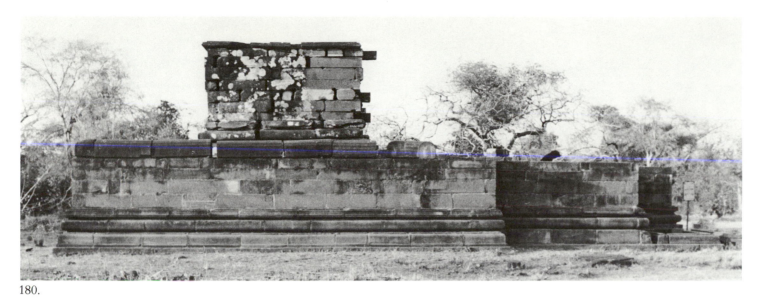

180.

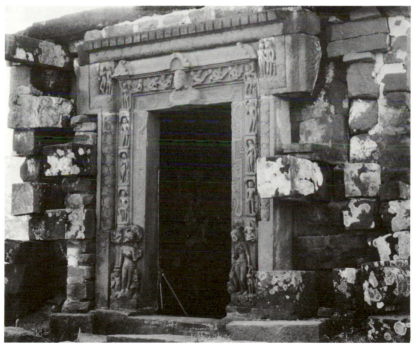

180. Bhumara. Śiva Temple, ca. 520–
530.
181. Bhumara. Śiva Temple, doorway.
Opening 182 × 90 cm.

181.

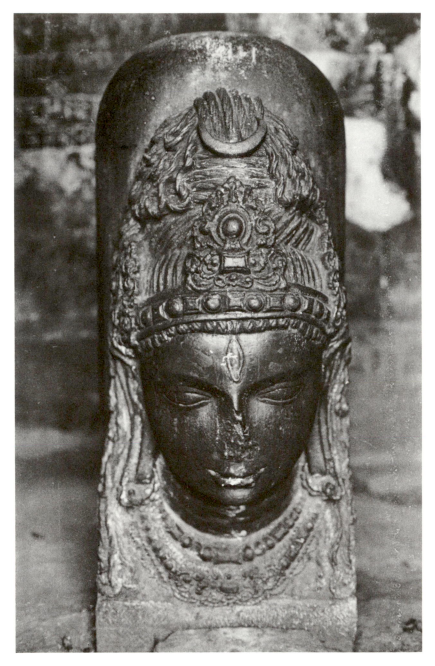

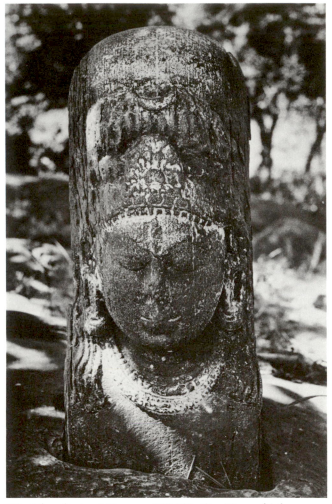

183. Khamharia. *Liṅga*, ca. 520–530. Ca. 40 cm. high.

182. Bhumara. *Liṅga* in temple. 98 × 44 cm.

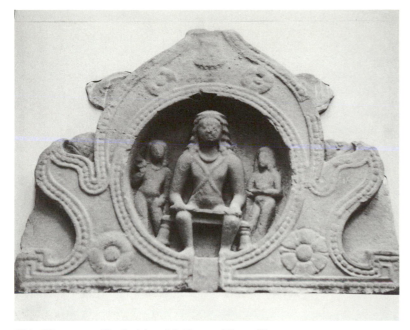

184. Bhumara. *Candraśālā* with Yama. 79 × 60 cm.

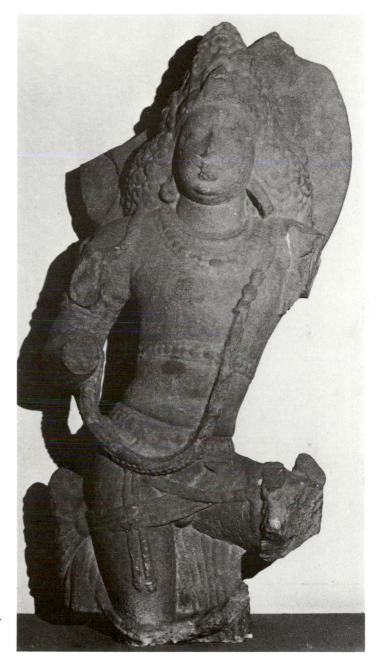

185. Bhumara. Guardian. 110 cm. high.

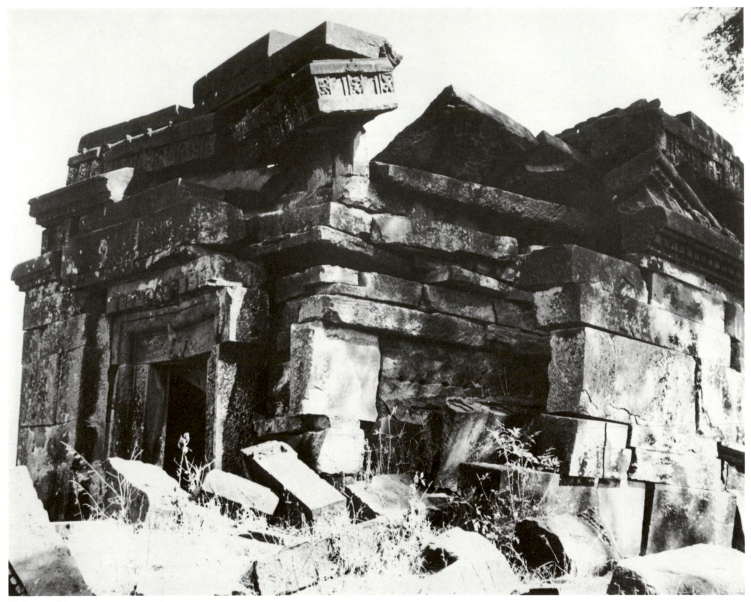

186. Maṛhiā. Vāmana Temple, ca. 530-540.

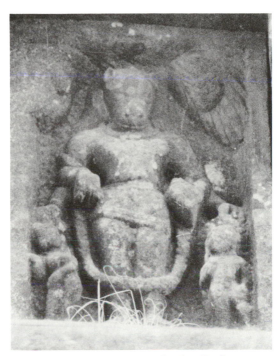

187. Maṛhiā. Vāmana Temple, detail of superstructure, Hayagrīva.

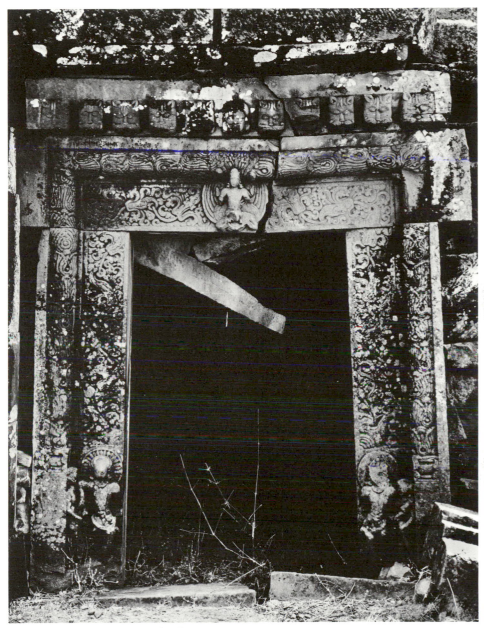

188. Maṛhiā. Vāmana Temple, doorway. Opening 137 × 81 cm.

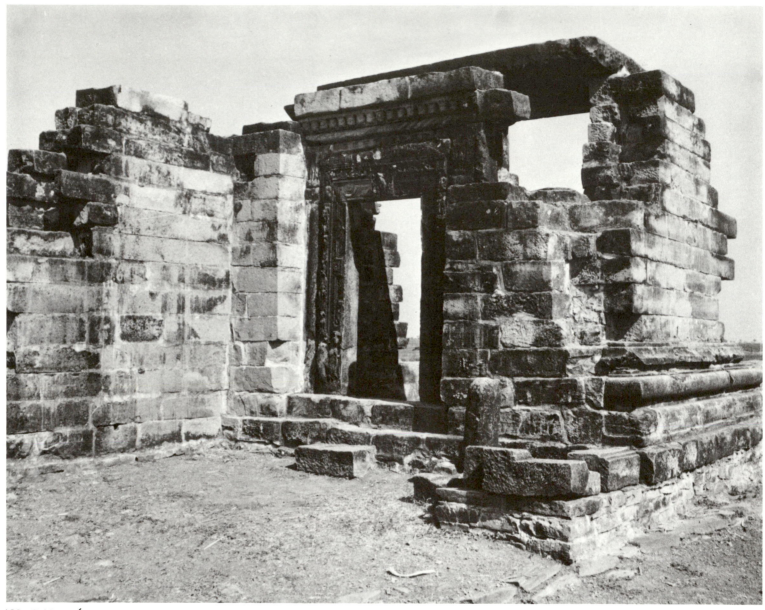

189. Sakhor. Śiva Temple, ca. 530.

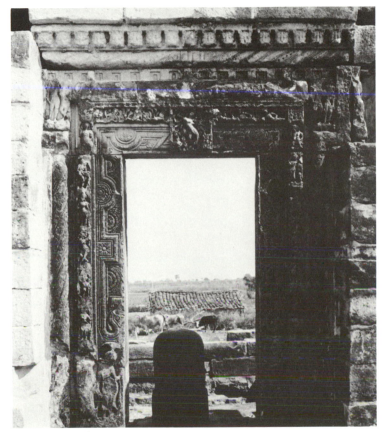

190. Sakhor. Śiva Temple, doorway. Opening 190 × 80 cm.

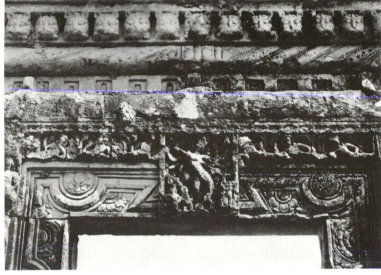

191. Detail of Plate 190.

192. Tala. Devarāni Temple, side, ca. 480–530.

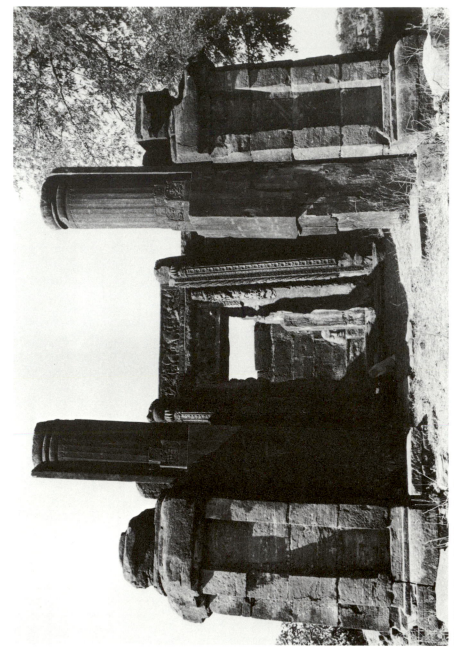

193. Tala. Devarāni Temple, front.

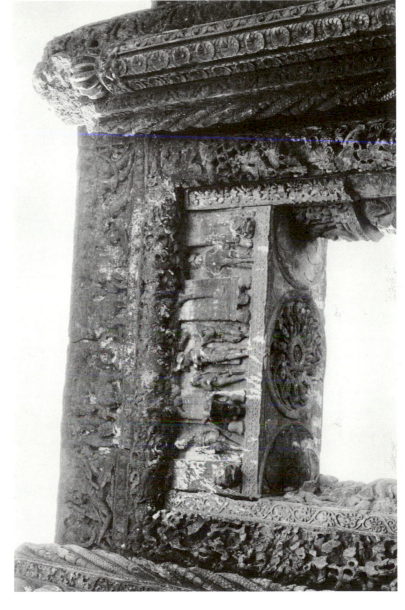

194.

195.

194. Tala. Devarāṇī Temple, jamb of inner doorway.

195. Tala. Devarāṇī Temple, lintel of inner doorway. Opening 216 × 115 cm.

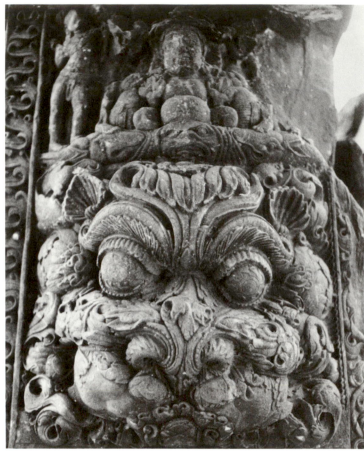

196. Tala. Devarānī Temple, side face of jamb. Ca. 110 cm. wide.

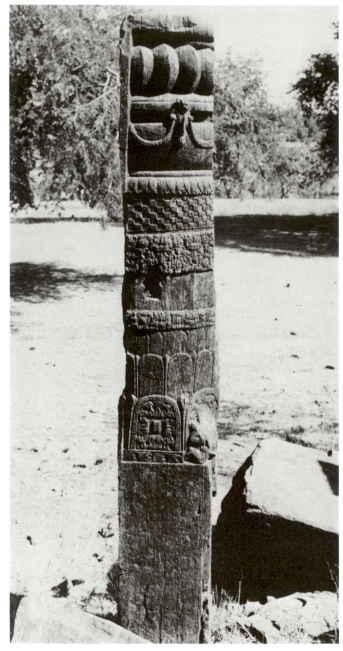

197. Tala. Jeṭhānī Temple, column fragment. Ca. 300 × 60 cm.

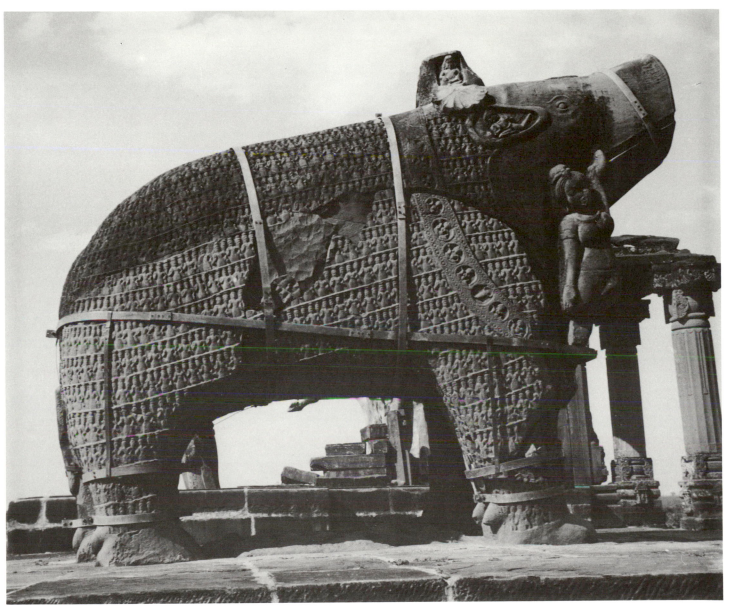

198. Eran. Varāha, ca. 490. Ca. 350 × 320 cm.

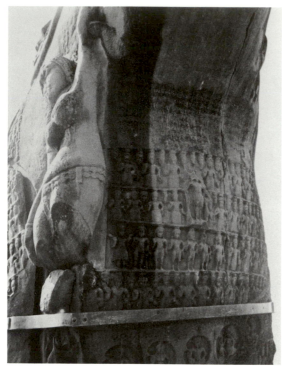

199. Detail of Plate 198 (neck).

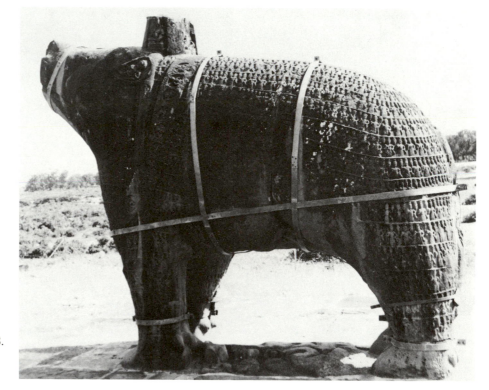

200. Opposite side of Plate 198.

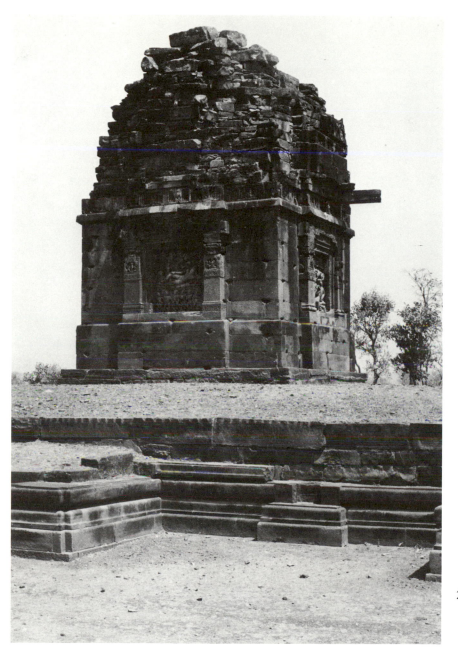

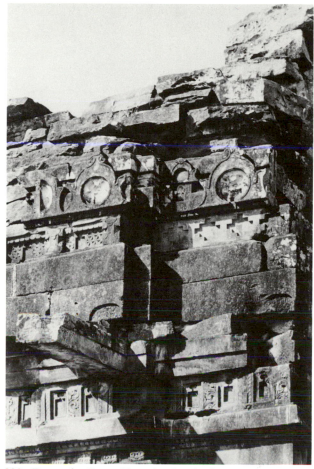

202. Deogarh. Gupta Temple, detail of superstructure on east.

201. Deogarh. Gupta Temple, view from southeast, ca. 500–550.

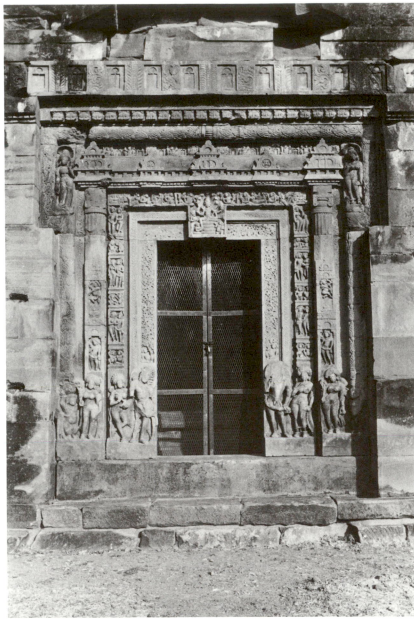

203. Deogarh. Gupta Temple, doorway. Opening 211 × 102 cm.

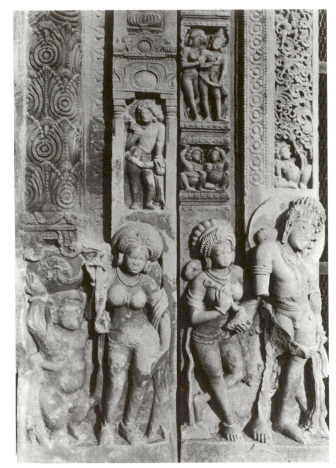

204. Deogarh. Gupta Temple, detail of doorway.

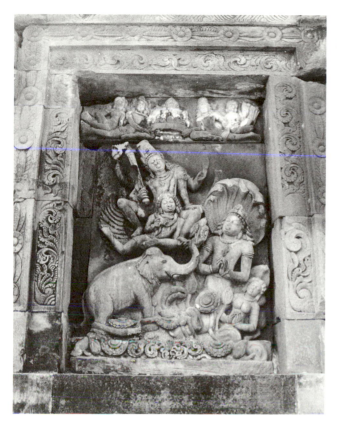

205. Deogarh. Gupta Temple,
Gajendramokṣa. 154 × 103
cm.

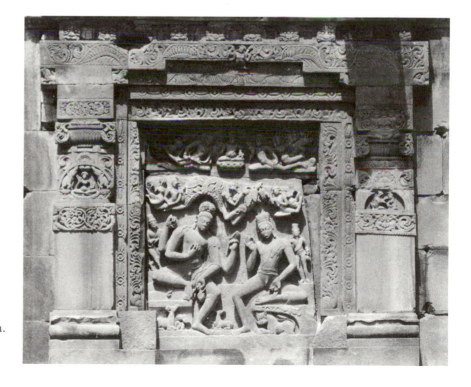

206. Deogarh. Gupta Temple,
Nara-Nārāyaṇa. 157 × 120 cm.

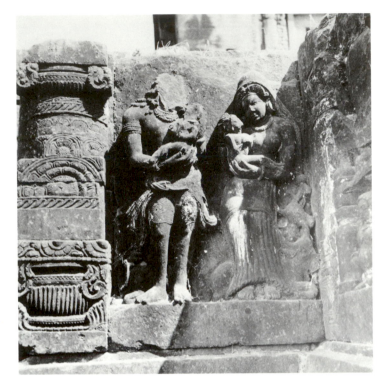

207. Deogarh. Gupta Temple,
plinth panel of Kṛṣṇa and
Balarāma (?). Ca. 80 cm. high.

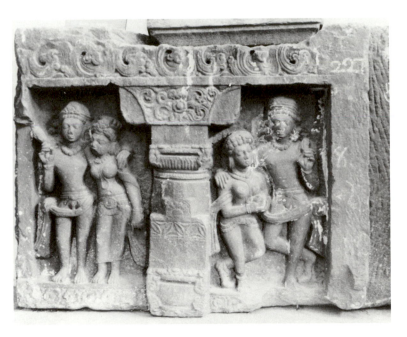

208. Deogarh. Gupta Temple,
plinth frieze. Ca. 50 cm. high.

210. Deogarh, Rajghati. Saptamātṛkās, ca. 550. 150 × 30 cm.

209. Deogarh. Pillar. Ca. 300 cm. high.

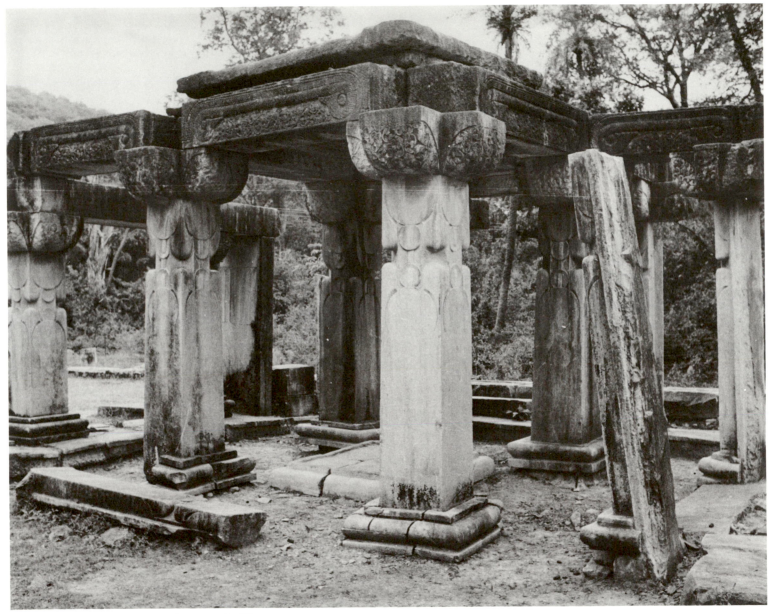

211. Mukuṅdara. Ruined temple, ca. 475–485.

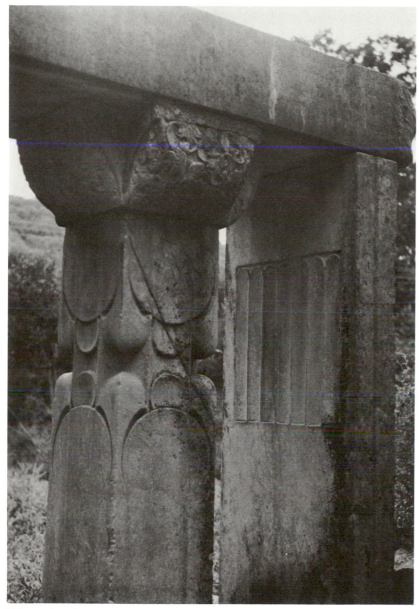

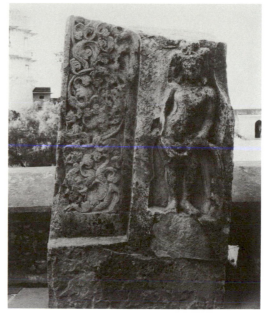

213. Mukuṅdara. Jamb fragment. 101 × 58 × 38 cm.

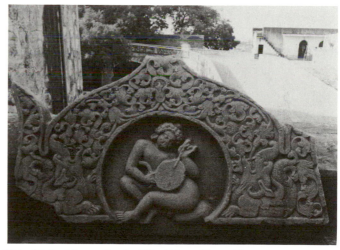

212. Mukuṅdara. Column. Shaft ca. 50 cm. wide.

214. Mukuṅdara. *Candraśālā*. 118 × 71 × 18 cm.

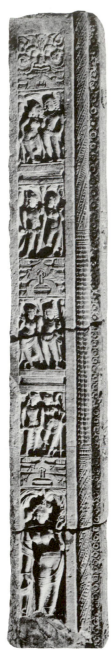

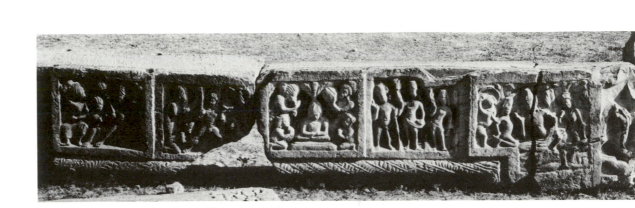

216. Nagarī. *Toraṇa* crossbar. 328 × 65 × 38 cm.

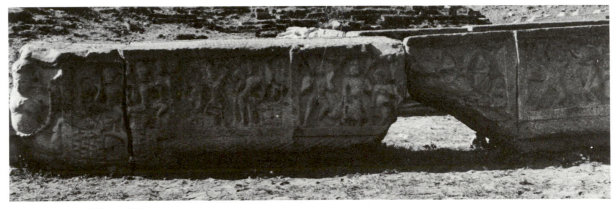

217. Reverse of Plate 216.

215. Nagarī. *Toraṇa* post, ca. 510–520. 434 × 46 × 60 cm.

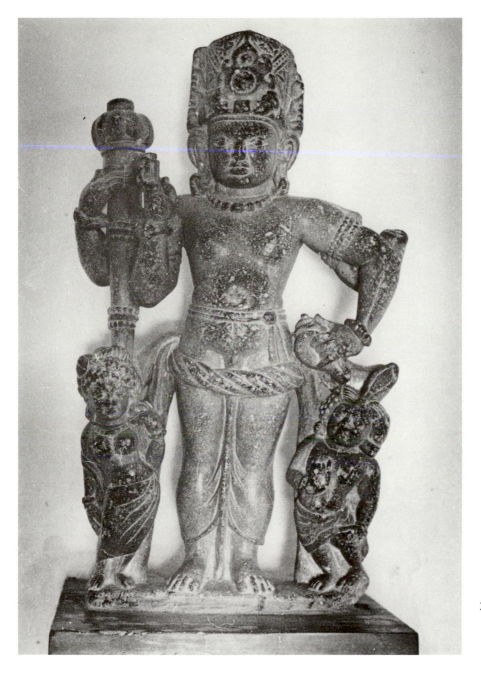

218. Mandasor. Viṣṇu, ca. 500. Ca.
60 cm. high.

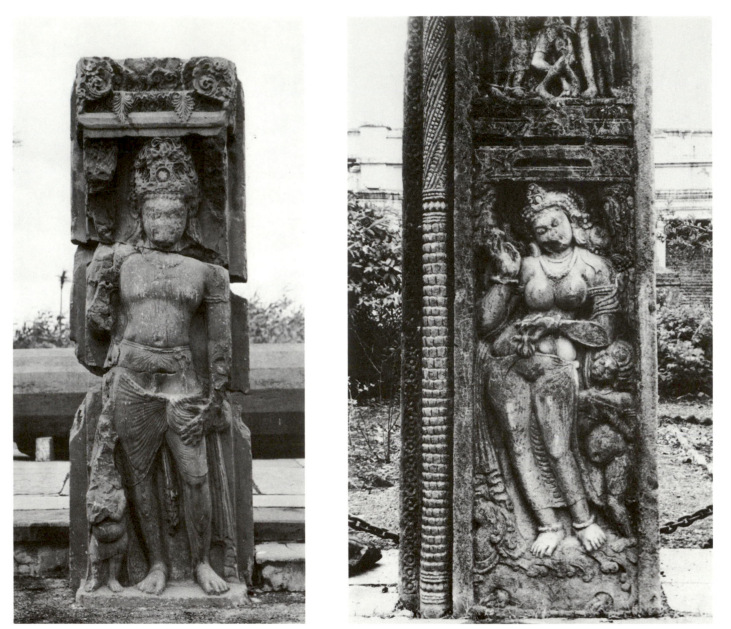

219. Mandasor, Soṅdni. Guardian, ca. 530–540.
260 × 83 × 50 cm.

220. Mandasor, Khilchipura. *Toraṇa* post, ca. 530–540. 560 cm. high.

221. Mandasor. Śaiva figure, built
into Mahādeva and
Sitalamātā Temple, ca. 530–
540. Ca. 100 × 75 cm.

222. Bhinmal. Viṣṇu, ca. 500. Ca. 45 cm. high.

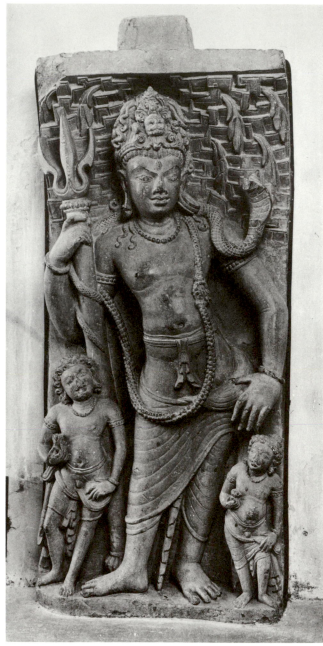

223. Śāmalājī. Guardian, ca. 510-520. 88 × 40 cm.

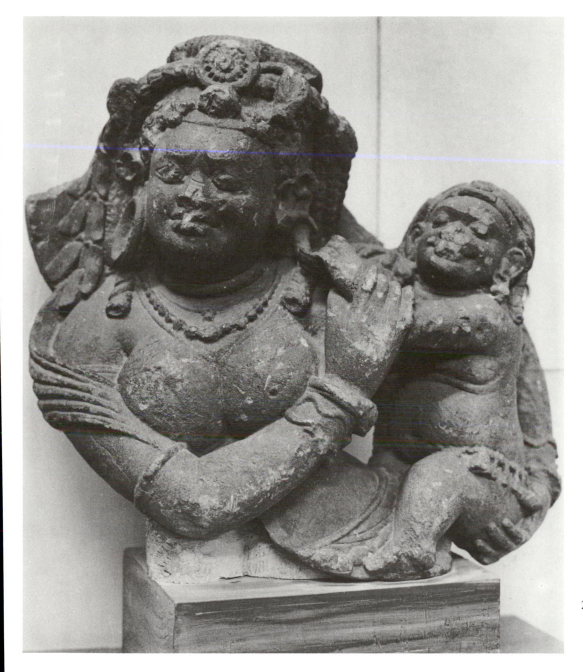

224. Śāmalājī. Mother, ca. 550. 39 × 37 cm.

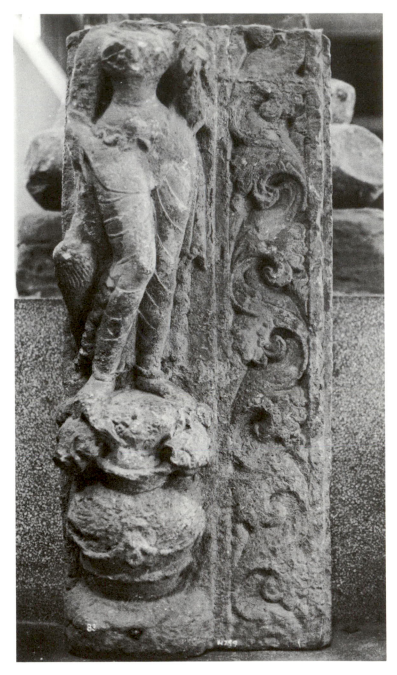

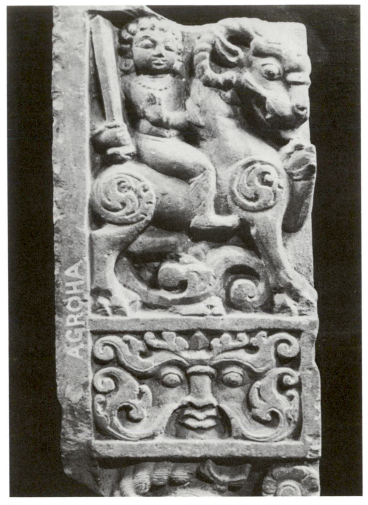

226. Agroha. Jamb fragment, ca. 500–520. 45 × 20 cm.

225. Murti. Jamb fragment, ca. 500–520. 80 × 37 cm.

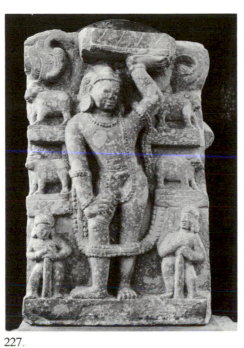

227.

227. Mathurā, findspot Gatāśrama Narain Ṭīlā. Kṛṣṇa lifting Mt. Govardhana, ca. 510-530. 55 × 48 × 12 cm.

228. Mathurā. Pillar with Yamunā, ca. 500. 118 × 19 cm.

229. Mathurā. *Candraśālā* with Lakulīśa, ca. 500. 99 × 63 × 13 cm.

228.

229.

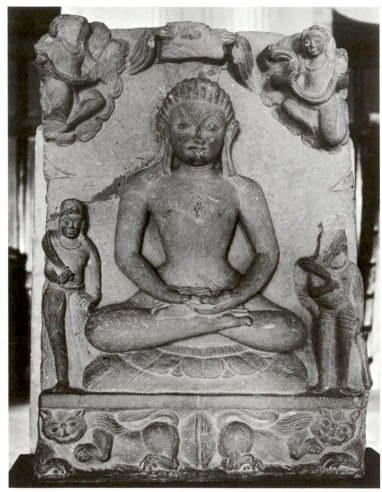

230. Mathurā. Ṛṣabhanātha, ca. 530–550. 65 × 44 × 11 cm.

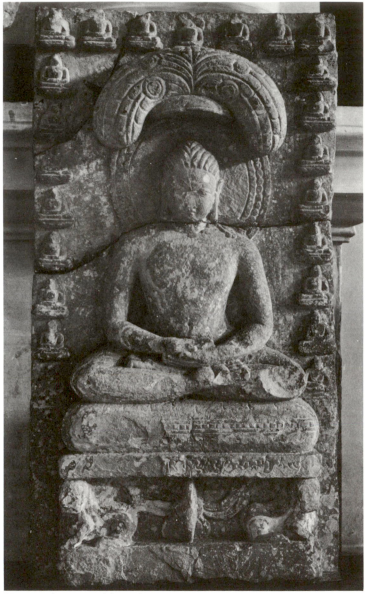

231. Mathurā. Ṛṣabhanātha, ca. 550. 96 × 50 × 6 cm.

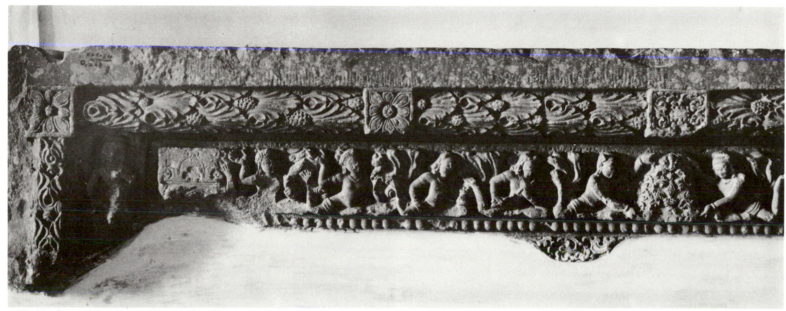

232. Mathurā. Lintel, ca. 490. 234 × 40 × 30 cm.

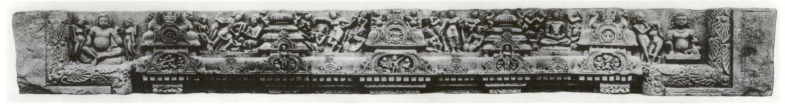

233.

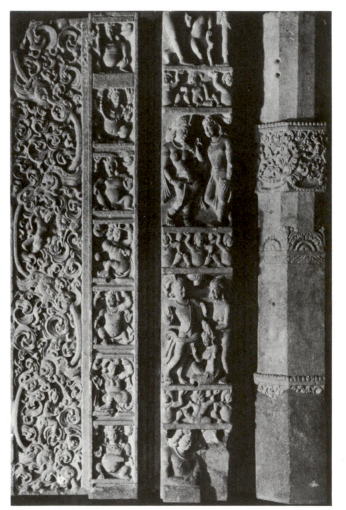

233. Sārnāth. Kṣantivādin lintel, ca. 500–525. 492 × 56 × 40 cm.

234. Sārnāth. Door jamb, ca. 500. Ca. 125 cm. high.

234.

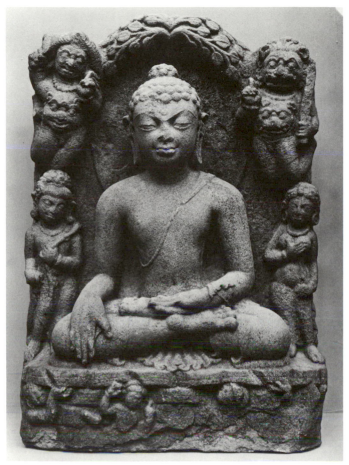

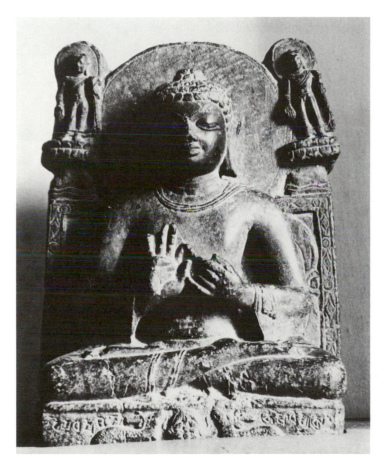

235. Sārnāth. Buddha's victory over Mara, ca. 525. Ca. 80 cm. high.

236. Telhara. Buddha, ca. 500. 37 cm. high.

237. Bodh Gayā. Railing post, Tortoise Jātaka, ca. 500. Ca. 40 cm. wide.

238. Rajaona. Pillar, Arjuna story, ca. 500. 43 cm. square.

239. Rajaona, second face of column in Plate 238.

240. Rajaona, third face of column in Plate 238.

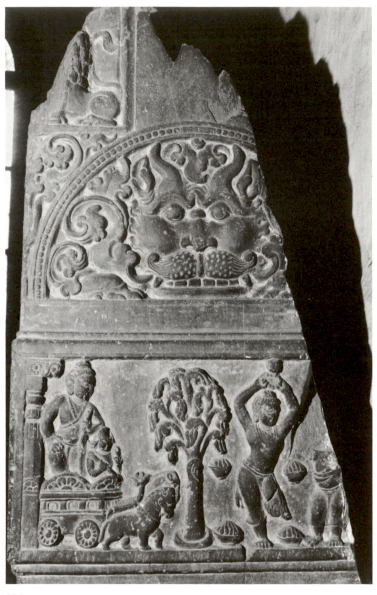

238.

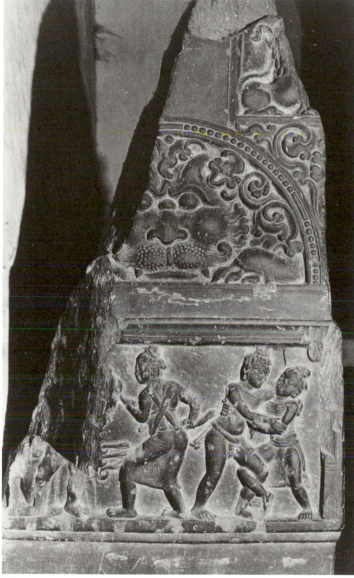

239.

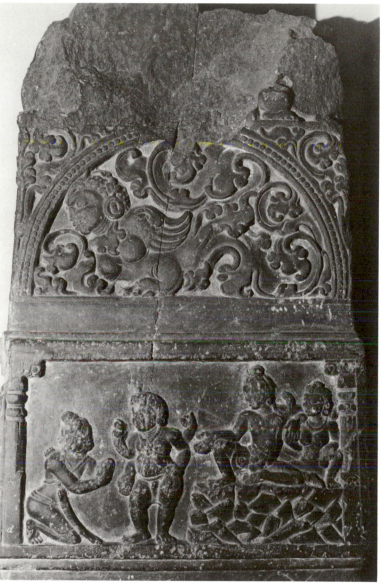

240.

241. Gaḍhwa. Pillar 16, side face. 114 × 46 × 28 cm.

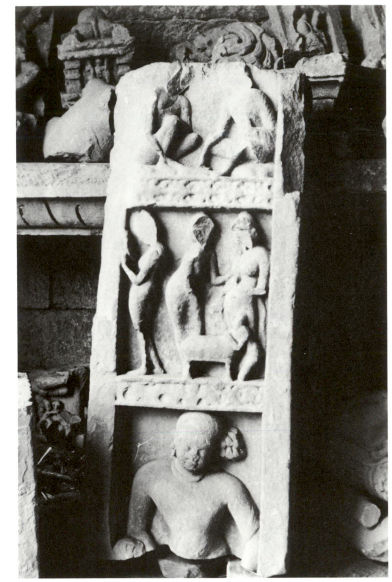

242. Gaḍhwa, front face of pillar in Plate 241.

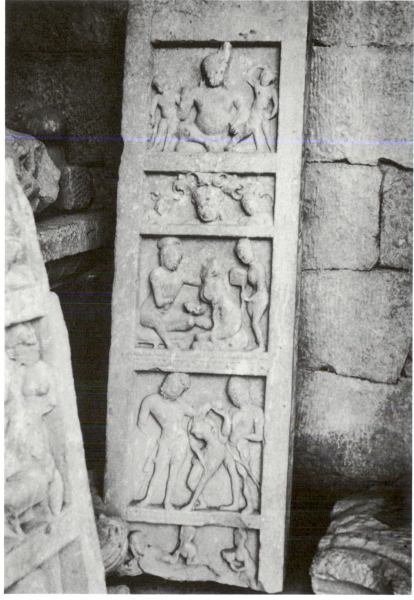

243. Gaḍhwa. Pillar 15. 158 × 46 × 28 cm.

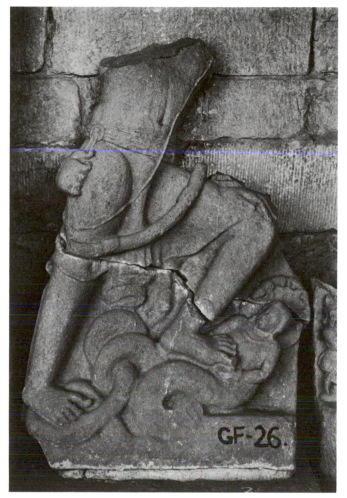

244. Gaḍhwa. Varāha, ca. 485. 119 × 70 × 18 cm.

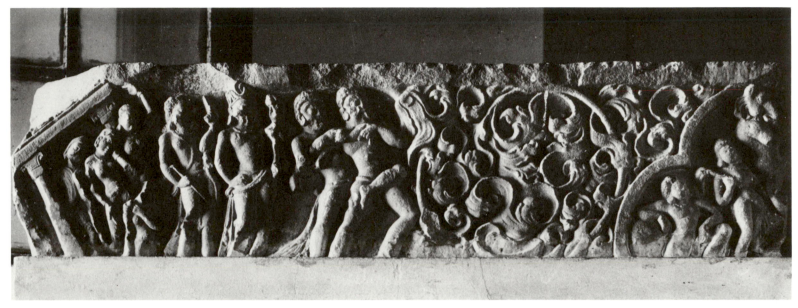

245. Gaḍhwa. Frieze of Bhīma fighting Jarāsaṇḍh, ca. 485. Ca. 150 cm. long.

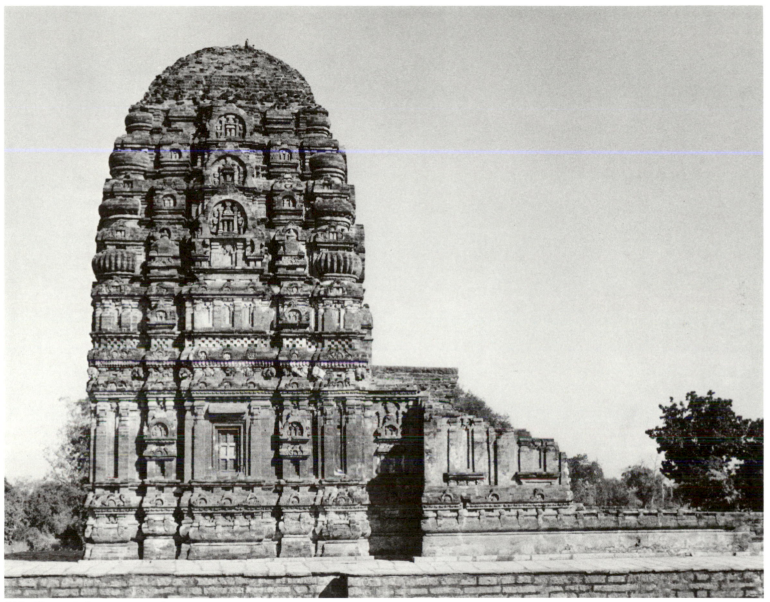

246. Sirpur. Lakṣmaṇa Temple, ca. 600.

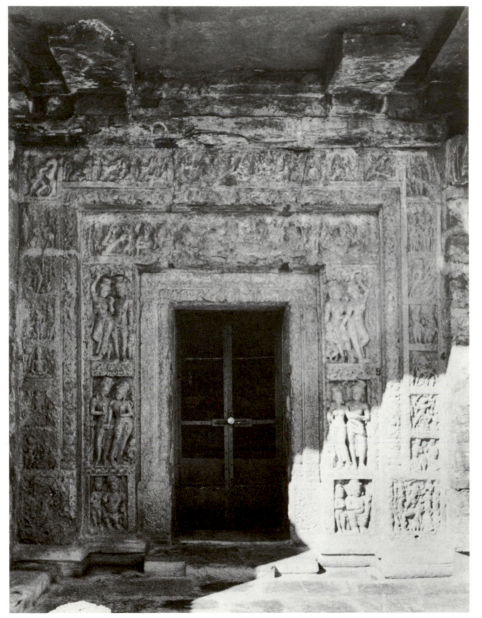

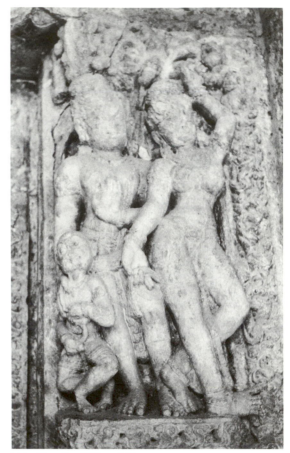

248. Detail of Plate 247.

247. Sirpur. Lakṣmaṇa Temple, door to shrine. Opening 200 × 100 cm.

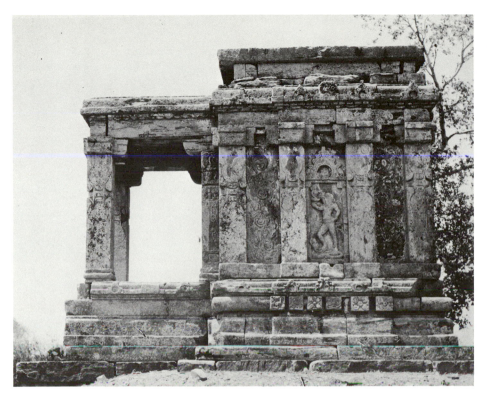

249. Mahua. Smaller Śiva Temple, north face, Varāha, ca. 600–650.

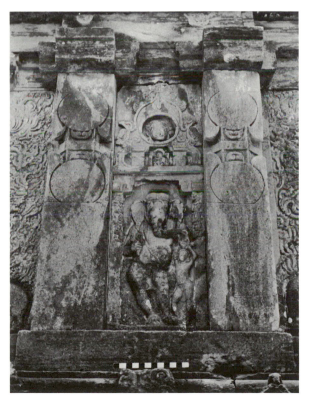

250. Mahua. Smaller Śiva Temple, south face, Gaṇeśa.

251. Gyaraspur. *Stūpa*, ca. 575-650.

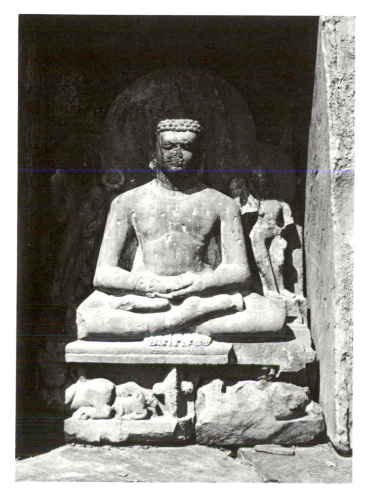

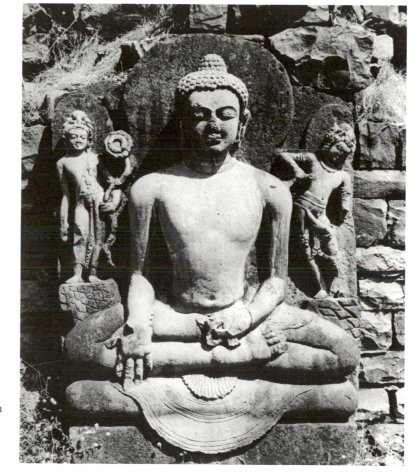

252. Gyaraspur. Buddha on east side. 158 × 109 × 48 cm.

253. Gyaraspur. Buddha on south side. 174 × 104 × 33 cm.

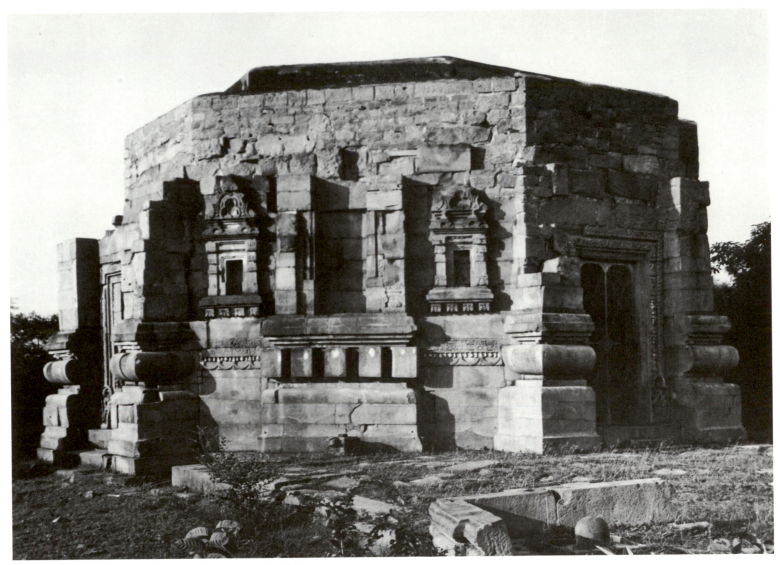

254. Muṇḍeśvarī. Shrine from southwest, ca. 600–650.

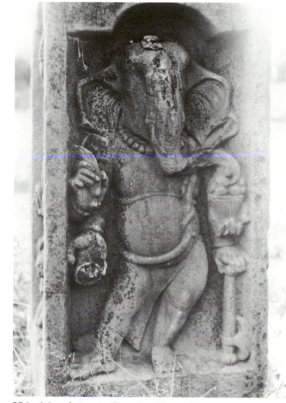

256. Muṇḍeśvarī. Gaṇeśa. 59 × 35 cm.

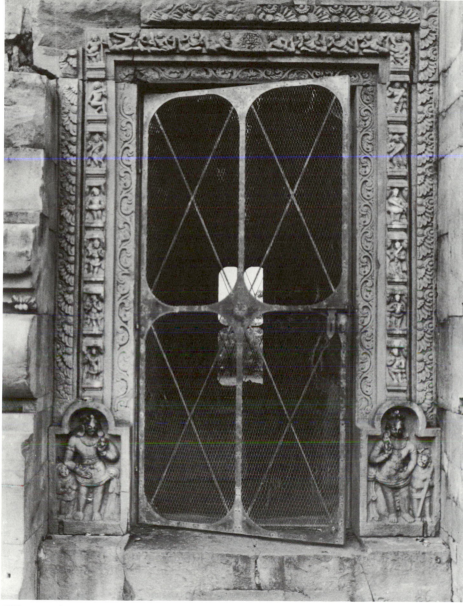

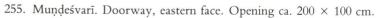

255. Muṇḍeśvarī. Doorway, eastern face. Opening ca. 200 × 100 cm.

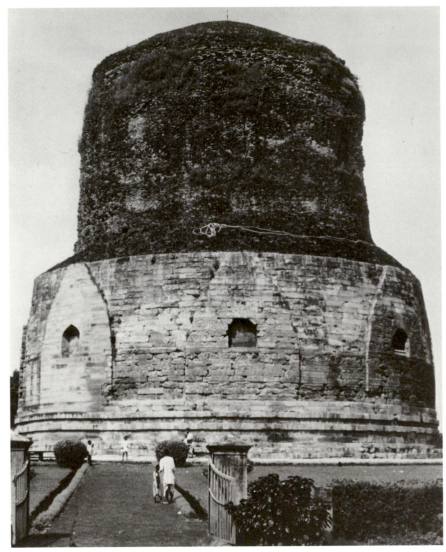

257. Sārnāth. Dhamekh *Stūpa*, ca. 600–650.

258. Detail of Plate 257.

259. Sārnāth. Lintel fragment, ca. 600. 105 × 42 cm.

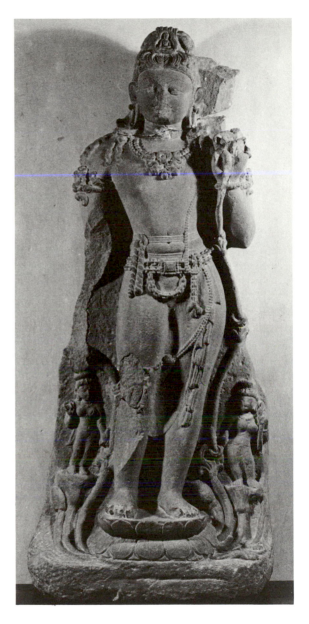

260. Sārnāth. Siddhaikavīra, ca. 650.
6. 120 cm. high.

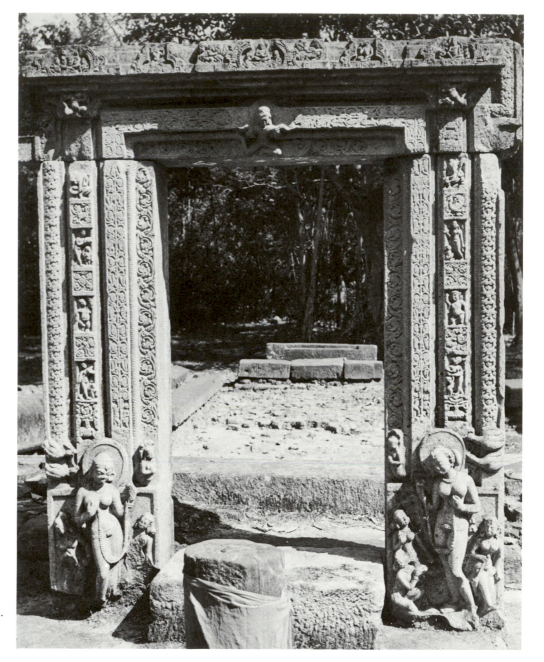

261. Tezpur, Dah Parbatiya.
Doorway, ca. 600–650.
Opening ca. 180 × 90 cm.

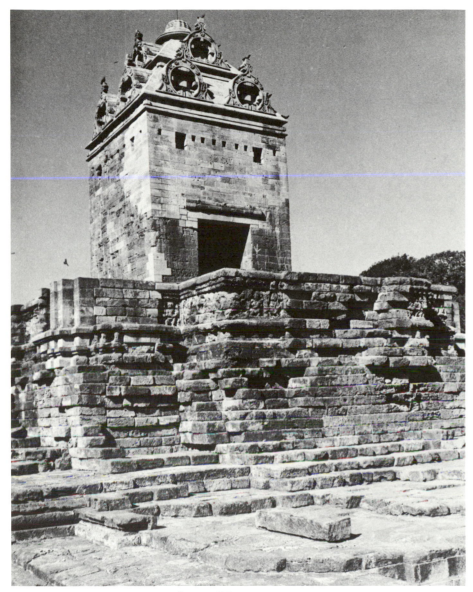

262. Gop. Jhiṇāvarī Gop Temple, ca. 600.

263. Gop. Jhiṇāvarī Gop Temple base.

264. Udaipur. Durgā, ca. 600. 99 × 45
× 13 cm.

265. Mandor. Saptamātṛkās, ca. 600–650.
200 × 60 cm.

264.

265.

266. Sārnāth. Buddha, First Sermon, 9th–11th c. 110 × 72 cm.

267. Nāchnā. Caturmukh *liṅga* in
Mahādeva Temple, 8th c.
Ca. 130 cm. high.

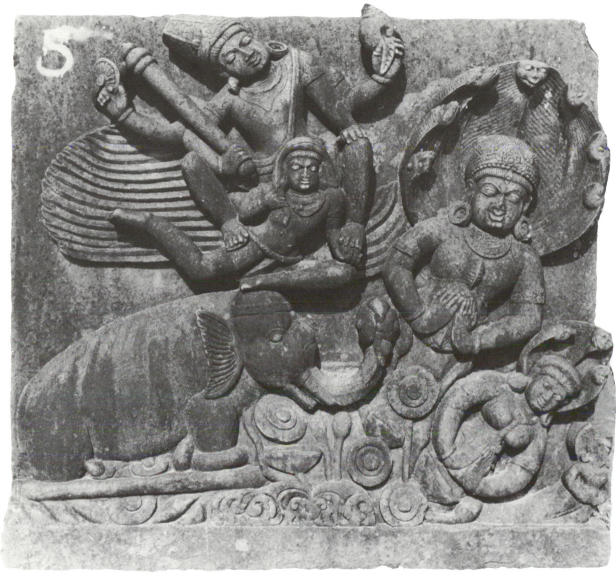

268. Deogarh. Varāha Temple, Gajendramokṣa, 8th c. 123 × 114 cm.